Bauhaus Effects in Art, Architecture, and Design

C000193156

Bringing together an international team of scholars, this book offers new perspectives on the impact that the Bauhaus and its teaching had on a wide range of artistic practices.

Three of the fields in which the Bauhaus generated immediately transformative effects were housing, typography, and photography. Contributors go further to chart the surprising relation of the school to contemporary developments in hairstyling and shop window display in unprecedented detail. New scholarship has detailed the degree to which Bauhaus faculty and students set off around the world, but it has seldom paid attention to its impact in communist East Germany or in countries like Ireland where no Bauhäusler settled. This wide-ranging collection makes clear that a century after its founding, many new stories remain to be told about the influence of the twentieth century's most innovative arts institution.

The book will be of interest to scholars working in art history, design history, photography, and architectural history.

Kathleen James-Chakraborty, School of Art History and Cultural Policy, University College Dublin, Ireland.

Sabine T. Kriebel, Department of History of Art, University College Cork, Ireland.

Routledge Research in Art History

Routledge Research in Art History is our home for the latest scholarship in the field of art history. The series publishes research monographs and edited collections, covering areas including art history, theory, and visual culture. These high-level books focus on art and artists from around the world and from a multitude of time periods. By making these studies available to the worldwide academic community, the series aims to promote quality art history research.

For more information about this series, please visit: www.routledge.com/Routledge-Research-in-Art-History/book-series/RRAH

Bauhaus Effects in Art, Architecture, and Design

Edited by
Kathleen James-Chakraborty
and Sabine T. Kriebel

Routledge
Taylor & Francis Group

NEW YORK AND LONDON

Cover image: Kabuki, 1981
Hair by Tim Hartley for Vidal Sassoon
Color and Perm by John Besson
Photograph by Al MacDonald
Image courtesy of SASSOON

First published 2022

by Routledge
605 Third Avenue, New York, NY 10158

and by Routledge
4 Park Square, Milton Park, Abingdon, Oxon, OX14 4RN

Routledge is an imprint of the Taylor & Francis Group, an informa business

© 2022 selection and editorial matter, Kathleen James-Chakraborty and
Sabine T. Kriebel; individual chapters, the contributors

The right of Kathleen James-Chakraborty and Sabine T. Kriebel to be
identified as the authors of the editorial material, and of the authors for
their individual chapters, has been asserted in accordance with sections 77
and 78 of the Copyright, Designs and Patents Act 1988.

All rights reserved. No part of this book may be reprinted or reproduced or
utilised in any form or by any electronic, mechanical, or other means, now
known or hereafter invented, including photocopying and recording, or in
any information storage or retrieval system, without permission in writing
from the publishers.

Trademark notice: Product or corporate names may be trademarks or
registered trademarks, and are used only for identification and explanation
without intent to infringe.

Library of Congress Cataloging-in-Publication Data
Names: James-Chakraborty, Kathleen, 1960- editor. | Kriebel, Sabine, editor.
Title: Bauhaus effects in art, architecture, and design / edited by Kathleen
 James-Chakraborty and Sabine T. Kriebel.
Description: New York : Routledge, 2022. | Includes bibliographical
 references and index.
Identifiers: LCCN 2021057882 (print) | LCCN 2021057883 (ebook) | ISBN
 9781032205397 (hardback) | ISBN 9781032214689 (paperback) | ISBN
 9781003268314 (ebook)
Subjects: LCSH: Bauhaus–Influence.
Classification: LCC N332.G33 B4265 2022 (print) | LCC N332.G33
 (ebook) | DDC 709.04–dc23/eng/20211217
LC record available at https://lccn.loc.gov/2021057882
LC ebook record available at https://lccn.loc.gov/2021057883

ISBN: 978-1-032-20539-7 (hbk)
ISBN: 978-1-032-21468-9 (pbk)
ISBN: 978-1-003-26831-4 (ebk)

DOI: 10.4324/9781003268314

Typeset in Sabon
by KnowledgeWorks Global Ltd.

Contents

Figures

Contributors

Kathleen James-Chakraborty is professor of art history at University College Dublin. Her books include *Modernism as Memory: Building Identity in the Federal Republic of Germany* (2018) and the edited collection *Bauhaus Culture from Weimar to the Cold War* (2006).

Sabine T. Kriebel teaches art history at University College Cork. She is the author of *Revolutionary Beauty: The Radical Photomontages of John Heartfield* (2014) and the co-editor with Andrés Mario Zervigón of *Photography and Doubt* (Routledge: 2016).

Kerry Meakin is the program chair of the BA in visual merchandising and display at the Technical University Dublin. Her article "The Bauhaus and the Business of Window Display – Moholy-Nagy's Endeavors at Window Display in London," appeared in 2021 in the *Journal of Design History*.

Ingrid Mayrhofer-Hufnagl is a postdoctoral fellow at the University of Innsbruck. Her book *Architecture, Futurability and Untimely: On the Unpredictability of the Past* is forthcoming.

Dietrich Neumann is professor of the history of art and architecture at Brown University where he also directs the John Nicholas Brown Center for Public Humanities. His books include *An Accidental Masterpiece: Mies van der Rohe's Barcelona Pavilion* (2020) and the edited collection *Architecture of the Night: The Illuminated Building* (2003).

Katharina Pfützner is a lecturer in product design at the National College of Art and Design in Dublin. She is the author of *Designing for Socialist Need: Industrial Design Practice in the German Democratic Republic* (Routledge, 2017).

Mariana Meneses Romero has lectured at Goldsmiths, University of London and held a postdoctoral fellowship at the Nottingham Trent University. She was a contributor to the *Bauhaus Imaginista* project.

Patrick Rössler is professor of communications at the University of Erfurt. His many Bauhaus-related publications include *Bauhausmädels. A Tribute to Pioneering*

Women Artists (2019) and *The Bauhaus and Public Relations: Communication in a Permanent State of Crisis* (Routledge, 2014).

Vanessa S. Troiano is a doctoral candidate in Art History at the Graduate Center of the City University of New York. She has taught at CUNY's Brooklyn and Queensborough campuses and Sotheby's Institute of Art. She received a Fulbright-funded teaching assistantship in Vienna and a Deutscher Akademischer Austausch Dienst (DAAD) scholarship at Goethe-Institut, Berlin.

Acknowledgments

This project began when Anne Fuchs, the director of the Humanities Institute at University College Dublin, proposed in 2018 that the three of us work together on a conference, which she entitled "Bauhaus Effects," to mark the centennial of the founding of the Bauhaus. We thank her for the great title and sense of intellectual direction. We quickly approached Thomas Lier and Heidrun Rottke of Goethe Institut, Dublin. They reported that they were already working with Francis Halsall, Declan Long, and Sarah Pierce of the National College of Art and Design on such an effort. We happily teamed up with them. Equally crucial to the success of the event was the support of the then German Ambassador to Ireland, Her Excellency Deike Potzel, who sponsored and attended the conference dinner after giving unusually thoughtful opening remarks. We also thank Catherine Heaney and her team at DHR for handling the publicity that resulted in the conference being widely covered by the Dublin media.

The conference was held from February 7 to 9, 2019 at the National Gallery of Ireland. We thank Sean Rainbird and his team, especially Sinead Rice, the Head of Education, for letting us use their auditorium. We are grateful to all of our speakers, including keynotes Heike Hanada and Irit Rogoff, as well as, in addition to the authors represented in this collection, Andrew McNamara, Jonathan Foote, Aleksi Lohtaja, Jan Frohburg, Jordan Troeller, Ruth Baumeister, Katarina Elvén, Suzanne Strum, and Philip Glahn for their contributions.

At UCD, we would also like to thank Orla Feely, Vice President for Research, for helping to fund the conference, as well as the support of the head of the School of Art History and Cultural Policy, Nicola Figgis, our school administrator Elizabeth Varley, and, finally, Carla Briggs, who handled everything related to IT and social media with her usual aplomb. Sarah Glennie, the director of the National College of Art and Design, was also instrumental in the success of the conference. At University College Cork, we thank Flavio Boggi, Head of the Discipline of History of Art.

Kathleen would particularly like to thank her sister Sally Murray James, graphic design trouble shooter extraordinaire. Sabine is grateful to Stephan Koch for his patience, support, and willingness to stare hard at Florence Henri photographs over the last several years, and to Linus Kriebel, who has been a steady fellow traveler since this project's inception.

Introduction

Kathleen James-Chakraborty and Sabine T. Kriebel

The centennial in 2019 of the founding of the Bauhaus, the twentieth century's most innovative and influential place to study art, architecture, and design, was marked by considerations of how its students and the pedagogical methods to which they were exposed circled the globe in the decades the followed. The nearly precise chronological overlap between the school's lifetime and that of Germany's first democracy, as well as the coincidence that both were established in Weimar and died in Berlin, lent itself especially well to soft power efforts on the part of the German government. These interpreted the school's legacy in ways that burnished Germany's reputation with audiences abroad. Already during the Cold War, both the United States and the Federal Republic had harnessed the Bauhaus to contemporary political goals. The 2019 effort was no longer simply intended, however, to tie modern art to political democracy. Instead, its purpose was to demonstrate the degree to which German architecture and design had served supported its export-based economy, including across the Global South. Germany, this expensive and expansive program of cultural outreach implied, was not only abreast of the global turn in art history but a source for diverse iterations of a universalizing modernism that encompassed economic and technological progress as well as artistic innovation.[1]

There was little that was soft, however, about the designs produced at the school, regardless of whether they featured Expressionist angles or hewed to a machined rectilinearity, and even less connection to contemporary attempts, almost entirely absent during the concurrent histories of the Bauhaus and the Weimar Republic, to project German cultural authority internationally.[2] Indeed, despite being founded in the same revolutionary ferment, the school never enjoyed the support of the national German government, being precariously funded instead at the state and local level. Moreover, charting the migration of its students, many of whom came from other European countries as well as from as far afield as the British Mandate of Palestine, Japan, and the United States, following the school's closure in 1933 conveniently overlooks the compromises that many Bauhäusler who remained in Germany made with the Third Reich, capitalist West, and Communist East Germany.[3] At the same time, focusing on what were indisputably the school's paradigm-changing pedagogies also overlooks the wide range of other fields on which it had an effect.

The present collection, based on a conference held at the National Gallery of Ireland in February 2019, is both a part of and a rejection of the approaches that dominated that year. The conference was generously funded by the German government, in our case through Goethe Institut, Dublin, and the German Embassy in

DOI: 10.4324/9781003268314-1

Ireland. Not surprisingly in consequence, the collection of chapters assembled here draws unprecedented attention both to the impact of the Bauhaus in Ireland and to the community of scholars in Ireland who are interested in the school, which is surprisingly robust despite the fact that Ireland sent only one student, Stella Steyn, to the Bauhaus and, following its closure, sheltered no one directly affiliated with it. The school's Irish reception is thus important for the degree to which it sits entirely outside the narratives privileged in most places in 2019. But specifically, Irish perspectives do not dominate this collection, even if many of the contributors live and work there. Instead, the goal is to demonstrate the wide range of practices upon which the school had an effect. These are astonishingly diverse and enduring.

The term "effects" stands in for the various operations of transmission, as multifarious as the individuals who have adopted and transformed Bauhaus ideas and practices. Rooted in process and change, the word "effect" names the state of becoming operative through a stimulus or action.[4] Sometimes stealthy and surprising, at other times more overtly derived, the repercussions of Bauhaus innovation were far reaching and often unpredictable. They were also temporally erratic, ranging from immediate or synchronic impacts on architecture, design, or photography in the 1920s and 1930s, to diachronic impacts, resting dormant only to reemerge in contexts as unexpected as counter-cultural hair design or millennial digitality. As many of our contributions illustrate, process mattered as much as product, conception was as legitimate as thing. Far from being a passive vessel, the recipient of ideas remains an active agent in shaping interpretation, and history, as Michael Baxandall is at pains to remind us.[5] In the case of Bauhaus effects, those agents of interpretation may be individual artists, collective exhibitions, or periodicals and books generated in collaboration; that is, they may originate in mind, in material, or in spatiality. Aesthetic practitioners, whether acting singly or in groups, respond purposefully to local, historical circumstances, negotiating a rich semiotic field by finding solutions to their visual problems through assimilating, aligning, paraphrasing, reviving, remodeling, subverting, reconstituting, or extracting from existing paradigms. Anyone familiar with Baxandall's text will recognize the array of active verbs; there are many more in this volume to describe the various reconfigurations of Bauhaus ideas in the course of time. Importantly, in charting these "effects," the Bauhaus has been repositioned also, its legacy shifting however modestly in the discursive field, becoming richer, more nuanced, diffuse, and paradoxical.

Bauhaus ideas did not, in other words, enter a particular cultural vocabulary though indeterminate means, like a vaporous entity or an invisible pathogen, but through human and material conduits.[6] There were teachers who taught, students who thought, objects that were mass-produced and imported across borders, books that were circulated, essays published, exhibitions mounted. The circulation of Bauhaus ideas was facilitated not only through strategic publicity, as Patrick Rössler shows, but also through the repercussions of politics, fascism in particular, whose nefarious spread throughout the European continent triggered mass emigrations, enabling Bauhaus ideas to take root and mutate across the globe.[7] A young Robert Rauschenberg would not have otherwise encountered the ideas of Josef Albers with such forceful immediacy; that Rauschenberg nominated himself Albers' "dunce" institutes a fractious narrative of incomprehension and friction rather than an inevitable transference. Bauhaus effects, that is, were also by turns resistant and contradictory.

Moreover, as Rössler observes, the Bauhaus' reputation sometimes exceeded its actual contribution, its cultural reverberations rendered exponential through canny publicity, its influence asserted in words rather than form. This too belongs to the historical record of Bauhaus effects. The school was equally an interpreting agent, assimilating, reconstituting, appropriating, even colonizing aesthetic solutions from elsewhere and repackaging them as its own. Rather than promoting an origin myth of the Bauhaus, this volume also understands the school as a productive interme-diary that synthesized artistic ideas from a rich interwar matrix of cultural, social, economic, and political discourses. Itself a shifting, contingent entity, the Bauhaus underwent multiple transformations, ideological and pragmatic, during the years of its complicated existence, as did the individuals who taught at the school. Concepts stereotypically associated with the Bauhaus, such as the integrity of materials, geomet-rical form, or machine aesthetics, for example, often belong to the broader legacy of modernism, from which the Bauhaus borrowed and to which it contributed in signifi-cant and indelible ways. That hair could be the elemental material at issue belongs to the identity politics of 1960s London, where values of bodily liberation were signified by geometrical simplicity and mobility. Answers to the questions of designing corpo-real emancipation were to be found, in abundance, in Bauhaus precedents. Perhaps more surprising is the longevity and reach of Klee's adage "taking a line for a walk," which encapsulated his emphasis on open-ended process and furnished a productive set of conceptual modalities for developing computer art, a medium whose existence could not be anticipated in the 1920s, inchoate though they were in the jacquard looms acquired by Gunta Stölzl for the Weaving Workshop.[8]

The first four chapters focus upon the look of the new in housing, typography, photography, and window display. These are the fields in which the school's impact was immediate, as has long been recognized but more can still be teased out, these authors show, regarding the Bauhaus' effects upon them. These chapters also illus-trate the connections between the hard-edged corners and polished metal surfaces that increasingly characterized Bauhaus products after 1922 and the consumer cul-ture and polarized politics of the interwar years, as well the school's ties to other European avant-gardes.

Kathleen James-Chakraborty's opening chapter addresses the houses and housing Walter Gropius, Hannes Meyer, and Ludwig Mies van der Rohe designed during their respective tenures as directors of the school. Following Robin Schuldenfrei's recent highlighting of the importance of luxury to modern German architecture and design in this period, she addresses the full range of housing types Gropius, Meyer, and Mies built, including comfortable villas for Bauhaus faculty, as well as basic rooms for students and apartments for Dessau's working and lower-middle classes.[9] She demonstrates the range of social classes and circumstances confronted by the leaders of a school that is often assumed to have focused on designing for the masses. Although most Bauhaus housing was cloaked in a relatively similar aesthetic, the degree of spatial experimentation was relatively modest, as was its impact upon the large programs of social housing completed in Berlin, Hamburg, and Frankfurt dur-ing these same years.

An arena in which the Bauhaus had an even greater impact was typography, the subject of a chapter by Patrick Rössler. The New Typography did not begin at the Bauhaus. Nevertheless, it was quickly co-opted by the school when it pivoted away from its original association with Expressionism. Asymmetric layout, lower

case writing, and sans serif typefaces became, especially in the hands of László Moholy-Nagy and Herbert Bayer, an easily recognizable component of the school's memorable branding efforts. The New Typography was obviously dependent upon Soviet Constructivism and German Dada, as well as the less political Dutch De Stijl.[10] Interestingly, the take up was not just commercial, although this aspect of the school's success has often been downplayed by those who would like to celebrate the Bauhaus as a product of the November Revolution. The New Typography appealed not only to those selling new products and fashions but also to government bodies anxious to demonstrate that they were up to date. In a link between the first two chapters, Rössler shows how the New Typography was used to advertise new housing estates in Frankfurt. He also maps its rapid dissemination across Europe in part through the audience for Bauhaus publications. Here, he reveals that it was quickly adopted by authoritarian as well as left-leaning regimes, as the notorious Nazi condemnation of what they labeled degenerate art did not necessarily require them to forego modern graphic design techniques.

Another artistic practice where the effect of the Bauhaus was clearly discernable by the time that the school was forced to close in 1933 was photography. Rose-Carol Washton Long has described how students shifted to it from painting, the medium favored by many of Gropius' early hires, including most famously Wassily Kandinsky and Paul Klee.[11] Photography proved especially popular with the school's female students, the subject of steadily increasing attention since the mid-1990s.[12] Among the most original of these was Florence Henri. Sabine Kriebel analyzes how Henri's most celebrated photographs, made in Paris after she had left Dessau, drew upon two different aspects of her Bauhaus experience. In addition to the methods she had learned from Moholy-Nagy and Lucia Moholy, who introduced her to photography, she absorbed aspects of the industrial aesthetic epitomized by the design of the chairs, lamp, and teapot she brought to Paris with her. There, in addition to her own production as an artist, she trained Lisette Model, Gisèle Freund, and Ilse Bing. Long after Henri herself returned to painting, these three women would continue to explore the *sachlich*, that is, sober or objective, approach they had learned from Henri, carrying it with them in the case of Model and Bing to the United States.

Located in Weimar and Dessau, both provincial cities, the Bauhaus kept metropolitan fashions at arm's length. Its faculty and students largely, for instance, eschewed the streamlined curves with which Erich Mendelsohn enlivened his Schocken department store in Stuttgart, for which nonetheless Moholy-Nagy contributed a print campaign.[13] Moreover, the school's female students disdained chic flapper fashion, even as they bobbed their hair. Many shockingly preferred pants to short skirts.[14] Nonetheless, as Kerry Meakin describes in her chapter on the Reimann School, approaches pioneered at the Bauhaus quickly came to influence the exhibition of consumer goods-in the display windows of German department stores and high-end shops. The Reimann School, a private commercial art school based in Berlin, used techniques borrowed from the Bauhaus to teach the art of staging such displays, even employing some of same faculty. Its short-lived London spin-off, in operation between 1937 and 1940 exported these techniques to Britain, where their impact continued well into the postwar period.

The second part of the collection features two chapters examining the utility of the Bauhaus in demonstrating the modernity of new nation states. This may seem paradoxical as the Bauhaus itself had a strongly international orientation that existed

in strong opposition to the nationalism that characterized both the Wilhelmine period that preceded it and the Nazi years that followed. One of its three directors, Hannes Meyer, was Swiss, and both Gropius and Mies were alert to new artistic ideas from across Europe, while students arrived in Dessau, in particular, from even further afield. Nonetheless, the embrace of modern design became a way for countries around the world to demonstrate that they were up-to-date. Essays on the very different circumstances of two young European nations, the German Democratic Republic (GDR) and Ireland, illustrate the range of ways in which this could operate.

The two cities with which the Bauhaus is most closely associated, Weimar and Dessau, were both part of the Soviet sector, following Germany's division by the victorious allies at the end of World War II. They thus ended up, along with many of the school's former students, in the GDR, also known as East Germany. In the first years after the war, Bauhaus alumni attempted to found successor institutions in the Soviet zone.[15] While Stalin was still alive, official policy in the Soviet bloc supported Socialist Realism, however. The Bauhaus, denounced as "formalist" in the 1950s, was viewed with considerable official suspicion by the communist state until the early 1970s, when the refurbishment of its Dessau building finally began in anticipation of the 50th anniversary of its completion. Katherina Pfützner makes clear that despite a lack of official recognition, design education in the GDR remained strongly informed by the lessons that many influential instructors had learned as Bauhaus students. She argues that the pedagogy and products of the GDR's most important design schools, the Burg Giebichenstein School in Halle and the Weißensee School in East Berlin, identify them as successors to the Bauhaus, albeit ones in which the corporate branding that was so prominent a feature of the Hochschule für Gestaltung in Ulm or the American career of Herbert Bayer, was necessarily absent.[16] After the completion of the renovation of the Dessau Bauhaus in 1976, the school's history became folded into the GDR's efforts to identify itself as the legitimate heir to a wide variety of aspects of German cultural heritage, from Luther to Goethe and Schiller.

While the GDR inherited people, buildings, and approaches tied to the Bauhaus, Ireland, which declared itself a Republic in 1949 after holding dominion status as the Irish Free State since 1922, had no direct Bauhaus legacy. Irish national identity was more often expressed in the first two-thirds of the twentieth century through literature, theatre, and music than avant-garde experimentation in the visual arts. Moreover, Irish artists and architects were more much more likely to look towards London or Paris than to Germany. The Bauhaus had almost no discernable influence in Ireland until long after its closure. From the 1920s through the 1950s, the country remained largely agricultural, and its most celebrated artists were known for their romantic depictions of its peasantry and rural landscapes. By the 1960s, however, modern art, architecture, and design closely tied to Bauhaus people and principles offered the country a means of expressing its ambition to modernize through increased engagement with the United States and the European Economic Community, which it joined in 1973. The degree to which lessons learned from former Bauhäusler shaped these efforts demonstrates that the school's legacy was now associated with mainstream corporate culture on both sides of the Atlantic as well as with established cultural elites.

The Bauhaus nonetheless continued to be a force prompting real change for decades after its closure in 1933, including in ways that have been overlooked in previous scholarship. The final four chapters in this volume capture both the variety and the

longevity of its effects upon the visual culture of the twentieth and twenty-first centuries from the 1940s to the present day.

In the first of these, Dietrich Neumann positions Sigfried Giedion's analysis of the Dessau Bauhaus building in a longer trajectory of interpretations of the relationship between space and time in modern architecture. Published in English in 1941 in the middle of a world war that would place the building off limits to most of his readers until the 1990s, Giedion's interpretation situated Gropius' design in relation to both cubism and Albert Einstein's theories of relativity. Although Einstein himself dismissed it, this interpretation powerfully shaped the way in which two generations of students and scholars who had not seen the building for themselves understood it. Neumann unearths multiple sources for Giedion's explanation. He takes us back to the late-nineteenth century, when space was conceptualized in new ways by German architectural theorists, including August Schmarsow and Adolf Hildebrand, and details as well the way in which it built upon German architectural criticism from the 1920s.

The reception of the Bauhaus itself is a slightly different story, however, from the continuing influence of its pedagogy. An important case study of this type of effect is captured by Vanessa Troiano, who documents the impact of Josef Albers' teaching at Black Mountain College upon Robert Rauschenberg. The large blue and white photograms Rauschenberg and his then wife Susan Weil produced under Albers' tutelage provided the point of departure for Rauschenberg's later combination of images, including his use of silkscreen techniques. Albers' own art remained utterly distinct from Rauschenberg's later pioneering of Pop, but this example highlights the degree to which, first at Black Mountain and later at Yale, his teaching had a powerful impact upon his many extremely talented American students, who also included Eva Hesse and Richard Serra, regardless of the direction that their work later took.[17]

Albers' students shaped the direction of modern American art for the rest of the twentieth century and into the twenty-first, but the aftereffects of the Bauhaus also extended into popular culture as Mariana Meneses Romero demonstrates in her contribution on the school's influence upon Vidal Sassoon. From the 1950s through the 1980s, Sassoon, who was based in London but had salons elsewhere, including New York, transformed the styling and coloring of hair light in part through his tremendous admiration for many different aspects of the Bauhaus. His introduction of casual haircuts that needed a minimum of styling was informed by the approach to structure and form taken by two architects he greatly admired and went out of his way to meet, Mies van der Rohe and Marcel Breuer, who had respectively taught and studied at the school. He also learned from and in turn taught his many students principles absorbed from Johannes Itten and Paul Klee. Sassoon's fascination with Oscar Schlemmer's Triadic Ballet informed punk hairstyles designed in the 1980s. This example demonstrates the degree to which the Bauhaus' ambition to inject art into daily life, a goal it shared with the German Werkbund, founded already in 1906, took hold in ways that remain well outside the purview of mainstream art history but were nonetheless transformational.[18]

In the final chapter in this collection, Ingrid Mayrhofer-Hufnagl describes one last way in which the effects of the Bauhaus, and again specifically of its pedagogy, continue into the present. She shows that Klee has been a key figure for those who, beginning in the 1960s, utilized the new technology of computing to produce pioneering digital art. Although Klee, who died in 1940, never anticipated the technology

that digital artists manipulate, his conception of form and of process proved enormous utility to them. This demonstrates the degree to which the development at the Bauhaus of new principles from which to teach an art that no longer depended upon representation, much less the human figure, proved transferrable to engineering very different from the daylight factories and their transportation-oriented products, that had been so key to the school's conception of industry.

In 2009, the most persuasive scholarship prompted by the school's ninetieth anniversary detailed the degree to which its early experiments had been grounded in Weimar's Golden Age engagement with everything from color theory to the stage.[19] By 1922, the Bauhaus had already transcended these specifically Germanic roots. It found compelling alternatives to Expressionism in new Dutch and Soviet forms of abstraction, which its faculty and students transposed into more different domains and media than the advocates of those styles had ever anticipated. Although this internationalist rejection of German nationalism should not be confused with universalism, the results, as this collection clearly proves, eventually had wide appeal. Today more than a century after its founding, and indeed nearly nine decades after its closure, the effects of the Bauhaus endure. What was once avant-garde and revolutionary has now been assimilated into everything from high art to hair styles. Just as the work of Johann Wolfgang von Goethe and Friedrich Schiller inspired the Bauhaus' first students and faculty, so today there remains much that contemporary counterparts of Gropius and those he gathered around him can continue to learn from them. As this book shows, they will thus insert themselves into this long and lively trajectory.

Notes

1. The most prominent fruits of this effort were associated with the Bauhaus Imaginista initiative. This included an eponymous exhibition that debuted at the Haus der Kulturen der Welt in Berlin, an exhibition catalogue, and a website. See Marion Osten and Grant Watson, eds., *Bauhaus Imaginista* (London: Thames and Hudson, 2019) and http://www.bauhaus-imaginista.org. For a critique, see Jordon Troeller, "Why the Bauhaus Still Matters in an Era of Neo-Nationalism," *Hyperallergic*, posted September 9, 2020, https://hyperallergic.com/585843/why-the-bauhaus-still-matters-in-an-era-of-neo-nationalism/, consulted July 3, 2021. For the utility of the Bauhaus to Cold War propaganda, see Paul Betts, "The Bauhaus as Cold War Legend: West German Modernism Revisited." *German Politics and Society* 14 (1996): 75–100.
2. Even at a national level, such efforts were relatively weak. They are documented in Christian Welzbacher, *Die Staatsarchitektur der Weimarer Republik* (Berlin: Lukas Verlag für Kunst, 2006).
3. Winfried Nerdinger, ed., *Bauhaus-Moderne im Nationalsozialismus, zwischen Anbiederung und Verfolgung* (Munich: Prestel, 1993).
4. See entry under https://www.merriam-webster.com/dictionary/effect. Accessed October 26, 2021.
5. Michael Baxandall, *Patterns of Intention: On the Historical Explanation of Pictures* (New Haven and London: Yale University Press, 1985) 58–62.
6. For a substantial study of the material transmission of aesthetic ideas in Europe during and after World War I, see Leah Dickerman, ed., *Dada: Zurich, Berlin, Hannover Cologne, New York, Paris*, (Washington: National Gallery of Art in Association with Distributed Art Publishers, New York, 2005).
7. Patrick Rössler, *The Bauhaus and Public Relations: Communications in a Permanent State of Crisis* (London: Routledge, 2014).
8. Paul Klee, *Pädagogisches Skizzenbuch*, Bauhausbücher 2 (München: Albert Langen Verlag, 1925) 6, 8.

9. Robin Schuldenfrei, *Luxury and Modernism: Architecture and the Object in Germany 1900–1933* (Princeton: Princeton University Press, 2018).

10. An important exception is Patrick Rössler, *Die neue Linie: The Bauhaus at the Newstand: 1929–1945* (Bielefeld: Kerber, 2010).

11. Rose-Carol Washton Long, "From Metaphysics to Material Culture: Painting and Photography at the Bauhaus," in Kathleen James-Chakraborty, *Bauhaus Culture from Weimar to the Cold War* (Minneapolis: University of Minnesota Press, 2006) 43–62.

12. Key texts include Sigrid Wortmann Weltge, *Women's Work: Textile Art From the Bauhaus* (San Francisco: Chronicle Books, 1993); Anja Baumhoff, *The Gendered World of the Bauhaus* (Frankfurt: Peter Lang, 2001); Ulrike Muller, *Bauhaus Women: Art, Handicraft, Design* (Paris: Flammarion, 2009); T'ai Smith, *Bauhaus Weaving Theory: From Feminine Craft to Mode of Design* (Minneapolis: University of Minnesota Press, 2014); Elizabeth Otto and Patrick Rössler, *Bauhaus Bodies: Gender, Sexuality, and Body Culture in Modernism's Legendary Art School* (London: Bloomsbury, 2019); Elizabeth Otto and Patrick Rössler, *Bauhaus Women: A Global Perspective* (London: Herbert Press, 2019); and Patrick Rössler, *Bauhausmädels. A Tribute to Pioneering Women Artists* (Cologne: Taschen, 2019).

13. Carol S. Eliel and Matthew S. Witkovsky, eds., *Moholy-Nagy: Future Present* (Chicago: Art Institute of Chicago, 2016) 99.

14. Kathleen James-Chakraborty, "Clothing Bauhaus Bodies," in *Bauhaus Bodies: Gender, Sexuality, and Body Culture in Modernism's Legendary Art School*, Elizabeth Otto and Patrick Rössler, eds. (New York: Bloomsbury, 2019) 123–44.

15. Greg Castillo, "The Bauhaus in Cold War Germany," in *Bauhaus Culture*, James-Chakraborty, ed. 171–93.

16. Rene Spitz, *The Ulm School of Design: A View Behind the Foreground* (Fellbach: Edition Axel Menges, 2002); and Ellen Lupton, *Herbert Bayer: Inspiration and Process in Design* (New York: Moleskine Books, 2020).

17. Irving Sandler, "The School of Art at Yale: 1950–1970: The Collective Reminiscences of Twenty Distinguished Alumni," *Art Journal* 42.1 (1982): 14–21; and Jeffrey Saletnik, "Josef Albers, Eva Hesse, and the Imperative of Teaching," *Tate Papers* 7 (Spring 2007). https://www.tate.org.uk/research/publications/tate-papers/07/josef-albers-eva-hesse-and-the-imperative-of-teaching, consulted October 30, 2021.

18. Frederic J. Schwartz, *The Werkbund: Design Theory and Mass Culture* (New Haven: Yale University Press, 1996).

19. Ulrike Ackermann and Ulrike Bestgen, eds., *Das Bauhaus kommt aus Weimar* (Berlin/Munich: Deutscher Kunstverlag, 2009).

1 Bauhaus Housing

Kathleen James-Chakraborty

How is the Bauhaus relevant today, a century after its faculty and students helped invent a vocabulary of forms that still seem modern? Form, and indeed even pedagogy, is only part of the story. Although the degree to which the school was inherently progressive has been much exaggerated, certainly many of those involved in integrating expressionism with craft and then abstraction with industry were motivated to address the pressing political and social issues of the day. One of these issues in 1920's Germany, as it is today in many parts of the world, was housing. Unpicking the complex relationship between the Bauhaus, housing, and houses highlights the Bauhaus' failure to make a more decisive and influential contribution to one of the most pressing architectural and social issues of its and our own time as well as its difficulty in aligning the industrial aesthetic it adopted early in its history with the efficiencies this was intended to foster.

Although the Dutch were the first out of the starting gates in providing substantial government support for social housing already before World War I, one of the chief achievements of Germany's Weimar Republic was the construction by city governments and trade unions of a substantial amount of social housing, much of which was designed in the abstract style associated with the Bauhaus (often termed at the time in Germany *Neues Bauen* or the New Building).[1] Yet, despite the commitment all three of the school's architect-directors had to designing housing, two of them – Walter Gropius and Ludwig Mies van der Rohe – were clearly torn between the aesthetic possibilities inherent in reforming the domestic life of relatively well-to-do clients and the more pragmatic approach required to provide accommodation for the masses, to which only Hannes Meyer was solely and unequivocally committed. Moreover, if housing comprised the New Building's most enduring and politically engaged success, it is also the arena in which postwar modern architecture has often been understood to have failed most decisively.[2] The Bauhaus' impact on housing as opposed to houses – and the two should not be conflated – was surprisingly limited, especially considering how central the school is to the story of the New Building, in particular, and modern architecture, in general, and how important housing was in turn to them. Demonstrating this absence of an enduring effect, which should instead be credited to other German "housers," including Ernst May, Bruno Taut, Fritz Schumacher, and Martin Wagner, is important in mapping the school's impact and the degree to which it can and should serve as a model today.

The Bauhaus addressed three very different types of housing. Single-family houses, including most notably for the school's own faculty, provided showcases for new

DOI: 10.4324/9781003268314-2

approaches to modern middle-class domesticity. The Törten housing estate in Dessau targeted the rather different problem of providing economical housing to relatively large numbers of tenants. Finally, there was student housing. The Bauhaus building in the same city housed a small number of students in rooms furnished with products designed and made at the school, while the Federal School of the German Trade Union Federation (ADGB) trade union school in Bernau also offered both student and faculty accommodation. It is important not to conflate these distinctive types, which focused on different issues and offered different solutions. The first, not surprisingly, provided the greatest means for aesthetic experimentation, while the second offered the chance to demonstrate efficient approaches to both construction and the organization of space. The third has attracted less attention, although the clear popularity of their dormitory rooms with Bauhaus students merits a second look today at a time when some developers favor building highly profitable housing for students over units intended for the working and lower-middle classes.[3]

One of the great advantages of the New Building was its relative affordability, for which there were several reasons. One was the absence of ornament. Architectural critics from more prosperous nations, such as Great Britain, remarked during the 1920s on this aspect of modern German commercial architecture, which would be widely imitated in Britain only in the 1930s, after the onset of the Great Depression.[4] Yet, there were several paradoxes at work. The absence of ornament might appear to save costs, but to be aesthetically impressive, it often required the high level of craftsmanship so clearly displayed in Lucia Moholy's original photographs of the Bauhaus building in Dessau, but which was missing in some of the parts of the Törten Siedlung designed by Gropius' office.[5] Moreover, the crisp white lines of the stucco boxes that Bauhaus architects favored by the early 1920s did not age well. Le Corbusier's Villa Savoye, not, of course, designed by a Bauhaus-affiliated architect, has famously been extremely expensive to maintain, and those Bauhaus-designed housing units that survived World War II have often also undergone multiple refurbishments.[6] Even more central to the rhetoric supporting the New Building was the claim by its proponents, including each of the Bauhaus' directors, that it was more efficient to construct. Mass production off-site of standardized building components as well as the Taylorization of the construction site were both upheld as ways in which the production of housing could avail the same savings in cost that the assembly line had brought to the manufacture of automobiles, most famously the Model T Ford.[7] Yet such a rhetoric routinely outpaced actual achievement, especially until the production of partially prefabricated tower blocks commenced after World War II.[8]

The gap between an aesthetic (no ornament) and a process (construction efficiency) is clearly displayed in the difference between the houses the Bauhaus designed for its directors, its faculty, and their supporters, and the housing erected for people who have usually been described as workers but were just as likely to be white-collar clerks.[9] Because, with one important exception, both usually shared some of the same features – including crisp unornamented volumes covered in white stucco, expansive windows, and flat roofs – the degree to which the first were actually relatively luxurious and the second quite bare bones has been largely overlooked until recently.[10] Somewhere in the middle were the Bauhaus students fortunate enough to be housed in the Prellerhaus wing of the Dessau Bauhaus and the faculty and student housing incorporated into the ADGB complex. Although relatively spartan, the Prellerhaus

proved enormously popular, even if the exterior balconies were photographed much more often than the interiors.

Of the Bauhaus' three directors, two cut their teeth as architects on the design of houses for those who could afford ambitious architects. During the period when both men were employed in his Berlin office, Peter Behrens chose Gropius rather than Mies to supervise the construction of the Cuno Villa in Hagen, probably because of Gropius' more elevated social background rather than because of his understanding of construction, which repeatedly proved faulty.[11] Meanwhile, throughout the German phase of his career, Mies' practice consisted almost entirely of relatively conventional single-family houses set in ample gardens.[12] These initially clustered in Berlin's western suburbs and nearby Potsdam, although the late twenties would see him building as far afield as Krefeld, near the Dutch border, in the west and Brno, in what was then Czechoslovakia and is now the Czech Republic in the east. Although he designed four modest blocks of flats in Berlin, it was his stewardship of the Weissenhof Housing Estate, an international housing exhibition held in Stuttgart in 1927, that propelled him into the upper tier of the European avant-garde and toward the eventual directorship of the Bauhaus. Built for civil servants rather than workers, its dwellings provided more room for aesthetic experimentation than other showcases for new approaches to housing. Only Le Corbusier, however, resisted the call to experiment with efficient construction and really blew the budget.[13]

Unlike Gropius and Mies, Meyer, who led the school between 1928 and 1930, had always been a houser. Before the war, the Swiss national studied in Britain, bringing back a familiarity with the Garden City movement that he used, first as an assistant to Georg Metzendorf in Munich, and then in his own practice, which he opened in Basel in 1919. Metzendorf was best known for his ongoing work on the Margaretenhöhe in Essen, a model housing estate sponsored by the Krupp family. Surrounded by a green belt, it was executed very much along Garden City lines, with the same nostalgia for the preindustrial village that characterized the housing in Parker and Unwin's Letchworth. In the last years before World War I, large industrial employers like Krupp led the way in Germany in the provision of well-designed housing built independently of the market; only during the Weimar Republic would high-quality dwellings for this class of occupants begin to be erected by those who were not motivated by the goal of retaining and controlling their workforces.[14]

Despite the role that one-off houses had played in their establishing their careers, both Gropius and Mies were attracted to the issue of mass housing, which provided the best means in the 1920s for German architects to prove their social relevance during a period of great political division and instability. Throughout the Weimar Republic, there was widespread agreement, however, across the political spectrum about the importance of addressing the housing crisis created by rapid industrialization and urbanization in the last decades before World War I. Social Democrats viewed it as a necessary intervention in the free market to further the living standards of the working classes, while those on the right followed Le Corbusier's example in advocating "architecture instead of revolution."[15] Buttressed by the national government, city governments and trade unions engaged in enormous building programs. Although much of this housing, particularly in Hamburg, where exposed red brick remained the norm, was built in relatively conventional styles, many architects were willing to relinquish the quaint sentimentality that continues to make the Margaretenhöhe so endearing.[16] In Berlin and Frankfurt, Bruno Taut and Ernst May led offices that

created thousands of units of housing that openly espoused New Building tenets. Most were erected on greenfield sites linked to their respective city centers by subways and trams. Like almost all housing erected in interwar Europe, the apartment blocks were low-rise walk-ups, with facilities for clothes washing often located on the uppermost floor. Small two-story terraced houses were also popular.[17]

Although already in 1920, Gropius envisioned the possibility of a housing estate to serve the school he had established only the year before in Weimar, the Bauhaus' first two architectural set pieces were both single-family homes. The Sommerfeld House in Berlin, designed in 1920 and completed in 1921 by Gropius and his partner Adolf Meyer, and Georg Muche's Haus am Horn in Weimar, a highlight of the Bauhaus exhibition held in 1923, were joined three years later by the director's and masters' houses in Dessau. The relatively modest courtyard house projects, including the Lemke House in Berlin, that occupied Mies and his students during his directorship, which began in 1930 and ended with the school's closure in 1933, also merit inclusion in any consideration of Bauhaus houses. Meanwhile, across the course of the 1920s both Gropius and Mies also designed a number of other single-family houses in a modern style. Of these, only the Auerbach House in Jena of 1924 had a significant connection to the Bauhaus.

Adolf Sommerfeld, the patron of the Sommerfeld House in Berlin, was one of the Bauhaus' earliest and most enthusiastic supporters.[18] Like many clients for the New Building, he was a successful Jewish businessman.[19] He turned to Gropius and Adolf Meyer at the peak of the Bauhaus' engagement with Expressionism and craft, before any hint of the shift back to their prewar engagement with industry and its products. In their house for him, Gropius and Meyer, supported by their Hungarian assistant, architect Fred Forbat, balanced references to rustic log cabins with sophisticated allusions to the work of Frank Lloyd Wright, the American architect whose Wasmuth Portfolio they frequently consulted while designing it (Figure 1.1). The architecture of the Crystal Chain, an Expressionist architectural group, of which Gropius was a leading member, clearly influenced the graphic representation of the house, if not necessarily the built result.[20]

Erected out of timbers from a salvaged ship, according to a structural system developed by Sommerfeld's firm rather than the architects themselves, the house was a carefully crafted showcase for Bauhaus talent, including stained glass windows by Josef Albers, furniture by Marcel Breuer, and decorative carvings in the stair hall by Joost Schmidt. A one-off dwelling luxurious enough to include a separate chauffeur's residence designed by Forbat, which survived the destruction of the main house in World War II, the Sommerfeld House was nonetheless a moderately scaled and relatively subtle expression of wealth. The house encompassed a display of up-to-the-minute style and artisanship instead of being rooted in either historicism or the understated display of rich materials that had emerged already before World War I and offered a compelling modernist alternative to conventional luxury.

Even after the Bauhaus shifted direction by 1923 toward industry and away from craft, and toward rectilinear abstraction, rather than the jagged Expressionist edges still featured in the Sommerfeld House, one-off houses continued to provide the most effective laboratory for the new approach. Sommerfeld continued to play a role, too, underwriting much of the cost of the Haus am Horn, which painter Georg Muche won an internal school-wide competition to design (see Figure 1.2). Executed in Weimar with the substantial assistance of Adolf Meyer, the somewhat gawky dwelling, in

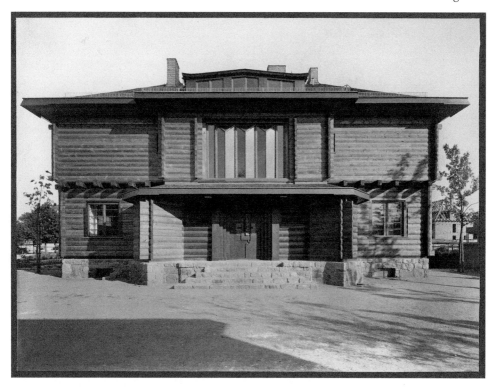

Figure 1.1 Sommerfeld House, Walter Gropius and Adolf Meyer, Berlin, 1920–21. Photograph
 by Carl Rogge, 1923. © Gropius: V-G Bild-Kunst. Courtesy of Bauhaus-Archiv Berlin.

which both service spaces and bedrooms were disposed around a square clerestory-
lit central space, offered visitors to the 1923 Bauhaus exhibition a comprehensive
opportunity to assess the school's approach to domesticity. Stylistic rather than social
conventions were challenged in a comfortable dwelling equipped with expensive
modern conveniences, as well as furniture and textiles designed by Bauhaus students.
Although not very large and intended to be an example of a model modular house for
a proposed Bauhaus housing estate that was never realized, the Haus am Horn was in
fact a showcase for products that remained, especially at a time of runaway inflation,
far beyond the reach of most Germans. Robin Schuldenfrei makes clear the degree to
which it served as advertising for the firms that supplied the building materials and
state-of-the-art technology, as well as for the quite luxurious furnishings.[21]

The Auerbach House completed the following year in Jena attracted much less
public attention but was a more compelling statement of the school's new aesthetic
direction (Figure 1.3). Like Sommerfeld, the Auerbachs were Jewish. Felix, who was
already approaching retirement when he commissioned the house, was a professor of
theoretical physics, while his wife Anna was a prominent campaigner for women's
rights. The couple committed suicide in February 1933 in despair over Hitler's rise
to power. A relatively inexpensive building constructed out of the same economical
material as the Haus am Horn, the Auerbach House, too, was designed in terms
of cubic volumes that the architect labeled "building blocks." The wall paintings
by Bauhaus student Alfred Arndt comprise its most outstanding feature. These flat

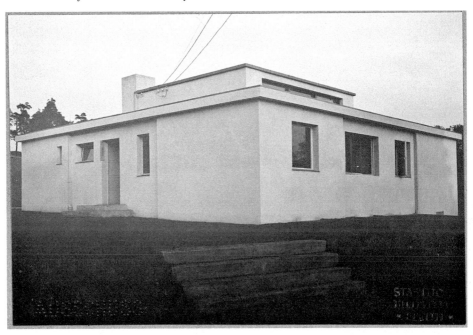

Figure 1.2 Haus am Horn, Georg Muche, Weimar, 1923. © Bildarchiv Foto Marburg.

Figure 1.3 Auerbach House, Walter Gropius, and Adolf Meyer with wall painting by Alfred Arndt, Jena, 1924. © SG Koezle – info@koezle.com

blocks of color modulate the experience of the spaces without adhering to what was then the De Stijl-inspired vogue at the Bauhaus for primary colors.[22]

The move from Weimar to Dessau provided Gropius with new architectural opportunities. This included, in addition to the famous Bauhaus building, a new house for himself in his role as the school's director as well as a triplet of paired semidetached houses for faculty members, all designed in 1925 and completed the following year.[23] Erected out of sight, but within an easy walk of the school, these dwellings were intended to help compensate for the move to a much less culturally lively, but perhaps more hospitable home for the controversial community. The original inhabitants included, in addition to Walter and Ise Gropius, the Moholy-Nagy, Feininger, Muche, Schlemmer, Kandinsky, and Klee families. The director's house featured furniture designed by Breuer, an up-to-the-minute kitchen, and what were for the time lavish bathrooms, and was the subject of considerable publicity. Schuldenfrei has demonstrated that Gropius had Moholy's photograph of a marble sink airbrushed to make it appear as if it were only ordinary porcelain.[24] The house was destroyed in World War II; a recent replica does not attempt to recreate the interior spaces.

The three double houses up the street inhabited by half a dozen other members of the faculty were only slightly more modest (Figure 1.4). Fascinated with the idea of modular housing, Gropius dreamed of using prefabricated elements here, but in the end more conventional means were employed in the service of a less overtly industrial

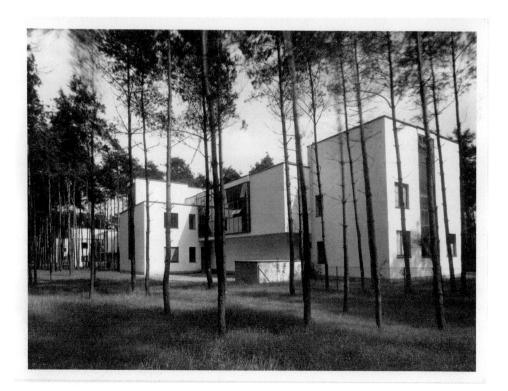

Figure 1.4 Klee and Kandinsky Masters' House, Walter Gropius, Dessau, 1926. Photograph by Lucia Moholy, 1926. © Estate of Lucia Moholy, Bild-Kunst, Bonn/IVARO Dublin, 2021. Courtesy of Bauhaus-Archiv Berlin.

aesthetic than was displayed at the Bauhaus itself. Nor was the aesthetic here depend-
ent, as in the Bauhaus building, upon the presence of a skeletal reinforced frame,
although the houses were built in part out of standardized material, namely rein-
forced concrete blocks. The gap between theory and practice remained wide in much
interwar modern housing, even when the budget was relatively generous. Gropius
did, however, somewhat modularize the design, rotating the otherwise identical floor
plan of each half in order to make the structure as a whole more varied. Each house
included a studio, but the plans were relatively conventional in comparison to those
of many of the experimental dwellings of the period, such as Gerrit Rietveld's house
for Tilly Schroder in Utrecht in the Netherlands or Mies' Tugendhat House in Brno.[25]
Two of the painters who lived in them, Wassily Kandinsky and Paul Klee, retained
their own furniture but took control of the wall colors, while Moholy-Nagy, like
Gropius, chose the easily portable tubular metal furniture designed by Breuer.[26]

The director and masters' houses were, as the film of the director's house featuring
Ise Gropius made clear, intended to establish a template for middle-class domesticity
of the near future. The newsreel-type documentary showed off the house's various
time-saving high-tech features to audiences who undoubtedly aspired to have both
them and the maidservant who demonstrated how they worked, regardless of how
they felt about the relatively small and austerely furnished rooms relative to these
amenities. The redefinition of luxury as the use of technology rather than the pro-
vision of space, the physical comforts embodied by deep upholstery, and the social
status conveyed by expensive materials all established the gap between mass housing,
on the one hand, and these dwellings and other showcases of modern design, such as
the Tugendhat House or Erich Mendelsohn's Berlin villa, on the other. Such comforts
were, not surprisingly, often controversial among advocates of the New Building.[27]

The degree to which modernism should be defined in terms of form or function
bedeviled the Bauhaus, particularly after Gropius' departure in 1928. His successor
Hannes Meyer, who arrived at the school in 1927 to teach architecture, moved in
1928 into the house Gropius had built for the director, but clearly took the side of
function and did not design one-off homes. These, however, had always been the
bread and butter of the practice run by Mies van der Rohe, who in turn replaced
him in 1930. Only when Mies reached the United States in 1938 would that change
substantially. By 1930, however, Mies had realized that wealthy clients like the
Tugendhats were few and far between. In his Bauhaus classes, he focused on the
far more modest courtyard house. The Lemke House in Berlin, realized in 1932–33
as he was moving the Bauhaus from Dessau to the national capital, is his only built
example of this approach. His clients, Martha Lemke, who was involved in graphic
design, and her husband Hans, who ran a printing company, had a limited budget.
The single-story, 160-meter house is in fact L-shaped, enclosing only two sides of the
garden onto which the large windows of its principal living spaces face. Although
the childless couple did not ask for a guest bedroom, there is a separate maid's room
located off the kitchen.[28]

Single-family houses of even this relatively modest scale posed an entirely different
problem from mass housing. Working for a union or a city government rather than
a married couple meant standardizing interior floor plans for clients one never met
and who were by definition a step below the architect's current social position even
if, like Mies, he (or much less often she) came from a relatively humble background.
After the collapse of the international economy in late 1929, which hit Germany

particularly hard, the profession focused on relatively humble dwellings. This was clear in the model houses Mies and his personal and professional partner Lilly Reich designed for a construction industry exhibition Mies organized in Berlin in 1931.[29] Standardized design of detached single-family houses remained unusual until the Third Reich, which romanticized the farmhouse as a model for modern urban and suburban houses.[30]

As early as 1920, Gropius held a competition in which students proposed designs for a housing estate in Weimar. Little survives regarding the submissions beyond highly stylized and very colorful drawings by Walter Determann, a student who not surprisingly became a painter rather than an architect.[31] Weimar, which until 1918 hosted a Grand Ducal court, was not an industrial city, and housing a rapidly expanding working class was not a major issue there. The shift to Dessau, where Junkers, a firm that built airplanes, was the mainstay of the local economy, provided welcome opportunities to experiment with the provision of large numbers of efficiently built units.

Was the New Building above all a new style, closely tied to the emergence of abstraction across the visual arts, or was it a new means of organizing the construction process, anchored in standardization? The answer, of course, was a little bit of both, not least because both were rooted in new technologies, whether the steel frame that enabled Mies to open up the interior of the high-end Tugendhat House or the infrastructure that allowed Margarete Schütte-Lihotzky to deliver running water and an electric stove to Frankfurt trade union workers and clerks and their families.[32] Nowhere was the tension between these two approaches more obvious than in Dessau, where Gropius designed houses for himself and his colleagues just to the west of the Bauhaus at the same time that he was building a large housing estate several kilometers south of the city center.

Gropius' private architectural office began work on the Törten housing estate in 1926; the estate was not officially a Bauhaus project, although it, like the school's shift to Dessau, depended on his relationship with the mayor Fritz Hesse (Figure 1.5).[33] The fan-shaped estate was located on what was then the edge of the city. Almost all German state-subsidized housing built in the interwar period was located on greenfield sites (aerial bombardment of urban centers during the war meant, of course, that after 1945, this was no longer the case).[34]

There were several reasons for not trying to redevelop existing housing. First, this avoided disrupting capitalist ownership structures, even as flooding the market with new units ideally decreased the pressure on the cost of renting existing ones. Second, land on the urban outskirts was much less expensive. Isolation was largely avoided because either distances were in fact quite small, as was the case in Dessau, or excellent public transportation was available, as in Berlin and Frankfurt, at a time when no one anticipated that the inhabitants of such units would ever be able to afford automobiles. Other factors also mattered. Conservatives were glad to see the occupants of social housing decanted to the edges of the city, where union members were less likely to be involved in disruptive political protests.[35] At the same time, those on the left welcomed what everyone agreed were healthier surroundings as the scourge of tuberculosis made access to fresh air and sunlight, both in short supply in crowded tenements, highly desirable.[36] Moreover, infrastructure, including running water and the provision of electricity, helped compensate for the still fairly crowded conditions in dwellings their designers often labeled as providing the *Existenzminimum*.[37]

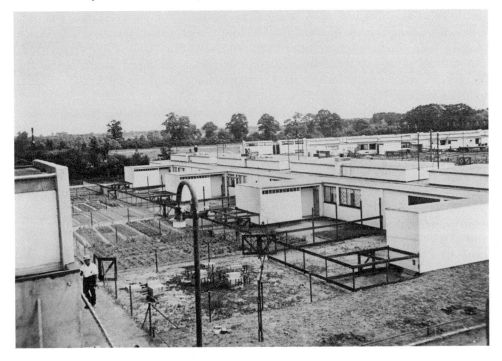

Figure 1.5 Törten Housing Estate, Walter Gropius, Dessau, 1927. © Bildarchiv Foto Marburg.

Traces of prewar Garden City planning, developed in England but, as the Margaretenhöhe demonstrates, already very popular in early twentieth-century Germany, survive here. They can be found in the ample scale of the gardens, which encouraged economic self-sufficiency in food production, as well as providing land for eventual extensions to the back. Garden City principles also informed the choice to build terraced housing instead of blocks of flats. The 314 one- and two-story dwellings originally varied in size from 57 to 75 square meters, making the largest of them just over half the size of the middle-class Lemke House, although Törten housed mostly families with children, rather than a childless couple. Working on such a small scale, it was impossible for Gropius to experiment with the open plans found in some of the private houses designed by adherents of the New Building. The spatial experimentation that led Sigfried Giedion to term the Bauhaus an example of space-time architecture and featured so strongly in many contributions to the Weissenhof estate as well as playing at least a supporting role in the design of the director's and masters' houses was completely absent here except in the case of the four-story apartment block with a flanking wing for four modest shop fronts.[38] Not coincidentally, that was also the only steel-framed building in an estate otherwise erected out of cement block and reinforced concrete.

On the other hand, the much larger number of units at Törten made it easier to experiment with standardization, even as Gropius developed multiple prototypes for what he hoped would be unusually efficient building techniques. Unfortunately, as was often the case when relatively inexperienced members of the avant-garde undertook such ventures, the standard of construction was not always very high, which is

one reason that the appearance of many of the units has changed over time. The city of Dessau's growing disenchantment with Gropius was certainly exacerbated by these problems, which may have hastened his decision to step down as the Bauhaus' director.[39] Taste was also a factor, however. As a Bauhaus-sponsored website describing the project dryly notes, "The Bauhaus also advertised furnishings for the interiors, but there was no demand for these items."[40] Over time, as in Le Corbusier's housing at Pessac in France, constructed between 1924 and 1926, inhabitants altered their environments to suit themselves.[41] More recently, however, historic preservation efforts have encouraged a return to the original streetscape.

Although many of the original inhabitants would, of course, have been excited to move out of even smaller city center apartments that lacked the amenities they found at Törten (which, however, did not have flush toilets), there is no reason to believe that the spare style of their new housing in any way reflected their own wishes. Elegant Berlin flats like the one Breuer, who was just beginning to shift from furniture to interior design, designed in 1926 for Erwin Piscator, one of Germany's leading avant-garde theater directors, were neither what most workers wanted nor what they could afford. Breuer's tubular metal furniture, although its lightweight frame intimated that it was casual because it could be easily moved about, was not inexpensive, but it had the additional virtue of not taking up much space in the often relatively small urban apartments in which the intelligentsia, who had a taste for such design, often lived.[42]

One of the most important issues in the design of any housing is how the tastes of those who will live in it are addressed. Consumer demand is often deemed sufficient when housing is a product of the "free" market, in which regulation nonetheless helps guarantee the quality of construction as well as fire safety. When demand is high, renters and buyers will, however, often settle for far less than their ideal conditions in order to have a roof over the heads. Moreover, there are multiple ways of accounting for the desires of potential inhabitants independently of market forces. In Weimar Germany, the most important of these was the involvement of trade unions answerable to their members and democratically elected city governments responsive to their voters. There is little evidence that either exerted much of this authority at the time, however, although conservatives often called for hipped roofs and live-in kitchens.[43]

Although Törten was not larger or more successful in aesthetic or economic terms than many other examples of social housing erected in Germany during the Weimar Republic, Gropius billed himself as a housing expert after he stepped down from the directorship of the Bauhaus in 1928. For a short while, he enjoyed real success in this arena. In 1928, he won a competition to design the Dammerstock housing estate in Karlsruhe. Under Gropius' leadership, 228 units were completed in time to feature in a housing exhibition the following year. He delegated responsibility for the design of all but three buildings to others but succeeded in setting the tone with a long apartment house block that would serve as a model for further construction on the site after World War II.[44] On the back of his success in Karlsruhe, he also contributed to Siemensstadt in Berlin, an estate erected between 1929 and 1931 under the general direction of Hans Scharoun.[45] Gropius would continue for the rest of his career to be interested in the issue of housing, although following his emigration to first England and the United States, he would realize very little of it. His most notable American housing, designed in partnership with Breuer, was Aluminum City Terrace, outside of Pittsburgh.[46]

Meyer's directorship of the Bauhaus lasted only two years before he was forced out and decamped for the Soviet Union, where he headed a term of German-speaking architects charged with implementing Stalin's first five-year plan.[47] Although the most important commission of his Bauhaus years, and indeed his career, was the Allgemeinen Deutschen Gewerkschaftsbundes (general German trade union) or ADGB school in Bernau, just north of Berlin, he left his mark in Dessau as well, with five apartment blocks erected as an extension of the Törten estate.[48] These were oriented, like some of May's housing in Frankfurt, in relation to the sun, with the living rooms facing south. On the north side, a stair tower gave access to balconies running nearly the length of each block from which the individual units could be accessed. This arrangement was unusual in Germany, where housing blocks erected during the 1920s were usually accessed through internal stairs, with two floor-through units per floor. Meyer may have borrowed it from Britain, where it was the norm for council housing.[49] Each block contained 18 flats. Featuring modern kitchens, bathrooms, and central heating, and with clothes washing facilities provided in the basement, they remain prized places to live. Promising less than Gropius had in terms of transforming the construction process, they proved to deliver more, although the inhabitants of Gropius' units certainly benefitted from the possibility of extending them far into their generous gardens.

In addition to the studio block, administrative offices, and classrooms, the Dessau Bauhaus contained 28 dormitory rooms of only 20 square meters each. Many of the school's most illustrious students lived at least briefly in them. One of the four floors was allotted to the women. Breuer designed the furnishings, while the coverlets were the work of Anni Albers, one of the school's most celebrated weavers. Today, one can rent them for a modest fee, if one is willing to live as the students themselves did, with only a sink in the room and the showers and toilets down the hall. Although the number of students housed on campus was always small, the contribution that their presence made to the school's atmosphere was enormous. As the emphasis of many of the school's students shifted from painting to photography, the so-called Prellerhaus provided a backdrop for documentation of their light-hearted antics.[50]

Until very recently, almost all scholarship on the leadership of the Bauhaus focused overwhelmingly on Gropius and Mies' directorships. Meyer's relatively early death after relatively unsuccessful stints in the Soviet Union and Mexico fit less comfortably into the Cold War narratives that valorized the Bauhaus in West Germany and the United States.[51] The housing for faculty and students that Meyer's Bauhaus-based office erected as part of the ADGB school was less celebrated and much more pragmatic than that in Dessau.[52] Like the Bauhaus itself, this complex was largely off limits to those on the wrong side of the Iron Curtain until November 1989. Moreover, there were no surviving photographs as seductive as Moholy's original photographs of Gropius' masterpiece. The complex has only been incorporated into the Bauhaus canon in the twenty-first century. Those who came for the four-week training courses stayed in balcony double rooms without balconies. These lined one end of the complex; the nearly equally efficient dwellings for their instructors had none of the bourgeois pretensions of the villas inhabited by Bauhaus faculty (Figure 1.6). In Bernau as at Törten, Meyer stuck to easy-to-maintain brick, refusing to cover it in the quickly stained white stucco that better accorded with the crisp volumes of De Stijl and Constructivist art.

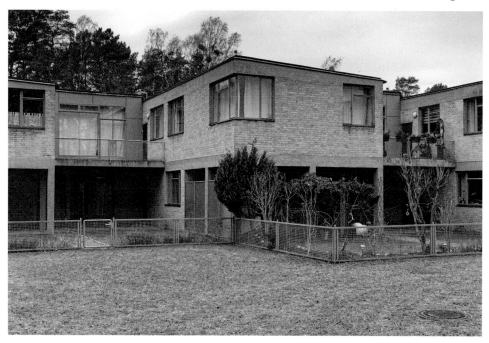

Figure 1.6 Faculty housing, School of the Allgemeinen Deutschen Gewerkschaftsbundes (ADGB), Hannes Meyer, Bernau, 1930. © Bildarchiv Foto Marburg/Uwe Gaasch.

Too often, the Bauhaus serves as shorthand for a socially inclusive approach to architecture that was in fact not often central to what it even attempted to achieve. Its effect has thus been exaggerated by both its supporters and detractors.[53] Yet, it is certain that its directors, faculty, and students were committed to reconfiguring domesticity in ways that continue to be influential. A school that focused on the making of things simultaneously was convinced that the appearance of objects mattered enormously and that a certain spartan understatement could be extremely elegant. While the new aesthetic it fostered certainly encouraged a relatively casual alternative to bourgeois conventions of domestic accumulation and display, these were not necessarily targeted directly at the working class. And yet, it is certain that the impact of its aesthetics quickly encompassed mass housing and accounted for many of its successes as well as some of its failures.

The Bauhaus' varied experiments with housing were part of a larger project to reconfigure modern life that spilled out beyond the school's walls to include the work of housers based in Berlin, Frankfurt, and Hamburg, as well as a number of smaller German cities such as Celle. Although the once avant-garde approach to architecture and design pioneered in Germany and a handful of other European countries in the 1920s and employed for some but by no means all of this housing influences many of the environments in which we study, work, and sometimes also shop and live, there remains considerable resistance to its view of domesticity. Comfort remains for many a matter of the welcoming curves of generous upholstery and the clutter of familiar mementoes. Not everyone wants to be a pioneer in a new world of abstract efficiency, and in an era in which climate change is our greatest challenge, an industrial aesthetic

no longer clearly communicates the possibility of social progress and greater equality. There was always a gap between those for whom the new was a lifestyle choice and those for which it simply offered the means of achieving a higher standard of living. Nonetheless, the buzz of the Prellerhaus, the earnestness of the ADGB trade union school, and the glamour of the master's houses remind us of the promise that the new once held. The challenge now is to rework that promise for our own time, in which we need sustainable dwellings for people of all ages and income groups.

Notes

1. Nancy Stieber, *Housing Design and Society in Amsterdam: Reconfiguring Urban Order and Identity, 1900–1920* (Chicago: University of Chicago Press, 1998).
2. Charles Jencks, *The Language of Postmodern Architecture* (1977. New York: Rizzoli, 1984) 9.
3. Carl O'Brien, "'Huge Increases' to Student Accommodation Costs ahead of Rent Cap," *Irish Times*, August 7, 2019.
4. W. Grant, "A New Utopia? Berlin – The New Germany – The Modern Movement," *The Studio* 98 (1929): 859–65.
5. Jeffrey Saletnik and Robin Schuldenfrei, eds. *Bauhaus Construct: Fashioning Identity, Discourse and Modernism* (London: Routledge, 2009) 1–9.
6. Kevin D. Murphy, "The Villa Savoye and the Modernist Historic Monument," *Journal of the Society of Architectural Historians* 65 (2003): 68–89.
7. Andreas Schwarting, *Siedlung Dessau-Törten: Rationalität als ästhetisches Programm* (Dresden: Thelman, 2010) 213–16.
8. Gilbert Herbert, *The Dream of the Factory-Made House: Walter Gropius and Konrad Wachsmann* (Cambridge: MIT Press, 1984); Barry Bergdoll and Peter Christensen, *Home Delivery: Fabricating the Modern Dwelling* (New York: Museum of Modern Art, 2008); Miles Glendinning and Stefan Muthesius, *Tower Block: Modern Public Housing in England, Scotland, Wales and Northern Ireland* (London: Yale University Press, 1994); and Robert Liebscher, *Wohnen für alle: Eine Kulturgeschichte des Plattenbaus* (Berlin: Vergangenheits Verlag, 2011).
9. Adelheid von Saldern, *The Challenge of Modernity: German Social and Cultural Studies, 1890–1960* (Ann Arbor: University of Michigan Press, 2002) 93–181, for who lived in social housing built during the Weimar Republic and their reception of it.
10. Robin Schuldenfrei, *Luxury and Modernism: Architecture and the Object in Germany, 1900–33* (Princeton: Princeton University Press, 2018). See also Winfried Nerdinger, *Walter Gropius: Architect der Moderne* (Munich: C. H. Beck, 2019) and Wolfgang Thöner and Alexia Pooth, eds., *Neue Meisterhäuser in Dessau, 1925–2014. Debatten, Positionen, Konstexte*, Edition Bauhaus 46 (Dessau: Stiftung Bauhaus Dessau, 2017).
11. Nerdinger, *Walter Gropius: Architekt der Moderne*, 45–47.
12. Barry Bergdoll and Terrence Riley, eds., *Mies in Berlin* (New York: Museum of Modern Art, 2001).
13. Christian Otto and Richard Pommer, *Weissenhof 1927 and the Modern Movement in Architecture* (Chicago: University of Chicago Press, 1991), and Karen Kirsch, *The Weissenhofsiedlung. Experimental Housing Built for the Deutscher Werkbund, Stuttgart, 1927* (New York: Rizzoli, 1989). Tom Wolfe, *From Bauhaus to our House* (New York: Washington Square Press, 1981) 31, is one of the many who mistakenly describes the Weissenhof as workers' housing.
14. Philip Oswalt, *Hannes Meyer neue Bauhauslehre: Von Dessau bis Mexico* (Basel: Birkhäuser, 2019).
15. Le Corbusier, *Towards a New Architecture* (1923. Los Angeles: Getty Research Institute, 2007).
16. Hartmut Frank and Wolfgang Voigt, *Fritz Schumacher. Reformkultur und Moderne* (Ostfildern: Hatje Cantz Verlag, 1997); and Norbert Beieke, *Margaretenhöhe: Das Jahrhundertwerk* (Essen: Beleke, 2006).

17. Norbert Huse, ed., *Vier Berliner Siedlungen der Weimarer Republik – Britz/Onkel Toms Hütte/Siemenstadt/Weße Stadt* (Berlin: Argon, 1987); and Claudia Quiring, Wolfgang Voigt, Peter Cachola Schmal, and Eckhard Herrel, eds., *Ernst May: 1886– 1970* (Munich: Prestel, 2011).

18. Celina Kress, *Adolf Sommerfeld/Andrew Sommerfeld: Bauen für Berlin 1910–1970* (Berlin: Lukas Verlag für Kunst- und Geistesgeschichte, 2011). I thank Mary Pepchinski for this reference.

19. For many other examples of this phenomena, see Kathleen James, *Erich Mendelsohn and the Architecture of German Modernism* (Cambridge: Cambridge University Press, 1997).

20. Barry Bergdoll, "Bauhaus Multiplied: Paradoxes of Architecture and Design in and after the Bauhaus," in *Bauhaus 1919–1933: Workshops for Modernity*, Barry Bergdoll and Leah Dickerman, eds. (New York: Museum of Modern Art, 2009) 43–45, and Wolfgang Pehnt, "Gropius the Romantic," *The Art Bulletin* 53 (1971): 382–86.

21. Schuldenfrei, *Luxury and Modernism*, 116–37. For its afterlife under Communism in the 1970s and 1980s, when Bernd Grünewald and his family resided there see in Norbert Korrek and Christiane Wolf, "The Long Path to the Restoration of the Bauhaus Dessau (1951–1976)," in *Dust and Data: Traces of the Bauhaus across 100 Years*, Inez Weizman, ed. (Leipzig: Spector Books, 2019) 254–56.

22. Ulrich Müller, *Raum, Bewegung und Zeit in Werk von Walter Gropius und Ludwig Mies van der Rohe* (Munich/Oldenberg: Akademie Verlag, 2004) 100–65; and Barbara Happe and Martin S. Fischer, *Haus Auerbach of Walter Gropius with Adolf Meyer* (Berlin: Jovis, 2009).

23. Wolfgang Thöner and Monika Markgraf, *Die Meisterhäuser in Dessau*, 2nd edition (Leipzig: Spectormag, 2018).

24. Schuldenfrei, *Luxury and Modernism*, 138–56.

25. Alice Friedman, *Women and the Making of the Modern House* (New York: Abbeville, 1998) 64–91, and Wolf Tegethoff, *Mies van der Rohe: The Villas and Country House* (Cambridge: MIT Press, 1985) 90–98.

26. Boris Friedewald, "Von der Freiheit und Größe heller und sparsam möbilierter Räume: Die Ehepaare László Moholy-Nagy und Lucia Moholy sowie Josef Albers und Anni Albers im Haus Burgkühnauer Allee 2 in den Jahren von 1926 bis 1933," in Thöner and Pooth, *Neue Meisterhäuser in Dessau*, 102–05.

27. Ann Grünberg, *Erich Mendelsohns Wohnhausbauten* (Berlin: Deutscher Kunstverlag, 2005).

28. Tegethoff, *Mies van der Rohe: The Vilas and Country Houses*, 123.

29. Wallis Miller, "Tangible Ideas: Architecture and the Public at the 1931 German Building Exhibition in Berlin," PhD dissertation, Princeton University, 1999.

30. Barbara Miller Lane, *Architecture and Politics in German, 1918–1945* (Cambridge: Harvard University Press, 1968) 206–10.

31. Marco de Michelis, "Walter Determann: Bauhaus Settlement Weimar. 1920," in Bergdoll and Dickerman, *Bauhaus*, 86–89.

32. Susan Henderson, "A Revolution in Women's Sphere: Grete Lihotzky and the Frankfurt Kitchen," in *Housing and Dwelling: Perspectives on Modern Domestic Architecture*, Barbara Miller Lane, ed. (New York: Routledge, 2007) 248–58.

33. Nerdinger, *Walter Gropius*, 176–78.

34. Dublin was unusual among European cities in placing interwar social housing in the historic city center. See Ellen Rowley, *Housing, Architecture and the Edge Condition: Dublin is Building, 1935–1975* (London, Routledge, 2018).

35. Lane, *Architecture and Politics*, 88–111.

36. Paul Overy, *Light, Air and Openness: Modern Architecture between the Wars* (London: Thames & Hudson, 2008).

37. Eric Mumford, *The CIAM Discourse on Urbanism, 1928–1960* (Cambridge: MIT Press, 2002) 27–44.

38. Sigfried Giedion, *Space, Time and Architecture* (Cambridge: Harvard University Press, 1941).

39. Nerdinger, *Walter Gropius*, 203–07.

40. https://www.bauhaus-dessau.de/en/architecture/bauhaus-buildings-in-dessau/dessau-toerten-housing-estate.html, consulted March 10, 2020.

41. Philippe Boudon, *Lived-in Architecture: Le Corbusier's Pessac Revisited*, Gerald Onn, trans (London: Lund Humphries, 1972).

42. Rudolf Fischer and Wolf Tegethoff, eds., *Modern Wohnen: Möbeldesign und Wohnkultur der Moderne* (Berlin: Gebr. Mann Verlag, 2016).

43. Richard Pommer, "The Flat Roof: A Modernist Controversy in Germany," *Art Journal* 43 (1983): 158–69. Beginning roughly half a century ago, however, architects like Ralph Erskine began to consult potential residents in ways that empowered them to share in the design of their own dwellings. Byker Wall in Newcastle is an early example of this approach; American architect Charles Moore, was also a pioneer in the development of participatory design workshops, although the commissions involved were more often for shared community spaces, such as churches

44. Kevin Barry, "Walter Gropius's Dammerstock and the Possibilities of an Architectural Resistance," in *Art and Resistance in Germany*, Deborah Ascher Barnstone and Elizabeth Otto, eds. (New York: Bloomsbury Visual Arts, 2018) 39–54.

45. Carsten Krohn, *Hans Scharoun: Buildings and Projects*, Julian Reisenberger, trans. (Basel: Birkhäuser, 2018) 65.

46. Kristin M. Szylvian, "Bauhaus on Trial: Aluminum City Terrace and Federal Defense Housing Policy during World War II," *Planning Perspectives* 9 (1994) 229–54.

47. Ivan Nevgodin, "Das Bauhaus in UdSSR – ein russiches Roulette," in *Bauhaus Global: Gesammelte Beiträge der Konferenz Bauhaus Global*, Annike Strupkus, ed. (Berlin: Martin Gropius Bau/Bauhaus Dessau, 2009) 105–09.

48. Claude Schnaidt, *Hannes Meyer: Buildings, Projects and Writings* (Stuttgart: Verlag Gerd Hatje, 1965) 38–39.

49. Rowley, *Housing, Architecture and the Edge Condition*, 190.

50. Rose Carol Washton Long, "From Metaphysics to Material Culture: Painting and Photography at the Bauhaus," in *Bauhaus Culture from Weimar to the Cold War*, Kathleen James-Chakraborty, ed. (Minneapolis: University of Minnesota Press, 2009) 43–62. See also Marie Neumüllers, "'. . . our own space around us:' Life in the Bauhaus," in *The Dessau Bauhaus Building*, Margaret Kentgens-Craig, ed. (Basel: Birkhäuser, 1998) 102–11; and Magdalena Droste and Boris Friedewald, eds., *Our Bauhaus: Memories of Bauhaus People* (Munich: Prestel, 2019).

51. Paul Betts, "The Bauhaus as Cold War Legend: West German Modernism Revisited," *German Politics and Society* 14 (1996): 75–100; and Kathleen James-Chakraborty, "From Isolationism to Internationalism: American Acceptance of the Bauhaus," in James-Chakraborty, *Bauhaus Culture*, 153–70.

52. Brandenburgisches Landesamt für Denkmalpflege und Archäologisches Landesmuseum, ed., *Die Bundeschule des ADGB in Bernau bei Berlin: 1930–1990–2018* (Berlin: Hendrik Verlag, 2019).

53. The popular association continues. For divergent uses see, Witold Rybcznski, "Bauhaus Blunders: Architecture and Public Housing," *National Affairs* (Fall 1993): 82–90; and Claudia Laszczak, "The Bauhaus Legacy – Decent Housing for All!," *Deutsche Welle*, May 26, 2020, https://www.dw.com/en/the-bauhaus-legacy-decent-housing-for-all/av-47580766, consulted September 13, 2021.

2 New Typography, the Bauhaus, and its Impact on Graphic Design

Patrick Rössler

The bone of contention appeared inconspicuous, almost negligible. It consisted of a simple page from a volume of 225, published on occasion of the Bauhaus' first exhibition in Weimar, held in 1923. Its title, *The New Typography*, however, coined a term that would dominate future discussions in the field, and its content described a change in graphic design that would later be attributed by many to the Bauhaus.[1] The author, constructivist and freshly appointed Bauhaus master László Moholy-Nagy, wrote in his distinctively precise style:

> Typography is an instrument of communication.
> It has to communicate a clear message in the most powerful form. …
> Thus, above all: unequivocal clarity in all typographic works. …
> The elasticity, variability and vigour of the typesetting material are to be used to create a new typographic language, whose utilisation is subject only to the laws of expression and its effectiveness.[2]

This programmatic announcement anticipated the fundamental transformation in the optical "feel" of every kind of printed matter that was about to take place in the 1920s – a transformation which bore a name that was no less misleading than it was succinct: "Bauhaus style." Soon, the advertising industry would use this term even in professional discourse, as a synonym for every innovation in the typesetting of contemporary printed matter.[3] One major effect of the Bauhaus was the impact its approach to typography had on graphic design. This is despite the harsh resistance it had to overcome among the traditionalists in the printmaking branch.[4] Its accomplishments in this area were in no way inferior to those in architecture or furniture design. Moholy-Nagy's vision of "typography," however, included more than just pure typesetting. Through what he termed "typographic arrangement," it encompassed all forms of arranging symbols on a plane for the purpose of reproducing a message for public use, that is, what would later be more broadly assembled under the term "graphic design."[5] Core applications included advertising brochures and posters, letterhead, and pamphlets, but also books and magazines that were issued in large numbers and spread the ideas of the "New Typography" to a wide range of disparate audiences.

Comprehensive reviews of the "New Typography" and commercial design at the Bauhaus are readily available elsewhere.[6] The Bauhaus played a crucial role in the development of functional typography – but as a *catalyst* rather than as an innovator.

DOI: 10.4324/9781003268314-3

From today's perspective, it was an unintentional masterwork of brand design and brand management that this radical change was discussed under the *Bauhaus label*, regardless of whether it was described as "elemental," "constructivist," "functionalist," or simply the "new" typography, and irrespective of how different the resulting designs ultimately were.[7]

The Bauhaus Approach to Typography

Initially, an orientation based largely on the formal repertoire of Expressionism dominated the design of printed matter at the Bauhaus. These clearly figurative and ornamental features with calligraphic elements are scarcely reconcilable with the generally dominant image of the institution as the cradle of functionalism associated with Gropius' program of art and technology as a new unity.[8] Nonetheless, these initial examples of typography are important for understanding the radical break initiated by the subsequent countermovement. Although Johannes Itten's successor at the Bauhaus, Hungarian-born Moholy-Nagy, would later become responsible for the institution's graphic design, it was in fact Oskar Schlemmer who first provided a fresh impetus. His 1922 signet with its basic geometric forms clearly illustrates that there was also a turn toward reductive, clear design in the institution's communications. Although he has received almost no acknowledgement as a Bauhaus typographer, Schlemmer was the first to establish a unified layout for the institution's by-laws, perhaps its very first printed materials featuring the New Typography. He also contributed to the advertising materials that were printed for the first major Bauhaus exhibition in 1923 and which placed the institution in the limelight before a broad public. It is scarcely possible to overstate their importance for the graphic design revolution that would soon follow – orchestrating, so to speak, Moholy-Nagy's conceptual fragment "New Typography."

The substantial importance assigned to the public marketing of this event was no coincidence, as demonstrated by the budget plan for the exhibition, which dates back to December 18, 1922. Twenty per cent of the total funds were intended for "propaganda, printing of advertising texts, journeys to establish connections with industry."[9] Abundant promotional and informational materials were subsequently created, and these kept an advertising department initiated specifically for this purpose intensely busy. Herbert Bayer – who was a student and only 22 years old at that time – was responsible for organizing the activity of the 19 students working on this in February 1923.[10]

Walter Gropius' own interests provided the impetus for this exhibition and, despite what he claimed to the Bauhaus' masters, it was not demanded by politicians.[11] The narrative of a forced concession was, however, an effective way to win over the Bauhaus community for the enormous effort required to stage an extensive retrospective of their own work. The exhibition was also intended to showcase Bauhaus products, thus serving the new desire to market them to manufacturers. Last, but not least, it demonstrated the institution's success on the occasion of the annual conference of the German Werkbund – the most important relevant professional association – which was held that year in Weimar. All of this made it indispensable to have an extensive national and international advertising campaign that conveyed the innovative character of the Bauhaus through an unmistakable public image.

This resulted in a new, functionalist approach to typography which banned all decorative elements, highlighted the dynamic impression of an asymmetric layout,

promoted the white space as a means of expression, advocated lower-case writing and the use of sans-serif typefaces, and substituted photography and photomontage for hand-drawn illustrations.[12] The Bauhaus produced posters, leaflets, and a catalogue in the new style, supplemented by press releases and cinema advertising. With this practice – now known as cross-media sales promotion – what are now viewed as up-to-date modern public relations (PR) and marketing concepts were carried out already in 1923.[13] At the same time, this aggressive PR campaign was certainly not uncontroversial within the Bauhaus. Thus, in October of 1922, Bauhaus master Gerhard Marcks was already directing a polemic gaze toward the future:

> The Bauhaus exhibition has begun! Posters on every Mitropa railway carriage! … The Bauhaus Internationale is being played on every square. Everyone smokes only Bauhaus-brand cigarettes. Great speculations in futures shake the stock market. And the reason why? In the museum there are a few cabinets filled with bits of cloth and little pots: that is what has Europe in such a state. Poor Europe![14]

When the school moved to Dessau, it converted what had originally been its fine-art printmaking studio into a printing workshop. As the "workshop for print and advertising," it would later also realize commissions for clients outside the Bauhaus.[15] Former student Max Gebhard recounted that the students worked independently at the composing machines and printed under supervision in the small workshop, where the available equipment included a jobbing press and a cylinder press. This "was an outstanding arena for experimentation and was adequate for carrying out advertising commissions (inserts, for example) from retail and industrial clients. … Generally, all of the printed matter, forms, posters and advertising brochures needed for the Bauhaus' own use were produced in the Bauhaus printers shop, based on designs by Herbert Bayer or students."[16] Combining areas of work which were otherwise divided in the printing industry laid the foundation for a new profession: the graphic designer, who was personally responsible for both the design and its realization.[17]

Consequently, the so-called "Bauhaus typography" encompassed three types of printed matter. First was the Bauhaus' own advertising – that is, informational brochures as well as invitations to celebrations, product catalogues, official printed matter like letterhead stationery, or the school's by-laws. Second were all the Bauhaus' publications, including most prominently the widely acclaimed series of the Bauhaus books and the issues of the Bauhaus magazine.[18] And finally, members of the Bauhaus designed commissioned works for external clients while they were students or during their professional careers following their graduation.

Advertising the Bauhaus

The 1923 exhibition was only the first peak in the Bauhaus marketing campaign; at that time, its extent appeared extraordinary for an art school, but – considering the various tasks and audiences that needed to be addressed through their communication – it was by no means inappropriate.[19] It, too, generated three very general groups of printed matter: (1) the more or less official documents related to professional correspondence, such as the letterhead of the institution and its masters, identity cards for the students, and the by-laws of the school; (2) the Bauhaus' own advertising, including brochures about its program or for presenting products from the Bauhaus

workshops; and (3) ads for specific occasions, announcing festivities, lectures, or exhibitions at the Bauhaus or elsewhere.[20]

In addition to Moholy-Nagy, it was particularly his student Bayer – from 1925 a junior master and head of the advertising workshop – who set himself the task of comprehensively reorganizing how the Bauhaus presented itself in public, at least to the extent this applied to its own printed matter. His goal was to unify this in the sense of what would now be called "corporate design." The basic pillars of his design philosophy – functionalist (i.e., "new") typography, Deutsche Industrie-Norm (DIN – German industrial standard) standardization, the use of lower-case letters only and the integration of photography – are clearly recognizable in all of the designs from the period he was at the Bauhaus.

Joost Schmidt succeeded Bayer in 1928, when Hannes Meyer commenced his duties as director. Schmidt later concluded, "What did I find when I was offered my position? A Bauhaus whose capabilities were exceeded many times over by its reputation and which was being promoted in an unheard-of manner."[21] With Meyer and Schmidt in charge, not only did the concept of advertising education change in very diverse ways, but the close link with the photography department also disappeared. This led to a noticeable stagnation, and the initial developments' continued advancement toward a holistic graphic design languished.[22] While the "study and work schedule of the advertising workshop, printers shop and photo department" in the Bauhaus advertising brochure printed in 1929, under the directorship of Meyer, clearly shows the increased value assigned to these areas of work within the institution's overall curriculum, it also reveals their division into individual "classes."[23] Because Meyer insisted that the Bauhaus' productive income through external commissions be increased precisely through the earnings of this workshop, its work was dominated by lucrative activities like exhibition design, to which all of the individual studios had to contribute.[24] Schmidt increasingly distanced his instruction from the topical, market-oriented advertising studies to which Bayer had been committed, and he developed a cycle of lessons based on 52 practical assignments, which can be reconstructed on the basis of preserved student works.[25]

Every social event at the Bauhaus was accompanied by printed announcements, invitations, and sometimes even posters. They ranged from the fragile brochure of the Metallic fest, held in 1929, which were printed on aluminum foil, to the jovial, symmetrically three-dimensional folded object for the 1930 Bauhaus Carnival festivities to the advertising flyers based on calendar sheets that publicized the Bauhaus' last costume party in February of 1933. The very popular Bauhaus jazz band also had its own advertising material, while other event announcements dealt with performances of the Bauhaus theatre and with the Bauhaus' exhibition activities.

Finally, the founding of the Bauhaus GmbH as a company was meant to enable the Bauhaus to achieve a level of financial independence from state financial assistance by professionalizing its contact with industry and retail.[26] The spectrum of realized printed matter ranged from the call for the design of the model house for the 1923 exhibition to the booklets and packaging for the Bauhaus chess set designed by Josef Hartwig to cards advertising the toys produced on the basis of Alma Siedhoff-Buscher's prototypes.[27] Of course, particular significance was assigned to the advertising materials for the two series of Bauhaus products which had the greatest market success. On the one hand, the furniture and utensils from the wood and metal workshops were offered for sale in a collection of individual sheets in the various

Figure 2.1 Insert sheet for the *Catalogue of Samples*, Herbert Bayer, c. 1927. Collection of
the author.

printed versions of the *Catalogue of Samples* (Figure 2.1). On the other, there were
wallpaper designs like those still successfully marketed today by the Rasch wallpaper
factory in Bramsche, Germany.[28]

Worldwide Circulation: Bauhaus Publications

With the move to Dessau, the Bauhaus intensified the production of periodicals that
had begun in Weimar and included the famous Bauhaus portfolios and the catalogue
of the 1923 exhibition. The establishment of the Bauhaus book series, whose publi-
cation Gropius considered to be a political necessity because it would permit him to
provide an account of the institution's work, developed into the biggest success story
of all.[29] It was conceived as an almost encyclopedic overview of innovations in art,
scholarship, and technology. A total of around 50 different titles were announced;
the publishing contract was based on a portfolio of 31 volumes.[30] Between 1925 and
1929, 14 volumes were in fact published, most of which were designed by Moholy-
Nagy.[31] They appeared with the Munich publisher Albert Langen and represent the
unique effort of an art school to integrate the teaching of all the visual arts.[32] The
project intensely occupied not just Gropius and Moholy-Nagy, but also Moholy-
Nagy's wife Lucia, who served the series as editor and copy editor and coordinated
their work with the publishing house.[33]

However, the four issues of the Bauhaus magazine, which were published in Dessau between 1926 and 1931, proved substantially better suited for rapid and up-to-date communication with various groups interested in the work of the school. Featuring varying formats and different numbers of pages, they, too, were designed by Moholy-Nagy and then later by Bayer or Schmidt; their editions of up to 3,000 copies were addressed to international audiences, thus offering the Bauhaus' PR a powerful instrument of communication.[34] The grand opening of the Dessau Bauhaus building provided the occasion for releasing the first issue. In addition, between 1930 and 1932, the communist student fraction used a hectograph to produce a student magazine against the will of Director Ludwig Mies van der Rohe, whom they reviled as elitist and authoritarian.[35]

Beyond this the Bauhaus repeatedly succeeded in placing extensive special sections about itself in magazines or even designing complete special issues that had a thematic affinity to the school and its ideas.[36] The most remarkable example of this was the 1926 Bauhaus issue of *Offset*, a trade journal for the graphic-design business. With its various contributions written by Bauhaus masters, its color inserts and typical Bauhaus design, it presented a balanced portrait of the institution's achievements, which also focused primarily on the Weimar phase.[37] In 1924, in the Bauhaus special issue of the magazine *Junge Menschen*, the journeymen and junior masters had already presented the ideas and work of the Bauhaus, in that case, without the otherwise obligatory contribution by Gropius.[38] The design by Schmidt adopted the corporate design of the Bauhaus in "New Typography." However, the issue was distributed with two different cover pages in order to avoid scaring off the magazine's audience; one of these was based on its customary appearance.[39]

Commissioned Works by Bauhaus Members

The Bauhaus' consistent use of the New Typography also stimulated the desire elsewhere for printed advertising materials designed in a modern way. Like the other workshops, the Bauhaus' advertising department offered its services to external clients. This began already before the move to Dessau. In the summer of 1923, during preparations for the large-scale exhibition, Gropius received a commission from Thuringia's Ministry of Finance; the Bauhaus was to design the state's emergency banknotes made necessary by the rampant inflation. All of the masters were extremely busy, so it was ultimately Bayer, still a student at the time, who created the requested design (Figure 2.2). Executed entirely in keeping with the principles of the New Typography, it has been often reproduced as one of the first manifestations of the movement, and it also circulated the avant-garde concept of layout in the form of millions of examples in the pockets of all Thuringia's citizens. It is thus almost impossible to exaggerate the significance of these banknotes for the history of graphic design.[40]

At the Dessau, Bauhaus commercial design developed into a lucrative service that was utilized by various businesses, but also by publishing houses for book and magazine covers. Or as Bayer stated in the Bauhaus magazine:

> The efforts of the bauhaus ... also extend to the field of advertising (promotion). ... [A]s a result of the competitive system, advertising has become a necessity today. beyond its purpose – namely, a propositional message from producers to consumers – it is additionally a cultural expression and economic factor and thus a characteristic feature of its era.[41]

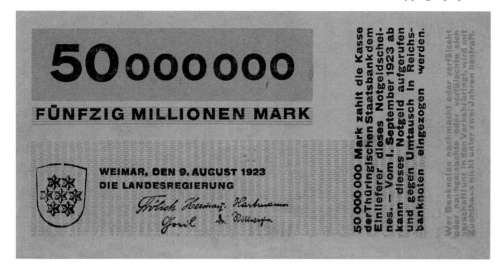

Figure 2.2 Emergency money for the State Bank of Thuringia, Herbert Bayer, 1923. Collection of the author.

The Bauhaus created, for instance, flyers for Dessau's tourism advertising and various kinds of printed matter for Fagus, a producer of shoemakers' lasts, whose factory building had been planned by Gropius and Adolf Meyer beginning in 1911.[42] This success also had a negative side; in his 1928 essay on the design of printed advertising materials, Bayer complained that at a Frankfurt printers shop, "almost 50% of all printing commissions are requested in 'bauhaus style,'" but that this had only led to an ornamental imitation through "crude dots and fat lines."[43]

After departing from the Bauhaus, both Moholy-Nagy and Bayer earned their living primarily by working on advertising commissions. Settling in the German capital of Berlin (and thus next to the pulse of the metropolitan *Zeitgeist*), Moholy-Nagy opened his own firm and Bayer was the artistic director of the "Dorland Studio," an internationally active advertising agency. Both of them employed numerous former members of the Bauhaus, including Max Gebhard, Kurt Kranz, Albrecht Heubner, Hin Bredendieck, Xanti Schawinsky, and the brothers Hans Ferdinand and Hein Neuner.[44] Schmidt, who continued the advertising course at the Bauhaus Dessau as Bayer's successor, carried out commissions for clients that included the local Junkers factory. Among the works commissioned from outside the Bauhaus, two certainly stand out, and their results were among the epoch's internationally most successful and pioneering printed matter. Bayer designed the booklet for the German Pavilion at the 1930 exhibition of Paris' *Société des Artistes Décorateurs*; with its transparent plastic cover, thumb-index and gatefold, it set new standards for design.[45] Moreover, both Moholy-Nagy and Bayer achieved extensive and lasting notice through their cover designs for the monthly lifestyle magazine *die neue linie* (the new line), published by Leipzig's Beyer-Verlag starting in 1929. Moholy's basic layout was maintained, with slight adaptations, almost until the magazine ceased publication in 1943; with its generously proportioned design, cropped photographs often filling whole pages, elegant sans serif font and the asymmetrical layout of its spreads, *die neue linie* embodied and provided a prime example of a "domesticated" modernism adapted for the mass market. Soon Bayer was also receiving commissions for the

monthly's covers, and these made his unmistakable style regularly visible at German and international news stands. Representing the most progressive lifestyle magazine of its time, *die neue linie* upheld some of the basic pillars of the typography of the Bauhaus despite the Nazi regime's efforts to enforce conformity.[46]

The Bauhaus as Catalyst of "New Typography"

Looking backwards, it is clear that "modern" functionalist graphic design defined the epoch. The Bauhaus exhibition of 1923 was a key event for the New Typography movement as a whole; the 21-year-old Leipzig typography student Jan Tschichold, for instance, made a pilgrimage to Weimar for the exhibition, which he would never forget.[47] Two years later, he provided the initial spark for the New Typography's diffusion throughout Germany with a special issue of the influential trade magazine *Typographische Mitteilungen* devoted to functionalist design (Figure 2.3). This issue, which was "originally conceived as a Bauhaus issue," found a broad readership in every area of the printing industry and unleashed a genuine clash of faith between the conservative representatives of the traditional art of book printing and innovators, who mostly came from artistic and advertising circles.[48] Tschichold's striking and distinctive style made him a leading figure of the movement, because the often cryptic utterances of the intellectual founding fathers gathered around Moholy-Nagy

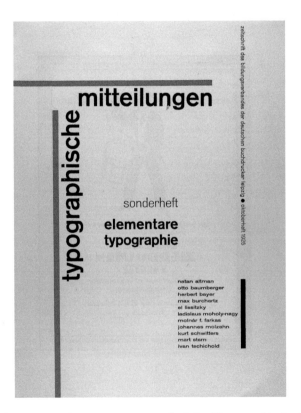

Figure 2.3 Special issue on "elementary typography" for *Typographische Mitteilungen*, Jan Tschichold, 1925. Collection of the author.

usually remained unintelligible for the practitioners at the typesetting machines.[49] As Paul Stirton notes:

> The New Typography and the great modernist project in graphic design was not invented by Jan Tschichold; he did not even coin the term. But he was the chief interpreter of the movement and has come to be regarded as its principal exponent. This role at the center of the movement is slightly misleading, however As he wrote in 1928, it was principally Willi Baumeister, Walter Dexel, Johannes Molzahn, and a few others who had "made the New Typography" a reality.[50]

We might add Kurt Schwitters, Max Burchartz, Wilhelm Deffke, and Hans and Grete Leistikow to this list, but still the movement represented only one approach to graphic design within its epoch. In his 1929 article on "Bauhaus advertising," Karl Theodor Haanen already described "New Typography" as a case of a "rationally, purely intellectually developed style" which is suited only for specific products and a small circle of viewers.[51] His vehement plea for the "strong forces" from Dessau that prompted the contemporary and, in doing so, would also drive the progress of advertising, farsightedly predicts the "language of the Bauhaus [as the] language of the people." Thus, it seems fair to say that the Bauhaus and its graphic designers, if not the sole inventors of a functionalist typography, were influential as catalysts for the spreading of the new visual language. Or, in the words of Werner David Feist, himself a student in the Bauhaus' advertising workshop:

> The problem was that none of the typographers at the Bauhaus were really professional typographic designers. Nonetheless the typography of the Bauhaus was very influential. The liberties that we took with the typography's appearance – letters placed at an angle, asymmetry, the use of elements like large dots and thick lines and the daring handling of space – made our work into an exciting and liberating element.[52]

Some Origins of the New Typography Movement

Already in June 1917, the readers of the *Neue Jugend*, an anti-militaristic monthly journal published by the newly founded Malik Verlag run by the Herzfelde brothers, found a startlingly unusual issue of their magazine in their letterboxes. It folded out into newspaper format, featured colorful characters and vignettes, but most of all a layout that at best looked like a graphic experiment by the Dadaists. Originally intended as a brochure for another of Malik's publications – the graphic folder of an artist friend George Grosz – this double sheet was destined to go down in the history of typography. Tschichold described it in 1928 as "one of the earliest and most significant documents of the New Typography," thus pinpointing the birth of that movement in Germany.[53]

Moreover, Tschichold prominently emphasized Russian Constructivism, whose program was also reprinted in his 1925 special issue, as a source for a functional graphic design. One of its leading exponents, El Lissitzky, spent time in Germany, where he used "New Typography" for the layout of periodicals, including the first two issues of the avant-garde magazine *G*, which were published in July and September 1923.[54] Two years earlier, he had used the new style in a brutal break

with the cozy, playful Art Deco worlds of European arts and crafts; his epochal 1921 cover for a special issue on Frank Lloyd Wright of the architecture magazine *Wendingen* spurned all decoration and delivered instead a study in balance with a vanishing point on the back cover.[55] This radical rejection of a classical aesthetic stood in dialogue with the De Stijl movement centered upon Piet Mondrian and Theo van Doesburg, who Tschichold identified as further inspiration for the "New Typography," because of its reduction to basic colors, vertical and horizontal lines characteristic of "Neoplasticism." The De Stijl journal itself is, as well, sparingly designed, the movement having many points of contact with Constructivism.[56]

However, not even Tschichold's horizon was free from blind spots; for example, he seems to have overlooked the visual adventures of the logo pioneer Deffke, who with his approach of extreme reduction would indeed fit into the program of functional design.[57] The same is true for another outsider in the sector, the self-appointed "advertising guru," Johannes Weidenmüller with his principles, far ahead of their time, for promoting products.[58] Although Weidenmüller's insights, even if crudely formulated, presaged many of the principles of modern corporate communications and were indeed taken notice of by the contemporary press including a long article in the Bauhaus magazine, Tschichold mentioned them in his writings only in passing.

New Typography in the Area Around Dessau

In the region to which the Bauhaus moved in 1925, local authorities and innovative companies from Magdeburg, Halle, and Dessau recognized the potential of functional design in print products for customer communication. Obviously in Dessau more and more publications started to appear in the new look, often printed by the well-established local firm Hofbuchdruckerei C. Dünnhaupt. Its high-level processing quickly turned it into the preferred place to produce quality modern-style print products. Modern advertising graphics were also created in the advertising office of the Junkers factories, which since 1923 had been under the management of advertising expert Friedrich Peter Drömmer, a friend of the early Bauhaus student Karl Peter Röhl.[59]

Magdeburg also developed from the mid-1920s onwards into a place where the visual language of the avant-garde enjoyed increasing attention. One important reason for this was the appointment of advertising graphic designer Deffke as the Director of the local Arts and Crafts School in 1925. Since 1923, the commercial graphics class at the school had been under leadership of Molzahn, an artist who knew Gropius from the *Arbeitsrat für Kunst* and who in the early 1920s had moved in Bauhaus circles. A creative relationship developed between Molzahn and architect Bruno Taut, planning and buildings director in Magdeburg. As well as his teaching activities, Molzahn also ran an advertising office in Magdeburg which was responsible for many designs of local-authority printed matter and later praised by Tschichold.[60]

Dexel, who had previously been the director of the Art Association in Jena, not far from Weimar, succeeded Molzahn in 1928 as head of the advertising class. Well-linked to the Bauhaus and its protagonists as well as by 1922 to van Doesburg, his posters and leaflets for the exhibitions in Jena are striking examples of a constructivist approach.[61] Probably the most outstanding of Dexel's achievements in his Magdeburg time was his success in the German Werkbund's competition to redesign the cover of its journal *Die Form* (Figure 2.4). His rigorously elemental and tightly composed design remained in use at the journal until it ceased publication in 1934,

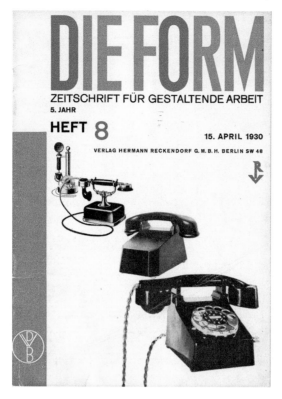

Figure 2.4 Cover, *Die Form*, Walter Dexel, 1930. Collection of the author.

and thanks to its wide readership, Dexel's entry played a significant part in the diffusion of the *New Typography*.

Modern graphic design established itself outside the academy in Magdeburg as well. Like Ernst May in Frankfurt, the town's buildings and planning director, Johannes Göderitz set up a graphic design department in his municipal buildings department and appointed Schawinsky to lead it. A graduate of the Bauhaus, Schawinsky worked from the end of 1929 to the end of 1931, relaunching the local magazine *Das Stichwort* and creating a lavishly produced brochure about the inland ports at Magdeburg. With its fold-out plates, photomontages, and consistent use of geometric forms for reader orientation, this 20-page brochure is a masterpiece of functional typography and every bit the equal of the best designs of the international avant-garde.[62]

In Halle, the new principles in visual communication were firmly associated with the arts and crafts school in Burg Giebichenstein, in particular with the teachings of Hans Finsler, who was Swiss, regarding photography and advertising theory. He found support in the young typographer Hermann Eidenbenz, who at the age of 24 was already a teacher at the school and had developed there a course in typography based on functional principles. Finsler photographed the products of the Burg workshops and the historical and modern buildings in and around Halle on behalf of the municipal authorities in a Neue Sachlichkeit (New Objectivity) style. These photographs were used in several brochures commissioned by the business and transport association of Halle.[63]

The Diffusion of "New Typography" across Germany

In the mid-1920s, the focal point of "new" functional typography was definitely Germany. But surprisingly, perhaps, the key figures were not located in its capital Berlin, or in the major trade city of Hamburg, or even in the book capital of Leipzig. For the dissemination of innovative design principles, we have to look instead to Munich, Hanover, and the Ruhr region.

When Tschichold was hired by Munich's Master School for Typography in 1926, its director, famous typographer Paul Renner, was about to launch his sans serif "Futura" that would turn into *the* typeface of functional graphic design.[64] And this changed little, despite the ambitious attempts of the Bauhaus masters Bayer, Josef Albers, and Schmidt to establish their own alternatives. Georg Trump, too, who like Tschichold was a teacher of type design and typography at Renner's Munich school, developed "City" in 1930, the first success in a long series of typefaces. Each launch was usually accompanied by lavish brochures with samples which attractively demonstrated how the new typeface could be used in advertising materials.

The movement had an acknowledged affinity with the typography experiments of the Dadaists, and so it is no surprise that the MERZ advertising bureau run by multitalented Kurt Schwitters received lucrative commissions from industry, trade, and government administration. He worked for the Bahlsen cookies company, for instance, and produced the printed matter for the Dammerstock Estate in Karlsruhe as well as tram signs for the Hanover public transport authorities. His numerous programs for the different local theatre groups in his hometown were especially widely distributed.[65] Also working in Hanover at this time was highly gifted artist Friedrich Vordemberge-Gildewart, a member of the De Stijl group and, with Schwitters, co-founder of "die abstrakten hannover." He was an ardent proponent of the "functional-optical" as the primary principle of typography, in stark contrast to the "aesthetic-optical" of abstract painting.[66]

Finally, in 1924, Max Burchartz, an often forgotten pioneer of the New Typography, founded the first German advertising agency in the modern style regarding both typography and the scope of its services. In his time in Hannover, Burchartz was also part of the circle around Schwitters, and during a short sojourn in Weimar, he was active in the milieu of the Bauhaus and De Stijl. In partnership with Johannes Canis, he ran his *Werbebau* (advertising building) agency from Bochum, providing a client base composed mainly of industrial concerns in the Ruhr district with modern advertising. In 1925, it designed a silver-gloss printed card folder, organized as a loose-leaf format into which folded double sheets could be inserted similar to the Bauhaus' Catalogue of Samples of the same year, for the products of Bochum-based mining and cast steel manufacturers' association.[67]

"New Typography" and the "New Frankfurt"

By the end of the 1920s Frankfurt, more than any other city, had adopted the new functional *Zeitgeist*. The urban development program led by May, the head of the public housing department, fostered a movement that affected many areas of life – including graphic design. The New Frankfurt, as it was termed, urgently needed a visual image that quickly and convincingly communicated modern community living.[68] The typographical core of this regional movement was undoubtedly the

influential journal *das neue frankfurt* (1926–31), later relaunched as *die neue stadt* (1932/33).[69] It touched upon all areas of the "new life," also covering such media as film and photography. Its perspective soon broadened from the Rhine-Main area to more general themes; these encompassed, as well as the "new building," "new furniture," as in standardized units, and – perhaps most famously – the ergonomically optimized Frankfurt kitchen.

With designs in the style of the New Typography by the Leistikow siblings, Dexel, Robert Michel, and later Willi Baumeister, this distinctive, square-format magazine quickly became an icon of German modernism. The distinctive design by Hans Leistikow, who from 1925 to 1930 was head of the graphic design department in the City Hall, featured a clear, sober page layout, photo-illustrative elements, and an effective cover (Figure 2.5). During the seven years of its existence *das neue frankfurt*, as the public manifestation of decisive change, mediated between the avant-garde and mass production, not least through its sporadic insert, the *Frankfurter Register*, in which the editors presented exemplary items of everyday equipment. In its two final years, the magazine was designed by Baumeister, a native of Stuttgart and director of the typography class at the School of Decorative Arts in Frankfurt. He was best known for his beautiful and clear design of all the advertising material for the technical devices of the Hartmann and Bauer factory, also based in Frankfurt.[70]

The popularity of *das neue frankfurt* can be reconstructed from the advertising price lists of the time. For 1930, a print run of 4,000 is documented, falling back

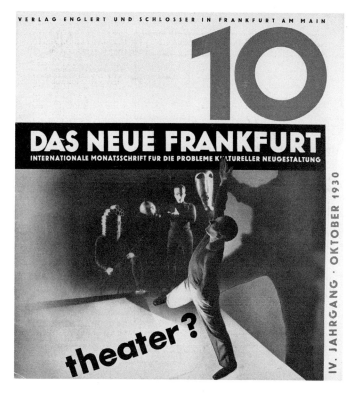

Figure 2.5 Cover, *das neue frankfurt*, Hans Leistekow, 1930. Collection of the author.

to 3,000 in 1931, and 2,500 in 1932. Although these were relatively low figures, the significance of this periodical for the cultural and intellectual revolution in the Weimar period cannot be overemphasized; copies of this magazine went to opinion-leading architects, artists, intellectuals, politicians, and entrepreneurs at home and abroad. These then passed the journal around in their circles and promoted it in their own publications. It represents another influential example – alongside the Bauhaus – of the corporate identity adopted by some modern institutions of the 1920s and which also at the same time contributed to the further dissemination of the New Typography.[71]

From "Bauhaus Style" to an "International Style"

After he left the Bauhaus for Berlin, Ernst Kállai cynically wrote, "Printed matter with bold rule lines and sans-serif lettering: Bauhaus style. everything written small: bauhaus style. EVERYTHING SPOKEN LARGE: BAUHAUS STYLE. Bauhaus style: one word for everything."[72] This cynical diagnosis pinpointed the ubiquity of the new visual style by the end of the 1920s. Meanwhile, the exhibitions and the publications of the *Ring neue Werbegestalter* (New Advertising Designers' Circle), founded in 1928 as their self-appointed professional association and led by Schwitters, brought about a cautious institutionalization of this new movement.[73] The "Ring" was an elite grouping which only accepted members upon recommendation and therefore seldom had more than 20 members. Their Bible was the biographically structured compendium *Gefesselter Blick* (The Captivated Gaze) of 1930 – an unusual book, conceived as a kind of international presentation of that which was intended as universal imagery.[74]

The only Bauhaus representative among the members was Moholy-Nagy, but his links to Dessau were not even mentioned, his entry being instead a single, terse sentence stating, "I am 34 years old and I am a painter," and giving his Berlin address. Bayer's membership application was never accepted, although he took part on several occasions in Ring activities and exhibitions. Instead, the Ring members demonstrated a certain reserve in collaborating with the Bauhaus. Despite a solidarity with its goals, statements by the Ring members in summer 1928 point to "a danger that one could regard our movement as one that is influenced by the Bauhaus ... The good thing about the Ring has so far been that it has managed without the Bauhaus ... in every liaison with the Bauhaus only the Bauhaus has benefited."[75]

Its international members came from the Soviet Union and the Netherlands, where Russian Constructivism and De Stijl had provided the key precedents for the New Typography. Revolutionary Russia was represented in the person of El Lissitzky.[76] Throughout the interwar period, Lissitzky produced impressive photo essays, for instance, for the large-format propaganda magazine *USSR in construction,* issued in four languages. In the Netherlands, protagonists included Piet Zwart and Paul Schuitema, who gave the biweekly publication of the architects' group *de 8 en opbouw* its very own unique look: a dominant "8" as a picture mark, complemented by freely placed photo elements.[77]

A glance at Switzerland and the Czechoslovak Republic, however, illustrates how this style penetrated other countries. The Czechs Karel Teige and Ladislav Sutnar joined the Ring, as did Max Bill, who had studied for one year at the Bauhaus.[78] A dedicated anti-fascist, Bill was responsible for the covers of the short-lived monthly

information for which in typical Bauhaus style he used only lower case and just a single spot color (red), much as Schuitema had with *de 8 en opbouw*.

During the Third Reich, after the Nazis came to power in 1933, it seemed certain that the advances represented by the New Typography would be lost. *Völkisch* (nationalist "folk") aspirations had driven the new rulers' long-standing advocacy of Germanic typefaces, and in 1934, it was decreed that official publications should henceforward use *Fraktur*. The Bauhaus was considered highly suspect, a seedbed for Bolshevism; its academics were persecuted, and their works removed from public collections. The media were to be brought into line by dint of laws and repression. In fact, it proved impossible to eradicate diversity completely. Susanne Wehde notes, "The National Socialists certainly did not impose a universal or uniform anti-Modernism on formal aspects of typography ..., and in fact permitted adoption of highly diverse formal canons and design programs in various applications."[79]

The Nazi avant-garde technocracy had no problem with a combination of German traditionalism and photomontages, typo-photos, geometric and asymmetrical page layouts, or sans serif typefaces when appropriate for particular communicative purpose (Figure 2.6). Functional design shed its original ideological connotations by degrees, to the point where it was even used for anti-Soviet propaganda. And for some protagonists, such as former Bauhaus master Bayer, it remained perfectly possible to continue practicing modernist design without having to come out as an aesthetic resistance fighter against the criminal Nazi system.[80]

On a global scale, the fundamental changes in the visual language of graphic design boosted by the Bauhaus and its members spread far beyond its original circles. The Jack was out of the box. Asymmetric layout, for instance, remains standard in many respects, as does the use of blank space and the minimization of the message to its

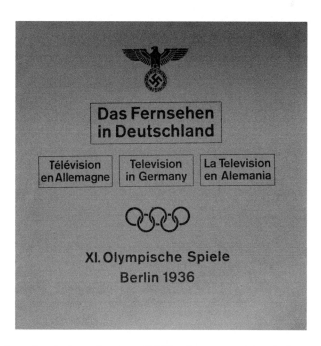

Figure 2.6 Brochure for the introduction of TV in Germany, 1936. Collection of the author.

very core. Yet for technical reasons, the inclusion of photography and the application of sans serif typefaces is even more common. Designers of the interwar period could not even dream of the opportunities offered by computer-based typesetting. Scholars highlighting the impact of the Bauhaus have analyzed, for example, the use of the Futura typeface, an important characteristic of New Typography over the years; others have focused on particular designers such as the American Paul Rand from the United States, or whole national scenes such as post-war Swiss graphics.[81] They all share a view on how the early impetus of the Bauhaus designers was adapted and advanced in a creative manner to contribute to our visual socialization. Today, the "clear message in the most powerful form" Moholy-Nagy had demanded in 1923 has become a widely shared reality in print media communication.

Notes

1. Alston W. Purvis and Cees W. De Jong, *The Enduring Legacy of Weimar: Graphic Design & New Typography* (Munich/London: Prestel, 2019) 35.
2. László Moholy-Nagy, "Die neue Typographie," in *Staatliches Bauhaus in Weimar 1919–1923*, Karl Nierendorf, ed. (Weimar/Munich: Bauhausverlag, 1923) 141.
3. For instance, Fritz Stammberger, "Wandelt sich die elementare Typographie?," *Typographische Mitteilungen* 26 (1929) 6–9.
4. Julia Meer, *Neuer Blick auf die Neue Typographie: Die Rezeption der Avantgarde in der Fachwelt der 1920er Jahre* (Bielefeld: Transcript, 2015).
5. Ute Brüning, "Die Druck- und Reklamewerkstatt: Von Typographie zur Werbung," in *Experiment Bauhaus*, Bauhaus-Archiv Berlin, ed. (Berlin: Kupfergraben, 1988) 154–55.
6. *bauhaus drucksachen typografie reklame*, Gerd Fleischmann, ed. (Düsseldorf: Edition Marzona, 1984); *Das A und O des Bauhauses*, Ute Brüning, ed. (Leipzig: Edition Leipzig, 1995); and most recently Purvis and De Jong, *The Enduring Legacy of Weimar: Graphic Design & New Typography*. This article draws as well upon my books *Bauhaus Typography. 100 Works from the Collection of the Bauhaus-Archiv Berlin* (Berlin: Bauhaus-Archiv, 2017) and *New Typographies. Bauhaus & Beyond: 100 Years of Functional Graphic Design in Germany* (Göttingen: Wallstein, 2018).
7. Patrick Rössler, *The Bauhaus and Public Relations: Communication in a Permanent State of Crisis* (London/New York: Routledge, 2014).
8. Walter Gropius, "Die Tragfähigkeit der Bauhaus-Idee," notes from 3 Feb 1922, cited in Hans M. Wingler, *Das Bauhaus: 1919–1933; Weimar Dessau Berlin und die Nachfolge in Chicago seit 1937* (1968. Bramsche/Cologne: Rasch, 1975) 62–63.
9. Document in the ThHStAW (Landesarchiv Thüringen – Hauptstadtarchiv Weimar), Bauhaus 32, sheet 3; the absolute amount of 2,000,000 Marks has little meaning today, because of high inflation at the time.
10. Brüning, *Das A und O des Bauhauses*, 60.
11. Patrick Rössler, "Das Weimarer Bauhaus und seine Öffentlichkeiten im Dialog," in *bauhauskommunikation: Innovative Strategien im Umgang mit Medien, interner und externer Öffentlichkeit*, Patrick Rössler, ed. (Berlin: Gebr. Mann, 2009) 13–47.
12. Rössler, *New Typographies*.
13. Josefine Hintze and Corinna Lauerer, "Medienereignisse am Bauhaus: Die Ausstellung 1923 und die Erweiterung des Bauhausgebäudes 1926," in Rössler, *bauhauskommunikation*, 185–204.
14. Notation by Gerhard Marcks, September 22, 1922, appendix to the minutes of the Masters' council of October 2, 1922; reprinted in: *Die Meisterratsprotokolle des Staatlichen Bauhauses Weimar 1919 bis 1925*, Volker Wahl, ed. (Weimar: Böhlau, 2001) 236.
15. Magdalene Droste, *Bauhaus 1919–1933* (Cologne: Taschen, 2006) 148.
16. Max Gebhard, "Arbeit in der Reklamewerkstatt," *form + zweck* 11.3 (1979): 72–74, 73.
17. Brüning, "Die Druck- und Reklamewerkstatt."

18. For the books, see Florian Illies, "Avantgarde im Format 23 × 18: Die Bauhausbücher als ästhetisches Programm," in *Modell Bauhaus*, Bauhaus-Archiv, Museum für Gestaltung, Stiftung Bauhaus Dessau and Klassik Stiftung Weimar, eds. (Ostfildern: Cantz, 2009) 235–49; for the magazines Juliana Raupp, "Architektur und Anekdoten: Die Zeitschrift 'bauhaus' – vom Fachperiodikum zum Publicityorgan," in Brüning, *Das A und O des Bauhauses*, 27–32.

19. Rössler, *The Bauhaus and Public Relations*.

20. Overviews are provided in Fleischmann, ed., *bauhaus drucksachen*, Brüning, ed., *Das A und O des Bauhauses*.

21. Hannes Meyer, "Mein Hinauswurf aus dem Bauhaus: Offener Brief an Oberbürgermeister Hesse, Dessau," in *Das Tagebuch* 11 (16 Aug 1930): 1307.

22. Ute Brüning, "Joost Schmidt: ein Curriculum für Werbegrafiker," in Rössler, *bauhauskommunikation*, 257–59.

23. *bauhaus: [junge menschen kommt ans bauhaus!]*, Bauhaus, ed. (Dessau: Bauhaus, 1928).

24. Droste, *Bauhaus*, 180.

25. Brüning, "Joost Schmidt," esp. colour plates VII–XII.

26. Frederick J. Schwartz, "Utopia for Sale: The Bauhaus and Weimar Germany's Consumer Culture," in *Bauhaus Culture: From Weimar to the Cold War*, Kathleen James-Chakraborty, ed. (Minneapolis: Univ. of Minnesota Press, 2006) 115–138, 125–30.

27. Brüning, "Die Druck- und Reklamewerkstatt," note 6.

28. Burckhard Kieselbach, *Bauhaustapete: Reklame & Erfolg einer Marke* (Cologne: DuMont, 1995).

29. Alain Findeli, "Laszlo Moholy-Nagy und das Projekt der Bauhausbücher," in Brüning, *Das A und O des Bauhauses*, 22–26.

30. Ute Brüning, "Bauhausbücher: Grafische Synthese – synthetische Grafik," in Rössler, *bauhauskommunikation*, 281–296; and Frank Simon-Ritz, "'Ein gut fundiertes und aussichtsreiches Unternehmen': Vom Scheitern des Bauhausverlags," in *Imprimatur: Ein Jahrbuch für Bücherfreunde* XXV (Wiesbaden: Harrassowitz, 2017) 293–308.

31. Ulrike Gärtner, "Statt Farbe: Licht – Statt Statik: Kinetik; Einblicke in László Moholy-Nagys Bauhausbücher," in *László Moholy-Nagy: Retrospektive*, Ingrid Pfeiffer and Max Hollein, eds. (Munich: Prestel, 2009) 86–89.

32. Minutes of the Bauhaus council of 18 Feb 1924, cited in Wahl, *Meisterratsprotokolle*, 325; and Reginald R. Isaacs, *Walter Gropius: Der Mensch und sein Werk* (Berlin: Gebr. Mann, 1983) 371.

33. Lucia Moholy, *Marginalien zu Moholy-Nagy: Dokumentarische Ungereimtheiten* (Krefeld: Scherpe, 1972) 44–47.

34. Raupp, "Architektur und Anekdoten."

35. Gerhard Paul, "Die kommunistische Hochschulzeitschrift 'bauhaus' über den sozialistischen Aufbau in der Sowjetunion," in *Dessauer Kalender 1977*, 27–33.

36. Patrick Rössler, "Inszenierungen für die Medienöffentlichkeit: Strategische Bildkommunikation durch das Bauhaus?," in *Das Bauhaus #allesistdesign*, Mateo Kries and Jolanthe Kugler, eds. (Weil: Vitra, 2015) 441–54.

37. *Offset-, Buch- und Werbekunst* 3 (1926): 356–410.

38. *Junge Menschen* 5.8 (1924).

39. For both, see Brüning, *Das A und O des Bauhauses*, 80.

40. Nele Heise, "Das Bauhaus in allen Taschen: Notgeldscheine als Vorboten der Neuen Typografie," in Rössler, *bauhauskommunikation*, 265–280.

41. Herbert Bayer, "typografie und werbsachengestaltung," *bauhaus* 2.1 (1928): 10.

42. Numerous examples are reproduced in Fleischmann, ed. *bauhaus drucksachen;* and Brüning, *Das A und O des Bauhauses*.

43. Bayer, "typografie," 10.

44. Patrick Rössler, *Herbert Bayer. Die Berliner Jahre. Werbegrafik 1928–1938* (Berlin: Vergangenheitsverlag, 2013) 45.

45. Ibid., 36.

46. Patrick Rössler, *die neue linie 1929–1943: Das Bauhaus am Kiosk* (Bielefeld: Kerber, 2007).

47. Werner Doede, "Jan Tschichold," in the supplement accompanying Jan Tschichold, *Die neue Typographie: Ein Handbuch für zeitgemäss Schaffende* (1928; Berlin: Brinkmann & Bose, 1981) 6–7.

48. "Sonderheft elementare typographie," Ivan Tschichold, ed., *Typographische Mitteilungen* 22 (1925): 212.

49. Meer, *Neuer Blick.*

50. Paul Stirton, *Jan Tschichold and the New Typography. Graphic Design Between the World Wars* (New Haven: Yale University Press, 2019) 13.

51. Karl Theodor Haanen, "Bauhausreklame," *Die Reklame* 22.1 (1929): 11–14.

52. Werner David Feist, *Meine Jahre am Bauhaus/My Years at the Bauhaus* (Berlin: Bauhaus-Archiv, 2012) 93, 95.

53. Tschichold, *Neue Typographie.*

54. Detlef Mertins and Michel W. Jennings, eds., *G. An Avant-Garde Journal of Art, Architecture, Design, and Film 1923–1926* (Los Angeles: Getty Publications, 2010).

55. Martjin F. Le Coultre, *Wendingen. A Journal for the Arts, 1918–1932* (New York: Princeton Architectural Press, 2001).

56. Frederike Huygen, *Modernism: In Print. Dutch Graphic Design 1917–2017* (Eindhoven: Lecturis, 2017).

57. Bröhan Design Foundation, eds., *Wilhelm Deffke. Pioneer of the Modern Logo* (Berlin: Scheidegger & Spiess, 2015).

58. Dirk Schindelbeck, "Von der 'Werkstatt für neue deutsche Wortkunst'zur 'anbietlehre: 'Johannes Weidenmüller, der vergessene Urahn der deutschen Werbung," in *Wege in die Moderne. Weltausstellungen, Medien und Musik im 19. Jahrhundert*, Roland Prügel, ed. (Nürnberg: Germ. Nationalmuseum, 2014) 68–80.

59. Claudia Perren, Torsten Blume and Alexia Pooth, eds., *Moderne Typen, Fantasten und Erfinder. Große Pläne! Zur angewandten Moderne in Sachsen-Anhalt 1919–1933* (Bielefeld: Kerber, 2016).

60. Norbert Eisold and Norbert Pohlmann, eds., *maramm Magdeburg. Ausstellungs- und Reklamestadt der Moderne* (Magdeburg: Forum Gestaltung, 2016).

61. Gerd Fleischmann, ed., *Walter Dexel. Neue Reklame* (Düsseldorf: Edition Marzona, 1987).

62. Eisold and Pohlmann, *maramm Magdeburg*, 44–49.

63. Thilo Koenig, ed., *Hans Finsler und die Schweizer Fotokultur: Werk, Fotoklasse, moderne Gestaltung 1932-1960* (Zurich: gta, 2006).

64. Christopher Burke, *Paul Renner. The Art of Typography* (London: Hyphen, 1998); and Petra Eisele, Annette Ludwig and Isabel Naegele, eds., *Futura. Die Schrift* (Mainz: Hermann Schmidt, 2016).

65. Volker Rattemeyer and Dietrich Helms, *Kurt Schwitters. Typographie und Werbegestaltung* (Wiesbaden: Museum Wiesbaden, 1990).

66. Volker Rattemeyer and Dietrich Helms, *Friedrich Vordemberge-Gildewart. Typographie und Werbegestaltung* (Wiesbaden: Museum Wiesbaden, 1997).

67. Gerda Breuer, ed., *Max Burchartz 1887–1961. Künstler Typograf Pädagoge* (Berlin: Jovis, 2010).

68. Klaus Kemp and Matthias Wagner, eds., *Alles neu! 100 Jahre neue Typografie und neue Grafik in Frankfurt am Main* (Stuttgart: avedition, 2016).

69. Heinz Hidrina, ed., *Das neue Frankfurt, die neue Stadt. Eine Zeitschrift zwischen 1926 und 1933* (Dresden: Verlag der Kunst, 1984).

70. Wolfgang Kermer, *Willi Baumeister. Typographie und Reklamegestaltung* (Stuttgart: Edition Cantz, 1989).

71. Patrick Rössler, "Frankfurt, Leipzig, and Dessau: 'Neue Typographie'–the New Face of a New World," in Peter Brooker et al., eds., *The Oxford Critical and Cultural History of Modernist Magazines, Vol. III (Europe 1880–1940)* (Oxford: Oxford University Press, 2013) 969–991.

72. Ernst Kállai, "Zehn Jahre Bauhaus," *Die Weltbühne*, April 26, 1930, 135.

73. Perdita Lottner, *Ring neue werbegestalter: 1928–1933. Ein Überblick* (Wiesbaden: Landesmuseum, 1990).

74. Heinz and Bodo Rasch, eds., *Gefesselter Blick. 25 kurze Monografien und Beiträge über neue Werbegestaltung* (Stuttgart: Wissenschaftlicher Verlag Dr. Zaugg & Co, 1930).

75. Quoted in Kees Broos, "Das kurze, aber heftige Leben des Rings 'neue werbegestalter,'" in *"Typographie kann unter Umständen Kunst sein." Ring 'neue werbegestalter.' Die Amsterdamer Ausstellung 1931* (Wiesbaden: Landesmuseum, 1990) 7–10.
76. Nancy Perloff and Brian Reed, eds., *Situating El Lissitzky. Vitebsk, Berlin, Moscow* (Los Angeles: GRI, 2003).
77. Dick Maan, *Paul Schuitema. Visual Organizer* (Rotterdam: 0/10 Publishers, 2006); Yvonne Brentjens, *Piet Zwart (1885-1977), Vormingenieur* (Zwolle: Waanders Uitgevers, 2008).
78. Eric Dluhosch and Rostislav Švácha, eds., *Karel Teige 1900-1951. L'enfant terrible of the Czech modernist avant-garde* (Cambridge: MIT Press, 1999); Iva Janáková, ed., *Ladislav Sutnar: Design in Action* (Zürich: Museum für Gestaltung, 2003); and Gerd Fleischmann, Hans R. Bosselt, and Christoph Bignens, eds., *Max Bill. Typografie Reklame Buchgestaltung* (Zürich: Niggli, 1999).
79. Susanne Wehde, *Typographische Kultur. Eine zeichentheoretische und kulturgeschichtliche Studie zur Typographie und ihrer Entwicklung* (Tübingen: Max Niemeyer, 2000).
80. Rössler, *Herbert Bayer.*
81. Alexandre Dumas de Rauly and Michel Wlassikoff, *Futura – une gloire typographique* (Paris: Norma, 2011); Steven Heller, *Paul Rand* (New York: Phaidon, 1999); and Richard Hollis, *Schweizer Grafik. Die Entwicklung eines internationalen Stils* (Basel: Birkhäuser, 2006).

3 Bauhaus Effects

Florence Henri and Modernist Photography in Paris

Sabine T. Kriebel

The Bauhaus spoiled Paris for her, wrote painter Florence Henri to artist Margarete Schall in August 1927. She wanted to return to Dessau, not only to her friends, but also for the "wonderful Bauhaus modern conveniences."[1] "Paris," she wrote to artist Lou Scheper in the same month, "makes an incredibly old-fashioned impression after the Bauhaus. I am no longer under its spell."[2] One Bauhaus "effect," for this particular individual, was to displace Paris as the capital of industrial modernity, at least in the domestic realm. To continue the experience of Bauhaus modernism in her Parisian private sphere, because "[a] comfortable home is the most important thing," Henri imported Bauhaus furniture.[3] Her purchases included a nickel-plated lamp and glass teapot by Wilhelm Wagenfeld and two armchairs and two tables in chromium-plated metal by Marcel Breuer. Unfortunately, the transfer of modernist design across the French border proved to be expensive; customs duty was very high. "For the nickel plating alone they want 20 fr[ancs] per kilo, and there are 60 kilo."[4]

Not only did Henri import Bauhaus design into Paris, she also carried with her the genesis of a new career in photography. "Now for some news," wrote Henri in another letter, "I'm taking photographs. If I enjoy it, I'll give up painting (provisionally) ... I'm so tired of all this painting that doesn't go anywhere, and I've got so many ideas for photographs ... I'd like to have a profession which produces results but also interests other people."[5] Again trading tradition for modernity, Henri was to develop a career in the photographic arts that, within a scant year, catapulted her into the vanguard of European artistic discourse and secured her place in modernist art history – albeit a history that is still being written to include the complexities and nuances of women's individual contributions, beyond their status as a marginalized group. Importantly, the Bauhaus was the catalyst for transformation.

The reverberations of Bauhaus ideas and things in Florence Henri's photographs are plainly evident yet underexplored. Though she only spent a summer at the school in Dessau, the ideas and objects she encountered there informed a photographic practice that "produced results and interested people" to no small degree, resulting in swift international recognition from Amsterdam to New York City, advertisements for designer Jeanne Lanvin, and a reputation that attracted to her Paris studio students such as Lisette Model, Gisèle Freund, and Ilse Bing – important and under-historicized women photographers in their own right. Focusing on Henri's compositional use of the reflective doublings seen in Lucia Moholy's practice, the constructivist compositions preferred by László Moholy-Nagy, the optical illusions courted by Josef Albers, the formal possibilities of Breuer's tubular steel chairs, Bauhaus advertising

DOI: 10.4324/9781003268314-4

tactics, and the mirrored balls of Bauhaus experiment, I argue that the provocations of the Bauhaus constituted a foundation for both the material and the conceptual terms of Henri's bequest to modernist visual culture.

Dessau 1927

Henri's 1927 sojourn at the Dessau Bauhaus was brief but formative. It was also the result of serendipity and was facilitated by the networks of friendship rather than of pointed deliberation. On a return trip from Berlin, Henri decided to stop off in Dessau to visit her friends Margarete Schall and Grete Willers, who were students at the school. Sufficiently inspired by what she witnessed, Henri enrolled as a non-matriculated student for four months, during the summer semester from April to July 1927.[6] She participated in the preliminary course (*Vorkurs*) co-taught by Moholy-Nagy and Josef Albers, which in addition to material and form studies also included, as Vanessa Troiano elaborates in this volume, studies in optical illusions, all of which figured in her subsequent photographic work.[7] Photographic experiments with light, perspective, and montage were also addressed in Moholy-Nagy's half of the course.[8] Henri studied with Kandinsky and Klee as well.[9] This was Henri's second time as a student in the Bauhaus School, having enrolled in 1923–24 in its Weimar location. It was, however, her first taste of Walter Gropius' new modernist quarters for it, which had just been inaugurated in December of 1926 and embodied the new industrial-technological ambitions of the institution, as well as of his nearby houses for himself and six of the school's faculty. As previous writers have noted, Henri's enrollment was primarily a way to participate in the Bauhaus again, for in age and experience she was closer to the teachers than the students; she developed significant friendships with several Bauhaus masters and their spouses including László Moholy-Nagy and Lucia Moholy, Josef and Anni Albers, Georg and El Muche, Herbert and Irene Beayer, and Hinnerk and Lou Scheper.[10]

Friends with Moholy-Nagy since her first Bauhaus experience, Henri moved into the Gropius-designed faculty (or Master's) house, that he shared with his wife Lucia. The Moholys lived in one half of the duplex and Feiningers in the other. These houses were in essence experimental labs for Germany's *Neues Wohnen*, or new modernist living, and their design embraced rationality, modularity, and spatial flow.[11] Not only were the houses outfitted with built-in cupboards, furniture, and lamps from the various Bauhaus workshops, they incorporated the latest in domestic technology including fitted kitchens, integrated bathrooms, living room ventilators, folding paravents as room dividers, and central heating and water, whose radiators and boilers were products of the Junkers Factory nearby.[12] The modern conveniences that so impressed Henri represented Gropius' belief that technology could facilitate a more comfortable life.[13] A Bauhaus film of 1926 *How to Live Healthily and Economically* documents the latest devices, including the electric tea kettle and plate warmer in the Gropius house with electric sockets installed nearby.[14] Only the Gropiuses, the Moholys, and the Muches decorated their houses in a purely Bauhaus style.[15] Had Henri befriended and lived with the Klees or Kandinskys, the history of modern photography might have looked a little different. Indeed, the Moholys' interior design most approximated that of Gropius; as Wolfgang Thöner notes, almost all of the interior shots of Gropius' 1930 book *Bauhaus Buildings in Dessau* were from the house of the Moholys, though this might have to do with the fact that Lucia was

the photographer and the house was flooded with natural light because there were two living room windows where others only had one.[16] The Moholy house had a Wagenfeld table lamp and the very Breuer chairs and table that Henri subsequently purchased for herself and imported to Paris. She had lived with these objects for a spell and wanted their continuing signifying presence in her personal space.

Over the course of the summer, Henri developed a close friendship with Lucia Moholy and served as model for her close-up, abstracting portraits.[17] They also discussed photography.[18] Moholy had been working as the unofficial photographer of the Dessau Bauhaus since its inception, documenting the various buildings and workshop products in the objective New Vision style, which made use of sharp focus, dynamic angles, the vicissitudes of light, and materiality. Trained in photography, Moholy was also instrumental in formulating some of the ideas in the 1925 Bauhaus book *Painting Photography Film* which outlined the premises of New Vision photography.[19] As Rolf Sachsse notes, for Moholy's photographic documentation of the shiny, reflective products of the Bauhaus metal workshop – of convex lamps, teapots, and tea strainers, and the like – it was important to emphasize the volume of objects through nuanced gray tones while avoiding unnecessary glare or reflections, including that of the photographer, in the gleaming surfaces.[20] Always making maximum use of natural light, Moholy set up her product still-lives on a glass plate balanced on stools in the corner of a room, offset by a background of lightly crumpled paper. The surroundings were muted so that the objects could shine. She avoided artificial light for her interior pictures, even to the point of artlessness, in the name of objectivity.[21]

Though Henri produced primarily cubist-informed painting and collages at the time (and expressed frustration with her progress), she also experimented with photography.[22] Her earliest known photograph was taken at the Bauhaus in 1927; titled *Window Composition*, it was a view through the window of the communal bath in the Bauhaus studio complex to the glass façade of the workshop building. Henri witnessed how the Moholys, the Bauhaus masters, and students alike explored the formal possibilities of light and light-reflecting surfaces – mirrored, refracted, illuminated, shadowed, and elusive.[23] She also participated in those experiments as a photographic subject. We have a photograph of Henri and Georg Muche posing with mirrored balls in the wooded area next to the faculty houses (Figure 3.1). Muche was known to Henri before her stay; she confessed to Schall in a 1926 letter that she was equally fascinated by Bauhaus master Georg Muche "as by Moholy-Nagy and the furniture."[24] A creative multi-talent, Muche was a painter, designer, architect, master of the Weaving Workshop, and one of the youngest to be appointed by Gropius to teach in the school. Muche's engagement with the Bauhaus was total and his contributions were multiple and wide-ranging, from his collaborations with Johannes Itten in the Preliminary Course to taking over the Weaving Workshop in 1921, to successful architectural designs including the experimental Haus am Horn. He also experimented with photography and supplied Moholy-Nagy with distorted images of himself and the space of the Weaving Workshop reflected in mirrored balls for *Painting Photography Film*. Though Muche identified with the Bauhaus and was known for his future-oriented thinking and teaching, he was increasingly split between modernity and tradition. Concerned that abstraction was going to lead to the end of European painting, Muche had reoriented his commitments to realism in order to get closer to humans and to nature.[25] Still failing to bridge his internal split, Muche left the Bauhaus after that summer semester of 1927 to teach in his friend

Figure 3.1 Florence Henri with Georg Muche at the Dessau Bauhaus, 1927. Florence Henri
 Archive, Genoa, Italy.

Itten's private art school in Berlin.[26] Henri and Muche's friendship lasted beyond the
Bauhaus, however, as the photograph that documents Henri's Parisian Bauhaus inte-
rior for posterity also includes Muche, who was in the city for a visit.

Photography's "New Stage"

In December of 1928, the avant-garde journal *i10* published Henri's photographic
experiments in issue 17/18, accompanied by a commentary from Moholy-Nagy
(Figure 3.2). Published in Amsterdam from 1927 to 1929, *i10* assembled articles
about the newest art, architecture, dance, music, and design, as well as leftist political
reflections ranging from essays by anarchist Pietr Kropotkin to accounts of the Soviet
Union. According to the publisher's recollections, it was Lucia Moholy who sug-
gested the title *i10* in view of the tenth anniversary of the Communist International.[27]
Moholy-Nagy was on the masthead as contributing editor for film and photography,
joined by J. J. P. Oud for architecture and Willem Pijper for music. Thus, the first
public exposure of Henri's photographic experiments landed in a small but influen-
tial international compendium of progressive and experimental thought. The reader
leafing through the December 1928 issue would have first encountered essays by
Gerrit Rietveld on small apartments in Antwerp, Moholy's review of an international
congress for art pedagogy in Prague, Ernst Bloch on the problem of Stravinsky, art

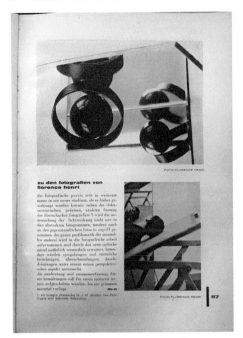

Figure 3.2 Page-spread of article by László Moholy-Nagy on Florence Henri, *i10*, no. 17/18, 20 December 1928. Photograph by the author.

historian Gerrit van Gelder on China and the West, historian and anarchist Max Nettlauer's "Never Again Dictatorship," and Walter Benjamin's reflections on Karl Kraus, before coming upon three photographic spatial constructions with mirrored objects accompanied by Moholy-Nagy's brief editorial "On Florence Henri's Photographs."

"Photographic practice enters a new stage," begins the article, suggesting that Henri's work initiated an innovative pathway for the medium, away from the precision documentary forms, and toward the exploration of light effects in object-based photographs. "The whole problem of manual painting is taken up in photographic work and through the new optical medium it is of course significantly expanded."[28] Henri had indeed transferred the problems invoked by her explorations of cubist painting – the doubt around figure-ground relationships, the dialectics of abstraction and objecthood, perceptual disjunction, and the autonomy of the beholder – into her photographic compositions, using the doubling of mirrors. As object- and light-reflecting devices, mirrors were iconic New Vision props that represented the abstract values and material properties of the movement's ambitions. "If we desire a revaluation in the field of photography so that it can be used productively," asserts Moholy-Nagy in *Painting, Photography, Film*, "we must exploit the light sensitivity of the photographic (silver bromide) plate: fixing upon it light phenomena (moments from light displays) *which we have ourselves composed* (with contrivances of mirrors or lenses, transparent crystals, liquids, etc.)."[29] As analogs to the photographic apparatus, mirrors extend or supplement the optical project of photography; both are light-sensitive surfaces that momentarily arrest fleeting optical impressions. As *things*, mirrors are not only manipulable and subject to the artist's agency, which was

a central aspect of Moholy-Nagy's theoretical conception (note the italics for *which we have ourselves composed*). They are finite objects that have edges and thus physical limitations. They generate borders in and between spaces, at once defining what is within and delimiting what is without. It is this latter property that Henri manipulated, imparting to interwar photographic practice a dimension of destabilization and uncertainty that exceeded that of Bauhaus experimentation. Judging from his commentary, however, Moholy-Nagy was sooner invested than she in the constructivist spatial relationships within the picture, of overlaps and interpenetrations of form and space. The "interpretation and synopsis of these efforts," he concluded, remained to be examined once more material was available for analysis. After all, Florence Henri was just beginning.

In the three examples published in *i10*, the effects of Bauhaus practice are palpable at the same time that Henri has indubitably introduced something new. The composition at the top of the page involving mirrors, a sphere, and a metallic ring form draws aspects of its material and compositional inspiration from Moholy's documentation of Bauhaus metal workshop designs. Riffing on the horizontal juxtaposition of glass plate surface and crumpled paper backdrop that typified Moholy's muted supportive infrastructure, Henri has used two mirrors but at a slight diagonal, employing their hard edges to create linear markers that *call attention* to their form in a manner reminiscent of the constructivist compositions that typified Moholy-Nagy's work of the early 1920s. Further, Henri's multiplication of modest means, using two balls, two rings, and two mirrors, to create four entirely different relational scenarios, not only resonates with Albers' minimalist maximalism, but also expands on New Vision ambitions in ways that were unprecedented. The dominant "protagonist" of this compositional scenario is a large solid ball encircled by a grounded ring in the front left of the picture. This is a relation of solidity and gravity, of existence and embrace, of undeniable and unproblematic *presence* in the picture. Surrounding this grounded protagonist, however, are three mirrored arrangements that upset the foundational narrative of gravity. Behind, on the left, is a truncated view that is suggestive of a planet and a ring, in which the upright halo transforms into a horizontal, weightless form in its reflected iteration. On impact, the ball and sphere and its mirrored, abbreviated *Doppelgänger*, look to form a single, vertical sculptural form, producing a third visual object out of what is essentially *one* formal relation.

Staged to the right of this earthly-saturnine pair is the paradox of balance. A small ball seems to balance precariously, even impossibly, on its supporting ring, while its reflected counterpart upends that tenuous relation into something altogether more banal: a ring rests on a ball, giving in to weight. Placing the smaller ball in the pictorial foreground and the larger ball slightly behind subtly inverts our assumptions of perspective wherein larger objects are closer and smaller ones signify distance. As a result, the composition adroitly destabilizes spatial knowledge in a manner reminiscent of cubism. Though this composition arguably negates Lucia's effacing pictorial strategies, drawing our attention to the surrounding structures – note that the studio window and possibly the photographer's body are reflected in the ball's surface – it would not exist in its systematic boldness without Moholy's precedent. The composition offers up four different spatial relations, four different meditations on gravity, and a several shifting experiences of precarity that serve to unground certainty in favor of perceptual enigma. While Moholy's compositions embraced perceptual clarity and documentary reason, Henri's iterations deliberately court confusion and

doubt, almost willfully questioning the surety of the photographic gaze that Moholy's object catalogs represent.

The self-portrait in the lower right is at first glance perhaps less remarkable, but the work plays with subject-object inversions in ways that equally upset hierarchies of figure-ground and thus destabilize material "knowing." Henri has placed a deck chair at a diagonal in front of the vertical mirror that will play a central role in several well-known compositions. The chair's serrated wooden struts and reclining mechanics register legibly and haptically in the foreground as pleasingly functional linear structures. They resonate with the modern constructivist aesthetics of the Dutch De Stijl and that design ethos underpinned the *i10*. Even the back of Henri's head and torso read as dark, abstracted, spherical, and triangular shapes that blend into the composition. Primed as humans are to seek faces, however, our eyes are drawn past the animate and inanimate abstractions of the foreground to the mirrored reflection to rest on Henri's bemused expression and truncated head. Behind her, the reflection shows an abstracted assemblage of horizontal and diagonal lines. We move, in other words, quite seamlessly from abstraction to figuration, detachment to engagement, in a pictorial system that destabilizes clear subject-object relations.

Henri's third photographic composition was published on the page's recto, a comparatively large reproduction positioned beneath a film review. This time, the seamless mirroring between object and its reflection has been interrupted by the juxtaposition of metallic vents, generating a narrative of entrapment and separation. Moreover, as previous accounts of Henri's ball compositions have noted, works such as this instantiate an uncanny human element, invoking associations ranging from narcissism to melancholy, virility to impotence.[30] The result, is in this case, is a rather forlorn image that serves to reinforce the film under review, *The Child of the Other* by E. Tscherwjakow. It also contrasts with more futuristic and optimistic representations on the previous page, and demonstrates, however subtly, the affective range of Henri's photographic abstractions. Together, all three pictures introduce a practice that owes a debt to Bauhaus practices but has set photography on an altogether more destabilizing and unnerving path.

Bauhaus Metals

Though singular in the context of the *i10* article, Henri's self-portrait in a reclining deck chair has its cognates in other self-portraits with furniture whose origins reside in her Bauhaus experience. We have evidence of several experiments that Henri conducted with the structural aspects of Breuer's tubular steel furniture – importantly, often to the point of unrecognizability. Their curvilinearity, metallic sheen, and hard industrial aesthetic are at issue rather than their functionality. It is unclear whether these photographs were exhibited publicly as "finished" artworks, but they certainly represent private investigations of the formal, abstract possibilities of Bauhaus furniture, contextualized by the aesthetic of technological modernity prized by Moholy-Nagy and Gropius. These interplays of bodily and linear form construct meaningful space for humans, much like architecture and furniture design, and riff on the way in which modular furniture was used to subdivide interior space, albeit here with ambivalent intentions.

An antidote to the massive, heavy, immovable furniture of the past, tubular steel furniture was designed for the future-present: thin, light, strong, mobile,

multifunctional, technologically conceived, and industrially produced. To paraphrase Gropius in his 1930 book *Bauhaus Buildings in Dessau*, grandparents' furniture is outmoded in the era of cars and trains. Conceived for the Dessau Bauhaus in 1925–26, Breuer's tubular steel tables and chairs were photographed by Moholy and Eric Consemüller for circulation in industry publications and the mass press in ways that were increasingly media savvy. Photography and reproductive media became their own carriers of meaning. As Magdalena Droste observes, up until late 1926, most press imagery of Bauhaus furniture was in the *sachlich* or detached-objective photographic mode that tended to foreground the object without human presence, until Consemüller conceived of the now-iconic image of a fashionable woman seated in the Breuer club chair, wearing a metallic mask designed by Oscar Schlemmer, rendering the domestic enigmatic.[31] First published in the *Illustrierte Blatt* of December 1926, Consemüller's ludic image appealed, Droste argues, to a mass audience schooled by the playful, human-centered, and often sensationalist new media of illustrated magazines.[32] Similarly, a collaboration by designer Herbert Bayer and Consemüller resulted in a 1927 sales catalog. The ad featured a front cover image of a woman seated in Breuer's club chair, printed as a film negative that resembled an X-ray photograph, coding Bauhaus furniture with signifiers of edgy modernity and rational science. Moreover, these photographs established the linkage between modern furniture and the liberated, fashionable New Woman, a trope which gathered momentum (and criticism) during the late 1920s.[33] By 1928, tubular steel furniture was an icon of modernity and progress in Germany, and advertised as such.[34] While Henri's purchase of Breuer furniture preceded the media spectacle, she may have seen some of the photographic imagery produced in 1926. In the summer of 1927, while Henri was in Dessau, Bauhaus tubular steel furniture enjoyed further public attention in Stuttgart at the Werkbund exhibition *The Dwelling* (*Die Wohnung*).[35] Occupying a position between Moholy's objective treatment of commodity objects and Consemüller's playful stagings, Henri's self-portraits are matter of fact in their materiality but playful in their composition and disregard for the furniture's functionality, exploring the poles of psychological presence and affective detachment.

In one self-portrait of 1928, for instance, we have a mirrored image of Henri in profile that has been taken at an oblique angle to avoid the reflection of the camera and its operator (Figure 3.3). As a result, the composition has essentially been divided into two spaces: a real space and a virtual space. Like the *i10* self-portrait, lived space in the foreground is replete with haptic presence. We see the alignment of four tubular steel bases, stacked as they might be in a Bauhaus display to show their modularity and stackability, though here upside down and illegible as Bauhaus commodities. At issue is their rectilinear solidity and their dazzling luminosity – in other words, the formal and reflective aspects that signify modernity. Light transforms the metallic horizontals into an almost immaterial, white phosphorescence until they bend into shadow and solidify into implacable form. In the mirror, four bars become two; they coalesce into a cold slice of light that bisects the composition and creates the illusion of a double frame. Though sleights of light and mirrors, matter dissolves in ways that would have delighted Moholy-Nagy.

Past the foreground conjuring tricks, we look into the reflection to attach to the only human element in the picture, her head turned at 90-degree angle from her torso to mimic the right-angled forms that surround her. That human is an apparition, however, for it is a photograph of a mirror image, a double mirage of presence. Henri

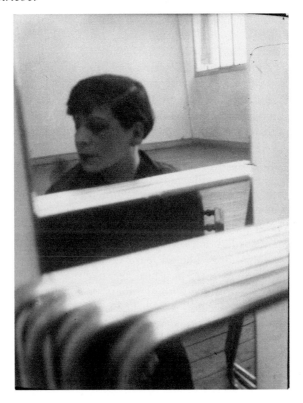

Figure 3.3 Self-Portrait, Florence Henri, 1928. Florence Henri Archive, Genoa, Italy.

in profile denies a connective gaze, absenting psychology and rendering her imitative flesh among things. The deep space of the room that looks to be in front of us is in fact behind us, inaugurating an interplay of mirrors and presence that expands our perceptual centrality. While such plays of dehumanization and abstraction were operative in Consemüller's iconic photograph, Henri's composition dispenses with the furniture's purpose to focus on the formal possibilities of bent reflective steel, subtly adapting her body to mimic the repetition of rectilinearity throughout the image, including bent furniture, the window frame and its subdivisions, finally culminating in the room's corner in as the picture's vanishing point. The human body has been subordinated to the formal regime of furniture and space.

A similar self-portrait of 1928 dispenses with the experience of virtuality to focus wholly on the formal and structural possibilities of Breuer's tubular steel furniture (Figure 3.4). Though characteristically enigmatic, the arrangement appears to involve nothing more than a Breuer chair turned on its side, its backrest facing us on the left, and its seat just discernible as a foreshortened plane on the right. Henri has playfully wedged her head and torso in the space between. Bauhaus furniture is here conceived as a frame for being. Though she looks relaxed in her narrow space, it is confining. The slight tilt of her head subtly interrupts the overall grid pattern of the composition and suggests a more harmonious relation to technology's embrace. Henri's compositional use of Breuer's tubular furniture riffs on their conception as modular, mobile, modern implements for human use, complementing and structuring everyday life in

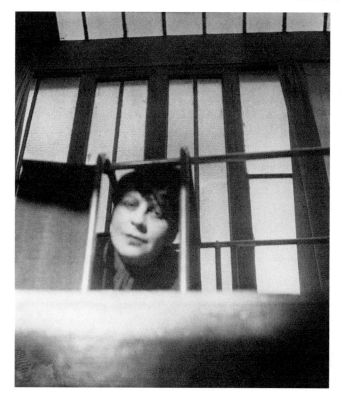

Figure 3.4 Self-Portrait, Florence Henri, 1928. Florence Henri Archive, Genoa, Italy.

ways that integrate both art and life as well as humans and technology. While the Bauhaus marketed this new furniture as a rational and scientific use of modern technologies, with the occasional ludic reference, Henri has transformed this flexible, modular aspect to the extent that it has been divorced from these functional objects to become a value in its own right. She has also embellished upon Albers' injunction to make creative use of the everyday materials to facilitate the integration of art and life. While Breuer used modern technology to create artful chairs, Henri wields technological chairs to create modern art.

One Modern Photographer

"France contributes many old-fashioned imitations but only one modern photographer: Henri Florence," declared the art critic for the *Rheinisch-Westfälische Zeitung* in January 1929, singling out Henri's work at the exhibition *Fotografie der Gegenwart* (Contemporary Photography) though clearly assuming her maleness.[36] Subsequently traveling to Hannover, Berlin, London, Vienna, and Dresden, the show was curated by Kurt Wilhelm Kästner for the Museum Folkwang in Essen, a city that Henri visited often to Schall and Willers, the same friends who precipitated her stay at the Bauhaus in 1927.[37] In 1929, a scant year after she took up photography, public recognition for Henri's photographic innovations was mounting in the country where they took root, culminating in the groundbreaking *Film und Foto*

Exhibition (FIFO) sponsored by the German Werkbund in Stuttgart from May 18 to July 7, 1929. An innovative, international display of modern photography in all its artistic, commercial, propagandistic, and journalistic dimensions, FIFO was co-curated by Moholy-Nagy and is often understood as a showcase of his ideas presented in *Painting Photography Film*.[38] A total of 21 Henri photographs were exhibited, on par with the display of established avant-garde practitioners Man Ray and Germaine Krull, and far exceeding that of most others represented.[39] Like the Essen show, FIFO also traveled to Zurich, Berlin, Vienna, Gdansk, Zagreb, Tokyo, and Osaka, though Henri's contribution was reduced to nine works.[40]

Furthermore, Henri's now-iconic 1929 self-portrait was included in Franz Roh and Jan Tschichold's book *Foto Auge*, published to accompany the FIFO exhibit and to foreground avant-garde photography (Figure 3.5).[41] As the comparison with El Lissitsky's *Composition* on the facing page of *Foto-Auge* makes clear, Henri's self-portrait aligns with other modernist abstractions of self, as formalist elements within a rationalized composition, though her use of reflective balls and mirror stems from Bauhaus precedent. By 1929, Henri's photographic work had become emblematic of an era and was widely circulated as such. Her friend and teacher Josef Albers was certainly pleased for her, writing to her on June 24, 1929, "… this, you certainly would not have imagined, but in my Stuttgart catalogue next to Florence Henri is

Figure 3.5 Left: Florence Henri, *Self-Portrait with Balls*, 1929; Right: El Lissitsky, *Composition*, 1929; from Franz Roh and Jan Tschichold, *Foto Auge* (Stuttgart: F. Wedekind, 1929). Photograph by the author.

written in bold letters: 'the best'. And it's true. As you see, classifying is fun and I do it willingly. Your old chief avant-gardist. And he knows absolutely everything. So, compliments are good for you!"[42]

Such widespread recognition would prove fortunate, for the crash of the stock market in the autumn of 1929 compromised the inheritance that had allowed Henri to focus primarily on her art. She opened a commercial photographic studio in Paris, providing images for advertising campaigns, portraits for a broad clientele, and photographic instruction to students. Her portraits, which included Wassily Kandinsky, the Essen curator Kurt Wilhelm Kästner, Jean Arp, Robert Delaunay, Fernand Léger, and Sonia Delaunay, drew on the blueprint of Lucia's close-up, cropped portrait style, but elicited from her subjects' further sensuality and dynamism by working with slight tilts of head or torso and three-quarter profiles. Later, she also explored the psychological effects of shadow.[43] Similarly, Henri's commercial photography, which included commissions for Columbia Records, Lanvin's Arpège perfume, La Lune pasta, and Selcroix salt, combined narrative and playful composition with the sharp objectivity of New Vision photography. Henri's Lanvin project became an extensive advertising campaign that was reproduced in many periodicals, while several of her portraits and advertisements circulated widely in magazines in France and Germany.[44] Invited to exhibit her work at the New York Art Center's 1931 *Foreign Advertising Photography* exhibition, Henri was awarded an honorable mention. She was the only woman to receive any distinction; the first prize went to the Bauhaus-trained designer Herbert Bayer.[45] On the basis of her Henri's reputation alone, German photographer Ilse Bing moved to Paris to develop her skills.[46] The Berlin-born, Frankfurt-based photographer Gisèle Freund studied with Henri as did the Austrian Lisette Model, both of whom left German-speaking lands for France to escape an encroaching National Socialism, and went on to develop influential international careers in their own right.

While Moholy-Nagy was certainly pivotal in promoting Henri's photographs, recognizing in them the elements of innovative imagery that he espoused, Henri's photographic project often undermined the constructivist logic and material transparency of his work as well as the overall Bauhaus project of clarity, rationality, and functionalism. Rooted in material facts and the nuances of formal relationships, the foundations of Henri's work appear to originate in the empirical knowing that underpinned Moholy's project, but they begin to erode under the slightest analytical pressure.[47] That aesthetics of destabilization has often led critics to describe Henri's photography as surrealist, though the operations of perceptual doubt and spatial dissolution are to be found in the Cubism that preoccupied her formation as a painter. She was still producing cubist-inspired works, however unsuccessfully, while absorbing her Bauhaus environment. Both Cubism and the Bauhaus, though polarized as artistic projects, sought to reconfigure aspects of what T. J. Clark has called "room space," rethinking the intimacy of nineteenth-century interiors in favor of modern orientations rooted in structure, weightlessness, and transparency, and whose effects oscillate from stabilizing to ominous, even monstrous.[48] Contemporary caricatures of Bauhaus furniture underscore this claim.[49] Stability and destabilization, logic and its dissolution, are two sides of the same response to post-World War I life, which was characterized by a foundational loss of ground – economic, political, social, and cultural. The return to clarity, rationality, solidity, and scientific logic represented not only the Bauhaus in 1927 when Henri matriculated, but the predominant aesthetic of the New Objectivity (*Neue Sachlichkeit*), which through its lucid realism presented

a concrete, knowable world and was paralleled by similar tendencies in France and Italy.[50] Though often considered the opposite of the disorientations that character-ized Dada and Surrealism, the hyper-realism and robust thingness of interwar art harbored a preternatural, uncanny, or magical dimension not lost on its contempo-raries – including Henri.[51] Her works use the illusion of rationality, materiality, and technological objectivity to show how swiftly we can lose our footing, landing in a world of enigma, perceptual contingency, and doubt.

Notes

1. Diana C. DuPont, *Florence Henri: Artist-Photographer of the Avant-Garde* (San Fran-cisco: San Francisco Museum of Modern Art, 1990) 132.
2. DuPont, *Henri*, 20.
3. Letter to Lou Scheper, August 29, 1927, DuPont, *Henri*, 133.
4. Letter to Lou Scheper, August 9, 1927, DuPont, *Henri*, 133.
5. Letter to Lou Scheper, February 11, 1928, DuPont, *Henri*, 133.
6. DuPont, *Henri*, 132. Letter of Schall (Essen) to Scheper (Dessau), March 1, 1927.
7. Giovanni Battista Martini and Alberto Ronchetti, "Biography," *Florence Henri* (New York: Aperture, 2015) 194. See also DuPont, *Henri*, 8.
8. DuPont, *Henri*, 19.
9. DuPont, *Henri*, 132.
10. Martini and Ronchetti, *Henri*, 194; and DuPont, *Henri*, 132.
11. Ulrich Kleiner and Axel Paul, *Georg Muche: Vom Bauhaus an den Bodensee* (Munich: Allitera Verlag, 2018) 57.
12. Wolfgang Thöner, "Modellwohnhäuser und Künstlerkolonie: Zum Entwurf und Bau der Meisterhäuser," in *Neue Meisterhäuser in Dessau, 1925–2014: Debatten, Positionen, Kontexte,* Wolfgang Thöner and Alexia Pooth, eds. (Leipzig: Spector Books, 2017) 44; and Christiane Kruse, *Das Bauhaus in Weimar, Dessau und Berlin: Leben, Werke, Wirkung* (Berlin: Braus Verlag, 2018) 103.
13. Regina Bittner, "Wohnen Ausstellen: Das Meisterhaus als Musterhaus," in Thöner and Pooth, *Neue Meisterhäuser in Dessau, 1925–2014,* 83.
14. Kruse, *Das Bauhaus in Weimar, Dessau und Berlin,* 104. See also Robin Schuldenfrei, *Luxury and Modernism: Architecture and the Object in Germany 1900–1933* (Prince-ton: Princeton University Press, 2018).
15. Kruse, *Das Bauhaus in Weimar, Dessau und Berlin,* 103.
16. Thöner, *Neue Meisterhäuser in Dessau,* 102, 105. This view is also repeated in Thöner, *Das Bauhaus Wohnt: Leben und Arbeiten in der Meisterhaussiedlung Dessau* (Leipzig: E. A. Seeman Verlag, 2002) 33.
17. Christina Zelich, "Florence Henri's Photography within the Avant-Gardes," *Florence Henri: Mirror of the Avant-Garde* (New York: Aperture, 2015) 8–9.
18. DuPont, *Henri*, 132 fn. 5.
19. Lucia Moholy, *Marginalien zu Moholy-Nagy: Dokumentarische Ungereimtheiten* (Krefeld: Scherpe Verlag, 1972) 55–56. See also Robin Schuldenfrei, "Images in Exile: Lucia Moholy's Bauhaus Negatives and the Construction of the Bauhaus Legacy," *His-tory of Photography,* 37 (2013): 182–203.
20. Rolf Sachsse, *Lucia Moholy* (Düsseldorf: Editionen Marzona, 1985) 16.
21. Wolfgang Thöner, "Von der Freiheit und Größe heller und sparsam möblierter Räume: Die Ehepaare László Moholy-Nagy und Lucia Moholy sowie Josef Albers und Anni Albers im Haus Burgkühnauer Allee 2 in den Jahren von 1926 bis 1933," in Thöner and Pooth, *Neue Meisterhäuser in Dessau, 1925–2014,* 101.
22. DuPont, *Henri*, 17.
23. Zelich, "Florence Henri's Photography within the Avant-Gardes," 8.
24. DuPont, *Henri*, 131.
25. Kleiner and Paul, *Georg Muche*, 40.
26. Kleiner and Paul, *Georg Muche*, 61.

27. Arthur Lehning, "Introduction," written in Amsterdam in 1928 to the Kraus Reprint of the Internationale Review *i10* 1927–1929 (Nendeln/Liechtenstein, 1979) n.p.
28. László Moholy-Nagy, "On Florence Henri's Photographs," *i10* 17/18 (1928): 117.
29. László Moholy-Nagy, *Painting, Photography, Film* (1925. Cambridge: MIT Press, 1969) 31.
30. Rosalind Krauss, "The Photographic Conditions of Surrealism," *October* 19 (1981): 34; Carol Armstrong, "Florence Henri: A Photographic Series of 1928. Mirror, Mirror on the Wall," *History of Photography* 18 (1994): 223; and Sabine T. Kriebel, "Florence Henri's Oblique," *October* 172 (2020): 8–34.
31. Magdalene Droste, "Stahlrohrstühle als Objekte medialer Bildstrategien und ihr doppeltes Leben," in *Modern Wohnen: Möbeldesign und Wohnkultur der Moderne*, Rudolf Fischer und Wolf Tegethoff, eds. (Berlin: Gebr. Mann Verlag, 2016) 195.
32. Droste, "Stahlrohrstühle als Objekte medialer Bildstrategien," 195.
33. Rudolf Fischer, "Vom Neuen Wohnen zur deutschen Wohnkultur? Mies van der Rohe und die Rezeption der Stahlrohrmöbel in den 1930er Jahren," in Fischer and Tegethoff, *Modern Wohnen*, 25.
34. Fischer, "Vom Neuen Wohnen zur deutschen Wohnkultur?" 13.
35. See Droste, "Stahlrohrstühle als Objekte medialer Bildstrategien," 183; and Fischer, "Vom Neuen Wohnen zur deutschen Wohnkultur?" 17.
36. DuPont, *Henri*, 135.
37. DuPont, *Henri*, 132.
38. On the role of László Moholy-Nagy in the FIFO see Olivier Lugon, "Neues Sehen, Neue Geschichte: László Moholy-Nagy, Sigfried Giedion und die Ausstellung *Film und Foto*," in *Sigfried Giedion und Die Fotografie: Bildinszenierungen der Moderne,* Werner Oechslin und Gregor Harbusche, eds. (Zurich: gta Verlag, 2010) 88–105.
39. Zelich, "Florence Henri's Photography within the Avant-Gardes," 13.
40. Martini and Ronchetti, "Biography," 197.
41. Treatment of this important work remains cursory for reasons of space. For an extensive reading, see Kriebel, "Florence Henri Oblique," 8–34.
42. Martini and Ronchetti, "Biography," 197.
43. DuPont, *Henri*, 22, observes that the interiority, absorption, and private psychological nuances of Henri's work set her work apart from most of the Bauhaus photography.
44. Martini and Ronchetti, "Biography," 199.
45. Martini and Ronchetti, "Biography," 199–200.
46. Martini and Ronchetti, "Biography," 198.
47. Rolf Sachsse notes that Henri was probably the only student of both Lucia Moholy and László Moholy-Nagy.
48. T. J. Clark, *Picasso and Truth* (Princeton: Princeton University Press, 2013).
49. Markus Eisen, "Stahlrohrmöbel in der deutschen Karikatur zwischen 1928 und 1934," in Fischer and Tegethoff, *Modern Wohnen*, 215–233, as well as Siegfried Kracauer's assessments reprinted in Droste, "Stahlrohrstühle als Objekte medialer Bildstrategien," 209.
50. Kenneth E. Silver, *Chaos & Classicism: Art in France, Italy, and Germany, 1918–1936* (New York: Guggenheim Museum Publications, 2010).
51. Franz Roh, *Nach-Expressionismus, Magischer Realismus: Probleme der neusten europaischen Malerei* (Leipzig: Klinkhardt und Biermann, 1925); and Misch Orend, "Der magischer Realismus," *Klingsohr. Siebenbürgische Zeitschrift*, January 5, 1928, 25–27, reprinted in *The Weimar Republic Sourcebook*, Anton Kaes, Martin Jay, and Edward Dimendberg, eds. (Berkeley: University of California Press, 1994) 494–95.

4 The Bauhaus and the Fundamentals of Window Display

Kerry Meakin

The Bauhaus' impact on contemporary design extended as far as shop window display, as manifested in its relationship with the Reimann School, where the subject was taught first in Berlin and then London. Although today one school is world-renowned and the other almost forgotten, the work of the Reimann School introduced many German city dwellers to design ideas pioneered in first Weimar and then Dessau. After the closure of the Bauhaus in 1933, the Reimann School even employed some of the Bauhaus' faculty, first in Berlin and then in London, where it briefly re-opened in 1937.

Both schools were rooted in Wilhelmine design reforms championed by the German Werkbund, which was founded in 1907. The Werkbund focused attention on applied arts education. In tandem with career opportunities for women, this prompted the founding in 1910 Berlin of the Higher Technical School for Decorative Art (*Höhere Fachschule für Dekorationskunst*), which offered instruction in the design of shop window displays. Before and after its merger with the Reimann School, a private commercial and fine arts academy, in 1912, the education it provided had a profound effect on the development of the international reform of shop window display. Three women associated with the school in its early years, Elisabeth von Stephani-Hahn, Else Oppler-Legband, and Lilly Reich, led the way in this regard. Reich would later teach at the Bauhaus. Beginning in the mid-1920s, Georg Fischer, the Reimann's chief instructor in display window design, applied approaches to modern art and design pioneered at the Bauhaus and layered them onto this Werkbund legacy. Fischer admired the work of Bauhaus masters, László Moholy-Nagy and Oskar Schlemmer, and their influence is apparent in his student's work. These new display techniques, including the achievements of the school's international students, were showcased in German trade fairs before being exported to Britain.

The Birth of the Display Window Dresser

During the late-nineteenth century, important developments in shop window display practice and techniques occurred in the United States and Europe. Aided by the interest in the spectacle of the Chicago World's Fair in 1893, entrepreneurs and individuals wishing to acquire a well-paid white-collar career in America were drawn to the role of the window trimmer. Seen very much as a role for men in early twentieth-century America and Britain, window dressing was viewed in a different light in Germany.[1]

DOI: 10.4324/9781003268314-5

German unification prompted faster economic growth than occurred in any other European country during the late-nineteenth and early twentieth centuries.[2] Especially in Berlin, this boom spurred the need to provide retail services. Georg Wertheim, the proprietor of the first German department store, established in Stralsund in 1876, was adroit in establishing a foothold in the capital. With his three brothers, he opened a store on Rosenthaler Strasse in 1885.[3] Its excellent location on the fringe of the central business district allowed its profits to bankroll further branches, including the flagship store on Berlin's Leipzigerplatz and Leipziger Strasse, designed by architect Alfred Messel and erected between 1896 and 1904. By 1905, this new branch was responsible for approximately a third of department store sales in Prussia.[4] Another landmark department store on the Leipziger Strasse was Tietz, which opened in 1900, and was designed by Bernhard Sehring and Louis Lachmann.[5] Both stores grew out of the German garment industry, in which Jews played a prominent role.[6]

Significant social changes also occurred during this period, partially aided by the emergence of public spaces deemed respectable for unaccompanied women. These included department stores.[7] The Wertheim flagship store was the epitome of modernity and a leader in Berlin in terms of fashion, taste, style, and art.[8] In his comprehensive anthology of Berlin's department stores, published in 1907, Paul Göhre described the display windows flanking the main entrance of Wertheim as "in constant flux and [a] beautiful arrangement [containing] modern art and craft objects: furniture, carpets, vessels, robes, pictures." He continued, "You can immerse yourself in their beauty ... They attract you, but they do not push anything ... offering commercial art [as in a] museum hall, exquisite taste, [and a] fine art feeling."[9] The emerging art of window display profited from the architecture of the purpose-built department store. Plate glass, having already been introduced to American department stores in the late-nineteenth century, allowed for larger windows without the interruption of structural supports. Many architectural journals featured articles on the artistic synthesis of architecture and advertising, including the design of shop windows and their displays.[10]

The rise of the department store and its new architecture in Berlin called for a more skillful approach to window dressing and with this a new professional identity, that of the display window dresser. A remarkable development at Wertheim was the 1904 decision to engage a female director of decoration, Elisabeth von Hahn.[11] At the age of 36, Hahn became the full-time director of display windows at Wertheim, where she was employed for the following 21 years, holding the position of artistic adviser until 1925.[12] Hahn repeatedly referred to Messel, the architect of the flagship Wertheim store, as the father of display window art, crediting him with the development of the most advanced example of modern department store architecture and display windows.[13] In the spirt of the *Gesamtkunstwerk* (total work of art), Hahn acknowledged Messel's demand that the shop windows for Wertheim be artistically designed, and thus laid the foundation for the appreciation of the shop window as a cultural achievement.[14]

The German Werkbund and Taste Education

By the turn of the twentieth century, disgruntlement regarding what was seen as the over-ornamentation of products had emerged. Historicism involved the ceaseless duplication of components of previous styles.[15] Sociologist Georg Simmel discussed

the much-maligned "multitude of styles that confronts us when we view the objects that surround us, from building structure to book design, from sculptures to gardens and furniture."[16] Meanwhile, architect Karl Widmer argued that reliance on historicism was due to the rapidity of the Steam Age, and that artistic capacity could not keep up with the speed of modern mass production.[17]

Widespread discontent with the state of modern design in Europe roused a number of individuals and groups to promote change. During the years 1896–1903, when he served as the Cultural and Technical Attaché at the German Embassy in London, architect Hermann Muthesius observed British developments in art, architecture, and technology.[18] He was heavily influenced by the Arts and Crafts Movement there, which formed one of the critical precedents for the establishment of the Werkbund. The Werkbund, an association that brought together architects, designers, critics, and manufacturers, encouraged the design of quality products and the use of authentic materials and craftwork. It championed *Sachlichkeit*, an objective or sober approach that rejected historical nostalgia and excessive ornamentation. As Despina Stratigakos noted of its members, "They [had] a common goal: to save German culture from bric-a-brac."[19]

The Werkbund rejected the conversion of products into decoration, without regard to form or function. In 1911, Paul Westheim described German window displays as "occasionally afford[ing] a sleazy feuilleton joke of calico, tin cans, handkerchiefs or soap."[20] He condemned the use of products to create three-dimensional objects that did not refer to the product's original purpose, complaining about "Rosettes, unnatural folds, creased, twisted, crushed and nailed fabrics, warships made of napkins and shirts, [and] Moorish arches made of sheets or handkerchiefs."[21] To him, these outmoded display method led display window dressers "'defiled' the goods they advertised."[22] He continued:

> There are no good and no decorative concepts that could not be handled with taste. No matter whether it is precious individual items or cheap commodities; the conscious structure of the form is the deciding factor through which the decorator seizes the eye of the passer-by. In fact, these principles are becoming more and more prevalent. The Berlin showcases have undergone tremendous transformation in recent years. Whereas in the past it was only A. Wertheim which was unsurpassably decorated by Miss von Hahn, one can already find some joyful surprises ... for example, with Emil Jacoby, Herr. Hoffmann, Brühl and others ...[23]

The Werkbund aimed to use window display to educate the general population. Three of its female members – Stephani-Hahn, Oppler-Legband, and Reich – were at the forefront of this reform movement.

In 1909, Oppler-Legband, who had studied under Henry van de Velde and Peter Behrens, joined Muthesius and Karl Ernst Osthaus on a travelling lecture series presented under the auspices of the Werkbund and titled: "The Taste Education of the German Merchant." Within a year, more than 5,000 people had attended the talks, which included "Shop Window and Interior Decoration" and "Fashion and Taste."[24] The same year, the Werkbund ran the first of a series of highly successful window display competitions.[25] The talks featured an impressive selection of the windows from these competitions, including examples by Stephani-Hahn, Reich, and leading artists,

architects and designers van de Velde, Behrens, Julius Klinger, and August Endell, who created patterns or structures from the arrangement of the goods.[26] The architects may have turned to window display in order to retain control over the design of shops and their facades. For their part, participating artists, such as Klinger, may also have welcomed the guaranteed income.[27] Principles of "pattern" and "structural" ornamentation deemed appropriate to modern urban life were also derived from the latest psychological research as well as what Muthesius described as an "objective scientific point of view."[28]

Photographs of the display window competition were also published in the 1913 edition of the Werkbund's year book.[29] One, van de Velde's geometric, symmetrical installation for Tropon was an example of pattern ornamentation.[30] However, Stephani-Hahn took a structural approach, which also featured symmetrical arrangements and introduced additional elements, including portable screens.[31] In an article that appeared in the same volume, Friedrich Naumann suggested that "one does not have to show everything that one has, only show that one has something good."[32] A review of the competition by Erich Vogeler described the new window style as being "made purely out of the things themselves, simply by clever use of their colours and forms, by the tone and rhythm of the structure; all the decorative effects are out."[33] The competitions were also the impetus for a new training school in window display. However, in the 1910s, displays of this caliber were far and few between. This was the case even in Germany where despite the Werkbund's efforts, tastefully arranged displays such as those designed by Endell for the Salamander shoe chain, were hailed as exemplars rather than the norm.[34]

The Higher Technical School for Decorative Arts and the Reimann School

Change in applied art teaching began with the restructuring of over 30 schools of applied and fine arts in a government-sponsored effort overseen by Muthesius that would directly influence the Bauhaus.[35] His innovations entailed changes in staff and curricula. In the case of display windows, the task was not to only educate the public in taste but also re-educate the tastemakers.[36]

As the head of the newly formed Higher Technical School for Decorative Arts, established to offer professional training in display window decoration, Oppler-Legband was well situated to lead the display window reform.[37] She was averse to display windows being used as warehouses and, like Westheim, was opposed to the practice of making products into fanciful compositions, such as waterfalls made from handkerchiefs, and seasonal sleighs created from napkins.[38] Oppler-Legband was the artistic director of the ladies' fashion department at the Wertheim department store from 1903 to 1904, and remained on the board of artistic advisors until at least 1912; she had dressed display windows.[39] The Technical School was run in collaboration with the Werkbund, the German Association for Business Education, and the Association of Berlin's Specialized Shops and supervised by a board of trustees, who included Muthesius and Behrens.[40] During the first year, more than 100 pupils attended; as the reputation of the school grew, several Berlin companies were eager to hire its graduates.[41] In 1912, it affiliated with the well-known Reimann School.[42]

Meanwhile, in 1902, Albert and Klara Reimann had opened a small private art school with 14 students.[43] Four years later, when the courses proved popular, Albert

officially set up the Reimann allowing students freedom of expression. His teaching methods involved allowing students to experiment with different materials, paint, clay, wood, metal, and stone.[44] The school was apparently the first to introduce the workshop system.[45] It was one of small number of schools, including Obrist-Debschitz's in Munich, and van de Velde's in Weimar, where the emphasis was already on the autonomous artist.[46] Even in its early days, the instructors at the Reimann were considered professional experts.[47] Alongside commercial art subjects, the school also offered sculpture and painting. The teaching methods were forward-thinking, encouraging students to create their designs based on their subjective perceptions.[48] The school was radical in one other way; it prioritized work that was for and could be produced by women. Unlike at the Bauhaus, there was no attempt to confine the female students to a weaving workshop; instead, beginning in 1910, it provided classes in the physically demanding discipline of window display.[49]

Albert Reimann embraced the merger at the beginning of 1912 with the Higher Technical School for Decorative Arts; he had already spotted an opportunity to teach the art of window display, writing in later years that most of the larger merchants did not know what their shop windows were for.[50] The location of the school in the center of Berlin, the fashion capital of Germany, was also hugely beneficial. Tobias Hoffmann notes, "Reimann had an eye for the needs of a modern society; Berlin was in tune with the times. In Weimar, the city of German classical music, and later in the city of Dessau, there was no need for fashion, shop window decoration or film."[51]

The education the Reimann subsequently provided had an enlightening effect on the development of window display. Stephani-Hahn, who considered window display an applied art and was described as the true pioneer of artistic window dressing, was one of the instructors.[52] Her contribution was to apply concepts regarding color, harmony, line, and rhythm derived from her fine art studies in conjunction with new principles of pattern and structural ornamentation to the design of display windows. She also propagated her methods internationally through her textbook on display methods.[53] In the 1910s, Stephani-Hahn was considered the most important teacher affiliated with the school's decorating department.[54]

Other prominent faculty during the early Higher Technical School's early years included graphic designers Lucian Bernhard and Julius Klinger, who taught lettering and poster design. Ernst Friedmann, who had been working as a show window decorator since 1902, taught practical styling classes, and Behrens taught lighting systems.[55] Friedmann had previously been the artistic adviser to the short-lived magazine *Das Schaufenster* and Behrens had designed window displays for the electrical giant, the Allgemeine Elektricitäts-Gesellschaft (AEG).[56]

Oppler-Legband left following the merger, possibly because the Higher Technical School was taking a more professional stance by aligning with the Reimann or because she had other projects she wished to concentrate on such as the exhibition "The Woman at Home and at Work," which she helped design.[57] Before her departure, however, she played an under-reported and pivotal role in introducing the concept of *sachlichkeit*; her interest in unembellished forms extended to window display, exhibition design, and fashion. She applied the same principles in all her roles, as fashion and artistic director in Wertheim, as a member of the Werkbund, in her exhibition work, and in her later career as an art director and costume designer for the cinema.

Klinger became director of the decorative classes, where he remained until May 1915, when he was conscripted into the Austrian army. Bernhard and Behrens do not

appear in the list of former teachers published in the 25th Anniversary of *Farbe und Form*, the school's in-house journal. They may have departed with Oppler-Legband in 1912.[58] From 1913 to 1919, Bruno Seydel taught window display due to his exemplary show window displays for the Michels Silk Shop. By 1916, despite the war, the Reimann had 450 students.[59]

Of those who studied display window design in Berlin in the 1910s, Reich was undoubtedly the most famous, although by the 1920s her focus was exhibition rather than shop window displays. Although she first worked under Josef Hoffmann in the Vienna Workshops, upon her return to Berlin in 1911 she studied at the newly established Higher Technical School, where Oppler-Legband was her most influential teacher.[60] She also designed dress displays at Wertheim under the creative direction of Stephani-Hahn.[61] A decade younger than Oppler-Legband and 20 years younger than Stephani-Hahn, Reich modelled herself on these experienced professional women, who were pioneers in the field.[62] Virginia Pitts Rembert claims:

> Reich might have practiced the typical female accomplishments had she not of studied with Else Oppler-Legband ... Oppler-Legband's interests and capabilities demonstrated to Reich the wide range of art activities then open to women, especially in the areas of fashion, window, scenery, and interior design.[63]

In her display work at Wertheim, Reich was trained to handle the draping of fabrics as shown in Stephani-Hahn's publication *Schaufensterkunst*.[64] Used to highlight the textures and colors of Germany's textile industry, this was a significant focus of window display at the time.[65]

It is also possible that Oppler-Legband introduced Reich to Ludwig Mies van der Rohe. Mies, who later became Reich's partner as well as the third director of the Bauhaus, worked for Bruno Paul before joining Behrens, where he was employed from 1908 to 1911 before setting up his own architectural practice.[66] Oppler-Legband was in a relationship with Behrens, who she met in 1901 when she took a master's course in applied arts he taught in Nuremberg.[67] She also introduced Reich to Muthesius.[68] Reich became a member of the Werkbund in 1912; the following year a photograph of her symmetrical window for the Elefanten-Apotheke pharmacy, where she displayed the medicines flanked by the utensils used to make it, appeared in its year book.[69] Also in 1912, Reich participated with Oppler-Legband and Stephani-Hahn in the exhibition "The Women in Home and Work."[70] Reich and Oppler-Legband's contributions used simple geometry, avoided ornamentation, and employed white in the color scheme.[71] This was also where Reich first adopted what became her characteristic use of silk and draping techniques. In collaboration with Anna Muthesius and Oppler-Legband, she helped organize the Werkbund's exhibition in Cologne two years later. One of her many roles at the exhibition involved designing a series of display windows, described on the plan as a corridor of vitrines.[72]

In 1915, Reich collaborated with Gerson, Berlin's haute couture store, on their fashion shows and displays.[73] Between 1915 and 1919, she was involved in several exhibitions connected to the Werkbund. However, Reich's professional turning point was in 1926 at the International Fair in Frankfurt.[74] In 1927, she further cemented her reputation by collaborating with Mies on the design of several exhibits displayed in Stuttgart's newly built Weissenhof housing estate, which was constructed under Mies' leadership as a housing exhibition. In September of that year, the pair designed

the Velvet and Silk Café for "The Fashion of Ladies" exhibition in Berlin, for which they designed walls formed by large panels of silk, rayon, and velvet.[75] Stephani-Hahn and Else Oppler-Legband contributed as well to this exhibition. *Die Elegante Welt* reported:

> [In] this display, designed with the participation of other important artists such as Mies van der Rohe, Frau Oppler-Legband, Stephani Hahn ... it is clear what far-reaching connections there are between fashion and various industrial groups... [T]he displays have been grouped around an elegant cafe, which is a part of the exhibition.[76]

The Reimann School during the Weimar Republic

Meanwhile, due to the lack of manufacturing during World War I, the demand for display window decorators temporarily contracted. However, by the early 1920s, interest in studying the subject intensified, requiring the teaching space for the Reimann's window display department to be doubled. Contacts with retailers enabled the students to acquire professional skills during their training by interning in department stores, shoe stores, and pharmacies.[77] Upon her departure, Stephani-Hahn ensured continuity by recommending that her Wertheim protégée Georg Fischer replace her.[78] She discussed Fischer's position as Chief Decorator in the November/December edition of *Farbe und Form* in 1925, believing the addition of a vigorous professional decorator as a teacher in the school would see even more professional young people graduate.[79]

A large influx of international students was crucial in keeping the school afloat during the years of hyperinflation and in its success later in the decade; by 1921, there were 160 international students, including 25 from Russia.[80] The decade that followed was the school's heyday. Maria May, who directed an art school in Hamburg after having earlier led the Reimann's textile workshops, wrote in 1949 in the newspaper *Die Welt*:

> If the Berlin of the twenties became a center of new art, a place of artistic revival, it is not least due to Reimann's work. The youth pushed for their new teachings, they found a creative atmosphere and armaments for their own work in the Reimann school. [It was] a breeding ground that led to artistic freedom and discipline.[81]

Reimann staff and students were commissioned on an ongoing basis to create window displays for Berlin companies such as AGB textiles, the Berlin electricity board, the Leiser shoe shops, and the department stores Ka De We and Wertheim.[82] Albert Reimann recalled afterwards, "Shop windows in the best areas were made available to us ... We fulfilled desires so tastefully that every new window was a new advertisement for us ... There was soon no exhibition in Berlin, which was not decorated by the 'Reimannschule.'"[83] In September 1927, students even participated in the Women's Fashion exhibition in Berlin, helping with decorations and displaying some of their work.[84] The esteem in which the Reimann was held is also demonstrated by status of the contributors to a 1926 debate on art, craft, and the machine in *Farbe und Form*, which included the prominent art critics Adolf Behne and Paul Westheim, as well as Walter Gropius.[85]

The display classes at the Higher Technical School were considered a pillar of the Reimann.[86] The Reimann celebrated its 25th anniversary in 1927 with a large exhibition of students' work in the atrium of Berlin's former Decorative Art Museum. The well-attended exhibition then spent two years travelling through German cities.[87] By this time, modern German methods of window display were being disseminated at home and abroad through journals, conventions, and the international students attending the Reimann school. Reimann graduates worked on displays at Saks Fifth Avenue, New York, with designers Donald Deskey in 1927, and Frederick Kiesler in 1928.[88] Kiesler's *Contemporary Art Applied to the Store and Its Display,* published in 1930, featured work by Reimann students.[89] The Werkbund's earlier desire that displays limit the quantity and variety of goods and focus attention only a single or at most only a few items was finally being applied on a broad scale. Display window designers were now being inspired as well by abstract painting and sculpture in their assertion of the qualities of a product.[90] A further significant development was an increased emphasis on supplying information in the form of text.[91] Both of these developments allied the Reimann and its students with the commercialization of Bauhaus teaching and designs. Furthermore, several students, including toy designer Alma Siedhoff-Buscher, sculptor and costume designer Ilse Fehling, and Takehiko Mizutani, the Bauhaus' first Japanese student, moved from the Reimann to the Bauhaus.[92]

Berlin was where in 1922, the year before Gropius hired him to teach the Bauhaus' preliminary course, László Moholy-Nagy met Dadaists, Russian Suprematism and Constructivists, and members of De Stijl.[93] Kurt Schwitters and his "Merz" collages had a decisive influence upon Moholy-Nagy's work as did the work of Kasimir Malevich and El Lissitzky.[94] Constructivism departed from the traditional desire to mirror nature. Instead, it aimed to project order and harmony through the expression of color.[95] This elimination of psychological associations allowed for pure structural relations. Moholy-Nagy was devoted to the conquest of space in which he advocated the use of "forms of the simplest geometry as a step towards objectivity."[96]

When Moholy-Nagy arrived at the Bauhaus after making a name for himself in Berlin through the Sturm Gallery, Theo van Doesburg, a leading advocate of De Stijl, was also present in Weimar.[97] The German economy was at its worst in 1922–23. Gropius' shift toward Moholy-Nagy, De Stijl, and Constructivism was an attempt to shift the Bauhaus from craft and toward the needs of industry. Inflation also deprived display window dressers and their employers of money and material resources. This led the display practitioner to turn to the example of the Bauhaus in order to develop new and striking techniques. Moholy-Nagy and Oskar Schlemmer facilitated the radical rebuttal of figurative art and had a profound effect on Fischer's teaching in particular, while Melzer adopted De Stijl's right angles and horizontal and vertical lines.[98]

Christine Kühnl-Sager has described the Reimann as being inspired by the Bauhaus during the 1920s.[99] Abstraction afforded window display designers new means to emphasize structure and pattern.[100] From the mid-1920s until 1935, Fischer took the principles of Constructivism and applied them to the display techniques already developed by the Werkbund, and in particular by Stephani-Hahn, Oppler-Legband, and Reich. In the 25th anniversary edition of *Farbe und Form,* he wrote that "the shop window … has the task, apart from sales, of acting as a taste-producing device. This includes an independent new and distinguished taste."[101] Fischer believed that "the pupil has to … familiarize himself with the respective spatial conditions, to arrange the goods according to their individual characteristics, to look for all possibilities in

the sales-technical sense to increase constantly the turnover of goods."[102] By analyzing the mindset of his audience, Fischer aimed to attract, not only those who already intended to buy but also to create a "desire of possession" in the indifferent passer-by that encouraged them to make a purchase.[103] Although he considered window display an art, he realized that window displays primarily served an economic purpose.[104]

Fischer developed window display principles that correlated with new art movements. Faculty and students at the Reimann and the Bauhaus shared an interest in Dada, De Stijl, and Constructivism; the Berlin-based design school often brought Bauhaus teachings into the daily life of the metropolis more obviously than the Bauhaus itself, which had a more provincial location that assisted it in maintaining a greater distance from fashion. By the late 1920s, at a time when most British and American window displays still focused on the creation of realistic, melodramatic scenes, Constructivism's influence in Germany mandated the creation of simplified but dramatic window displays.

Other Reimann faculty contributed to the shift toward a Bauhaus-inflected modernism. Georg Tappert, a founding member of the November Group, established in 1918 by artists who supported Germany's recent revolution, taught life drawing and composition at the Reimann from 1919 until 1924.[105] Moriz Melzer, also a member, taught the portrait class from 1921, as well eventually as classes for decorative and stage painting.[106] He also taught composition to window display students. Melzer's two-dimensional elevation drawings in a 1931 issue of *Neue Dekoration* highlighted how to compose and articulate space in a display window (Figure 4.1).[107]

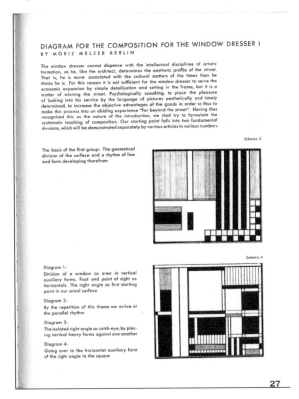

Figure 4.1 "Diagram for the Composition for the Window Dresser," *Neue Dekoration* 2.9 (1931): 27. Courtesy of the Staatsbibliothek, Berlin.

He wrote of the asymmetrical diagrams that "psychologically speaking," it placed "the pleasure of looking into the service of the language of pictures" and "increase[d] the objective advantages of the goods" in a way that enhanced the experience of seeing them "far beyond the street."[108]

The recommended layouts bear strong similarities to De Stijl, which, unlike Suprematism and Constructivism, favored the right angle. The vertical and horizontal lines of Melzer's elevation drawing correlate with the suggested window compositions. In many of three-dimensional De Stijl designs, the vertical and horizontal lines do not bisect each other, leaving each element independent and unobstructed. These principles are evident in the simple arrangement of Reimann student work from 1928 (Figure 4.2). The works of Constructivist artists Vladimir Tatlin and El Lissitzky influenced the design of the structures into which products were placed. Using a few simple forms and primary colors, their methods could be transposed to create an eye-catching modernist display that worked not only from a distance, but also rewarded the passer-by on close inspection.[109] Cubes, circles, and triangles migrated from abstract art to window display.[110] Features inspired by painting and sculpture were given a marketing rationale. Bright colors, primary forms, and unrealistic and straightforward patterns enhanced decipherability and memorability. In 1929, German art critic and historian, Adolf Behne asserted that the most beautiful art exhibition in Berlin also the cheapest and largest in the city, could be found in the shop windows of the large shopping streets.[111]

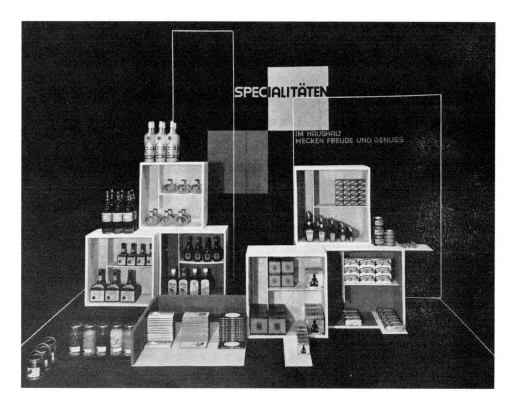

Figure 4.2 Vertical and horizontal display of food products. Reimann School illustrated prospectus, 1931. Courtesy of Bauhaus Archiv, Berlin. Photograph by the author.

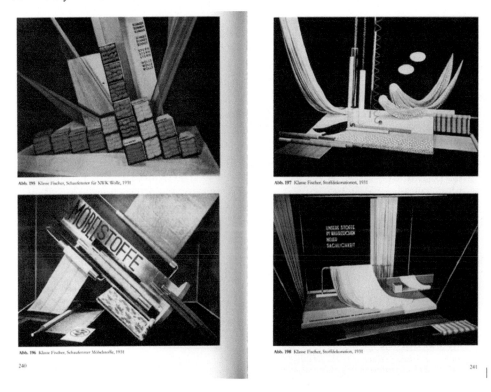

Figure 4.3 Four sample window displays, *Neue Dekoration* 2 (1931): 240–41.

Fischer designed two-dimensional squares, rectangles, and circles for use as props; these allowed his students to create three-dimensional installations (Figure 4.3). Metal cylinders provided height and allowed for the draping of fabric, while the combination of the two-dimensional shapes, lettering, and three-dimensional products created radical window displays and gave the planes seen in paintings a third dimension.[112] Black backgrounds inspired by Moholy-Nagy's 1922 artworks highlighted the product.[113] The close cooperation between the Reimann's display department and the retail industry was also of utmost importance. In 1932, Fischer and his students designed a series of shop windows for Bemberg AG, which sold branded men's accessories, shirts, and underwear; the following year, the school designed a range of three windows exhibiting Bemberg's swimwear range.[114]

The Display Window Exhibition of 1928

The impact of the Bauhaus upon the Reimann can be seen as well in the display window exhibition, a showcase for new methods of decorating shop windows, that took place from October 14 to November 18, 1928 in Leipzig's Grassi Museum (Figures 4.4 and 4.5) and in other designs from the period.[115] Window display was for the first time the sole focus of an art exhibition, the main intention of which was to present the work of the window dresser. Participants from Germany, Holland, Austria, and France installed 150 windows.[116] The Reimann's display included a streetscape of

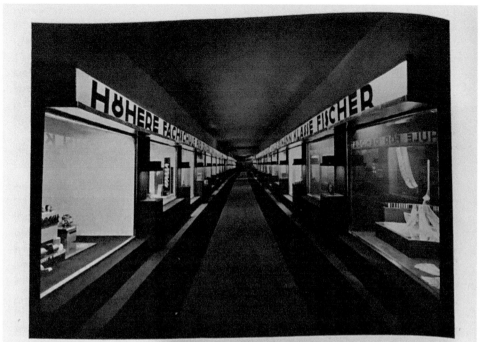

The show window street of the Reimann School, Berlin (Professor Fischer's Class) at the Leipzig Schaufensterschau. The effect is heightened by a mirror at the end of the room.

Figure 4.4 "The Show Window Street of the Reimann School, Berlin (Professor Fischer's Class) at the Leipzig Schaufensterschau," *Commercial Art* 6.2 (February 1929): 68.

Figure 4.5 "Two Good Examples for the Factual Presentation of Electro-Technical Objects. Worthy of Note is the Special Kind of Lighting." *Farbe und Form* 10.11 (1928): 182. Courtesy of Bauhaus Archiv, Berlin. Photograph by the author.

18 individual windows, where the students, under Fischer's direction, designed and dressed windows using products provided by various companies.[117]

The exhibition was an overwhelming success. The director of the Grassi Museum highlighted the artistic effects achieved in a primarily commercial subject area. The doctrine of pattern and structural ornamentation had progressed. While students still emphasized grouping, color, and the creation of rhythm, Fischer's class applied constructivist methods, emphasizing diagonals and oblique surfaces. The displays demonstrated a rational aesthetic that highlighted the function of the products.[118] For instance, Bosch cycling accessories were exhibited with the wheel lights demonstrated diagonally on large plain circles (Figure 4.5 left). Motor products were labelled and presented in rows; the use of the sidewall of the window is reminiscent of El Lissitzky's use of three-dimensional space in his Proun Room of 1923 (Figure 4.5 right). The following year, the Reimann's display department took part in a much larger international trade fair and congress on advertising, staged in Berlin.

These examples of the Reimann's absorption of lessons learned from Bauhaus masters were hardly unique. Schlemmer's later space and light experiments were orientated toward Constructivism. His earlier work, however, such as his Three Profiles paintings of 1920, were borrowed by the Reimann's students.[119] Schlemmer overlaid multiple abstract heads in profile, presenting them from various perspectives and in a range of tones but always as flat, two-dimensional abstract forms. The impact of these is apparent in the Reimann window displays aimed at women (Figure 4.6).

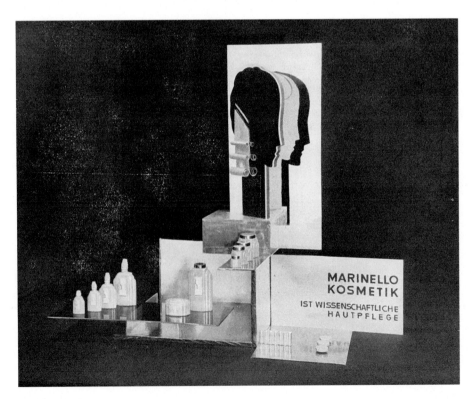

Figure 4.6 Cosmetic's display. Reimann School illustrated prospectus (1931). Courtesy of Bauhaus Archiv, Berlin. Photograph by the Author.

The influence of Moholy-Nagy's constructivist work is also evident in a Reimann student's window display of 1927, which was composed of bottles placed in a linear way, utilizing nearly all the space in the window. It is evocative of Moholy-Nagy's *Composition Z VIII* of 1924. Moholy-Nagy's work continued to be an influence; a 1931 Reimann window display for clocks featured elements similar to those found in Moholy-Nagy's kinetic Light-Space Modulator, which was first displayed in 1930 in a Werkbund exhibition in Paris.[120] Such constructivist arrangements particularly lent themselves to hard consumable products such as homeware and machinery.

Although Charlotte Klonk has argued that the modernist principles used by Bauhaus faculty members Gropius, Moholy-Nagy, and Reich were confined to exhibitions for the building trade, the use of constructivist methods by Fischer, and his colleague, expressionist artist Moriz Melzer, and their students prove that the Reimann was also an avant-garde pioneer of the art of displaying products.[121] The Bauhaus influence was derived from two-dimensional artworks rather than interpretations of exhibitions.

Hans Werner Klünner has suggested that the Reimann had a multiplier effect in the spread of progressive artistic ideas.[122] The school's vast achievements in innovative areas of design such as fashion, costume design, and window display influenced the everyday life of many people, he argues, far more than pioneering works of abstract art.[123] He also claims that the school implemented the fundamentals developed by the Bauhaus in fashion, illustration, advertising, and window display. This is supported by the Reimann's transcribing of Moholy-Nagy's early space, light, and show experiments, which were reclaimed from their two-dimensional iteration to become three-dimensional window displays. Instead of machine age objects, consumable products were used to create three-dimensional montages. Even Klonk attributes the aesthetic rationality and persuasiveness of window displays that emerged in Germany to the 1928 exhibition experiments developed by former Bauhaus teachers and students.[124]

Important distinctions between the two institutions remained, however. Although both the Bauhaus and the Reimann taught craft and drawing as well as commercial art, the Reimann was perceived as more pragmatic. Yasuko Suga believes the main focus of the two institutions was different, as at the Bauhaus, education originally revolved craft and product design and female faculty were rare.[125] Female students featured prominently, however, in *Farbe und Form*, and women taught window display, fashion, and stage costume classes at the Reimann.[126] Although these disciplines were perceived as lower status compared to more traditionally masculine fields such as architecture and graphic design, which eventually featured more prominently at the Bauhaus, the Reimann was more emphatically welcoming. Both schools, however, responded more quickly to change than did more conventional arts academies sponsored by the state.

The 1930s: From Berlin to London

By 1931, in a spirit of optimism the main Reimann building was remodeled and extended, the new façade proudly proclaiming the range of subjects on offer – Painting, Sculpture, Interior Design, Advertising, Textile Design, Film, Photography, Fashion, Stage Design, Window Dressing, and Ornament.[127] A travelling exhibition

showcasing the work of the school travelled to the United States in the second half of the year.[128] The Higher Technical School, which had previously been housed in Schöneberg district's town hall, was provided with much-needed space in the main building.[129] Afterwards, Albert Reimann reflected that he had believed that the school's high profile would prevent it from becoming affected by economic downturn and the rise of Nazism.[130] Nevertheless, the school was forced to design and display posters of Adolph Hitler.[131]

Unlike the Bauhaus, which closed in 1933, the Reimann School was able to continue after Hitler became Chancellor in 1933. Albert Reimann was no longer allowed to operate as an artist; yet, he could remain as head of the school, which was placed under the control of a Nazi staff committee.[132] The same year, the Nazi work council proposed that the school's employees donate their gross monthly income from July to September to help combat unemployment.[133] In early 1934, the paramilitary wing of the Nazi Party patrolled the front of the school, preventing staff and students from "entering this un-German college."[134] The Reimann, like the Bauhaus, was cosmopolitan and therefore was perceived as anti-German. The parallels between the two institutions were reinforced when after the closing of the Bauhaus, the Reimann offered teaching places to former Bauhaus members, including Walter Peterhans, Joost Schmidt, and Georg Muche.[135]

In 1935, Albert Reimann had little choice but to sell the school to architect Hugo Häring. In 1935, according to Kühnl-Sager, a "Nazi organisation of German advertising men and women, which was planning its own college, applied for the closure of the department of window design on the grounds that it did not teach the 'essentials of German advertising.'"[136] The same year, the government set up the German Display Association, which put the profession under the state's control. Window dressers were now *Gebrauchswerber*, a title corresponding more to today's visual merchandiser. The association required everyone to qualify to practice window display; identification cards were issued on proof of the qualification.[137]

In 1936, Häring changed the name of the school to Art and Factory: Private School for Design (*Kunst und Werk – Privatschule fur Gestaltung*). On February 25, 1937, the SS newspaper *The Black Corps* described the school and Häring as being as destroyers of German architecture and accused it of tolerating Jewish students and staff.[138] By 1938, due to the prohibition against admitting Jewish students and the lack of international students, enrolment dropped from 450 in 1935 to 250.[139]

By this time, the Reimann's international reputation for pioneering display window was well established. The window display teachings of the Higher Technical School at the Reimann were known throughout Germany and the world.[140] British art critic Holbrook Jackson believed participation in the 1928 and the 1929 exhibitions "clearly demonstrated the worldwide dominance of the Schule Reimann in the field of shop window display."[141] The display department received international acclaim, including as far away as Japan.[142] Displays from Fischer's students featured in international journals with the display design teaching regarded as a model example by other countries.[143]

The Reimann decamped in 1937 to London, under the leadership of Albert and Klara's son Heinz. Here, it attracted many of faculty and the international students who had earlier taught and studied in Berlin.[144] Already before its arrival, it had had

an impact in the British capital. In 1926, a photograph of a Reimann School students' work was featured in the official organ of the British Association of Display Men, *Display: The Merchants & Window Display Record*, where it was described as a masterpiece; the organization had been already following German developments for three years.[145] Teaching in Britain of display methods in the 1920s was sporadic and consisted of short private courses in comparison to what was on offer in the same years in Berlin. In 1928, Jackson stated:

> Schools of display are being founded in all the principal German cities. The display section of the Reimann School at Berlin is turning out display men and display women in considerable numbers. They have all been schooled in the new technique and the new methods and they are beginning to carry the gospel into all the cities of Europe, and some of the Reimann graduates have already reached this country.[146]

His article discussed the new modernist methods of display and featured the work of recent Reimann graduate Hans Kiesewetter.[147] Kiesewetter was by then teaching at the Arundell School of Display in London.

Connections between the Bauhaus and the Reimann continued in London, where Moholy-Nagy was briefly the creative director for the new Simpsons of Piccadilly department store.[148] His responsibilities there included window display. After freelance work in Berlin as a display designer and exhibition constructor, Moholy's former Bauhaus student Heinz Loew, who had also taught sculpture in Dessau under the supervision of Joost Schmidt, was appointed the Head of the Reimann School's Display Department.[149] In 1939, he designed of the Hall of Metals for the British Pavilion at the World's Fair in New York as well as a BBC travelling exhibition. Else Taterka, an instructor at the Reimann in Berlin, came to teach in London, as did Natasha Kroll, a Reimann alumna who had joined the faculty in Berlin after her time as a student. From the early 1940s until 1954, Kroll was responsible for display at Simpsons of Piccadilly. She later became the first female set designer for the BBC, receiving a Royal Designers for Industry Award in 1966 for her work in shop display and television design.[150] Prominent local artists who also taught at the school with Edward McKnight Kauffer, remembered him as being one of the most vital members of the teaching staff.[151]

On December 17, 1938, Albert Reimann and his wife travelled from Germany to visit Heinz in London, where they remained.[152] The school was forced into liquidation six months into World War II. Heinz Reimann joined the British Army, and the school's building was destroyed during the Blitz.[153] The legacy of Reimann School endured, however, in the Britain in the influx of designers immersed in the language of modern art who travelled from the continent as the Nazis rose to power.

The Reimann schools provided a conduit for the import of Bauhaus artistic concepts into commercial design. In this, they built upon precepts advocated by the Werkbund. Although the schools outlasted the Bauhaus, in the end, their impact, too, would be international. In the case of the Reimann, German display window reform eventually provided the impetus for bold new directions in the use of modernism in British displays, introducing Bauhaus-infused approaches to composition into postwar British high streets.

Notes

1. Anca I. Lasc, "The Travelling Sidewalk: The Mobile Architecture of American Shop Windows at the Turn of the Twentieth Century." *Journal of Design History* 31.1 (2018): 21, for 1903 American comments regarding the unsuitability of women for this profession.
2. Frederic J. Schwartz, *The Werkbund: Design Theory and Mass Culture before the First World War* (New Haven and London: Yale University Press, 1996); Stephen Broadberry, "Explaining Anglo-German Productivity Differences in Services since 1870," *European Review of Economic History* 8 (2004): 229–62.
3. Tim Coles "Department Stores as Retail Innovations in Germany: A Historical-Geographical Perspective on the Period 1870 to 1914" in *Cathedrals of Consumption: The European Department Store, 1850–1939*, Geoffrey Crossick and Serge Jaumain, eds. (Aldershot: Ashgate, 1999) 72–96.
4. Ibid; and Kathleen James "From Messel to Mendelsohn: The Critical Dimension of German Department Stores," in Crossick and Jaumain, *Cathedrals of Consumption*, 252–78.
5. Frederic Bedoire, *The Jewish Contribution to Modern Architecture, 1830–1930* (Jersey City: KTAV Publishing House, 2004).
6. Paul Lerner, *The Consuming Temple: Jews, Department Stores, and the Consumer Revolution in Germany, 1880–1940* (Ithaca, NY: Cornell University Press, 2015).
7. Paul Greenhalgh, *Modernism in Design* (London: Reaktion Books, 1997). See Despina Stratagokis, *A Women's Berlin; Building the Modern City* (Minnesota: University of Minnesota Press, 2008) for more on women in Berlin during this period.
8. Paul Göhre, *Das Warenhaus* (Frankfurt: Rutten & Leonig, 1907) 10–11. See also Nina Schleif, "From 'Cultural Factor' to Propaganda Instrument: The Shop Window in German Cultural History 1907-33" in *Word on the Street*, Elisha Foust and Sophie Fuggle, eds. (London: igrs books, 2011) 152–70.
9. Göhre, *Das Warenhaus*, 10–11.
10. James, "From Messel to Mendelsohn," 270.
11. Swantje Kuhfuss-Wickenheiser, *Die Reimann-Schule in Berlin und London 1902–1943* (Berlin: Shaker Medis, 2009) 227.
12. Hahn, assumed her husband's name on marriage in 1912, becoming Stephani-Hahn.
13. Kuhfuss-Wickenheiser, *Die Reimann-Schule in Berlin und London 1902–1943*, 226.
14. For Richard Wagner's concept of the Gesamtkunstwerk, see Michael Tanner, *Wagner*, 2nd edition (New Jersey: Princeton University Press, 2002).
15. Schwartz, *The Werkbund*; see also Katherine M. Kuenzli, *Henry Van de Velde: Designing Modernism* (New Haven & London: Yale University Press, 2019).
16. Georg Simmel, *The Philosophy of Money*, Tom Bottomore and David Frisby, trans. (1900. London: Routledge Classics, 1990) 462.
17. Despina Stratigakos, "Masculine Reason or Feminine Spirit: Gender Battles in the Werkbund's Canonization of National Style" in *Partisan Canons*, Anna Brzyski, ed. (Durham, NC: Duke University Press, 2007) 141, 153.
18. John V. Maciuika "Wilhelmine Precedents for the Bauhaus: Hermann Muthesius, the Prussia State and the German Werkbund" in *Bauhaus Culture: From Weimar to the Cold War*, Kathleen James-Chakraborty, ed. (Minneapolis: University of Minnesota Press, 2006), 7–8.
19. Despina Stratigakos, "Women and the Werkbund: Gender Politics and German Design Reform, 1907–14" *Journal of the Society of Architectural Historians* 62 (2003): 490.
20. Paul Westheim, "Schaufenster und Schaufensterdekoration" *Das Kunstgewerbeblatt* 12.7 (1910/11): 131.
21. Ibid.
22. Ibid., 132.
23. Ibid.
24. Ibid., 102. Magdalena Droste "Lilly Reich: Her Career as an Artist," in *Lilly Reich: Designer and Architect*, Matilda McQuaid and Magdalena Droste, eds. (New York: Museum of Modern Art, 1996) 58, for a brief biography of Oppler-Legband.

25. "Abbildungen" *Die Kunst in Industrie und Handel. Jahrbücher des Deutscher Werkbundes* (1913): 93–108. 1913 was also the inaugural year of the Verband Kunstlerischen Schaufensterdekorateure Deutschlands (Society of Artistic Display Window Decorators); followed by *Verein Berliner Schaufensterdekorateure* (Association of Berlin Window Decorators) in 1920; and the *Bund der Schaufensterdekorateure Deutschlands* (Alliance of German Display Window Decorators) in 1925. See Robin Schuldenfrei *Luxury and Modernism: Architecture and the Object in Germany 1900–1933* (Princeton: Princeton University Press, 2018) 84. Nina Schleif, *SchaufensterKunst: Berlin und New York* (Cologne: Böhlau, 2004) 87, describes the years 1913 and 1914 as a time of *"Schaufenstereuphorie."*

26. Charlotte Klonk "Patterns of Attention: From Shop Windows to Gallery Rooms in Early Twentieth-Century Berlin." *Art History* 28 (2005): 468–96; Charlotte Klonk, *Spaces of Experience* (New Haven & London: Yale University Press, 2009) 61; Lauren Kogod, "The Display Window as Educator: The German Werkbund and Cultural Economy," in *Architecture and Capitalism: 1845 to the Present*, Peggy Deamer, ed. (London and New York: Routledge, 2014) 50–71; and Schuldenfrei, *Luxury and Modernism*, 61.

27. Hans Wedendorf, "Nebenberufe fir Kiinstler," *Die Gegenwart* 44.11(1915): 167–69, for the recommendation that artists support themselves in this way.

28. Hermann Muthesius, *Stilarchitektur und Baukunst* (Mulheim-Ruhr: K. Schimmelpfeng, 1902) 50. See also Theodor Lipps *Asthetik: Psychologie des Schonen und der Kunst* (Hamburg und Leipzig: Verlag von Leopold Voss, 1906); and Theodor Lipps, "Über 'Urteilsgefühle'," *Archiv für die gesamte Psychologie* 7 (1906): 1–32.

29. "Abbildungen" *Die Kunst in Industrie und Handel. Jahrbücher des Deutscher Werkbundes* (1913): 93–108.

30. "Schaufenster Henry van de Velde Weimar," "Abbildungen," *Jahrbücher Deutscher Werkbund* (1913): 105.

31. "Schaufenster von Elisabeth v. Hahn-Stephani," "Abbildungen," *Jahrbücher Deutscher Werkbund* (1913): 107.

32. Friedrich Naumann, "Werkbund und Handel," *Die Kunst in Industrie und Handel. Jahrbücher des Deutscher Werkbundes* (1913): 14.

33. Erich Vogeler, "Schaufenster: Nach dem Berliner Wettbewerb," *Der Kunstwart* 23 (1909): 231–41.

34. Schuldenfrei, *Luxury and Modernism*.

35. John V. Maciuika, *Before the Bauhaus: Architecture, Politics, and the German State, 1890–1920* (Cambridge: Cambridge University Press) 6.

36. Kogod, "The Display Window as Educator."

37. Westheim, "Schaufenster und Schaufensterdekoration," (1910/11): 132.

38. Sebastian Müller, *Kunst und Industrie: Ideologie und Organisation des Funktionalismus in der Architektur* (Munich: Hanser, 1974), 126.

39. Esther da Costa Meyer, "Cruel Metonymies: Lilly Reich's Designs for the 1937 World's Fair." *New German Critique* 76 (1999): 161–89; and Despina Stratigakos, "Women and the Modern Metropolis," in *Thick Space: Approaches to Metropolitanism*, Dorothee Brantz, Sasha Disko, and Georg Wagner-Kyora, eds. (London: Transaction Publishers, 2014) 279–306.

40. Hans Werner Klünner, "Die Schule Reimann in Berlin," in *Kuntschule Reform 1900–1933: Bauhaus Weimar, Dessau, Berlin, Kunstschule Debschitz, München, Frankfurter Kunstschule, Akad. Breslau, Reimann-Schule*, Rolf Bothe, Hans Werner Klünner, Ekkehard Mai, and Hans Maria Wingler, eds. (Berlin: Gebr. Mann Verlag, 1977) 252–61.

41. Christiane Lamberty, *Reklame in Deutschland 1890–1914. Wahrnehmung*, Professionalisierung *und Kritik der Wirtschaftswerbung* (Berlin: Dunker & Humblot, 2000).

42. Felix Brusberg, *Einleitung. The Reimann Schule 1902–1943* (Brochure from an exhibition at the Galerie Brusberg, Berlin, 2016) 1.

43. Bothe, Klünner, Mia, and Wingler, *Kunstschulreform 1900–1933*.

44. Michael Frenchman, "Come to the ball," *The Guardian* (November 9, 1964): 7.

45. Klünner, "Die Schule Reimann in Berlin," 252.

46. Type written notes from Wingler, "Einfuhrung" *Kunstschulreform 1900–1933* (1977), 2, Bauhaus Archiv, Berlin. Wingler credits the Obrist-Debschitz school as the first fully

fledged representative of the workshop approach, 5. Klünner, "Die Schule Reimann in Berlin," 229. See also Tobias Hoffmann, "Die Reimann-Schule Berlin im Kontext der Schulen Reformbewegung um 1900," *Schule Reimann 1902–1943*. Brochure of the Schule Reimann exhibition at the Galerie Brusberg, Berlin (October 14–November 19, 2016), 5.

47. Kuhfuss-Wickenheiser, *Die Reimann-Schule.*
48. Peter Blundell Jones, *Hugo Häring: The Organic Versus the Geometric* (Stuttgart & London: Edition Axel Menges, 1999).
49. Jeremy Aynsley, Graphic Design in Germany, 1890–1945 (London: Thames and Hudson, 2001); Yasuko Suga, "Modernism, Commercialism and Display Design in Britain: The Reimann School and Studios of Industrial and Commercial Art," *Journal of Design History* 19 (2006): 137–54; Leonard Barkan *Berlin for Jews: A Twenty-First Century Companion* (London: University of Chicago Press, 2016); and Kuhfuss-Wickenheiser, *Die Reimann-Schule,* 364.
50. Albert Reimann, *Die Reimann Schule: Ihr Aufbau und Ihre Entwicklung 1900–1938* (Berlin: Verlag Bruno Hessling, 1966) 47.
51. Hoffmann, "Die Reimann-Schule Berlin," 5.
52. Silke Strempel, "Karl Ernst Osthaus: Forderer der Kunstlerischen Schaufenstergestaltung," in *Deutsches Museum fur Kunst in Handel und Gewerbe*, Sabine Roder and Gerhard Storck, eds. (Ghent: Pandora, 1997) 391.
53. Elisabeth von Stephani-Hahn, *Schaufensterkunst* (Berlin: Verlag L. Schottlaender, 1919). See also Kuhfuss-Wickenheiser, *Die Reimann-Schule in Berlin und London.*
54. Kogod, "The Display Window as Educator," 54.
55. Schleif, *SchaufensterKunst,* 68.
56. Ibid., and Tilmann Buddensieg, ed., *Industriekultur: Peter Behrens and the AEG, 1907–1914* (Cambridge: MIT Press, 1984).
57. Stratigakos, "Women and the Werkbund," 490–511.
58. *Farbe und Form: 25 Jahre Schule Reimann 1902–1927* 12.1 (April 1927): 10.
59. Klünner, "Die Schule Reimann in Berlin" (1977). Other faculty included Leo Nachtlicht, Erich Knuppelholz, and Carl Beyerlen.
60. Matilda McQuaid, "Lilly Reich and the Art of Exhibition Design," in McQuaid and Droste, *Lilly Reich,* 10.
61. Droste, "Lilly Reich: Her Career as an Artist," 47; Da Costa Meyer, "Cruel Metonymies," 161–189; and Stratigakos, "Masculine Reason or Feminine Spirit."
62. Droste, "Lilly Reich: Her Career as an Artist," 48. Most of the women who influenced Reich took part in the exhibition Women at Home and at Work.
63. Virginia Pitts Rembert, "Review of Lilly Reich: Designer and Architect by Matilda McQuaid and Magdalena Droste," *Woman's Art Journal* 18.2 (1998): 57.
64. Stephani-Hahn, *Schaufensterkunst.* 28–46.
65. Matilda McQuaid, "Lilly Reich and the Art of Exhibition Design," in McQuaid and Droste, *Lilly Reich,* 10.
66. Guy Julier, *The Thames and Hudson Encyclopaedia of 20th Century Design and Designers* (New York: Thames and Hudson, 1993).
67. Stanford Andersen, *Peter Behrens and a New Architecture for the Twentieth Century* (London: MIT Press, 2000).
68. McQuaid, "Lilly Reich and the Art of Exhibition Design."
69. Ibid., 10. Reich's window display featured in the *Jahrbücher des Deutscher Werkbundes* (1913): 103.
70. Stratigakos, "Women and the Modern Metropolis."
71. Ibid.
72. McQuaid, "Lilly Reich and the Art of Exhibition Design."
73. Da Costa Meyer, "Cruel Metonymies: Lilly Reich's Designs for the 1937 World's Fair."
74. McQuaid, "Lilly Reich and the Art of Exhibition Design."
75. Ibid. See also Sonja Gunther, *Lilly Reich 1885–1947* (Stuttgart: Deutsche Verlags-Anstalt, 1988), who claims the design was entirely Reich's.
76. Droste, "Lilly Reich: Her Career as an Artist," 59. Reported in *Die Elegante Welt,* September 21, 1927, 59.

77. Kuhfuss-Wickenheiser, *Die Riemann-Schule in Berlin und London 1902–1943.*
78. Schleif, *SchaufensterKunst*; Kuhfuss-Wickenheiser, *Die Reimann-Schule.*
79. Kuhfuss-Wickenheiser, *Die Reimann-Schule*, 229.
80. Klünner, "Die Schule Reimann in Berlin," 248.
81. As quoted in Felix Brusberg, "Einleitung" *The Reimann Schule*, 1.
82. Aynsley, Graphic Design in Germany, 1890–1945, 131.
83. Reimann, *Die Reimann Schule*, 40.
84. Klünner, "Die Schule Reimann in Berlin" (1977): 248.
85. Albert Reimann "Eine Rundfrage uber das Thema: Kunst/Handwerk/Maschine," *Farbe und Form* 11.6/7 (July, 1926): 73.
86. Klünner, "Die Schule Reimann in Berlin" (1977): 256.
87. Ibid.
88. For Reimann students work in Saks, see "The Reimann School," *Art and Industry* 22.129 (March 1937): 101. For Deskey's Saks window, see Frederick Kiesler, *Contemporary Art Applied to the Store and Its Display* (New York: Brentano Publishers, 1930) 130. For Kiesler's Saks window, see 24.
89. Kiesler, *Contemporary Art Applied to the Store and Its Display*, 128, 129, 132, 133, 138.
90. Anna Dahlgren *Travelling Images: Looking across the Borderlands of Art, Media, and Visual Culture* (Manchester: Manchester University Press, 2018).
91. Schuldenfrei, *Luxury and Modernism.*
92. "Alma Siedhoff-Buscher," *100 Years of Bauhaus.* Accessed July 9, 2019: https://www.bauhaus100.com/the-bauhaus/people/students/alma-siedhoff-buscher/; "Ilse Fehling," *100 Years of Bauhaus.* Accessed July 9, 2019: https://www.bauhaus100.com/the-bauhaus/people/students/ilse-fehling/; and "Japanese individuals at the Bauhaus," *100 Years of Bauhaus.* Accessed July 9, 2019: https://www.bauhaus100.com/magazine/follow-the-bauhaus-into-the-world/from-dessau-to-tokyo/
93. László Moholy-Nagy, *The New Vision: And Abstract of an Artist*, 4th Revised Edition (1947) 80.
94. Ibid., 72. See also Sybil Moholy-Nagy *Experiment in Totality* (New York: Harper & Brothers, 1950) 22, 29.
95. Moholy-Nagy, *The New Vision*, 38.
96. László Moholy-Nagy, *Painting, Photography, Film* (London: Lund Humphries, 1969) 147. See also Walter Gropius "Introduction" to Moholy-Nagy *Experiment in Totality*, 8.
97. Magdalena Droste, *The Bauhaus, 1919–1933* (Berlin: Taschen, 2002) 57–60.
98. According to an interview with Fischer's second wife, Bertl in Munich in 1988. See Kuhfuss-Wickenheiser, *Die Reimann-Schule in Berlin und London 1902–1943*, 230.
99. Christine Kühnl-Sager, *Final Sale. The End of Jewish Owned Businesses in Nazi Berlin.* Catalogue ed. Christoph Kreutzmüller (New York, Berlin: Leo Baeck Institute) 48.
100. Edward N. Goldsman "Advanced Display: Cubism-Futuristic-Rhythmic," *Display* 7.9 (December, 1925): 332–36.
101. *Farbe und Form: 25 Jahre Schule Reimann 1902–1927* 12.1 (April 1927): 137.
102. Ibid.
103. Ibid.
104. Deborah Smail, "Sadly Materialistic: Perceptions of Shops and Shopping in Weimar Berlin." *Journal of Popular Culture* 34 (2000): 147.
105. Joan Weinstein, *The End of Expressionism: Art and the November Revolution in Germany, 1918–1919* (Chicago: The University of Chicago Press, 1990).
106. See Klünner, "Die Schule Reimann in Berlin," 153.
107. Moriz Melzer, "Diagram for the Composition for the Window Dresser 1," *Neue Dekoration* 2.9 (1931): 27.
108. Ibid.
109. Anna Dahlgren, "The Art of Display," *Journal of Art History* 79 (2010): 160–73.
110. Ibid., 160.
111. Adolf Behne, "Kunstausstellung Berlin," *Das neue Berlin* 1 (1929): 150–52; cited in Kuhfuss-Wickenheiser, *Die Reimann-Schule*, 225.
112. Kuhfuss-Wickenheiser, *Die Reimann-Schule in Berlin und London 1902–1943.*

113. For an example of this, see Moholy-Nagy's Untitled Construction (1922).
114. Kuhfuss-Wickenheiser, *Die Reimann-Schule in Berlin und London 1902–1943*.
115. The Confederation of Shop Decorators of Germany, and the State Academy for Graphic Arts and Book Trade, Leipzig assisted in the organization of the exhibition.
116. "The 'Schaufensterschau,'" *Display* 10.3 (June 1928): 146.
117. Kuhfuss-Wickenheiser, *Die Reimann-Schule in Berlin und London 1902–1943*.
118. Klonk, *Spaces of Experiment*, 107.
119. Reimann Schule illustrated prospectus (1931). Courtesy of Bauhaus Archiv.
120. A 1931 window for clocks created at the Schule Reimann at the Rathaus Schöneberg. Accessed August 22, 2017: https://www.deutsche-digitalebibliothek.de/item/TQIN MGR6LPE3P2HXKLH72VF6I7VSJFVS;
 Ines Katenhusen, "Alexander Dorner's and László Moholy-Nagy's 'Space of the Present' at the Hanover Provincial Museum," in *Artificial Light Play: The Aesthetics of Light in the Classic Avant-Garde*, Ulrike Gärtner, Kai-Uwe Hemken, and Kai-Uwe Schwierz, eds. (Bielefeld: Leipzig, 2009).
121. Klonk, "Patterns of Attention," 490; Klünner, "Die Schule Reimann in Berlin."
122. Klünner, "Die Schule Reimann in Berlin," (1977): 153.
123. Ibid.
124. Klonk, *Spaces of Experience* 107.
125. Suga, "Modernism, Commercialism and Display Design in Britain," 137–154.
126. Ibid.
127. Barkan, *Berlin for Jews: A Twenty-First Century Companion* (2016).
128. Klünner, "Die Schule Reimann in Berlin," 249.
129. Kühnl-Sager, *Final Sale*.
130. Reimann, *Die Reimann Schule*.
131. Michael Frenchman, "Come to the Ball," *The Guardian*, November 9, 1964: 7, an interview with Albert Reimann on the occasion of his 90th birthday.
132. Kühnl-Sager, *Final Sale*.
133. Ibid.
134. Ibid., 49.
135. Klünner, "Die Schule Reimann in Berlin" (1977) 250. See also Suga, "Modernism, Commercialism and Display Design in Britain." Peterhans taught at Reimann from 1934 to 1938. Schmidt accepted a post there in 1935; however, he was soon prevented from teaching due to his past affiliation with the Bauhaus. Muche was dismissed from his professorship at in Breslau in 1933; on his return to Berlin, he taught until 1938 at the Reimann.
136. Kühnl-Sager, *Final Sale*, 50.
137. *Display* 16.12 (1935): 730.
138. Klünner, "Die Schule Reimann in Berlin," 251.
139. Ibid.
140. The display work of the Reimann and the Arundell Display School featured alongside the work of De Stijl artists, Piet Mondrian and Theo van Doesburg in Kiesler, *Contemporary Art*, 99, 128–133. Kiesler, 114, further suggested inspiration for window backgrounds could come from: "the paintings of such artists as Mondrian, Braque, Ozenfant, Doesburg, Arp, Leger, Miro and others."
141. Holbrook Jackson, "Design and the Display of Merchandise: The Influence of Modernist Painting and Architecture," *Commercial Art* 4 (1928): 238.
142. Yoichiro Tazuke, "Shinpi wo Sakura Berurin Shogyo Bijutsu," *Atorie* (Atelier) 6.9 (1929): 118.
143. Suga, "Modernism, Commercialism and Display Design in Britain," 140.
144. Klünner, "Die Schule Reimann in Berlin," 250.
145. "Rare Examples from Germany" *Display* 7 (February 1926): 394; and "Window Display in Germany," *Display* 5 (1923): 243–46.
146. Jackson, "Design and the Display of Merchandise," 232.
147. Ibid. Kiesewetter's work also featured in *Farbe und Form* (1927): 172; (1928): 212; and (1929): 215. See Kuhfuss-Wickenheiser, *Die Reimann-Schule in Berlin und London 1902–1943*, 541.

148. Kerry Meakin, "The Bauhaus and the Business of Window Display – Moholy-Nagy's endeavours at window display in London," *Journal of Design History* (May 23, 2021) https://doi.org/10.1093/jdh/epab019

149. Loew studied at the Bauhaus from April 1926 until October 1928.

150. Letter to Natasha Kroll from the Royal Society of the Arts. Natasha Kroll Archive, Brighton University.

151. Suga, "Modernism, Commercialism and Display Design in Britain," 144. See also Ruth Artmonsky, *Showing Off: Fifty Years of London Store Publicity and Display* (London: Artmonsky Arts, 2013) 113; and "Reimann Comes to S.W.1," *Display* 18 (1937): 606–07.

152. Kühnl-Sager, *Final Sale.*

153. Suga, "Modernism, Commercialism and Display Design in Britain."

5 A Discreet Succession

The Bauhaus and Industrial Design Education in the German Democratic Republic

Katharina Pfützner

For decades, it was assumed that the posthumous legacy of the Bauhaus went unabsorbed in socialist countries, where creative practices were typically determined by socialist realism, a Soviet doctrine that entailed a rejection of modernism and the denunciation of associated institutions and practitioners. In West Germany and the United States, the Bauhaus had been recast as paragon of freedom and democracy in the context of postwar cultural regeneration efforts and rising Cold War tensions.[1] To facilitate this, the school's social aims and related activities needed to be suppressed, along with the tenure of its second and most socially engaged director, Hannes Meyer.[2] Thus, reconfigured from "hotbed of leftist architecture to a bold yet innocent school of fine arts," the Bauhaus became firmly associated with the West.[3] Consequently, Bauhaus revival attempts were documented to have taken place in the United States and in postwar West Germany, but no Bauhaus successors were identified in the socialist German Democratic Republic (GDR), the country that was home to the main Bauhaus sites of Weimar and Dessau and to most of the school's architectural legacy after the war.[4]

Post-Cold War Bauhaus historiography has been busy deconstructing these myths.[5] There is now a general awareness that the school was associated with social concerns, although these tend to appear primarily as an indistinct foil for discussions of other issues, such as the school's commercial activities.[6] Moreover, comprehensive surveys tend to attribute this perspective to Meyer alone, rather than presenting it as something that had infused the Bauhaus program from the outset and for most of the school's existence.[7] The lacuna around Meyer is finally being addressed, but his continued absence from scholarly discussions can sometimes be striking.[8] The Bauhaus is also no longer seen as relevant only to the West. Some of the failed or short-lived Bauhaus revival attempts in the territory of the future GDR in the period from 1945 to 1952 have been chronicled, and it has been shown that the country's industrial designers drew on the Bauhaus heritage too, as suggested by many of the objects they designed from the late 1950s onward.[9]

These resemblances were not the result of stylistic borrowing, but of a very similar education offered to industrial design students in the GDR, which contributed to a widespread adoption of a similar socially oriented design approach. An examination of the industrial design education provided by the GDR's main design schools, the Burg Giebichenstein school in Halle and the Weißensee school in Berlin, reveals that these schools could, to varying degrees over the course of the GDR's existence, be considered Bauhaus successors. A brief outline of the main aims and methods of the

DOI: 10.4324/9781003268314-6

Bauhaus fills in some of the above-mentioned gaps, while also drawing on rehabili-
tative scholarship on Hannes Meyer, and the pioneering analysis of the East German
architectural historian Karl-Heinz Hüter.[10]

The Bauhaus

The Bauhaus was established in 1919. Walter Gropius, its first director, instituted a
tripartite curriculum that required students to complete an analytical preliminary
course, followed by practical workshop-based craft training and – from 1927 and for
some of the students only – training in architecture. For much of the time, the main
priority was thus the learning of a craft in one of the workshops, complemented by
instruction from an extraordinary panel of high-profile painters, including Lyonel
Feininger, Wassily Kandinsky, and Paul Klee, which was intended to hone the stu-
dents' aesthetic sensibility. Yet, although Gropius explicitly evoked craft-training
traditions in Weimar in the use of the designations "master" and "apprentice" instead
of "professor" and "student" or the requirement to pass journeyman's and master
craftsman's examinations before the Apprenticeship Board upon completion of stud-
ies, he did not aim to train better craftsmen. As Hüter has shown, Gropius had sought
to offer training for industrial designers as early as 1916 and had considered craft
training as more of a pedagogical tool to this effect – offering the student the oppor-
tunity to acquire technical skills and material experience – than an end in itself.[11] Yet
Gropius was unable to make this explicit in his 1919 Bauhaus manifesto and other
early communications without antagonizing the politically powerful craft organiza-
tions in Thuringia.[12] Thus, the school's reorientation toward industry, announced by
Gropius in his 1923 lecture "Art and Industry – a New Unity" and completed after
the move to Dessau, was in fact a reassertion of his primary intentions.[13]

A further central aim of the Bauhaus, already clearly articulated in 1919, was
the creation of a community of creative practitioners from multiple disciplines who
would work together, live together, and socialize together on an even footing. This
constituted the marriage of two ideals: that of a fairer, more democratic society and
that of the restoration of the unity of the arts, the latter embodied in the highly syn-
thesized total work of art or *Gesamtkunstwerk*. The Bauhaus was to model these
ideals within its own community, but also worked toward their societal realization by
educating the next generation of creative practitioners to collaborate. The renowned
cohesion of the Bauhaus community was in no small part rooted in the school's
democratic management; all important decisions fell to the Masters' Council, which
also entailed an element of student representation.[14] It was further reinforced by the
sheer amount of time spent together; the Dessau Bauhaus provided on-campus stu-
dent accommodation while the master houses were located just around the corner;
"friendly relations between masters and students outside of work," including the
legendary costume parties, had already been envisaged in the Bauhaus manifesto.[15]
Significantly, this tight-knit community also worked collectively, completing several
building projects in which all Bauhaus workshops and departments participated by
contributing to construction, fit-out, and furnishing. A new type of unity was dis-
covered in built environments consisting of spaces and furnishings that had been
designed by different specialists with a shared emphasis on function and the sat-
isfaction of human needs, based on increasingly rigorous research and analysis.[16]
In addition to horizontal cooperation between different workshops, Meyer, who

succeeded Gropius in 1928, instituted "vertical brigades" consisting of students from different year groups tackling real-life projects together, thereby not only learning skills from each other, but also how to organize individuals with different abilities into effective work collectives.[17]

A final crucial aim was what Hüter has referred to as *Volksverbundenheit* – connection with the people: the Bauhaus was not focused on catering for the rich, but on meeting the needs of the broad masses. This perspective was most categorically articulated and implemented under the directorship of Meyer, who had coined the motto "people's needs, not luxury needs." But Gropius had also already been animated by the very same concern, as can be seen from the platforms and proclamations he co-authored as founding member of the Working Council for Art (*Arbeitsrat für Kunst*).[18] A pamphlet from March 1919, for instance, announced, "Art should no longer constitute an indulgence for the few, but happiness and life for the masses."[19] This belief also informed the characteristic emphasis placed at the Bauhaus, especially after 1923, on designing products for machine mass production rather than handcraft. Thus, Gropius justified the industrially oriented work of the Bauhaus workshops in 1926 with a reference to the more cost-effective satisfaction of the manual laborers' daily needs.[20] An important method employed at the Bauhaus to prepare students for this kind of work was industry collaboration. Suitable contacts were sought almost from the outset; yet, a variety of internal and external factors prevented a significant realization of these plans in the Weimar years. Only the ceramics and metal workshops actually managed to work with industrial manufacturers.[21] In Dessau, however, workshops were reconfigured and upgraded with suitable machinery, and a company, Bauhaus Ltd, was set up to handle license agreements, which facilitated a considerable expansion of work with industry partners. This development gathered further momentum under Meyer, an outspoken advocate of "learning on the job," who completed several construction projects with students and almost doubled the Bauhaus' income.[22]

This concern for the needs of ordinary people also led to the prioritization of function and usability and the rejection of formalism.[23] Increasing emphasis was placed on an objective analysis of the properties determining an object's use value. Gropius called this *Wesensforschung*, or research into the "essence" or "fundamental nature" of objects: "An object is determined by its nature. In order to design it to function properly …, its nature must first be studied—because it should serve its purpose perfectly, i.e. fulfil its functions practically, be durable, inexpensive and 'beautiful.'"[24] Based on this research, he argued, it was possible to design exemplary products of universal validity that should be standardized, so that even greater cost-effectiveness could be achieved through economies of scale, "The creation of standard types for practical everyday objects is a social necessity."[25] The development of such products became one of the main tasks of the Bauhaus workshops. Meyer continued these efforts. He instituted extensive and systematic user research to precede any planning activities and sought to place this type of research on a firmer footing by introducing more scientific and technical instruction into the curriculum.[26] He also oversaw the development of standardized construction methods and furniture. Ludwig Mies van der Rohe, the third and final director of the Bauhaus, was less interested in social aspects and discontinued much of this work in the school's waning years. Nevertheless, the adoption and advocacy of this socially oriented design approach, later referred to as functionalism, should be seen as one of the most defining aspects of the Bauhaus as a whole.

Early Abortive Bauhaus Revival Attempts and the Formalism Debate

The first few years after the end of World War II in May 1945 saw a considerable number of Bauhaus revival attempts in the territory that would later become the GDR. Little is known about the efforts of Bauhaus alumni Alfred Arndt and Franz Ehrlich, mentioned briefly by the GDR design historian Heinz Hirdina, to resurrect the Bauhaus in Weimar and Dresden, respectively.[27] Bauhaus graduate Hubert Hoffmann came agonizingly close to reopening the Bauhaus in Dessau in 1945–47 with the support of Mayor Fritz Hesse, who had been instrumental in attracting the Bauhaus to Dessau in the first place in 1926 and who had been reappointed mayor after the war.[28] Hoffmann had gathered a substantial number of former Bauhaus students and masters in Dessau as prospective teachers; organized the necessary buildings, equipment and resources; written a detailed teaching program – closely oriented on Hannes Meyer's Bauhaus, but updated with the inclusion of departments for landscape design and horticulture – and built public support, so that by early 1947 the Bauhaus could theoretically have reopened. However, in 1946 Hesse lost his re-election bid to a politician of the emerging Socialist Unity Party (SED), later the GDR's ruling party, who had no interest in the Bauhaus. Hoffmann missed Hesse's support, particularly in the spring of 1947, when he was dismissed from his post as chief town planner on the basis of what appears to have been defamation, after seemingly making some enemies in Dessau.[29] He left the city, and the project ran aground.

A more successful, albeit short-lived attempt to restore the Bauhaus took place in Weimar, when the local art academy, formerly home to the Weimar Bauhaus, was reopened in August 1946.[30] The school was firmly oriented on its illustrious predecessor, adopting most of its main ideas and methods, and employed several of its former students, although it did not, as originally planned, take the Bauhaus name because of protests by Hesse.[31] Hüter consequently characterized the State School for Architecture and Fine Arts, as it was instead called, as a "renewed Bauhaus" in all but name.[32] It did not last long; the mounting hostility toward modernist culture may have contributed to the departure of the rector in 1949 and his replacement with one that was less sympathetic to the Bauhaus. Moreover, a major reform of the higher education system resulted in the school's reconstitution as a dedicated architecture school in 1951, entailing the closure of the fine art department and thereby putting an end to the idea of an integrated arts education in Weimar.

A final set of Bauhaus revival attempts in this region is associated with Dutch modernist architect Mart Stam, who taught urban planning as a visiting lecturer at Hannes Meyer's Bauhaus in 1928–29.[33] In 1948, Stam was appointed acting director of two schools in Dresden, the Academy of Fine Art and the School for Arts and Crafts, with the intention of merging both institutions into one, just as Gropius had in 1919 consolidated the Weimar Arts and Crafts School and the Weimar Art School to form the Bauhaus. However, Stam's plans to focus the visual and applied arts under the aegis of architecture on the practical needs of the masses were vehemently opposed by the established artists within the academy. This led to an intractable dispute, which was settled in 1950 by appointing Stam as the director of a new applied art school, which had been opened in Berlin-Weißensee. His efforts to establish a Bauhaus-type education at this second institution, ending with his dismissal in 1952, will be discussed below.

Shortly thereafter any further Bauhaus revival attempts became utterly inconceivable. The ruling SED party adopted the Soviet doctrine of socialist realism, which led to the denunciation of modernist culture and its heritage. According to this doctrine, the arts should raise the social consciousness of the people; thus, all cultural output needed to communicate clearly and stirringly. Modernist practices were deemed too inaccessible to function in this manner and thus rejected as "formalist." Work that appropriated the classical cultural heritage was thought to appeal more directly to the people. In addition, modernism and its international orientation had become associated with the "imperialist" United States, whose strong cultural influence, it was argued, needed to be counteracted by a return to national traditions.[34] Beginning in November 1948 and with increased frequency from January 1951, these arguments were presented to the public in a series of newspaper articles that sparked off widespread discussions – the so-called Formalism Debate.[35] As part of this debate, party ideologues conducted a fierce and concerted campaign against functionalist design and architecture – in this context often referred to as "Bauhaus style" – employing newspaper articles, public exhibitions, speeches at party and professional conferences, and interventions in educational institutions. Noncompliant individuals and organizations were often publicly named and censured; some practitioners were dismissed from positions of influence or saw their work otherwise obstructed. As a result, many simply left the country.

This active campaign against functionalist design and the attendant vilification of the Bauhaus receded in the mid-1950s, following a reorientation in the architectural sphere that began in December 1954 in the aftermath of Stalin's death.[36] Yet the socialist realist position on design was not officially renounced, nor was the Bauhaus exculpated, giving rise to an extended period of ambiguity and unease and very gradual liberalization. Finally, in 1976, the restoration and publicly celebrated reopening of the Bauhaus building in Dessau on its 50th anniversary marked the school's full rehabilitation.[37] The intervening period saw lingering hortatory references to socialist realist design in published design discourse into the late 1950s, scathing attacks in national newspapers on "formalist" designers as late as 1963, and an erratically enforced taboo on the Bauhaus until almost the very end. Consequently, GDR designers, whose published texts and designed objects consistently betrayed a functionalist design approach closely related to that advocated at the Bauhaus did not describe their practice explicitly as functionalist, or acknowledge its relationship to the Bauhaus, until the mid-1970s.[38]

It is therefore not surprising that GDR design schools did not claim to be drawing on the legacy of the Bauhaus after the early 1950s, despite the fact that the designers they produced seem to have been clearly indebted to it. An examination of the GDR's two main design schools and the industrial design education they provided offers evidence of the extent to which their aims and methods resembled those of the Bauhaus.

The Burg Giebichenstein School in Halle

The larger and older of the two main schools to educate industrial designers in the GDR originated in the same reform movement as the Bauhaus. It was established as an applied arts school in 1915, when architect Paul Thiersch was appointed as the director of an existing craft school in the city of Halle. Thiersch had worked for Peter Behrens and Bruno Paul and shared many of the prevailing ideas, such as the

importance of a workshop-based education and the *Gesamtkunstwerk* as a goal.[39] The school quickly developed a strong reputation, from 1922 as Applied Arts School Burg Giebichenstein, a name derived from the converted castle which at that point became its permanent home. It was more craft-oriented than the Bauhaus, especially after 1923, when the latter school began to focus more explicitly on designing for industrial production. This was one of the reasons that Gerhard Marcks, form master of the Bauhaus ceramics workshop, and several others who were similarly uncomfortable with Gropius' embrace of industry after 1923, including ceramicist Marguerite Friedländer and weaver Benita Koch-Otte, transferred to the Burg Giebichenstein school when the Bauhaus closed in Weimar in 1925.[40] Others followed later, when Marcks became the school's acting director after Thiersch's departure in 1928, among them architect and Bauhaus teacher Hans Wittwer, Meyer's former associate, in 1929, and furniture designer Erich Dieckmann in 1930. Perhaps ironically, the effect of this influx from the Bauhaus was a greater opening up to industry, and the workshops collaboratively completed several high-profile commissions, including – to excellent critical acclaim – the furnishing of two apartments in Behrens' terraced house in the Weissenhof Siedlung in Stuttgart in 1927 and the well-regarded construction and furnishing of a restaurant for the Halle-Leipzig airport, overseen by Wittwer in 1929/31.[41]

In 1933, many of the faculty members, including all those who had previously worked at the Bauhaus, were dismissed or forced to resign by the Nazis, and the school's development took a different turn; but after 1945, concerted efforts were undertaken to reconnect with the school's prewar past, and that of the Bauhaus, under the school's new director, architect Hanns Hopp.[42] Bauhaus graduate Walter Funkat, a graphic designer, joined the faculty in 1946 and replaced Hopp as director in 1949, a position he would hold for the next 15 years. He was also joined by Friedrich Engemann, who had studied and taught at the Bauhaus in Dessau and Berlin and later supported Hubert Hoffmann's abortive efforts to revive the Bauhaus in Dessau. In Halle, Engemann taught furniture and interior design and took charge of the architecture department after Hopp's departure.[43] A preliminary course was introduced shortly after the war, for which artist and theoretician Lothar Zitzmann, appointed in 1954, methodically developed a highly regarded teaching system that, according to Funkat, built upon the core ideas of the Bauhaus preliminary course but was expanded and adapted to the specific profile of the school (Figure 5.1).[44] This preliminary course remained obligatory for all students entering the school, as it had been at the Bauhaus until almost the very end, throughout the existence of the GDR.[45] Yet, in contrast to the Bauhaus, the school retained, at least initially, its characteristic focus on craft production – accordingly, Funkat recalled early debates under Hopp about a suitable teaching concept for the school revolving around the ideas of Ruskin, Morris, and van de Velde[46] – although there was always room for, and indeed a growing interest in, design for industrial production, too.

This situation changed very definitively in 1958, when the school was granted university status as the School for Industrial Design Halle-Burg Giebichenstein and consequently began to formally institute industrial design education. The creation of a department for technical design, as well as departments for mass-produced furniture and interiors, containers (in porcelain, ceramics, glass, metal, or plastics), toys, and textiles, relegated the crafts to the background.[47] Correspondingly, the school's three faculties, introduced in 1967, were home to the preliminary course and foundation

GRUNDLAGEN VISUELLER GESTALTUNG

Figure 5.1 A summary of Zitzmann's preliminary course, illustrated with examples of student work, published by the Burg Giebichenstein school in 1990. Photo: Karl August Harnisch, Archiv Burg Giebichenstein Kunsthochschule Halle, S 1.2.3, 652.

studies; workplace and equipment design; and industrial design for the home, education, and recreation, whereas the crafts and fine arts remained peripheral to this organizational structure until their amalgamation into a fourth faculty in 1973.[48] Significantly, the importance GDR designers attached to the industrial mass production of design solutions was rooted, much like Gropius' and later Meyer's endorsement of the same, in their overriding concern for the "genuine" needs of the general population. In fact, GDR designers – who were not employed to increase sales, profits, or market share, since those were not parameters against which socialist manufacturers measured their performance – shared the functionalist design approach arising out of this social orientation at the Bauhaus even more comprehensively. In addition to supporting efficient mass production, they also prioritized practical functionality and usability, emphasized product longevity, and rejected formalism.[49] This approach was adopted relatively unanimously in the GDR, as reflected in the designers' practical design work and in their published and unpublished discourse, where it constituted the basis on which they originated a range of further socially responsible ideas and design practices over the years.[50] Educators at the Burg Giebichenstein design school often contributed vital ideas to this discourse. For example, industrial designer and product semiotician Horst Oehlke helped to expand the prevailing conception of a product's functions by theorizing its communicative potential and deriving valuable

Figure 5.2 Modular furniture system MDW, Rudolf Horn and team, manufacturer VEB
Deutsche Werkstätten Hellerau, 1967. Photo: Friedrich Weimer, Archiv Burg
Giebichenstein Kunsthochschule Halle, S 1.2.12, 172.

guidelines for the responsible application of these insights in practice.[51] Key impulses
also came from furniture designer Rudolf Horn, particularly relating to the idea of
active user participation in the finalization of design solutions to optimize the sat-
isfaction of "real, non-manipulated needs" and the ways in which designers might
facilitate such adaptations on an ongoing basis (Figure 5.2).[52] Thus, the primary con-
cern for the needs of the people and the functionalist design approach it gave rise
to at the Bauhaus certainly also informed teaching and research activity at Burg
Giebichenstein after its reconfiguration as a school for industrial design in 1958.

A further significant similarity between the two institutions can be found in
their shared emphasis on industry collaboration as a training method. In addition
to organizing obligatory industry placements for students in their penultimate year
of study, the school's various institutes and departments themselves also carried
out research and development work for industry.[53] By 1967, teachers and students
reportedly worked on contracts with over 100 manufacturers and 15 industry associ-
ations.[54] Furthermore, from 1965 several industrial manufacturers, including makers
of textiles, glass, porcelain, and toys, were directly integrated into the school's struc-
ture to support the realistic teaching of technology and to provide laboratories for
experimental work by students and teachers.[55] The popular modular furniture system
Montagemöbelprogramm Deutsche Werkstätten (MDW) resulted from such a col-
laboration (Figure 5.2). Developed in 1966–67 for the furniture manufacturer VEB

Deutsche Werkstätten Hellerau by a design team led by Rudolf Horn at the school's Institute for Furniture and Interior Design, it was conceived as a pool of coordinated components that could not only be efficiently manufactured and variously assembled to construct different domestic furniture solutions, but also repeatedly reconfigured to adapt it to the user's changing needs.[56]

One aspect of the original Bauhaus program that seemed to have lost its relevance by the late 1950s was the aim of training well-rounded designers to contribute to the creation of "total works of art" within an architectural framework. In Halle, the teaching of architecture was phased out between 1965 and 1970, and industrial design education entailed early specialization soon after the common preliminary course, which made routine interdisciplinary work more difficult. This specialization was seen as necessary to facilitate collaboration with industry, which itself was rigidly structured.[57] However, an updated version of the *Gesamtkunstwerk* idea emerged in the GDR in the 1960s, which also influenced design education in Halle. Based on the cooperative, rather than competitive nature of relationships between socialist manufacturers, "complex design" aimed for harmonized environments consisting of spaces and objects that related to each other – both functionally and aesthetically.[58] To facilitate such "complex design" work at Burg Giebichenstein, a significant range of interdepartmental, and even cross-faculty, design projects were organized beginning in the late 1960s.[59] For example, in 1987–88, second to fifth year students from various departments, evoking Meyer's vertical brigades, designed the furnishings, signage, and equipment for a children's hospital in Halle-Dölau, including coordinated waiting room furniture; hospital beds; food trolleys; tableware and eating utensils; garments; bedclothes; and diverse toys, games, and play equipment, all united by specific functional considerations, such as cleanability, versatility, and longevity, but also by the overarching aim to create a playful and reassuring child-appropriate ambience (Figure 5.3).[60]

A final notable parallel between the two schools were the many legendary parties thrown over the years, particularly the exuberant, witty, and often politically provocative carnival celebrations – typically occasions to suspend classes for a week to facilitate the construction of elaborate decorations, the rehearsal of performances, and the crafting of imaginative costumes.[61] Yet, it is doubtful that the school community as a whole was quite as cohesive as that of the Bauhaus, not least because of the permanent presence, as almost everywhere in the GDR, of representatives of the ruling SED party among both staff and students, who channeled an additional set of interests with which not all students and teachers identified. This is not to say that there were frequent disagreements about teaching content or methods, especially not in the design departments, but there was an awareness that if conflicts with the SED did arise, the consequences could be traumatic, particularly in the early years. For instance, in 1951, during the Formalism Debate, painter Ulrich Knispel was publicly censured and eventually dismissed for leading a summer school resulting in "formalist" paintings – an episode that almost led to the school's closure.[62] The SED also had a direct influence over the school's teaching program. Beginning in the 1950s, it devised mandatory courses in Marxist–Leninist philosophy for all third-level students in the GDR, which consisted of weekly lectures and seminars throughout their course of study.[63] The subject was called "social science" and was taught at Burg Giebichenstein alongside other theoretical subjects such as cultural and art history, sociology, psychology, and aesthetics.[64] This, too, was a divergence from the Bauhaus,

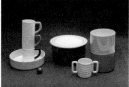

Figure 5.3 Designs for Children's Hospital Halle-Dölau: play structure for waiting area, Günter Hänel and Udo Fleischhauer (final year), supervised by Rudolf Horn; serving trolley, Merten Milkowski (third year), supervised by Horn, Erich Schubert, and Horst Stäudtner; children's ward crockery, Kay Leonhardt and Ulrike Friedemann (third year), supervised by Hubert Kittel; 1988. Photos: Karla Voigt, Archiv Burg Giebichenstein Kunsthochschule Halle, S 1.4, 10001; S. 1.4, 7156; S. 1.2.3.3.

which had had much greater autonomy over its curriculum and where formal political instruction had always been studiously avoided in the hope of self-preservation.[65]

The Weißensee School in Berlin

While reconfiguring itself into an industrial design school, the Burg Giebichenstein school was able to recruit teaching staff from among the graduates of another GDR school which, although much younger, had begun to train industrial designers a few years earlier. Situated in the Berlin district of Weißensee, this institution had opened its doors in 1946 with a program that placed it squarely within the traditions of the Bauhaus, although its founders do not appear to have invoked this heritage by name.[66] In contrast to traditional art schools, it prioritized the applied arts with the aim of meeting "the most pressing of daily needs;" designers of everyday objects were to make use of the discovery of "new means, materials and methods" in order to facilitate their "realization in mass production."[67] The proclaimed focus on design for industrial production was not initially reflected in the school's structure; three

departments offered teaching in artistic foundations, craft, and architecture, recalling the tripartite Bauhaus curriculum. By the summer of 1949, however, a restructuring had led to the existence of departments for ceramics, metals, and textiles, all subsumed into a faculty of industrial design, rather than craft. From the outset, students were required to complete a common foundation course in painting, sculpture, and the graphic arts before they could specialize in one of the applied arts in their second year of study. In a further parallel to the Bauhaus, the Weißensee school also sought to establish industry contacts and obtain research and development contracts, although the results of these efforts were very mixed in the immediate postwar years.[68]

This was not the only problem. The school's first years were beset with multiple difficulties, ranging from shortages of almost everything to leadership problems, which impeded the realization of its proclaimed goals. But when Dutch modernist architect Mart Stam, with his very similar vision of a Bauhaus-type design school in the service of society, was installed as the school's new director in May 1950, after running into difficulties in Dresden, he was able to build on the existing structures. To assist him in his mission, Stam appointed several former Bauhaus students to the school's faculty, including Selman Selmanagić as head of the architecture department, Theo Balden for the foundation course, and Karl Hermann Haupt to teach graphics. Stam himself was firmly focused on design for mass production, in order "to satisfy the needs of all of the workers of our democratic republic."[69] To expand the school's work with industry partners, Stam established an in-house Institute for Industrial Design with departments for ceramics, household objects, furniture, and textiles – mirroring the product design specializations taught at the school – as a site for both on-the-job training and research and development work for the manufacturing industry.[70] A number of additional former Bauhaus students, including Max Gebhard, Marianne Brandt, and Albert Buske, were among its earliest employees. Here, students worked on real-life design projects, such as heating appliances, light fixtures, ventilators, irons, vacuum flasks, crockery, opera glasses, toys, furniture fittings, and various textile products (Figure 5.4).[71] Evoking Gropius' efforts at the Bauhaus to establish standardized product types, Stam also began a collaboration with the GDR's central body for quality control, the German Office for Material and Product Testing (DAMW), as part of which GDR designers contributed, under the auspices of the school's design institute, to quality control, as well as standardization and typification efforts.[72] His ultimate goal was the manufacture of large quantities of well designed, affordable products that satisfied the people's daily needs, "high-quality products – not just for a few – but for everyone."[73]

This period ended abruptly when the Formalism Debate caught up with Stam and led to his dramatic dismissal in September 1952.[74] Under his successors – all painters or "social scientists" – the school's emphasis shifted from design to fine art. Its official name changed from the School for Applied Art to the School for Fine and Applied Arts in 1953 and, in 1969, to Art School Berlin. The fine art departments were prioritized in the allocation of teaching staff, resources, and workshop space, and students reported a traditional hierarchy again with painting and sculpture garnering most respect.[75] Stam's industrial design institute had already been uncoupled from the school and placed under the control of the Ministry for Culture in the summer of 1952. These adjustments were strategic. As pointed out in a 1963 review of the school's work by an SED task force, while "problems of aesthetics and the method of socialist realism were relatively well resolved" in the fine arts, the applied arts

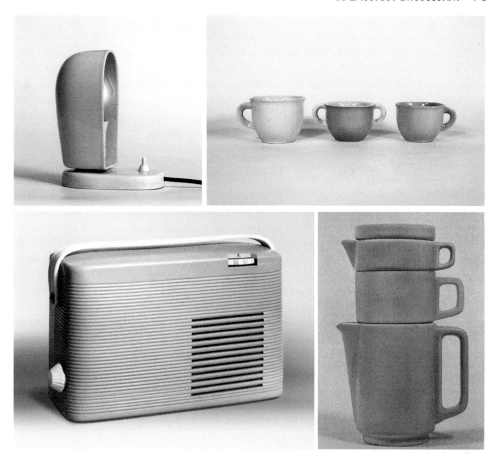

Figure 5.4 Design work at the Institute of Industrial Design: rotating table lamp B4-04, Marianne Brandt and Albert Krause, probably 1951. Photo: Armin Herrmann, Stiftung Industrie- und Alltagskultur. Cups for childcare settings, Margarete Jahny, manufactured by VEB Steingutwerk Dresden, 1951. Photo: Marion Kaiser, ©Industriemuseum Chemnitz im Sächsischen Industriemuseum. Plaster model for Puck portable radio, Albert Krause, manufactured by VEB Funkwerk Halle, 1951. Photo: Walter Danz, Albert Krause Estate, Halle (Saale). Stackable tea/coffee pot set for self-service restaurants, Albert Krause, manufactured by VEB Steingutwerke Annaberg, 1950. Photo: Maria Steinfeldt, Akademie der Künste.

were still seen as an "ideological no man's land."[76] Fine art teaching, although still considered inconsistently aligned with the official doctrine in Weißensee, was easier to monitor and call into line. It was hoped that the fine arts, thus elevated, would eventually guide the applied arts toward socialist realism.

The Weißensee school's resemblance to the Bauhaus thus waned again. Not only did the fine arts take center stage in the school's teaching program, but their tight regulation according to anti-modernist directives also limited their scope for the kind of experimentation and innovation seen at the Bauhaus. On the other hand, several ideas lived on. All students continued to complete the universal foundation course, though beginning in autumn 1952, fine and applied arts students were taught

in separate groups, and there appears to have been some degree of customization of teaching content for specific student groups over the years.[77] Also attributed to the Bauhaus, and closely related to this largely shared foundation course, was the school's characteristic pursuit of interdisciplinarity – an idea here often referred to as synthesis or, following Selmanagić, who remained head of architecture until his retirement in 1970, interlinkage. Although the official focus was typically on the collaboration between fine artists and architects to create public construction-based art, interdisciplinary learning was encouraged throughout the school.[78] Students from different departments attended each other's classes, collaborated on projects, and shared teachers like graphic designer Friedrich Panndorf, who had trained under former Bauhaus student Hajo Rose in Dresden and taught across almost all of the school's departments.[79] For industrial design students, this meant opportunities to work on "complex design" projects with students from other disciplines, for example in their final year with architecture students, designing large passenger ships to be constructed at the Boizenburg shipyards for export to the Soviet Union, as well as on more object-focused collaborations, such as a kite design project undertaken with graphic design students in year three.[80]

In fact, despite attempts to orient the work of the school on socialist realist principles, the institution's industrial design education itself remained remarkably aligned with that of the Bauhaus. From 1953 until 1972, it was effectively in the hands of architect, sculptor, and graphic designer Rudi Högner, who had been appointed in 1948 by Mart Stam to teach with him in Dresden and transferred to Weißensee in 1952.[81] Högner focused the work of the department on more technical objects, which were even harder for ideologues to police than the less technical applied arts, and immediately upon his arrival began to establish industry contacts to support learning through real-life projects and industry placements, making up for the loss of Stam's industrial design institute.[82] Much of the resulting student work went into production. By the end of the 1960s, the Weißensee industrial design department, which maintained relations with over 300 manufacturers, could claim credit for products that had reached production volumes of several hundred thousand units – extraordinary figures for any design educational institution – among them cameras, projectors, radio and television sets, electrical appliances, and food processors.[83]

Furthermore, from the outset this focus on mass production and industry collaboration was rooted, as it had been at the Bauhaus, in a functionalist design approach that prioritized the efficient satisfaction of the needs of the population, although Högner made no references to the modernist heritage. He did, however, explain the role of design by pointing to the needs of millions of people "yearning for well ordered, bright, healthy and functionally appropriate" homes and workplaces; he stressed the importance of standardization and typification and contended that responsible designers "primarily order and simplify, as well as avoid unnecessary complications, disguised adornment and ambiguities, in order to increase [an object's] use value."[84] Consequently, already the products developed by the very first cohort of Högner students were designed for optimum functionality and manufacturability and devoid of all modish or historicist decorative detailing (Figure 5.5). This is worth noting, because 1953 had marked the height of the Formalism Debate during which many ideologues had argued that design was not socialist realist unless it was decorated.[85] This approach, thus instilled in the first generation of GDR industrial designers, became the hallmark of GDR design. Over the years, Weißensee

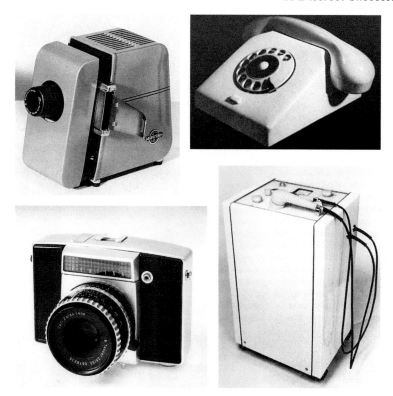

Figure 5.5 Weißensee student designs supervised by Rudi Högner. Aspectar 150 slide projector, Manfred Claus, manufactured by VEB Pentacon Dresden, 1957. Photo: Franziska Adebahr. W 58 desk phone, Ekkehard Bartsch and Christian Berndt, manufactured by VEB Fernmeldewerk Nordhausen, 1958. Photographer unknown. Pentina SLR camera, Jürgen Peters, manufactured by VEB Pentacon Dresden, 1958. Photo: Christel Lehmann. Ultrasound massager, Erich John, manufactured by VEB Transformatoren- und Roentgenwerk Dresden. Photographer unknown. Photographs from Heinz Hirdina, *Gestalten für die Serie. Design in der DDR 1949-1985* (Dresden: Verlag der Kunst 1988) 60, 59, 98, 59.

students continued to work on design projects that emphasized functionality and usability, informed by thorough research and analysis of user needs, as well as cost-efficient mass-producibility. In 1971, for example, Gabriele Krause graduated with a project on seating design for childcare settings (Figure 5.6).[86] Drawing on data generated as part of a recent research project on child anthropometry, she designed a simple well-proportioned chair in five different sizes, which allowed all children of the relevant age group, ranging from twelve months to seven years, to adopt a healthy posture with both feet resting firmly on the ground.[87] Designed for durability and cost-effective mass production, the chair consisted of a plastic seat pan – lightweight and easy to clean – mounted into a tubular steel frame, which was flared for improved stability and stackability. Even the color palette was determined by considerations of use. Krause specified five tones – one for each chair size to allow easy differentiation – which were rich and vibrant to appeal to children and carefully coordinated to harmonize when multiple chair sizes were used in the same space.

Figure 5.6 Stackable playschool chair in different sizes, Gabriele Krause, supervised by Rudi Högner, commissioned by VEB Dynamobau Berlin, 1971. Photo: Gabriele Krause and Dominique Kahane, Private Archive Gabriele Krause.

Conclusion

Despite party directives to the contrary, there were thus strong continuities between the Bauhaus and the GDR's two main design schools, particularly the Burg Giebichenstein school in Halle, with its nonacademic, practical, workshop-based education; its craft tradition; its co-location of various creative disciplines and emphasis on interdisciplinary "complex design" work; its shared Bauhaus-based preliminary course; and its prioritization of design for mass production, supported by an exceptional degree of industry collaboration, to satisfy the needs of the population in the most efficient way possible. The Weißensee school in Berlin was on a similar trajectory, but its subordination of design to the fine arts after the early 1950s diminished this resemblance to the Bauhaus on an institutional level. Its industrial design education, however, remained as aligned with the Bauhaus as that provided in Halle. This suggests that the visual similarity between mature design work from the Bauhaus and the work of GDR designers is deeply rooted in a very similar design education provided at the relevant institutions and also just one small aspect of a much more comprehensive continuity.

These findings shed some further light on the question, raised already under Meyer's tenure at the Bauhaus, of the role played by fine art in a Bauhaus-type design education – especially the significance of instruction by modern painters.[88] Neither

of these two GDR schools employed painters who openly practiced abstraction. Instruction in form and color theory, the main subjects taught by Klee and Kandinsky at the Bauhaus, was instead delivered by a variety of other artists and, increasingly, by designers. On the other hand, the social ideals of the Bauhaus, and the functionalist design approach these engendered, remained central in both design education and practice in the GDR. In light of a renewed interest in socially responsible design in recent years, their adoption and adaptation by GDR designers over the course of the second half of the twentieth century suggests that perhaps this is the most relevant aspect of the legacy of the Bauhaus for design practitioners today.

I am profoundly grateful to all who have contributed so generously with information, images, and critical input, especially Doreen Frauendorf in the archive of the Burg Giebichenstein University of Art and Design, Udo Fleischhauer, Günter Höhne, Carola Hütcher in the Industriemuseum Chemnitz, Kathleen James-Chakraborty, Elizabeth Krause, Gabriele Krause, Renate Luckner-Bien, Mario Prokop, and Michelle Russell in the library of the National College of Art and Design, Dublin.

Notes

1. Paul Betts, "The Bauhaus as Cold-War Legend: West German Modernism Revisited," in *German Politics & Society* 14 (1996): 75–100.
2. Betts, "Bauhaus as Cold-War Legend"; and Karen Koehler, "The Bauhaus Manifesto Postwar to Postwar: From the Street to the Wall to the Radio to the Memoir," in *Bauhaus Construct: Fashioning Identity, Discourse and Modernism*, Jeffrey Saletnik and Robin Schuldenfrei, eds. (London, New York: Routledge, 2009) 13–36.
3. Betts, "Bauhaus as Cold-War Legend," 78.
4. Hans Maria Wingler, *The Bauhaus: Weimar, Dessau, Berlin, Chicago* (Cambridge, Mass: MIT Press, 1969); Jeannine Fiedler and Peter Feierabend, eds., *Bauhaus* (Cologne: Könemann, 2000).
5. Betts, "Bauhaus as Cold-War Legend"; and Kathleen James-Chakraborty, "Beyond Cold War Interpretations: Shaping a New Bauhaus Heritage," *New German Critique* 116 (2012): 11–24.
6. Frederic J. Schwartz, "Utopia for Sale: The Bauhaus and Weimar Germany's Consumer Culture," in *Bauhaus Culture: From Weimar to the Cold War*, Kathleen James-Chakraborty, ed. (Minneapolis: University of Minnesota Press, 2006) 115–138; and Robin Schuldenfrei, "The Irreproducibility of the Bauhaus Object," in Saletnik and Schuldenfrei, *Bauhaus Construct*, 37–60.
7. Magdalena Droste, *Bauhaus 1919–1933* (Berlin: Bauhaus-Archiv, 1993).
8. For example, Schuldenfrei's discussion of the school's failure to design for mass production limits itself to the period 1923–28, although the era under Meyer (1928–30) was by far the most productive in his regard (Schuldenfrei, "The Irreproducibility of the Bauhaus Object"). For recent scholarship on Meyer, see Thomas Flierl and Philipp Oswalt, eds., *Hannes Meyer und das Bauhaus. Im Streit der Deutungen* (Leipzig: Spector Books, 2018); and Philipp Oswalt, ed., *Hannes Meyers neue Bauhauslehre* (Basel: Birkhäuser Verlag, 2019).
9. On Bauhaus revival attempts, see Greg Castillo, "The Bauhaus in Cold War Germany," in James-Chakraborty, *Bauhaus Culture*, 171–93; and for its impact on design, see Paul Betts, "The Bauhaus in the German Democratic Republic: Between Formalism and Pragmatism," in Fiedler and Feierabend, *Bauhaus*, 42–49; and Florentine Nadolni, ed., *shaping everyday life! bauhaus modernism in the gdr* (Weimar: M BOOKS, 2019).
10. Wingler, *Bauhaus*; Frank Whitford, *Bauhaus* (London: Thames and Hudson, 1984); Droste, *Bauhaus*; Fiedler and Feierabend, *Bauhaus*; Claude Schnaidt, *Hannes Meyer: Buildings, Projects and Writings* (London: Teufen, 1965); Flierl and Oswalt, *Hannes Meyer*; Oswalt, *Hannes Meyers neue Bauhauslehre*; Karl-Heinz Hüter, *Das Bauhaus in Weimar: Studie zur gesellschaftspolitischen Geschichte einer deutschen Kunstschule* (Berlin: Akademie-Verlag, 1976).

11. Walter Gropius, "Vorschläge zur Gründung einer Lehranstalt als künstlerische Beratungsstelle für Industrie, Gewerbe und Handwerk, Januar 1916," in Hüter, *Bauhaus*, 201–03; in English in Wingler, *Bauhaus*, 23–24. For more on this, see Hüter, *Bauhaus*, 108–48.

12. The Chamber of Handicrafts, for example, when consulted for an evaluation, had successfully opposed Gropius' appointment in 1916 on the basis that his proposal was more oriented on the needs of industry than those of the crafts guild. See Hüter, *Bauhaus*, 109.

13. Gropius also often stressed this in later years, for example in a letter written to Hüter in 1968 after reading Hüter's *Bauhaus* manuscript. See Karl-Heinz Hüter, "Dem Bauhaus die Bahn brechen: Von den Schwierigkeiten zu erben in Zeiten des Kalten Krieges," in *Die geteilte Form: Deutsch-deutsche Designaffären 1949–1989*, Günter Höhne, ed. (Cologne: Fackelträger Verlag, 2009) 72–107, here 102.

14. This cohesion was particularly pronounced in the Weimar years as described in Hüter, *Bauhaus*, 61–81, but characterized the Dessau era too.

15. Walter Gropius, "Program of the Staatliche Bauhaus in Weimar, April 1919," in Wingler, *Bauhaus*, 32.

16. This idea originated in Weimar but gathered momentum in Dessau. See Marcel Breuer, "Form und Funktion," *Junge Menschen. Monatshefte für Politik, Kunst, Literatur und Leben* 8 (1924) 191, reprinted in Hüter, *Bauhaus*, 281–82; Walter Gropius, "Bauhaus Dessau—Principles of Bauhaus Production, 1926," in Wingler, *Bauhaus*, 109–10; and Hannes Meyer, "bauhaus and society, 1929," in Schnaidt, *Hannes Meyer*, 99–101.

17. Hannes Meyer, "Bauhaus Dessau 1927–30: My Experience of a Polytechnical Education," in Schnaidt, *Hannes Meyer*, 109–11. See also Oswalt, *Hannes Meyers neue Bauhauslehre*, 13; and Anne Stengel, "Baupraxis als Lehre," in Oswalt, *Hannes Meyers neue Bauhauslehre*, 130–42.

18. Hüter, *Bauhaus*, 55–61.

19. Cited in Hüter, *Bauhaus*, 18.

20. Gropius, "Principles of Bauhaus Production," 110.

21. Hüter, *Bauhaus*, 134–48.

22. See Hannes Meyer, "My Dismissal from the Bauhaus: Open Letter to Oberbürgermeister Hesse," in Schnaidt, *Hannes Meyer*, 103; Martin Kieren, "The Bauhaus on the Road to Production Cooperative: The Director Hannes Meyer," in *Bauhaus*, ed. Fiedler, 204–14; Norbert Eisold, "Entwerfen für die Produktion. Die Bauhauswerkstätten unter Hannes Meyer 1928 bis 1930," in Oswalt, *Hannes Meyers neue Bauhauslehre*, 175–89.

23. Walter Gropius, "Grundsätze der Bauhausproduktion," in *Neue Arbeiten der Bauhauswerkstätten*, Walter Gropius, ed. (München: Langen, 1925) 5–8. (This original German text is more instructive than the shortened later version, published in English as "Principles of Bauhaus Production," in Wingler, *Bauhaus*, 109–10.)

24. Ibid., 5.

25. Ibid., 7.

26. In his own words: Meyer, "building," in Schnaidt, *Hannes Meyer*, 95–97. See also Schnaidt, *Hannes Meyer*, 47; Dara Kiese, "Ganzheitliche Erziehung," in Oswalt, *Hannes Meyers neue Bauhauslehre*, 22–43; and Hubert Hoffmann, "Erinnerungen eines Architekturstudenten," in Oswalt, *Hannes Meyers neue Bauhauslehre*, 116–29.

27. Heinz Hirdina, *Gestalten für die Serie: Design in der DDR 1945–1985* (Dresden: Verlag der Kunst, 1988) 18. See also brief reference to Arndt's attempt in *Bauhaus und Bauhäusler: Erinnerungen und Bekenntnisse*, Eckhard Neumann, ed. (Cologne, DuMont Buchverlag, 1985) 99.

28. Svenja Simon, "Der Versuch der Wiedereröffnung des Bauhauses in Dessau nach 1945," in *...das Bauhaus zerstört, 1945–1947, das Bauhaus stört...*, Stiftung Bauhaus Dessau, ed. (Dessau: Anhaltische Verlagsgesellschaft, 1996) 8–33.

29. Ibid., 24–8.

30. Karl-Heinz Hüter, "Dem Bauhaus die Bahn brechen: Von den Schwierigkeiten zu erben in Zeiten des Kalten Krieges," in *Die geteilte Form: Deutsch-deutsche Designaffären 1949–1989*, Günter Höhne, ed. (Köln: Fackelträger Verlag, 2009) 79–83. See also Hirdina, *Gestalten*, 18–9.

31. Simon, "Der Versuch," 10–11 and Hirdina, *Gestalten*, 18.

32. Hüter, "Dem Bauhaus die Bahn brechen," 82.

33. On Stam's work in the GDR, see Cornelia Hentschel, Walter Scheiffele, and Jens Semrau, eds., *die frühen jahre, mart stam, das institute und die sammlung industrielle gestaltung* (Berlin: Lukas Verlag, 2020): Simone Hain, "ABC und DDR. Drei Versuche, Avantgarde mit Sozialismus in Deutschland zu verbinden," in *Kunstdokumentation SBZ/DDR 1945–1990: Aufsätze, Berichte, Materialien*, Günter Feist, Eckhart Gillen and Beatrice Vierneisel, eds. (Köln: DuMont, 1996) 430–43; and in Berlin, see Hiltrud Ebert, "Von der 'Kunstschule des Nordens' zur sozialistischen Hochschule. Das erste Jahrzehnt der Kunsthochschule Berlin-Weißensee," in Feist, Gillen and Vierneisel, *Kunstdokumentation*, 160–85; and Castillo, "The Bauhaus," 177–80.

34. Katharina Pfützner, *Designing for Socialist Need: Industrial Design Practice in the German Democratic Republic 1949–1990* (London, New York: Routledge, 2018) 173–80.

35. Ibid., 180–83.

36. Ibid., 182–83.

37. Ibid., 183–96, and Hüter, "Dem Bauhaus die Bahn brechen," 95–104.

38. Pfützner, *Designing for Socialist Need*, 19–58.

39. Joachim Skerl, "Das 'Problem der Form:' Zum Standort der Burg in den Auseinandersetzungen um die Form in den zwanziger und dreißiger Jahren," in *75 Jahre Burg Giebichenstein 1915–1990: Beiträge zur Geschichte*, Renate Luckner-Bien, ed. (Halle: Burg Giebichenstein, 1990) 17–28.

40. Renate Luckner-Bien, "Burg und Bauhaus," *Bildende Kunst* 11 (1986): 504–06. For more on Marcks' time in Halle, see Renate Luckner-Bien, *Marcks kann lachen: Der Bildhauer Gerhard Marcks in Halle an der Saale* (Halle/Saale: Hasenverlag, 2019).

41. Angela Dolgner, "Architektur an der Burg," in Luckner-Bien, *75 Jahre Burg Giebichenstein*, 180–97. The only other two schools permitted to participate in the Weissenhof exhibition were the Bauhaus in Dessau and the successor institution of the Bauhaus in Weimar, the Bauhochschule.

42. On the school's history between 1933 and 1945, see Andreas Hüneke, "Wenn einer aus dem Rahmen fällt … Zum Schicksal der 1933 entlassenen Lehrkräfte," in Luckner-Bien, *75 Jahre Burg Giebichenstein*, 73–80 and Gottfried Kormann, "'Meisterschule des deutschen Handwerks' Die Schule zwischen 1933 und 1945," in Luckner-Bien, *75 Jahre Burg Giebichenstein*, 84–89.

43. For more on Engemann, see Dolgner, "Architektur an der Burg," 192.

44. Walter Funkat, "Anfänge. Ein Monolog," in Luckner-Bien, *75 Jahre Burg Giebichenstein*, 93. For a more detailed discussion of the course, see Dietmar Petzold, "Über Möglichkeiten, künstlerisches Gestalten zu lehren—ein geschichtlicher Exkurs am Beispiel einer Schule," in Luckner-Bien, *75 Jahre Burg Giebichenstein*, 154–61. See also Lothar Zitzmann and Benno Schulz, *Grundlagen Visueller Gestaltung* (Halle: Hochschule für industrielle Formgestaltung Halle Burg Giebichenstein, 1990).

45. Renate Luckner-Bien, "Geschichte und Gegenwart. Die Burg Giebichenstein nach 1958," in *Burg Giebichenstein: die hallesche Kunstschule von den Anfängen bis zur Gegenwart*, Angela Dolgner, ed. (Halle: Burg Giebichenstein – Hochschule für Kunst und Design, 1993) 67. At the Bauhaus, the preliminary course ceased to be mandatory under Mies van der Rohe shortly before its closure.

46. Funkat, "Anfänge," 91.

47. See Johannes Langenhagen, "Zur Entwicklung der Sektion Produkt- und Umweltgestaltung im Bereich der Produktion," in Luckner-Bien, *75 Jahre Burg Giebichenstein*, 235–59; and Rudolf Horn, "Sektion Produkt- und Umweltgestaltung im Bereich des Wohnungs- und Gesellschaftsbaus," in Luckner-Bien, *75 Jahre Burg Giebichenstein*, 198–221.

48. Luckner-Bien, "Geschichte und Gegenwart," 68.

49. For an in-depth discussion of this design approach and its attendant priorities, see Pfützner, *Designing for Socialist Need*, 19–58.

50. Ibid., 87–169.

51. See Horst Oehlke, "Funktion—Gestalt—Bedeutung (Zur Semantik der Produkterscheinung)" in *2. Kolloquium zu Fragen der Theorie und Methodik der industriellen Formgestaltung 16./17. November 1978* (Halle: Hochschule für industrielle

Formgestaltung Halle – Burg Giebichenstein, 1980) 17–34; and Horst Oehlke, "Seminar zum Funktionalismus: Visualisierung als Aufgabe funktionaler Gestaltungsweise," *form+zweck* 6 (1982): 36–40.

52. Rudolf Horn, "Serie, Vielfalt und Bedarf," *form+zweck* 6 (1986): 21–23, here 21. See also Rudolf Horn, "Gestaltung und industrielle Produktion im Möbelbau," in *Bildende Kunst* 2 (1986): 69–73; and Rudolf Horn, "Der Nutzer als Finalist," *form+zweck* 6 (1981): 43–44.

53. On industry placements, see Erwin Andrä, "Verpflichtende Tradition und neue Aufgaben: Aus der Arbeit der Hochschule für industrielle Formgestaltung Halle-Giebichenstein [sic]," *Bildende Kunst* 4 (1967): 191–95; and Paul Jung, "Potential für die Praxis: 25 Jahre Hochschule für industrielle Formgestaltung Halle Burg Giebichenstein," *form+zweck* 3 (1983): 10–12. On industry work carried out at the school, see Langenhagen, "Zur Entwicklung der Sektion"; Horn, "Sektion Produkt– und Umweltgestaltung"; and Renate Luckner-Bien, "Traditionslinien. Ein Beitrag zur Geschichte der Keramik," in Luckner-Bien, *75 Jahre Burg Giebichenstein*, 134–53.

54. Andrä, "Verpflichtende Tradition," 194.

55. Ibid. and Luckner-Bien, "Geschichte und Gegenwart," 68.

56. "Gestaltung, Produktion und Konsumtion des Industriemöbels," in *form+zweck* 1 (1968): 24–31; and Marc Schweska and Markus Witte, "Revolution aus Tradition? Das Montagemöbelprogramm Deutsche Werkstätten (MDW)," in *Wunderwirtschaft: DDR–Konsumkultur in den 60er Jahren*, Neue Gesellschaft für Bildende Kunst, ed. (Köln: Böhlau Verlag, 1996) 80–89.

57. Luckner-Bien, "Geschichte und Gegenwart," 68.

58. For a more detailed discussion of this, see Pfützner, *Designing for Socialist Need*, 139–63.

59. Horn, "Sektion Produkt– und Umweltgestaltung," 201–02.

60. Rudolf Horn, "Überlegungen zu einer Gemeinschaftsarbeit 'Haus für kranke Kinder'," in *HiF-Design: Mitteilungen der Hochschule für Industrielle Formgestaltung Halle Burg Giebichenstein* 1 (1989): 6–8 and further articles in this issue dealing with the contributions of the various departments.

61. Angela Dolgner and Renate Luckner-Bien, *Da wackelt die Ruine: Feste der Kunsthochschule Burg Giebichenstein* (Halle/Saale: Hasenverlag, 2009).

62. Funkat, "Anfänge," 92.

63. See, for example, official guidelines from around 1956 "Stoffverteilungsplan für den gesellschaftswissenschaftlichen Unterricht an Konservatorien, Schauspielschulen und Fachschulen für angewandte Kunst in der Deutschen Demokratischen Republik," and from 1986 "Lehrprogramm des Marxismus-Leninismus an den Universitäten und Hochschulen der Deutschen Demokratischen Republik" (Burg Archiv).

64. For most of the time, "social science" consisted of courses in dialectical and historical materialism (taught in first year), political economy (taught in second year), and scientific socialism and the history of the labor movement (taught in third and fourth years). Preserved timetables from the 1980s (Burg Archiv) illustrate how these classes fitted into the students' weekly schedules.

65. This applies to the tenures of all three Bauhaus directors. Philipp Oswalt, "Die verschwiegenen Bauhaus-Krisen," in Flierl and Oswalt, *Hannes Meyer*, 247–76, especially 255–60.

66. Hiltrud Ebert, "Von der 'Kunstschule des Nordens,'" 162 (note 11).

67. Ibid., 163, cited from official opening speech.

68. Ibid., 167–69.

69. Mart Stam, "Neue Möglichkeiten auf dem Gebiet der industriellen Gestaltung, 1950" in *Drei Kapitel Weißensee: Dokumente zur Geschichte der Kunsthochschule Berlin-Weißensee 1946 bis 1957*, Hiltrud Ebert, ed. (Berlin: Kunsthochschule Berlin-Weißensee, 1996) 270.

70. The establishment of this institute had already been decreed under Stam's predecessor in March 1950, but it only became a reality under Stam in April 1951.

71. Mart Stam, "Die Aufgabe unserer Hochschule ist die Ausbildung von Nachwuchs, 6.12.1951," in Ebert, *Drei Kapitel Weißensee*, 84; and Sammlung industrielle Gestaltung,

Einblicke, Ausblicke (Berlin: Sammlung industrielle Gestaltung, 1991) 11. Design work under Stam was highly collaborative with little concern for individual authorship. The resulting objects can therefore often not be attributed to a single designer or even the Institute for Industrial Design alone. Both the stackable pot set and the cups in Figure 5.4, for example, originated with Margarete Jahny, then a student of Marianne Brandt at the Dresden Academy of Fine Art around the time of Stam's departure from the school, and were brought to Berlin for further development by others. Brandt followed Stam to Berlin in July 1951 and Jahny joined the institute in 1954.

72. Mart Stam, "Zur Tätigkeit auf dem Gebiet der Industriegestaltung, April 1952," in Ebert, *Drei Kapitel Weißensee*, 87–92. For more on the GDR designers' contributions to product appraisals, standardization and typification throughout the existence of the state, see Pfützner, *Designing for Socialist Need*, 32–5 and 64–7.

73. Stam, "Neue Möglichkeiten," 272.

74. Ebert, *Drei Kapitel Weißensee*, 104–7.

75. On perception of hierarchy, see interviews in Jens Semrau, ed., *Was ist dann Kunst? Die Kunsthochschule Weißensee 1946–1989 in Zeitzeugengesprächen* (Berlin: Lukas Verlag, 2004). On prioritization of fine arts, see archived document "Bericht der Arbeitsgruppe über die Hochschule für bildende und angewandte Kunst in Berlin-Weißensee" in Semrau, *Was ist dann Kunst?*, 332.

76. Ibid.

77. See Theo Balden's remarks in "Protokoll der Dozentensitzung zum Grundstudium, 24.3.55," in Ebert, *Drei Kapitel Weißensee*, 256–63, and on the foundation course in later years, see interviews and symposium proceedings in Semrau, *Was ist dann Kunst?*

78. See Walter Womacka, "Der Größe unseres Anliegens gerecht werden," *Bildende Kunst* 2 (1969): 100–02, for an illustration of this emphasis on construction-based art.

79. Wolfgang Henze and Rudolf Kaiser, "Keramiker für die Praxis gerüstet," in *Bildende Kunst* 2 (1968): 81–85; Dietmar Palloks, "Lernen, im Kollektiv zu gestalten," *form+zweck* 4 (1974): 32–35; Semrau, *Was ist dann Kunst?*

80. Interview with Erich John in Semrau, *Was ist dann Kunst?*, 250; and Anita Maatz and Hans-Jürgen Ehmann, "Drachen," *form+zweck* 5 (1977): 29–30. For further examples of interdisciplinary project work by industrial design students, see Joachim Doese, "Ideenprojekt für einen Kindergarten," *form+zweck* 2 (1974): 23–26; Palloks, "Lernen," 4; and Mario Prokop, "Getrennt, aber nicht isoliert," *form+zweck* 6 (1978): 24–25.

81. Högner began to work in the Appliances department, previously Metals and later called Industrial Design. Departments for ceramics and textiles, also concerned with design for industrial manufacture, continued to exist alongside this department. Also, despite Högner's prominent role, he was not formally in charge of the department until 1958, when he replaced the graphic artist Ernst Rudolf Vogenauer as its head.

82. See Högner's report from April 18, 1955 in Ebert, *Drei Kapitel Weißensee*, 282–84. See also Alfred Hückler, "Bemerkungen zu Ausgangspositionen im Industrie-Design nach 1945 an der Kunsthochschule Berlin-Weißensee unter Rudi Högner," in *Zwei Aufbrüche: Symposium der Kunsthochschule Berlin-Weißensee*, Samson D. Sauerbier, ed. (Berlin: Kunsthochschule Berlin-Weißensee, 1997) 137–53.

83. Rudi Högner and Erich John, "Über die Ausbildung des Industrieformgestalters," *Bildende Kunst* 2 (1968): 77–80. Student work became increasingly less likely to go into production over the course of the 1970s and 1980s, but industry involvement in education remained high. See Dietmar Palloks, "Designaufgaben differenzieren," *form+zweck* 5 (1982): 21–5.

84. Rudi Högner, "Zu den Problemen der Formgestaltung in der technischen Industrie," *Bildende Kunst* 8 (1962): 427, 432.

85. Walter Heisig, *Zu den aktuellen Fragen der angewandten Kunst in Industrie und Handwerk* (Berlin: Institut für angewandte Kunst, 1953) 7.

86. Gabriele Krause, "Diplomarbeit: Kinderstühle," *form+zweck* 1 (1972): 30–31.

87. Anthropometric data from Erika Atze, "Funktionsmaße für Kindermöbel in Abhängigkeit von der Körpergröße," unpublished doctoral dissertation, Medizinische Akademie Magdeburg, 1969.

88. See Oswalt, "Die verschwiegenen Bauhaus-Krisen," 260–62.

6 The Bauhaus and the Republic of Ireland

Kathleen James-Chakraborty

Since the middle of the twentieth century, accounts of the Bauhaus' impact following its closure in 1933 have focused on the Federal Republic of Germany and the United States, to which two of its three directors and many of its most celebrated staff and students emigrated in the 1930s. Only recently has scholarship opened up to the rest of the world, paying new attention to those who went to – among other places – the British Mandate of Palestine, Chile, China, and even North Korea.[1] The focus on Bauhaus influence in the postwar period in the United States and West Germany has often been understood as an indication of a commitment to democratic values.[2] What happens when we turn our attention to Ireland, a small European nation haunted by neither fascism nor the Holocaust but by the struggle for home rule and independence? Here, we find a history of turning to both Germany and the United States for assistance in first achieving and then defining that independence in a context where there was not initially much enthusiasm for modernity in the visual arts. Beginning in the 1960s, however, a broad range of initiatives in art, architecture, and design assisted the Republic in establishing increased cultural distance from Britain. Although the buildings of Ronnie Tallon and Robin Walker, the establishment of the Kilkenny Design Workshops, and the art featured in the early ROSC (an Irish word that the organizers defined as "poetry of vision") art exhibitions were, with one exception, not the handiwork of those who had taught or studied at the Bauhaus; they were inconceivable without it. The breadth of the school's accomplishment was finally displayed in the country in a 1979 exhibition held at the newly opened Douglas Hyde Gallery at Trinity College in Dublin, although an earlier Bauhaus exhibition, sponsored by the German (now Goethe) Institute was staged in University College Dublin's Aula Maxima on St. Stephen's Green already in 1967.[3] Even before that, however, Bauhaus-inflected modernism assisted Ireland in establishing an image of cosmopolitanism and progress which, if it often in reality continued to remain elusive, served as inspiration for the more inclusive society the country enjoys today.

Irish connections to the school were extremely tenuous. Only one Irish student, Stella Steyn, studied briefly at the Bauhaus, and she spent most of the rest of her life in Britain.[4] Walter Gropius, its founder and first director, gave a lecture in Dublin in 1936, which prompted the first mention of the school in the *Irish Times*.[5] Here, the object of the Bauhaus was described as not being "to propagate any style, system, dogma, formula, or vogue, but to exert a revitalizing influence on design. It did not base its teaching on any particular idea or form but sought the essence of life

DOI: 10.4324/9781003268314-7

itself behind life's ever-changing forms."[6] This attempt to extract the school from the circumstances of its birth and maintain its relevance long after its closure would provide the foundation for its eventual impact in Ireland. Much later, in 1959, in one of the few other direct Irish connections to the school, Margaret Leischner, a textile designer who studied at the Bauhaus before teaching weaving at the Royal College of Art, designed carpets for Irish Ropes.[7]

Modernity and modernism in the built environment and the visual arts were not foreign to Ireland, but they took different forms there those espoused by the Bauhaus. When the Free State turned in the 1920s to the German electrical firm Siemens to dam the Shannon River for hydropower, German technical expertise proved not to include a machine-age aesthetic.[8] The country's first Cubist-inspired artists and designers, Eileen Gray, Evie Hone, and Mainie Jellett all traveled to Paris rather than Dessau or Berlin, as for that matter did its major literary figures, James Joyce and Samuel Beckett.[9] Dublin's ambitious social housing, designed by Herbert Sims between 1932 and 1948, was based on Dutch and British rather than German models. Busáras, the city's most ambitious postwar example of modern architecture, a product of Michael Scott's talent-laden office, was indebted above all to the example of Le Corbusier and his Brazilian followers.[10] The first instance of substantive German impact upon art and architecture came in the 1950s, with the interest that Irish architects had in modern German churches and the work that German sculptors, Imogen Stuart and Gerda Frömel, contributed to Irish churches during these years, but this was an aspect of German modernism that owed little to the Bauhaus.[11]

Nonetheless by the early 1960s, Bauhaus-inflected modernism contributed to the transformation of Irish art, architecture, and design. The buildings of Ronnie Tallon and Robin Walker, the establishment of the Kilkenny Design Workshops, and some of the art exhibited at ROSC were fundamentally indebted to the school's teachings and were all transformative for the visual arts in Ireland. This demonstrates that the school's enduring impact had much less to do with the presence of Bauhaus-trained émigrés, although pedagogical ties certainly played a role, and much more to do with what might be termed the "pull" factor, as a relatively small group within Ireland's intelligentsia exploited modernism's ability to promote the story they wanted to tell about their homeland beginning about four decades after it had gained independence from Britain, a period that coincided, not incidentally, with the first sustained economic boom it had experienced in its young history as a nation state.[12] A forward-looking segment of the Irish visual arts community turned to approaches associated with the school to assist them in demonstrating to themselves and to international audiences (especially Americans and continental Europeans, including fellow members of the European Economic Community, which Ireland joined in 1973) that they were no longer dependent on Britain. This although a number of prominent Bauhäusler were present in Britain in the 1930s and several settled there permanently, ensuring that Irish awareness of the school came through the neighboring island.[13] In this context, the Bauhaus was no longer a controversial avant-garde institution, but the source of forms and ideas whose appeal lay precisely in the fact that they were, while relatively new to Ireland, already widely accepted by both economic and political establishments abroad. And yet what has often been seen as a universal, abstract formal language proved useful to the reinterpretation of some of Ireland's most cherished local artistic traditions.

Architecture

During the middle decades of the twentieth century, Michael Scott was Ireland's most significant modern architect. Much like Gropius, whom he helped bring to Ireland to lecture, Scott relied heavily on talented collaborators. The Scott office included architects with ties both to the United States, where ambitious young Irish architects were increasingly going to study and practice, and to Germany. Kevin Roche, who worked briefly under Scott on Busáras, was not particularly comfortable at the Illinois Institute of Technology, where the architecture program was directed by Ludwig Mies van der Rohe, and quickly struck out to work for Eero Saarinen.[14] Winfried Cantwell, another member of the Busáras team, helped organize exhibitions of postwar German churches. But it was Scott's eventual partners, Ronnie Tallon and Robin Walker, who were responsible for adapting Mies' postwar vocabulary to articulate the Republic of Ireland's cultural ambition. The Chicago-based architect's curtain-walled pavilions and office towers, clearly framed in steel, provided a gridded sense of order that referred metaphorically to industry but achieved high cultural status through the quality of the proportions and the details. Walker studied and worked for Mies in Chicago, transferring his loyalty to the third and final director of the Bauhaus after having earlier worked for Le Corbusier in Paris; although he remained behind in Ireland, Tallon was if anything a more skilled interpreter of the German-American master.[15]

Tallon and Walker achieved the rank of partner in 1957, but it was only upon Scott's retirement in 1975 that the firm was renamed Scott Tallon Walker. Nonetheless, it was their contribution to what was then known as Michael Scott and Partners that first sent Irish architecture in what was certainly seen at the time as an American direction, even as it certainly was inflected with a strong German accent. Five commissions instigated during this period capture the scope of the practice and its relationship to Irish – or at least upper middle-class south Dublin's – changing sense of national identity. These are Walker's recently demolished Bord Fáilte headquarters (1961) facing Dublin's Grand Canal and his Restaurant building on the Belfield Campus of University College Dublin (1970), as well as Tallon's P. J. Carroll's factory in Dundalk (1969), and back in Dublin, his radio building (1971) for national broadcaster Raidió Teilifís Éireann (RTE) on the Montrose campus he also master-planned, and his Bank of Ireland building on Baggot Street (1978). Where Walker turned to concrete, Tallon preferred steel in his more literal and more perfectly proportioned riffs on some of Mies' most famous structures, including Crown Hall at the Illinois Institute of Technology (1956) and the Seagram Building on New York's Park Avenue (1958).

The Miesian modernism adopted by Tallon and Walker was, of course, not identical with what little Mies had realized during the three years, from 1930 to 1933, in which he had served as director of the Bauhaus in first Dessau and then Berlin. In the United States, to which he emigrated in 1938, Mies began after World War II to build on a much larger scale than anything he had realized in Germany. His architectural vocabulary changed, too, as he began to either expose the steel frame of his pavilions or, when this flouted the fire code, to imply that he was doing so by attaching I-beams to their exterior. This apparently pragmatic and anonymous, if in fact carefully detailed, approach to architecture proved to accord with the needs of both real estate developers and corporate clients, even if had a limited appeal to

private patrons for domestic commissions. Part of its cachet, however, certainly lay in its association with a sophisticated, imported aesthetic, which proved particularly attractive in a Cold War context for what were seen as its antiauthoritarian associations.[16] In Ireland, the same forms communicated a new ambition on the part of semi-state bodies as well as private capital to modernize in a way that integrated Ireland into international norms.

Although Richard Coleman, an architectural heritage consultant who testified in 2017 in favor of its demolition and replacement with a larger, more up-to-date and energy-efficient office block, declared: "It is very difficult to love this building," in 1961 Bord Fáilte's new headquarters made a bold statement about the way that Ireland wanted to present itself through the offices of its state-owned tourist board.[17] Walker's son Simon declared that the five-bay centrally planned structure "testifies to an appreciation of the Georgian vernacular, especially Walker's concern to build at low cost in the same spirit as the Georgian terrace."[18] Over time, the conversion of the American daylight factory prototype upon which the Dessau Bauhaus building was explicitly modeled into a new paradigm for the Dublin office block began to appear dowdy to many observers, but at a time when Ireland's economy was overwhelmingly agricultural rather than industrial, this was the opening gambit in engaging with a technological future that would by the end of the century see the country manufacturing computers and pharmaceuticals for major international corporations.

Paradoxically, when the firm built an actual factory, it looked more like a sleek office park than had this actual office block. The Carroll cigarette factory, now used by Dundalk Institute of Technology, was designed to showcase Irish light industry (Figure 6.1).[19] The ancestry of its curtain-wall facades can be traced from Mies' early projects for skyscrapers and office blocks through his erstwhile rival Gropius' Bauhaus building and Mies' own American pavilions. Mies' American oeuvre was greatly influenced as well by industrial structures such as the mining pithead for the Zeche Zollverein, which opened in Essen in 1932, but his single factory building, completed in Krefeld in 1937, dates to before he began exposing the steel framing of his pavilions or layering I-beams onto the facades of his towers.[20] His buildings for the Illinois Institute of Technology, like the Carroll factory, transpose their industrial sources into something far more elegant, just as Gropius had refined his own American industrial sources in his design of the Bauhaus' Dessau quarters. In Dundalk, the contrast between the grid of black steel and dark glass of this low-slung factory, and the shimmering Frömel sculpture set into its reflecting pool, announced the Carroll firm's commitment to building a landmark for its community and that a sophisticated marriage of architecture and the allied arts could be found well outside the national capital.

Around the world in the 1940s through the 1960s, the modern university campus represented one of the most optimistic statements about the future, regardless of the level of economic development or political progressiveness present on the ground. In Britain, as in much of the rest of Europe, university architecture in the 1960s was characterized by an enthusiasm for system-inspired planning, pulled into three dimensions by a reliance on either what was supposed to be standardized construction or on monumental plasticity sculpted in reinforced concrete.[21] These buildings were larger and often tougher than either the Bauhaus' original home in Weimar, designed before World War I by Belgian architect Henry van de Velde, or its iconic Dessau building.

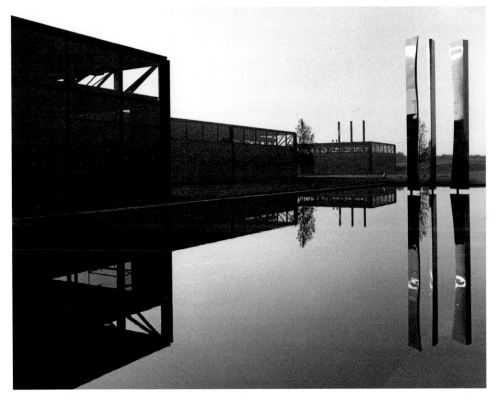

Figure 6.1 P. J. Carroll Factory, Michael Scott and Partners, Dundalk, 1969. John Donat/
 RIBA collections.

In Ireland, however, Andrzej Wejchert's contributions to University College Dublin's
new Belfield Campus and Paul Korelak's Berkeley Library at Trinity, opened in 1967,
were outliers in the degree to which they embodied these two divergent British posi-
tions. Walker's Restaurant Building in Belfield defined a middle ground between
these poles. Its bold exterior frame allowed, as in Mies' New National Gallery in
Berlin, for a largely undivided interior space, while the Japanese garden onto which
basement offices looked out added a subtle and nearly secret feature.[22] The citation
for the Royal Institute of the Architects of Gold Medal noted that "A fine proportion
has been achieved between the expression of the structural elements, contrasting with
the horizontal floors which appear to float on air."[23]

 More often, however, Irish state bodies and businesses, as the example of the
Carroll factory has already shown, preferred steel elegance, which was associated
with a clear preference for the United States, and to a lesser degree the European
continent, as a source of cultural influence. Nowhere was the association with domes-
tic cultural change stronger than in the introduction of Irish television broadcasting
in 1961. Tallon was responsible for the master plan for University College Dublin's
neighbor, the national broadcaster RTÉ's Montrose campus, which was laid out along
the lines of an American office park, although the more specific influence was cer-
tainly Mies' Crown Hall at Illinois Institute of Technology.[24] Although the television
studios were completed first to great acclaim, it was his jewel-box of a radio building

Figure 6.2 Radio Building, RTÉ, Michael Scott and Partners, Dublin, 1971. John Donat/ RIBA collections.

that set a serene tone, serving as an entrance pavilion to studios placed underground in the interest of better soundproofing (Figure 6.2). The small above-ground portion of the building, spoke, however, to the modesty of Irish broadcasting not long after Roche supervised the completion of the 38-story CBS (Columbia Broadcasting System) tower in New York after Saarinen's premature death.[25]

Overlapping with the design and construction of the Radio Building was the more ambitious bronze-clad Bank of Ireland cluster of office blocks on Baggot Street, the tallest of which rises to eight stories (Figure 6.3). Although not as prominent on the city's skyline as Liberty Hall, the high-rise headquarters of the Services, Industrial, Professional, and Technical Union (SIPTU) facing out over the Liffey, the bank headquarters certainly represented the highest level of aesthetic ambition in any Irish office block of its era. Here Tallon quoted the detailing Mies employed on the Seagram Building, just five blocks east of where the CBS building opened in 1965. The Irish architect worked carefully to slot the three blocks into the slightly irregular plot, creating a raised plaza between them. He also mixed manganese into the bronze, which accounts for the appropriately Irish green patina as it aged (it has recently been resurfaced and is once again a dull black). Recently renovated and re-branded as Miesian Plaza, the building now houses two government departments as well as the offices of private companies.

The Irish were not alone in Europe in turning to Miesian modernism; Copenhagen, Düsseldorf, and Milan were among the other European cities with ambitious high-rise

Figure 6.3 Front block, Bank of Ireland (now Miesian Plaza), Michael Scott and Partners, Completed 1978. John Donat/RIBA collections.

hotel and office blocks, many of them erected already in the 1950s, that would not have been out of place in an American downtown. These, however, were cities accustomed to being in the forefront of European architecture, a status to which Dublin had only rarely achieved since the great building boom of the eighteenth century.

Design

One of early postwar references to the Bauhaus in the *Irish Times* came in 1956, when painter Louis le Brocquy reviewed an exhibition of industrial design on view in Dublin. For le Brocquy, the Bauhaus was "a small, but highly organized and significant, rebellion" that "conceived and taught a new revitalization of form at all levels of utility and consciousness." It would be nearly another decade, however, before "the sensuous unity" le Brocquy called for would be established in Ireland, "and art reasserted its sensible, inherent power within the varied structures of easel painting or chair, textile or building."[26]

If much of the most impressive Irish architecture of the 1960s and early 1970s channeled the Bauhaus indirectly through the medium of Mies, the government-sponsored design program did so by way of a detour through Scandinavia. Established in 1963 and opened two years later in the stable blocks of Kilkenny Castle, the Kilkenny Design Workshops were another indication of Ireland's increasingly outward-looking approach to the intersection between economic development and the visual arts.[27] The Workshops initiative built upon the impact that Dutch graphic

designers, some of them trained in the Bauhaus tradition, had already had in Ireland during the 1950s, especially in their contributions to the branding of Aer Lingus.[28]

As the general manager of Córas Tráchtála, the Irish Export Board, William H. Walsh, commissioned a report by a team of Scandinavian designers that resulted in an unprecedented government initiative to foster Irish craft with a sharp eye, much like the German Werkbund, an important predecessor to the Bauhaus had also had, on the export market.[29] The five man team, which included members from Denmark, Finland, and Sweden, were asked to focus on industrial design, but in the early years the workshops ended up promoting craft above all. The team's report noted that:

> A remarkable feature of Irish life … is the manner in which today's Irish culture has developed a distinct leaning towards literature, theatre, the spoken word and abstract thinking, rather than creation by hand or machine and the visual arts.[30]

If they had added music to the list, their words would certainly have rung true for the rest of the twentieth century, at the least. In a sharp break with the Bauhaus, they believed that progress must be built upon respect for the past, and thus identified "rural handicraft, the Georgian tradition and the early Christian culture," as the appropriate foundation for Irish industrial design.[31]

Despite these rhetorical gestures, in practice Kilkenny Design Workshops (KDW), located in the small cathedral city after a bid to have Mies design a new School of Architecture and Design in Dublin failed, had an outsize impact well beyond their closure in 1988 in bringing Irish design into an orbit defined as much by the Werkbund, the Bauhaus, and the Hochschule für Gestaltung, a Bauhaus offshoot in Ulm, Germany, that opened in 1953 and closed in 1968, as by anything imported from Scandinavia.[32] Although the rhetoric surrounding the KDW was often more pragmatic than artistic, the end results tied Ireland into contemporary European design culture. They also opened up international markets, including in the United States, as well as on the continent.[33]

The workshops were accompanied by a shop, of which a larger branch would soon open in Dublin, which sold many of the goods made on site. Training Irish consumers was almost as important as developing a new generation of skilled artisans, the initial focus of the workshops. The revival of silversmithing, which built upon the renown of eighteenth-century Irish-made silver, was an example of KDW's concern with contemporary craft. The influence of Bauhaus student Marianne Brandt is clear in the teapot, one of the design workshop's early products, which was crafted in 1965 by the Finnish silversmith Bertil Gardberg (Figure 6.4).

Arguably even more consequential, however, were the eventual collaborations with industry. One of the first was the commission in 1970 to design a large variety of housewares for the German firm Württemburgische Metalwarenfabrik (WMF), most of which were then manufactured in Ireland, significantly improving the international reach of Irish firms as well as their technological prowess. It is the case of Telectron, however, that illustrates the degree to which KDW helped lay the foundations for Ireland's later success, especially in the manufacture of computers for Apple and Dell and of the development of software development as a linchpin of the twenty-first-century Irish economy. Telectron was an Irish manufacturer of telecommunications equipment.[34] In a branding exercise that recalled Peter Behrens' work for the Allgemeine Elektricitäts-Gesellschaft (AEG), between 1974 and 1978 KDW

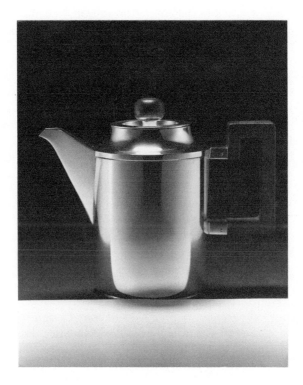

Figure 6.4 Teapot, Bertil Gardberg for Kilkenny Design Workshops, 1965. Image copyright
 Clive Barda. Photograph: Collection National Irish Visual Arts Library (NIVAL),
 NCAD, Dublin.

assisted Telectron's engineers in designing the casing for its equipment as well as a
new graphic design identity (Figure 6.5). Other examples of graphic design drew upon
indigenous motifs, such the use of Gaelic lettering in the logo for Telecom Éireann.[35]

These were exactly the kinds of collaborations with local industry that Henry van
de Velde had achieved at the Grand Ducal School of Arts and Crafts in Weimar, the
predecessor to the Bauhaus, and that Gropius had argued would support the Bauhaus,
although in fact they made a significant contribution to the school's bottom line only
in the brief period between 1928 and 1930 when Hannes Meyer was its director. In
Ireland, the impact was more enduring. In Germany, design had been layered on top
of a modern manufacturing base. In Ireland, however, modern design was integral to
the process through which at least some Irish manufacturers were able to shift from
producing for only a local market to operating competitively on a European scale.
Equally importantly, these innovations paved the way for the entrance of interna-
tional companies to open factories in Ireland. If in architecture the Bauhaus legacy
tied Irish visual culture to the United States, here, although many of those interna-
tional firms would be American, the vibe was more continental. In many ways, KDW
set the stage for Ireland's successful integration in 1973 into the European Economic
Union, the predecessor of the current European Union. It also served as a model for
the export of Irish design expertise to the Global South, where it served as a model of
government-assisted efforts.[36]

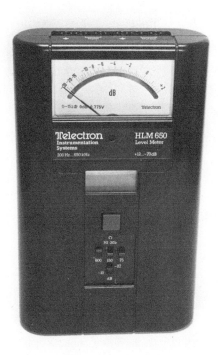

Figure 6.5 Telectron HLM Level Meter. Kilkenny Design Workshops, 1980. Collection, National Irish Visual Arts Library (NIVAL), NCAD, Dublin.

Painting and Sculpture

The ROSC art exhibitions in Dublin, which began in 1967 and took place roughly every four years through 1988, emerged out of a circle closely tied to the importation of Miesian architecture to Ireland.[37] Michael Scott chaired the executive committee for the 1967 exhibition; Robin Walker's wife Dorothy, an art critic who was Ireland's leading champion of abstract art, was also a member of the group. The intention was to make up for the absence of a national museum of modern art. The Hugh Lane, Dublin's Municipal Gallery, was not seen as fulfilling that role, although it had recently hosted an important display of contemporary American art from the Herbert F. Johnson collection.[38] Introducing Irish audiences to cutting-edge art from abroad, something that had only happened before in the early years of what became the Hugh Lane, was another important step in integrating Irish visual culture into broader European and American currents.

The first ROSC exhibition was accompanied by the display of the art of early Christian Ireland, although this was confined in the end to the National Museum and not, as originally planned, included within the installation by Patrick Scott of modern art in the halls of the Royal Dublin Society (Figure 6.6). This juxtaposition implied a link between the stylization of Ireland's most cherished artistic heritage and contemporary abstraction. The 52 artists whose work was exhibited notoriously did not include any representation from Ireland, unless one counts Irish-born Francis

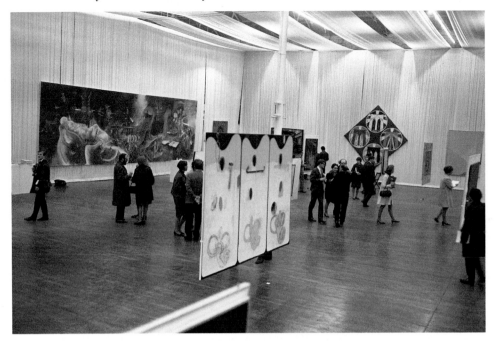

Figure 6.6 Press preview of ROSC 1967 exhibition at the Royal Dublin Society. © SKP & Associates Ltd trading as Lensmen & Associates, Lensmen Photographic Agency and Lensmen Photographic Archive. Courtesy of Irish Photo Archive.

Bacon. Expressionism, whether American Abstract Expressionism, or Tachisme and the CoBrA group from the continent dominated. They were chosen by a trio of international experts. These included Irish–American James Johnson McSweeney, then the director of the Museum of Fine Arts in Houston, and previously in charge of first the department of painting and sculpture at the Museum of Modern Art in New York before being appointed director of the Guggenheim, where he oversaw the construction of Frank Lloyd Wright's building. Europe was represented by Jean Leymaire, a professor at the University of Geneva, and William Sandberg, the director of the Stedelijk Museum in Amsterdam, although he was identified in the ROSC program as the chair of the Israel Museum in Jerusalem.

Although many of the original faculty at the Bauhaus were painters, the school's major contributions are generally rightly seen as having been in design and architecture. The painters, most of whom were associated with Expressionism, made their major contribution as teachers instructing their students in the principles of abstraction as well as providing a precedent for making a bold break with established ways of working. One of the most promising of the original students, Josef Albers, began in 1925 to assist László Moholy-Nagy in teaching the celebrated preliminary course, which he ran on his own following Moholy-Nagy's departure from the school in 1928.[39] Albers was the only Bauhäusler to exhibit at ROSC. Already in 1968, Irish critic Brian Fallon described him and another Bauhaus alumnus, Max Bill, as "genuine innovators in the field of color," adding that "with his subtle variations of luminosity, [he] distils a kind of softly pulsating radiance full of intellectual serenity."[40] His work was included in 1971, the year after his *Homage to the Square – Aglow*, was

acquired by the Hugh Lane.[41] The impact of his teaching in the United States, first at Black Mountain College and then at Yale, could be discerned, however, in the work of a new generation of American artists who, although in no way formally associated with the Bauhaus, nonetheless benefited enormously from the new pedagogical principles developed there. Black Mountain students who had studied with Albers in the first two ROSC exhibitions included Kenneth Noland and Robert Rauschenberg; work by his Yale colleagues Al Held, Lester Johnson, Richard Lindner, and Mark Tobey was also on view. Albers' influence as a teacher reemerged at ROSC exhibitions in the 1980s when the work of Yale students, including Jonathan Borofsky, Robert Mangold, Brice Marden, and Richard Serra, was featured. The Bauhaus' lingering influence in Europe could also be viewed at the early ROSC exhibitions. Danish painter Asger Jorn, one of the most important European artists whose work was displayed in 1967, belonged to the short-lived Imaginist Bauhaus circle, which in the 1950s attempted to build upon the radical school's legacy.[42] These connections were not much noticed at the time or remarked upon since, but the impact of ROSC upon subsequent generations of Irish artists cannot be easily detached from the impact of approaches to the teaching of art pioneered at the legendary German art school.

While the initial exhibition consisted largely of abstract works, later ROSC exhibitions introduced Irish audiences numbering well into the tens of thousands to minimalism, pop, and conceptual art. This occurred at a time when relatively few people from Ireland were traveling frequently to see the latest gallery shows in New York and the major centers of contemporary European art, although a handful of Irish expatriates, such as Brian O'Doherty (Patrick Ireland), and Sean Scully, became influential figures in New York, while still maintaining their ties to Ireland. Even fewer in Ireland chose, or indeed could afford, to collect such art, which remains only sparsely represented in Irish museums.

Although the tie to the Bauhaus might at first seem tenuous, the ROSC exhibitions largely featured artists who either shared the school's commitment to abstraction or had, at the least, been at least partially educated in ways that were strongly influenced by its creation of a pedagogical alternative to academic training rooted in drawing from the nude or the plaster cast. Even more important for Ireland was undoubtedly the precedent the school set for an international artistic culture that spanned from the United States across Europe to Japan. Whether modernism's aspiration to universalism was appropriate or achievable, the Bauhaus' complete rejection of nationalism belatedly offered a path forward out of provincialism for a small country like Ireland that had, before the 1960s, not yet aspired to understand, much less be embrace artistic modernism in the visual arts. As Philippa Garner wrote in a 1978 letter to the editor to the *Irish Times* defending abstract art (although she herself was a figurative painter), "Irishness is the quality of time and place. Internationalism is often the lack of both, especially place ... However, to be truly international is good as it is a shared experience which transcends time and place."[43]

Growing Awareness

Between the opening of the first ROSC exhibition in 1967 and the mounting of the Bauhaus exhibition in Dublin in 1979, references to the school became a regular occurrence in the *Irish Times*. A tepid review of the first ROSC exhibition, for instance, dismissed much of the art on view as derivative, in the case of Op-Art of the

Bauhaus.[44] The problem, however, was with Op-Art rather than its putative source. Already in 1968, John FitzMaurice Mills, wrote of a Bauhaus exhibition that visiting it at the Royal Academy in London "for specialists and students of the 20-century aesthetic scene ... will be an act of imperative pilgrimage." He added that "the fruitage of the Gropius ideals can be seen in a great majority of the things we use, we enjoy, we live in."[45] The paper's extensive coverage of this show makes clear the school's increasing relevance to its readers.[46] The following year, in a demonstration of which awareness of it was percolating into other fields, Diarmaid O Suilleabhain called for "an Irish language Bauhaus ... theatre."[47]

Interest in the school was also manifested as well in small exhibitions, such as the one devoted to Walter Gropius on which the local Goethe Institute collaborated in 1974 with Córas Tráchtála, a semi-state body established to boost the sale of Irish manufactures. Part of a series of exhibitions "through which the export board has sought to raise the standards of Irish industrial design," it was launched with a lecture by architect's widow Ise. Reporter Michael Viney, apprehensively noted the similarity between Gropiusstadt, a recent high-rise housing development in Berlin, and the housing in the Dublin suburb of Ballymun, as "uneasy shadows," while also commenting upon the influence of Mies upon the campus of RTÉ and the Bank of Ireland building on Baggot Street.[48] In a follow-up, a young Ruari Quinn, later an influential Labor Party politician, wrote that it opened "at a time when art education and particularly design in Ireland are still in a state of limbo. Decisions, based upon the recommendations of various reports, are now required from the Government."[49]

By the time the Bauhaus exhibit arrived in Trinity College's new Douglas Hyde Gallery in 1979, it was a sign of Ireland's growing self-confidence in the visual arts. Even when modernism was beginning to be being called into question, Irish commentators realized the cosmopolitanism that being familiar with the school conveyed. Writing on the eve of the exhibit's opening, Liam Kelly, a lecturer at the National College of Art and Design, defended Gropius, noting that the Bauhaus' first director "sought, then, to achieve his social aims principally through the industrial process and standardization, recognizing that industrial method was now an essential feature in twentieth century life and that the craft tradition which wished the machine would go away was being simply unrealistic and retrogressive."[50]

The opening did not, however, pass off without incident, as students used it as an opportunity to attempt to pelt tomatoes at Jim Tunney, the Minister of State for Education. They missed their target but ensured that their opposition to plans to hike university fees by a quarter made the news.[51] Lectures by Peter Hahn, of the Bauhaus Archive in Berlin, and Dennis Sharp, of the Architectural Association in London, apparently passed off more smoothly; there was also a related program of concerts, although not all the audience stayed for the completion of a staging of Oscar Schlemmer's Triadic Ballet.[52]

The focus on Gropius in the *Irish Times*' reception of the Bauhaus from the 1930s to the 1970s conflicts with the present-day scholarly understanding of the Bauhaus' importance as having been constituted by the collective – faculty, students, and their off-campus champions – but does not diminish the usefulness of the school he founded to a growing Irish ability to use the visual arts to communicate an outward facing engagement with the new. An awareness and appreciation of the school was one of the many avenues that signaled the country's ambition to become a modern, industrialized country with a standard of living that included access to both technology and

consumer goods clearly in keeping with such aspirations. Bauhaus-inflected archi-
tecture, design, and art never dominated any aspect of the Irish visual arts, but they
were an important component of the country's emergence from out from its colonial
relationship with Britain.

Notes

1. Marion von Osten and Grant Watson, eds., *Bauhaus Imaginista* (London: Thames and
 Hudson, 2019); and Ines Weizman, ed., *Dust and Data: Traces of the Bauhaus Across
 100 Years* (Leipzig: Spector Books, 2019).
2. See, for instance, Walter Gropius, *Apollo in the Democracy: The Cultural Obligation of
 the Architect* (New York: McGraw-Hill, 1968).
3. Advertisement in the *Irish Times*, July 20, 1967.
4. There is very little published on Steyn. For a basic biography, see https://www.
 adams.ie/irish-artist-directory/stella-styne-art-sold-at-auction. See also Alicia Foster,
 "Stella Steyn: The Irish Artist who went to the Bauhaus," *ArtUK*, October 26, 2020,
 https://artuk.org/discover/stories/stella-steyn-the-irish-artist-who-went-beyond-the-
 bauhaus
5. Sean Rothery, *Ireland & The New Architecture, 1900–1940* (Dublin: Lilliput Press,
 1991) 127–28, 208.
6. "Architecture and Design, The International Trend, Professor Gropius' Views," *Irish
 Times*, November 11, 1936.
7. "Little Patriotism in Irish Public's Purchases," *Irish Times*, March 8, 1967.
8. Sorcha O'Brien, "Technology and Modernity: The Shannon Scheme and Visions of
 National Progress," in Linda King and Elaine Sisson, *Ireland, Design and Visual Cul-
 ture: Negotiating Modernity, 1922–1992* (Cork: Cork University Press, 2011) 59–71;
 and Gareth Doherty, "Power: *Art You Getting the Light?* Ardnacrusha, the Rural
 Electrification Scheme and Illuminating Ireland's Periphery," in *Infrastructure and the
 Architecture of Modernity in Ireland*, Gary Boyd and John McLaughlin, eds. (London:
 Routledge, 2015) 29–44.
9. Enrique Juncosa and Christine Kennedy, eds., *The Moderns* (Dublin: Irish Museum of
 Modern Art, 2011). See also Paul Larmour, *Free State Architecture* (Dublin: Gandon
 Editions, 2009); Séan Kissane and Anne Boddaert, *Analysing Cubism* (Cork: Crawford
 Art Gallery, 2013); and Jennifer Goff, *Eileen Gray: Her Work and Her World* (Dublin:
 Irish Academic Press, 2015).
10. Sarah A. Lappin and Una Walker, "Bus Transportation – *Cáras Iompair Éireann*
 and Michael Scott," in Boyd and McLaughlin, *Infrastructure and the Architecture of
 Modernity in Ireland*, 65–85; Ellen Rowley, *Housing, Architecture and the Edge Condi-
 tion: Dublin is building, 1935–1975* (London: Routledge, 2018); and Ellen Rowley, ed.,
 *More than Concrete Blocks: Dublin's Twentieth-century Buildings and their Stories,
 1940–72* (Dublin: Dublin City Council, 2019).
11. Carole Pollard, "A Lifelong Affair – Liam McCormick and Imogen Stuart," in *Mod-
 ern Religious Architecture in Germany, Ireland, and Beyond: Influence, Process and
 Afterlife since 1945*, Lisa Godson and Kathleen James-Chakraborty, eds. (New York:
 Bloomsbury Visual Arts, 2019) 41–61; and Paula Murphy, "Gerda Frömel," in *Sculp-
 ture: Art and Architecture of Ireland*, Paula Murphy, ed. (New Haven: Yale University
 Press, 2014) 126–29. For a more general account of modern Irish design, see Linda King,
 "'Particles of Meaning': The Modernist Afterlife in Irish Design," in *Modernist After-
 lives in Irish Literature and Culture*, Paige Reynolds, ed. (London: Anthem Press, 2016)
 125–40.
12. Mary E. Daly, *Sixties Ireland: Reshaping the economy, state and society, 1957–1973*
 (Cambridge: Cambridge University Press, 2016).
13. Alan Powers, *Bauhaus Goes West: Modern Art and Design in Britain and America*
 (London: Thames & Hudson, 2019).
14. Eeva-Liisa Pelkonen, ed., *Kevin Roche: Architect as Environment* (New Haven: Yale
 University Press, 2011).

15. Ellen Rowley, "From Dublin to Chicago and Back Again: An Exploration of the Influence of Americanised Modernism on the Culture of Dublin's Architecture, 1945–1975," in King and Sisson, *Ireland, Design and Visual Culture*, 210–31.

16. The literature on Mies is large. This interpretation is particularly indebted to Paul Betts, "The Bauhaus as Cold War Legend: West German Modernism Revisited," *German Politics and Society* 14 (1996): 75–100; Alice Friedman, *Women and the Making of the Modern House: A Social and Architectural History* (Harry N. Abrams, 1998) 126–57; Phyllis Lambert, ed., *Mies in America* (New York: Harry N. Abrams, 2001); and Franz Schulze and Edward Windhorst, *Mies van der Rohe: A Critical Biography* (Chicago: University of Chicago Press, 2012).

17. Olivia Kelly, "Plan to demolish Bord Fáilte Building subject of Bord Pléana hearing," *Irish Times*, 1 November 2017. See also Frank McDonald, "Architype or eyesore: Plans to demolish Bord Fáilte HQ meet with mixed response," *Irish Times*, September 19, 2017.

18. Simon Walker, "Bord Fáilte building is a Dublin welcome to mid-century modernity," *Irish Times*, February 18, 2015.

19. Murray Fraser with Joe Kerr, *Architecture and the 'Special Relationship': The American Influence on Post-War British Architecture* (London: Routledge, 2007) 26.

20. Walter Buschmann, "Zeche Zollverein in Essen," *Rheinische Kunststätten* 219 (1987): 9; Lucy M. Maulsby, "Verseidag Administration Building Project," Terrence Riley and Barry Bergdoll, eds., *Mies in Berlin* (New York: Museum of Modern Art, 2001) 300–03.

21. Stefan Muthesius, *The Post-War University: Utopianist Campus and College* (New Haven: Yale University Press, 2000). See also Elaine Harwood, *Space, Hope, and Brutalism: English Architecture, 1945–1975* (New Haven: Yale University Press, 2014).

22. Finola O'Kane and Ellen Rowley, eds., *Making Belfield: Space + Place at UCD* (Dublin: University College Dublin Press, 2020) 186–91.

23. https://www.irisharchitectureawards.ie/gold-medal/winner/restaurant-building-ucd, consulted August 3, 2019.

24. Kevin Donovan, "Media America at Home – the RTÉ Television Center," in Boyd and McLaughlin, *Infrastructure and the Architecture of Modernity in Ireland*, 87–100; and Merlo Kelly, "RTÉ Campus, Montrose, Donnybrook, Dublin 4," in Rowley, *More than Concrete Blocks, 1940-1972*, 260–71. See also Louise Mozingo, *Pastoral Capitalism: A Study of American Suburban Corporate Landscapes* (Cambridge: MIT Press, 2011).

25. Tony Reddy, "Kevin Roche John Dinkeloo and Associates," *Architecture Ireland* 302 (2018): 45.

26. Louis le Brocquy, "Art and Manufacture," *Irish Times*, April 5, 1956.

27. Nick Marchant and Jeremy Addas, *Kilkenny Design: Twenty-One Years of Design in Ireland* (London: Lund Humphries, 1984); Ruth Thorpe, ed., *Designing Ireland: A Retrospective Exhibition of Kilkenny Design Workshops 1963–1988* (Kilkenny: Crafts Council of Ireland, 2005); and John Turpin, "The Irish Design Reform Movement of the 1960s," *Design Issues* 3 (1986): 3–21.

28. Linda King, "(De)constructing the Tourist Gaze: Dutch Influences and Aer Lingus Tourism Posters, 1950–1960," in King and Sisson, *Ireland, Design and Visual Culture*, 166–87.

29. Kaj Franck, Erik Herlow, Ake Huldt, Gunnar Billmann Petersen, Erich Chr. Sorensen, "Design in Ireland: Report of the Scandinavian Design Group in Ireland, April 1961," [report], Córas Tráchtála/The Irish Export Board, 1961–04, EdepositIreland, http://hdl.handle.net/2262/77735. See also Joanna Quinn, "The Scandinavian Group and the Design in Ireland Report," in Thorpe, *Designing Ireland*, 4–9; for the German context Frederic J. Schwartz, *The Werkbund: Design Theory and Mass Culture before the First World War* (New Haven: Yale University Press, 1996); and John Maciuika, *Before the Bauhaus: Architecture, Politics and the German State, 1890–1920* (Cambridge: Cambridge University Press, 2005).

30. Franck, Herlow, Huldt et al., "Design in Ireland," 1.

31. Ibid, 6.

32. Paul Hogan, "Introduction," in Thorpe, *Designing Ireland*, 2, for the innovativeness of the effort as well as the invitation to Mies.

33. Only in the area of marketing to the United States did tradition appear to play a significant role. See Anna Moran, "Tradition in the Service of Modernity: Kilkenny Design Workshops and Selling Irish Design at American Department Store Promotions, 1967–1976, in King and Sisson, *Ireland, Design and Visual Culture*, 190–207.

34. For Ireland's role in a later chapter of this industry through the provision of cloud computing, see John McLaughlin, "Data Clouds and Precipitation," in Boyd and McLaughlin, *Infrastructure and the Architecture of Modernity in Ireland*, 185–99.

35. These case studies are illustrated and/or discussed in Marchant and Addas, *Kilkenny Design*, 22–23, 39–41, 52–53, 99–101, 182–83.

36. Joanna Quinn, "The Story of Kilkenny Design Workshops," in Thorpe, *Designing Ireland*, 21.

37. Peter Shortt, *The Poetry of Vision: The ROSC Art Exhibitions*, 1967–1988 (Dublin: Irish Academic Press, 2018). See also Róisín Kennedy, *Art & The Nation State: The Reception of Modern Art in Ireland* (Liverpool: Liverpool University Press, 2021).

38. Kennedy, *Art and the Nation State*, 168–69.

39. Charles Darwent, *Joseph Albers: Life and Work* (London: Thames and Hudson, 2018).

40. Brian Fallon, "French Posters Make a Rich Exhibition," *Irish Times*, May 14, 1968. Just over a month later, Fallon found a second opportunity to praise Albers while reviewing an exhibition of the work of Michael Byrne. Here Fallon described Albers' Homage to the Square series as "a highly refined, abstract, almost mystical art," adding that "Its purism and self-denial are positive virtues." Brian Fallon, "Painterly painting," *Irish Times* June 22, 1968. See also Brian Fallon, "Op Art at the Hendriks Gallery," *Irish Times*, May 1, 1969, and Brian Fallon, "A Better Show than Last Time?" *Irish Times*, October 25, 1971.

41. http://emuseum.pointblank.ie/online_catalogue/work-detail.php?objectid=1

42. Ruth Baumeister, "Asger Jorn's Bauhaus Politics," in Joowon Park, ed., *Alternative Langauges: Asger Jorn, the Artist as a Social Activist* (Seoul: Museum of Modern and Contemporary Art, 2019) 160–71.

43. Philippa Garner, "Letter to the Editor," *Irish Times*, September 1, 1978.

44. "A hawk's eye view of the world's gallery," *Irish Times*, November 13, 1967.

45. John FitzMaurice Mills, "Art Forum," *Irish Times*, September 16, 1968.

46. In addition to Mills, "The Dream of Gropius," September 24, 1968, see Raymond McGrath, "The New Architecture and the Bauhaus," *Irish Times*, January 2 and 3, 1969.

47. "Irish Language Theatre Called for," *Irish Times*, February 7.

48. Michael Viney, "Gropius Offers Lessons for Irish Designers," *Irish Times*, October 8, 1974.

49. Ruari Quinn, "Father of the Bauhaus," *Irish Times*, October 10, 1974.

50. Liam Kelly, "The Bauhaus Legacy," *Irish Times*, March 6, 1979.

51. Christina Murphy, "Tomatoes Aimed at Tunney by Students in TCD," *Irish Times*, March 7, 1979.

52. Advertisements, *Irish Times*, March 7 and 15, 1979; Kane Archer, "Triadic Ballet in Burke Hall," *Irish Times*, March 27, 1979.

7 Space Time and the Bauhaus

Dietrich Neumann

In 1941, Swiss architectural historian Sigfried Giedion published his canonical *Space, Time and Architecture*, one of the best-selling and most influential books on the Modern Movement. It went through 5 different editions and about 20 printings and was translated into all major languages. Based on his Charles Eliot Norton lectures at Harvard in 1938, the book's argument unfolded with the help of carefully juxtaposed images, laid out with the assistance of former Bauhaus master Herbert Bayer.[1] Its climax and centerpiece is the juxtaposition of Pablo Picasso's cubist painting *L'Arlésienne* (1911–12) and the Dessau Bauhaus building by Walter Gropius of 1926 – the only instance of two full-page photos facing each other (Figure 7.1).[2] "The Bauhaus," Giedion claimed, "was the only large building of its date which was so complete a crystallization of the new space conception."[3]

Before diving deeper into this claim and Giedion's comparison, it is important to acknowledge the authorship of the uncredited photo on the right. It shows the new Bauhaus building upon completion on a wet day in January 1927, the street not yet paved, the ground a muddy mess, and Gropius' Adler limousine seemingly stuck right in the middle. It was taken by Lucia Moholy, then the wife of Hungarian Bauhaus teacher László Moholy-Nagy (Figure 7.2). The couple had married in 1921 and moved to Weimar when Moholy-Nagy became a teacher at the Bauhaus there. Moholy apprenticed in Otto Eckner's photography studio, and, in 1925 and 1926, studied photography at the Leipzig Academy for Graphic and Book Arts, commuting there first from Weimar and then from Dessau, as the Bauhaus (which did not yet have a photography department) moved. She took about 500 photos of the Bauhaus, the Masters' Houses, the school's products, and teachers. She developed and enlarged many of them in her own darkroom in one of the Masters' Houses in Dessau. The couple left Dessau with Gropius in 1928, settled in Berlin and separated a year later. Moholy was Jewish and fled Germany in 1933 in great haste. Gropius ended up with her glass negatives, taking them along when he immigrated to the United States in 1938 and using them extensively afterward, in particular in his 1938 Bauhaus exhibition at the Museum of Modern Art in New York and in publications he supported, such as Giedion's *Space Time and Architecture*. While Gropius had initially acknowledged her authorship in his book on the Bauhaus Buildings of 1930, as soon as she was out of sight, he not only ceased to credit her, but also kept the fact that he was in possession of her negatives from her for 22 years.[4] Even after he admitted this in 1954, he returned them only after she finally sued, in 1961. Moholy promptly donated the negatives to the Bauhaus Archiv in Berlin.[5]

DOI: 10.4324/9781003268314-8

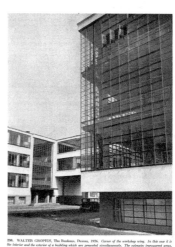

Figure 7.1 Left: *L'Arlésienne*, Pablo Picasso, 1911–12; right: Bauhaus, Walter Gropius, Dessau, 1926; page spread from Sigfried Giedion, *Space Time and Architecture* (Cambridge: Harvard University Press, 1941): 402–03.

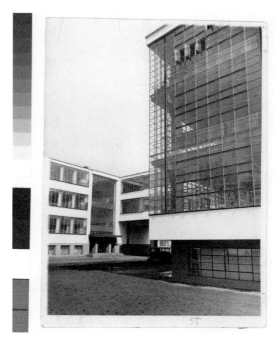

Figure 7.2 The Bauhaus, northwest corner of the workshop wing, photograph by Lucia Moholy, gelatin silver print with applied color, Bauhaus Archiv, Berlin, 1927. © 2021, Artists Rights Society (ARS), New York, VG Bild-Kunst, Bonn.

But back to our image pair. Giedion had studied with Swiss art historian Heinrich Wölfflin (more about whom below), and this pairing was a very Wölfflinian move. Wölfflin had invented dual slide projection for his lectures in 1895, and it remained a common tool in art history lectures until the arrival of PowerPoint just over a century later.

What made the two images comparable in Giedion's eyes is explained in the accompanying texts. For "L'Arlésienne," he quoted Alfred H. Barr Jr., the director of the Museum of Modern Art (Figure 7.3). Writing in the catalog for its recent Picasso exhibition of 1939/40, Barr declared, "In the head may be seen the cubist device of simultaneity – showing two aspects of a single object at the same time, in this case the profile and the full face. The transparency of overlapping planes is also characteristic."[6] Giedion's caption for the Bauhaus building on the right stated, "In this case it is the interior and the exterior of a building which are presented simultaneously. The extensive transparent areas, by dematerializing the corners, permit the hovering relations of planes the kind of 'overlapping' which appears in contemporary painting." In addition, the transparency of the corner allowed us to see parts of the building behind it, which we would normally only have encountered after turning that corner. At first sight, this might seem like a plausible argument.

Giedion's *magnum opus* of 1941 is fascinating in many ways; it offers insightful, often original chapters on, for example, Baroque Architecture, iron construction and world's fairs, Haussmann's Paris, and the origins of reinforced concrete, all interlaced

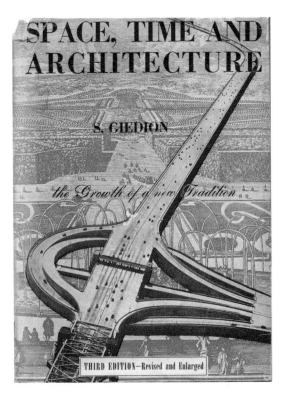

Figure 7.3 Dust jacket, *Space, Time, and Architecture*, Herbert Bayer, collection of Cooper Hewitt, Smithsonian. © 2021, Artists Rights Society (ARS), New York, VG Bild-Kunst, Bonn.

with observations on the history of technology in addition to many surprising juxta-positions. The book also engages much of the new vocabulary and ways of looking at buildings that had enriched the architectural discourse in recent decades. These included, for instance, the notion that an observer had to move through and around certain buildings to fully understand them, which came hand in hand with assump-tions about the design process, suggesting that walls or ceiling vaults had been moved into place or were depicting movement in some way, resulting in spaces that penetrated each other. Giedion also adopted concepts informed by other fields, in particular physics, when he used terms such as "simultaneity," "fourth dimension," and "space-time." As clear and perceptive as he could be in his straight telling of his-torical developments, he could get confused and muddled when engaging with such terms. In fact, the grand claim behind the book's title, that a new space-time concept was the "true, if hidden, unity, a secret synthesis in our present civilization," and particularly applicable to architecture, is its least convincing element.[7]

The Bauhaus building can serve as a perfect tool to untangle some of the refer-ences in Giedion's arguments. The comparison with the painting lifted Gropius up to the level of the era's most prominent living artist, the "fecund and versatile genius" Picasso, and suggested a *Zeitgeist* that connected the painting and the building across media and a fourteen-year time gap.[8] Earlier in the book, Giedion had explained that, just at the moment when the cubists explored objects "... from several points of view," Albert Einstein began his "famous work *Elektrodynamik bewegter Körper*, with a carful definition of simultaneity."[9] Einstein had actually pointed out the exact opposite, namely that simultaneity was never absolute, but dependent on the frame of reference of the observer. This, ironically, also applied to Giedion's perceived sim-ultaneity of the activities of the Cubists and Einstein's writings, which, as Lynda Dalrymple Henderson has pointed out, reached the public with such delay that it is "most unlikely that the Cubists of 1911 and 1912 would have known anything at all of the new theories."[10] While the Cubists shared an interest in the much discussed "fourth dimension," this referred to something quite different from its later use, when it meant time. Their use was "an outgrowth of nineteenth-century n-dimensional geometry" and assumed the existence of a fourth spatial, Euclidean dimension, imperceptible to viewers who lived in three dimensions, just as the inhabitants of *Flatland* in Edwin Abbott Abbott's 1884 eponymous novel are unable to comprehend the third dimension.[11] The notion of time did enter the cubist discourse independently when artists and critics such as Jean Metzinger and Albert Gleizes, whose book on Cubism was in a way its founding manifesto, pointed out that it took time to move around an object to reach different viewpoints.[12]

Giedion's interpretation of the Bauhaus building in *Space, Time and Architecture* assumed a similar stance. While first emphasizing its "simultaneity," he also declared (somewhat contradictorily) that, "The eye cannot sum up this complex at one view: it is necessary to go around it on all sides."[13] How central this argument was to his book becomes clear on its dust jacket where Herbert Bayer's design showed the Randall's Island highway interchange above an image of the gardens of Versailles (Figure 7.3). This intersection, a part of the Triboro Bridge sequence connecting the Bronx with Queens and Manhattan, had been initiated by Robert Moses and opened in 1936. As Giedion explained, the cloverleaf was a "modern sculpture," and "expressive of the space-time conception both in structure and handling of movement." The "meaning and beauty of the parkway," Giedion observed, "cannot be grasped from a single

point of observation ... It can be revealed only by movement, by going along in a steady flow ... The space-time feeling of our period can seldom be felt so keenly as when driving ..."[14] In 1910, German architect Peter Behrens had already pointed to changing modes of perception and their potential influence on architectural design stating, "When we race through the streets of our metropolis in a super-fast vehicle, we can no longer recognize the details of the buildings. [...] Such a way of looking at the world, which has become a constant habit, needs an architecture with forms as coherent and calm as possible."[15]

The association of spatial experience with movement had also been made by a number of art historians in the late-nineteenth century. Wölfflin, for instance, had notably identified the key difference between the static Renaissance and the vibrant Baroque as the difference between "linear and voluminous," "flat and spatial," and "calm and moving." For him, Italian Baroque architecture suggested "the impression of continuous movement" and "spatial infinity."[16] Similarly, Giedion in *Space, Time and Architecture* compared the static Renaissance with the movement inherent in Baroque architecture. At San Carlo alle Quattro Fontane in Rome, the "undulating wall of Borromini's invention gave flexibility to stone, changed the stone wall into an elastic material. The undulating wall is the natural accompaniment to the flowing spaces of the flexible ground plan."[17] In Balthasar Neumann's pilgrimage church Vierzehnheiligen, the "necessity of passing on from each subdivision to the other parts of the scheme that includes it produces the final impression that the whole interior is in motion."[18] Wölfflin's rival August Schmarsow pointed to the "kinesthetic implications" of our spatial experience in other works, analyzing the relationship between the viewer's movement and the experience of architecture, and he laid out his revolutionary new theory that "the essence of architectural creation" was not in a building's structure, material, or ornament, but most importantly in the interior spaces it enclosed.[19] In 1914, Wölfflin's student Paul Frankl observed in his *Principles of Architectural History* that in certain structures there is "a great flood of movement that urges us round and through the building."[20] And, he noted the "smooth flow of space" in Baroque architecture, in great contrast to the compartmentalized Renaissance architecture before 1550.[21] This might have been the first time that the metaphor of "flowing space" was used.[22]

Astonishingly, such notions of a perceived movement in the design process and the resulting shapes, as well as in the enclosed space and the path of the observer, were soon applied as well to examples of contemporary architecture, whose quiet forms, of course, had as little in common with the exuberant Baroque as possible.

As early as 1918, Dutch architect J. J. P. Oud described Frank Lloyd Wright's "plastic" architecture as a result of a "movement of the planes His masses slide back and forth and left and right; there are plastic effects in all directions." He predicted "entirely new aesthetic possibilities for architecture."[23] Adolf Behne echoed this in 1923, when he observed that the rooms in Wright's houses were "not inserted next to one another but set in motion—as asymmetrically as life itself ... He achieves the aesthetic composition of the house from the basic elements of accelerated horizontal movement."[24]

The notion of spatial "flow" was also adopted from Baroque architecture for modern buildings, possibly for the first time in a discussion of Ludwig Mies van der Rohe's Brick Country House design of 1924 whose spaces, critic Walter Curt Behrendt noted, "flow toward each other as their perimeters have been almost

Figure 7.4 Brick Country House project, Ludwig Mies van der Rohe, Kunsthalle Mannheim, 1924. © 2021, Artists Rights Society, New York VG Bild-Kunst, Bonn.

entirely dissolved (Figure 7.4)."[25] A few years later, Mies' Pavilion at the Barcelona World's Fair with its openly connected interior spaces and wall high glass screens, became the poster child for this new metaphor (Figure 7.5). Gustav Adolf Platz wrote of it that "This 'empty'—flowing as it were—space, created from precious, partially transparent surfaces, is the result of the new art of building." He further declared this "abstract space" the most "noble, the most cultivated form for our time."[26] Both Platz and another prominent critic Justus Bier (also a Wölfflin student) noted how the Pavilion's "richness of spatial experiences" could only be experienced "as one wanders through its spaces."[27]

How was it possible that terms such as "movement," "flow," and spatial penetration could so easily be transferred from exuberant Baroque forms to the straight sobriety of most modern architecture? Perhaps, it helped that in the 1920s, a general sense of Einstein's Special and General Theories of Relativity, published in 1905 and 1915, reached public consciousness after British astronomers had found proof of the impact of gravity on the movement of light in 1919, which resulted in Einstein receiving the Nobel Prize in Physics in 1922.[28] It is hard to overstate the seismic impact of this discovery. While the details of Einstein's work were hardly accessible to the general public and had no effect whatsoever on anyone's personal experiences, no one could escape the gravitational pull that the scientific proof of an indelible connection of space and time brought about.[29] Time, thus, could be considered a "fourth dimension" expanding the three-dimensional space of Euclidean geometry.

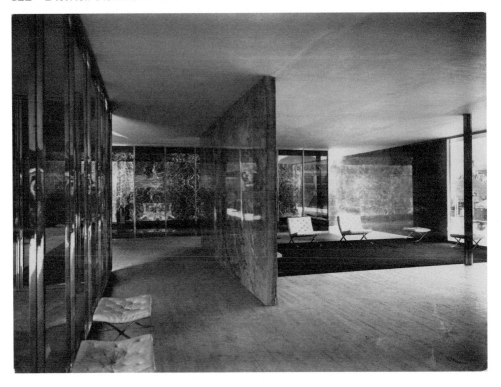

Figure 7.5 German Pavilion, World's Fair, Ludwig Mies van der Rohe, Barcelona, 1929. Photography by Sasha Stone. © Klassik Stiftung Weimar.

Mathematician Hermann Minkowski had first published this idea in his 1908 lecture "Space and Time," which inspired his pupil Einstein's General Theory of Relativity. In an attempt to explain his complex model to the general public, Minkowski had written, "Henceforth space by itself, and time by itself, are doomed to fade away into mere shadows, and only a kind of union of the two will preserve an independent reality ... No one has ever noticed a place unless at a certain time, neither a time without a distinct place."[30] These were probably the only sentences in the essay that non-mathematicians could understand, but they were evocative enough to inspire others to attempt their own interpretations. Some philosophers noted that artists and savants had always known about this connection: there was the romantic poet Novalis, who had declared in 1799 that "space and time are one ... space is stolid time—time is moving, variable space," or philosopher Friedrich Wilhelm Joseph Schelling, who asserted in 1806 that "space or time are never and nowhere separate from each other."[31] One might add Karl Marx's 1857 prediction of the "annihilation of space by time" in the global marketplace, or the famous quote from the first act of Richard Wagner's *Parsifal* from 1882, as Gurnemanz guides the Arthurian knight to the Castle of the Holy Grail that "Here Time becomes Space."[32]

Similarly, in the field of architecture, the indelible connection of time and space seemed to offer the legitimation of older theoretical ideas through newly discovered cosmic principles, and, as Adrian Forty put it, it "allowed architects to rub shoulders with the socially superior discourses of physics and philosophy ... to present their

labor as mental rather than manual."[33] The earlier observations that spatial sequences reveal themselves in motion could now, with a nod to Einstein and a slight of hand be put to use for the legitimation of modern architecture.

In his 1924 essay, "The Notion of Time in Architecture," Berlin architect Paul Zucker explained that any "purposeful movement" through architectural space required time and that the relationship between movement, time, and architecture held the key to its understanding.[34] Fritz Schumacher, chief planning director in Hamburg, followed suit, stating "As a result of our movement the notion of space is joined by the notion of time … The essence of architectural impact reaches into the fourth dimension, now commonplace thanks to the theory of relativity, which draws its scientific conclusions from the fact that all observations and events are bound by time."[35] Dutch artist Theo van Doesburg, somewhat less simplistically, declared "The new architecture calculates not only with space but also with time as an architectural value. The unity of space and time will give architectural form a new and completely plastic aspect, that is, a four-dimensional, plastic space–time aspect."[36]

It did not take long, before Mies van der Rohe's Barcelona Pavilion of 1929 was, in all seriousness, presented as an example of "space-time" in architecture. For Walter Riezler, art and music critic, and editor of the Werkbund Journal *Die Form*, it was the perfect example of this new paradigm. He wrote that "The way in which the different rooms, entirely without firm boundaries, flow into each other, and the entire building opens itself up towards the outside, is without parallel in the entire field of architecture …." For him, this "four-dimensional space, moving with time" was immediately relevant for "atonal music and the new sense of space in the arts."[37] Following Zucker and Schumacher, Riezler emphasized the importance of movement for the understanding of modern architecture, noting that time was logically an essential component for the experience of space. Riezler conceded the obvious, though – namely, that time would also elapse when a viewer walked through a Gothic or Renaissance space (and, we might add, even when a viewer stood still) – but what made those premodern spaces different, he claimed, was that their symmetrical floor plans were still based on a "static" idea and would be comprehended as such.

Riezler delivered these remarks at a conference in 1930 organized by Germany's most prominent art historians, Aby Warburg, Erwin Panofsky, Ernst Cassirer, and Fritz Saxl. The "Fourth Congress for Aesthetics and General Art History" was held in Hamburg and dedicated to "Design of Space and Time in Art."[38]

Another speaker at the Hamburg conference, progressive Hannover museum director Alexander Dorner, explained that "the new idea of space results from a penetration of different spatial views, from a wandering through space, thus making time the fourth dimension of space … the notion of time is more or less latently embedded within this new notion of space."[39] Dorner identified the beginnings of the new relationship of time to space in an early nineteenth-century romantic painting, and saw further manifestations in panoramas, dioramas, and pleoramas. Joan Ockman has convincingly demonstrated that Giedion would later appropriate Dorner's ideas about space and time without crediting him, which led to considerable consternation on Dorner's part (both were then in the United States at that time – Giedion at Harvard and Dorner in nearby Providence as director of the Rhode Island School of Design Museum).[40]

Dorner lectured about the topic again at Berlin's Art Library in January of 1931, telling his audience that time had joined the previously known three dimensions.

Modern art was giving up the "window view," namely the frontal approach from merely one vantage point, and instead worked with observations from several viewing points. The superimposition of the different impressions would create an image which could only be comprehended through a kinetic, and thus time-bound, act of appreciation. In architecture, an absence of mass and volume would result, and abstract art would be the carrier of modern spatial thought for a long time. Dorner singled out Gropius' Bauhaus building with its ephemeral transparency and absence of facades as a perfect example, thus predating Giedion's central claim by ten years. The new interest in space and time, he pointed out, also explained the growing interest in the art of film. All was proof for the fact that "science is similarly solving the space-time-problem and accepting the space-time dimension."[41]

This lecture did not go over well with prominent art critic Karl Scheffler, who was in the audience and penned a long response, entitled "Abused Einstein." While he did not mention Dorner by name, it was clear who the "gaunt, pale, cool and superior" lecturer was, delivering such "hair raising" messages, making "Einstein the argument for a new spatial order" and forcing painters to walk around and through their subjects, in order to gain a simultaneous experience. In Scheffler's eyes, such "nonsensical theories" amounted to an "epidemic of religious insanity."[42] Dorner defended his lecture by pointing to the historical roots of the new spatial understanding in art, long before Einstein.[43] Despite occasional contemporary misgivings, the Einstein-inspired notion of the importance of time in the experience of space had a long afterlife.

American architect George Howe expressed similar ideas in 1936 at an occasion comparable to the above mentioned Hamburg conference, namely the 25th annual meeting of the College Art Association in New York. "In the pavilion of Mies van der Rohe," he declared,

> floors, coverings, supports, and vertical subdivisions have ceased to be space enclosures, and become mere planes and axes of reference by which space and time relations may be registered. In architecture ... movement, the movement of human beings through space, corresponds roughly to time in mathematics, and physical space delimited by one or more axes or planes to theoretical space. In this building the contemporary space–time idea as flowing, continuous, and relative is carried to the furthest limits of architectural expression.[44]

The occasion for George Howe's talk, entitled "Abstract Design in Modern Architecture," was not without significance and brings us back to the beginnings of this chapter. The session on 9 April 1936 in which Howe spoke was held at the Museum of Modern Art on the occasion of its current exhibition entitled "Cubism and Abstract Art."

In the catalog, Alfred Barr looked at Bauhaus architecture as a reflection of abstract art, rather than cubism. He found the façade of Gropius' Director's House in Dessau "directly under De Stijl influence and [...] handled as if it were an abstract painting like Doesburg's Cow. The variety of size and position of the windows can be rationalized functionally, but, nevertheless, the facade is essentially a pictorial and not an architectural conception."[45]

What interested Barr more was Mies' Brick Country House design of 1924 and its genealogy (Figure 7.4). "In the history of art there are few more entertaining sequences than the influence by way of Holland of the painting of a Spaniard living

Figure 7.6 Standing Female Nude, Picasso, Line Drawing, Metropolitan Museum of Art, New York, 1910. © Estate of Pablo Picasso/Artist Rights Society (ARS), New York, VG Bild-Kunst, Bonn.

in Paris upon the plans of a German architect in Berlin—and all within twelve years," he declared as he traced Mies' lineage from Picasso's cubistic line drawing *Standing Female Nude* of 1910 via Piet Mondrian's work of 1913–17, to van Doesburg's *Rhythm of a Russian Dance* of 1918 whose resemblance with Mies' plan he found "... obvious and by no means superficial (Figures 7.6 and 7.7)."[46] While Mies would coolly dismiss this notion years later, Barr had been the first to connect the work of the most celebrated contemporary artist, Pablo Picasso, with a piece of modern architecture.[47]

Giedion was surely familiar with Barr's book and his three-step genealogy of Mies' country house design. The Swiss critic followed the American curator's lead when he matched "*L'Arlésienne*" with Gropius' Bauhaus building. In order to drive the point home, Giedion offered a second genealogy in another, carefully laid out double-page spread in *Space, Time and Architecture*.[48] Here, he offered a four-step history of the Bauhaus from a Cubist collage by George Braque of 1913, to a painting by Mondrian, a Malevich "Architectonic" of 1920, and the Scheme for a Villa by van Doesburg and C. van Eesteren of 1923 (Figure 7.8).

Despite the fact that the openly connected spaces in Mies' Barcelona Pavilion had become a prime example for "space-time" in architecture, Mies' work is almost entirely absent from Giedion's book in its 1941 edition.[49] This was probably due to

Figure 7.7 Rhythm of a Russian Dance, Theo van Doesburg, Museum of Modern Art, New York, 1918. © Artist Rights Society (ARS), New York, VG Bild-Kunst, Bonn.

the influence of his friend Gropius, who was busy defending and cementing his legacy as the founder of the Bauhaus and as the leading voice of modern architecture in Germany.

Thankfully, we know what Albert Einstein himself thought of the appropriations of his theorem. Erich Mendelsohn, who had acknowledged to Einstein's influence on his own architecture, in particular his Einstein Tower in Potsdam, was, no doubt, piqued by the fact that his work was, like Mies', omitted entirely from *Space, Time and Architecture*, except for the unflattering sideswipe at his Einstein Tower being "as flaccid as jellyfish."[50] He wrote to Einstein in 1941, sending him an extract from the book. Did Einstein agree with Giedion's notion that fourth-dimensional "space-time could be applied to architecture, i.e., to a fixed object which is not moving and can be represented fully in three dimensions," he asked.[51] Einstein's response was swift. He composed a little rhyme for Mendelsohn:

Nicht schwer ist's Neues auszusagen
Wenn jeden Blödsinn man will wagen.
Doch selt'ner füget sich dabei
Dass Neues auch Vernünftig sei.

This roughly translates as "It's not difficult to say something new if you dare to say any nonsense, but it is rarer that new things are also sensible." He added

204. BRAQUE, Collage, 1913.

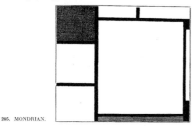

205. MONDRIAN.

206. MALEWITSCH, Architectonics, c. 1920.

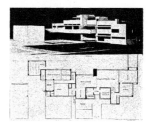

207. THEO VAN DOESBURG and C. VAN EESTEREN,
Scheme for a villa, 1923.

architectonic study of Malewitsch might be likened to it
equally well. The effect is as if the blind surfaces of the Male-
witsch sculpture had suddenly received sight. It is obvious
that in the second decade of this century the same spirit
emerged in different forms, in different spheres, and in totally
different countries.

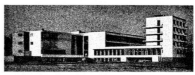

208. WALTER GROPIUS, The Bauhaus, 1926.

362

363

Figure 7.8 Collage, George Braque, 1939; untitled painting, Piet Mondrian; Architectonics,
Vladimir Malevich; Scheme for a Villa, Theo van Doesburg, and Bauhaus, Dessau,
in page spread from *Space, Time, and Architecture*, 362–63.

a handwritten note at the bottom of his typed letter that this was simply *Klug-
Scheisserei ohne jede vernünftige Basis!*[52] (perhaps best translated as "pretentious
bullshit without any reasonable basis in fact").

Perhaps Giedion's most astonishing interpretative leap, however, returns us back
to Moholy's photograph and to the question of representation. Picasso's *L'Arlésienne*
of 1912 was one of several paintings and sketches with that title that he produced
over the years. He was fascinated with Alfred Daudet's short story of 1866 with the
same title, about a beautiful young woman who is unable to be faithful. A young
man, desperately in love with her, commits suicide by jumping off the top floor of
his building. The many-sidedness of the portrait, in line with Cubist experiments at
the time, was an obvious match for a complex, deceptive, and duplicitous woman.
Giedion equals the simultaneity of the different views at *L'Arlésienne* with the com-
plexity of Gropius' architecture, with its extensive transparent areas, dematerialized
corners and hovering relations of planes. A survey of photographs of the Bauhaus by
Moholy and others, however, make clear that the transparency that Moholy's iconic
photo captured was a rare phenomenon. In fact, in all other views of it in Gropius'
1930 book on the building, the glass curtain wall is opaque, as it reflects the sky from
above (Figure 7.9).[53]

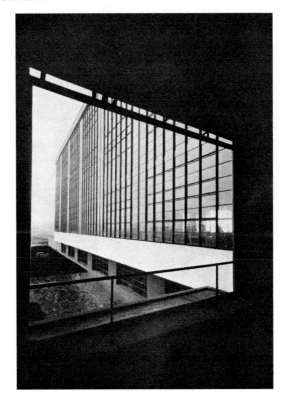

Figure 7.9 Bauhaus, photograph by Lucia Moholy, 1927. *Bauhausbauten Dessau* (Munich: Albert Langen Verlag, 1930) 51. © Bauhaus Archiv, Berlin, 2021, Artists Rights Society (ARS), New York, VG Bild-Kunst, Bonn.

It was thus Lucia Moholy's unusual interpretation of the building (just like Picasso's interpretation of a well-known subject matter) that made the famous comparison plausible, rather than Gropius' building itself. It was her choice of position and direction, film and exposure, the time of day with its overcast sky, the complete retraction of the curtains, usually drawn as the main façade faced southwest and the studios heated up on any sunny day. Thus, the omission of Moholy's authorship of this central image in Giedion's book is even more regrettable.

Two other photographers, both students at the time, tried to extract a more complex reading from the glass façade, both focused on the same, unusual vantage point and both ended up in Gropius' publication on the Bauhaus buildings. Lux Feininger, son of Bauhaus teacher Lyonel Feininger, photographed the inner corner in the back of the workshop wing where its glass curtain wall meets the large windows of the stair hall. It reflects and distorts the bathroom windows directly across from it, as they face the bright southern sun. (Figure 7.10) Another student, Gotthardt Itting (one of the few students who owned a Leica camera) photographed the same glass curtain wall, but from the roof of the main building, including the stair hall with its enormous single pane windows, both vaguely reflecting each other.[54] This was an inspired choice, as it avoided the strong skylight dominating the reflections, but it came at the cost of a viewpoint that was inaccessible to any visitor.

Figure 7.10 Bauhaus, photograph by Lux Feininger, 1928. *Bauhausbauten Dessau* (Munich: Albert Langen Verlag, 1930) 49. © Bauhaus Archiv, Berlin, 2021, Artists Rights Society (ARS), New York, VG Bild-Kunst, Bonn.

When Moholy-Nagy published his *von material zu architektur* in 1929, he did not use any of his former wife's photography (they had just separated), but instead illustrated the Bauhaus building merely with photographs by Itting (without commentary) and Lux Feininger. These served to support his own observations about contemporary architectural space, such as "Interior and Exterior penetrate each other in the reflection of the window. It is impossible to keep the two apart. The mass of the wall, which hitherto blocked off anything 'outside' has been dissolved and lets the environ flow into the interior."[55]

Giedion's famous comparison remained in all subsequent editions of *Space, Time and Architecture*. The expanded version, finished in 1953, for the first time included an extensive section on Mies, with the shortest possible reference to his Barcelona Pavilion as an example "of the new space conception."[56] A year later, Giedion finally published his biography of Gropius, in which he made his comparison between the Bauhaus and Picasso's *L'Arlésienne* again, but without repeating the juxtaposition of the two images. Instead, he used the Itting photograph and greatly abbreviated (without exactly clarifying) his previous argument. He wrote,

> The Bauhaus complex has no definite frontal façade. The interplay of transparency and piercing of space by bridges leads to an interpenetration of horizontal

and vertical planes that makes it impossible to grasp the whole of the complex from any single viewpoint, and results in an unprecedented effect of simultaneity that accords with the space-time conception.[57]

The year was 1954, and Gropius, after frequent inquiries, had finally admitted to Moholy that he was in possession of her negatives. Giedion, probably instructed by Gropius, now for the first time, generally acknowledged her "excellent photographs, taken with rare perception and clarity."[58]

Notes

1. Reto Geiser, *Giedion and America. Repositioning the History of Modern Architecture* (Zürich: gta Verlag, 2018) 138–89.
2. Sigfried Giedion, *Space, Time and Architecture. The Growth of a New Tradition* (Cambridge: Harvard University Press, 1944) 402–03.
3. Giedion, *Space, Time and Architecture*, 404.
4. Walter Gropius, *Bauhausbauten Dessau* (München: Albert Langen Verlag, 1930). Fifty six of the photographs in the book are by Lucia Moholy, many more than by any other photographer.
5. Robin Schuldenfrei, "Images in Exile: Lucia Moholy's Bauhaus Negatives and the Construction of the Bauhaus Legacy." *History of Photography* 37.2 (2013): 182–203.
6. Alfred H. Barr Jr., ed., *Picasso: Forty Years of His Art* (New York: The Museum of Modern Art, 1939) 77. Three years earlier Barr had written about *L'Arlésienne*: "... in which the head is made up of flat, overlapping, transparent planes, almost rectangular in shape. The profile of the face is superimposed upon a frontal view illustrating the principle of 'simultaneity'—the simultaneous presentation of different views of an object in the same picture." Alfred H. Barr Jr., ed., *Cubism and Abstract Art* (New York: Museum of Modern Art, 1936) 31.
7. Giedion, *Space, Time and Architecture*, v.
8. Barr, *Picasso*, 6.
9. Giedion, *Space, Time and Architecture*, 357.
10. Linda Dalrymple Henderson, *The Fourth Dimension and Non Euclidean Geometry in Modern Art* (1983. Cambridge, MIT Press, 2018) 515.
11. Henderson, *The Fourth Dimension*, 202.
12. Henderson, *The Fourth Dimension*, 202–03. Albert Gleizes, Jean Metzinger, *Du "Cubisme"* (Paris: Eugène Figuière et Cie., Éditeurs, 1912) 36.
13. Giedion, *Space, Time and Architecture*, 404.
14. Giedion, *Space, Time and Architecture*, 554.
15. Peter Behrens, *Kunst und Technik* (1910) quoted in *Quellentexte zur Architekturtheorie*, Fritz Neumeyer, ed. (Munich: Prestel, 2002) 358. For a similar comment on the facade of Mies' building for the Weissenhofsiedlung in Stuttgart, see Siegfried Kracauer, "Das neue Bauen: Zur Stuttgarter Werkbund-Ausstellung 'Die Wohnung,'" in *Frankfurter Zeitung*, July 31, 1927.
16. Heinrich Wölfflin, *Renaissance und Barock Eine Untersuchung über Wesen und Entstehung des Barockstils in Italien* (München: Theodor Ackermann, 1888) 18, 40, 52.
17. Giedion, *Space, Time and Architecture*, 47
18. Giedion, *Space, Time and Architecture*, 63.
19. Harry Francis Mallgrave and Eleftherios Ikonomou, eds., *Empathy, Form, and Space: Problems in German Aesthetics, 1873–1893* (Santa Monica: Getty Center for the History of Art and the Humanities, 1994) 39; and August Schmarsow, "The Essence of Architectural Creation," Mallgrave and Ikonomou *Empathy, Form, and Space: Problems in German Aesthetics, 1873–1893*, H. F. Mallgrave and E. Ikonomou, trans. (Santa Monica, CA, 1994) 281–97, originally published in German in 1893.
20. Paul Frankl, *Principles of Architectural History*, J. F. O'Gorman, trans. (Cambridge, Mass: MIT Press, 1968) 148, originally published in German in 1914.

Space Time and the Bauhaus 131

21. Frankl, *Principles of Architectural History*, 46.
22. Sculptor Adolf von Hildebrand, perhaps, deserves credit for formulating a fluid notion of space when he suggested that it was easiest to comprehend its continuity by imagining individual volumes being lowered into a body of water, which then surrounded them with a continuous flow. See Adolf von Hildebrand, *Das Problem der Form in der bildenden Kunst* (Strassburg: Heitz & Muendel, 1893) 32–33.
23. J. J. P. Oud, "Architectural Observations Concerning Wright and the Robie House," *De Stijl* 1.4 (1918): 39–41, reprinted in H. Allen Brooks, *Writings on Wright: Selected Comment on Frank Lloyd Wright* (Cambridge: MIT Press, 1983) 135–37.
24. Adolf Behne, *The Modern Functional Building*, Rosemarie Haag Bletter, ed., Michael Robinson, trans. (Santa Monica: Getty Research Institute, 1996) 99, originally published in German in 1926.
25. Walter Curt Behrendt, *Der Sieg des neuen Baustils* (Stuttgart: Akademischer Verlag Dr. Fritz Wedekind & Co., 1927) 51.
26. Gustav Adolf Platz, *Die Baukunst der Neuesten Zeit*, 2nd edition (Berlin: Propyläen Verlag, 1930) 80–81.
27. Justus Bier, "Mies van der Rohes Reichspavillon in Barcelona," *Die Form: Zeitschrift für gestaltende Arbeit* 16 (August 15, 1929): 423–30. See also Platz, *Die Baukunst der Neuesten Zeit*, 80–81.
28. Arthur Stanley Eddington, *Raum, Zeit und Schwere* (Braunschweig: Vieweg + Teubner, 1923) 114–25.
29. The "Space Time Continuum" that resulted from the work of Poincaré, Minkowski and especially Einstein suggested that movement through stellar space at lightning speed would slow down time.
30. Hermann Minkowski, *Raum und Zeit*, 1908, in Hendrik Anton Lorentz, *Albert Einstein, Hermann Minkowski, Das Relativitätsprinzip 1913* (Leipzig: Teubner, 1915) 57.
31. See the detailed account of debates about space and time in the 1920s in Ulrich Müller, *Raum Bewegung und Zeit im Werk von Walter Gropius und Ludwig Mies van der Rohe* (Munich: Oldenbourg Akademieverlag, 2004) 97–99. The contemporary philosophers who pointed at Novalis and Schelling are Käte Hamburger in 1929 and Werner Gent in 1930. See also Henderson, *The Fourth Dimension*.
32. Karl Marx, *Grundrisse, Marx-Engels-Werkausgabe* 42 (Berlin: Dietz, 1983) 538–39.
33. Adrian Forty, *Words and Buildings: A Vocabulary of Modern Architecture* (London: Thames and Hudson, 2000) 265.
34. Paul Zucker, "Der Begriff der Zeit in der Architektur," in *Repertorium für Kunstwissenschaft* 44 (1924) 237–45. Quoted in Andreas Denk, Uwe Schröder, Rainer Schützeichel, eds., *Architektur. Raum. Theorie. Eine kommentierte Anthologie* (Tübingen: Ernst Wasmuth Verlag, 2016) 301–11. Paul Zucker (1888–1971) worked and taught in Berlin from 1918–1937 and then immigrated to the United States, where he taught at the New School for Social Research and Cooper Union.
35. Fritz Schumacher, "Die Zeitgebundenheit der Architektur," *Deutsches Bauwesen* 5 (1929): 238–43.
36. Theo van Doesburg, "Towards Plastic Architecture" (1924), in Joost Baljeu, *Theo van Doesburg* (New York: Macmillan, 1974) 144. See also John G. Hatch, "Some Adaptations of Relativity in the 1920s and the Birth of Abstract Architecture," *Nexus Network Journal* 12 (2010): 131–47, and Henderson, *The Fourth Dimension*.
37. Walter Riezler, "Das neue Raumgefühl in bildender Kunst und Musik," *Vierter Kongress für Ästhetik und allgemeine Kunstwissenschaft, Hamburg, October 7–10, 1930, Beilageheft zur Zeitschrift für Ästhetik und allgemeine Kunstwissenschaft* 25 (1931): 179–216.
38. Angela Lammert, "Raum und Zeit in der Kunst um 1930: Ernst Cassirer, Aby Warburg, Carl Einstein," in *Topos Raum: Die Aktualität des Raumes in den Künsten der Gegenwart*, Angela Lammert, ed. (Berlin: Akademie der Künste, 2005) 58–71. Saxl, in particular, was in close contact with his colleagues George Bataille and Carl Einstein, who pondered similar questions at the time. Bataille, for example, published an entry on "Space" in his journal *Documents*, simultaneous with the conference in Hamburg. See Georges Bataille, "Espace," *Documents* 1 (1930): 41.

39. Alexander Dorner, "Zur Raumvorstellung der Romantik," *Vierter Kongress für Ästhetik und Allgemeine Kunstwissenschaft Hamburg 1930, October 7–10, 1930,* in *Beilage zur Zeitschrift fur Ästhetik und allgemeine Kunstwissenschaft* 25 (1931): 130.

40. Joan Ockman, "The Road Not Taken: Alexander Dorner's Way Beyond 'Art,'" in *Autonomy and Ideology: Positioning an Avant-Garde in America,* Robert E. Somol, ed. (New York: Monacelli Press, 1997) 82–120. See also Dietrich Neumann, "'All the Struggles of the Present:' Alexander Dorner, Henry-Russell Hitchcock and *Rhode Island Architecture,*" in *Why Art Museums? Alexander Dorner's Unfinished Project,* Sarah Ganz Blythe and Andrew Martinez, eds. (Cambridge, MIT Press, 2018) 69–92.

41. "Der neue Raum," *Vossische Zeitung* 54, Unterhaltungsblatt supplement (February 1, 1931): 4.

42. Karl Scheffler, "Der Missbrauchte Einstein," *Vossische Zeitung,* Unterhaltungsblatt supplement (February 22, 1931): 2.

43. Alexander Dorner, "Malt man 'nach Einstein'?" *Vossische Zeitung* 126, Unterhaltungsblatt supplement (March 15, 1931): 2.

44. George Howe, "Abstract Design in Modern Architecture," *Parnassus* 8.5 (October 1936): 29–31. At another talk, three years later, Howe applied what he learned from the Barcelona Pavilion to the works of Wright and Corbusier, as he described the sequence of spaces one transverses "going in and coming out" of their houses. He stated, "To feel space, the observer must flow through it, he must go in and come out, become conscious of the indoors and the outdoors as related parts of a continuous whole." George Howe, "Going in and Coming out: the Fundamental Architectural Experience." George Howe Papers, Avery Library, Columbia University, New York, quoted in David Leatherbarrow, "Space in and out of Architecture." *ARQTEXTO* (October 2008): 6–31. In 1947, Howe contributed a chapter entitled "Flowing Space: the Concept of Our Time" to Thomas Creighton, ed., *Building for Modern Man: A Symposium* (Princeton: Princeton University Press, 1949) 177–80.

45. Barr, *Cubism,* 156–58.

46. Barr, *Cubism,* 156. Barr referred to Picasso's drawing, which was in the exhibition (on loan from Alfred Stieglitz) multiple times. Due to an editing error, however, it was not included in the catalogue illustrations. It did show up in the Picasso catalogue three years later.

47. "I think that was a mistake that the Museum of Modern Art made. [...] I never make a painting when I want to build a house. We like to draw our plans carefully and that is why they were taken as a kind of painting." Peter Carter, *Mies van der Rohe at Work* (New York: Praeger, 1974) 180.

48. Giedion, *Space, Time and Architecture* (1941), 362–63.

49. See also: Fritz Neumeyer, "Giedion und Mies van der Rohe. Ein Paradox in der Historiographie der Moderne," *Architektur Aktuell* 183 (September 1995): 56–63.

50. Giedion, *Space, Time and Architecture,* 394.

51. Letter from Erich Mendelsohn to Albert Einstein, November 6, 1941, Mendelsohn Archiv, Kunstbibliothek Berlin. See also Joachim Krausse, "Vom Einsteinturm zum Zeiss-Planetarium. Wissenschaftliches Weltbild und Architektur," in *Der Einsteinturm in Potsdam,* Astrophysikalisches Institut Potsdam, ed. (Berlin: Ars Nicolai, 1995) 105–20, illustration 141.

52. Letter from Albert Einstein to Erich Mendelsohn, November 13, 1941, Mendelsohn Archiv. Picasso had settled the case in 1923 already: "Mathematics, trigonometry, chemistry, psychoanalysis, music, and whatnot, have been related to cubism to give it an easier interpretation. All this has been pure literature, not to say nonsense, which brought bad results, blinding people with theories." "Picasso Speaks," *The Arts* (May 1923): 315–26.

53. Gropius himself refrained from speculative interpretations comparable to those of Dorner or later Giedion. In his book on the Bauhaus Buildings of 1930, he used many of Lucia Moholy's photographs, among them the one in Giedion's comparison, but merely commented on the visibility of the concrete structure thanks to the glass façade in front. Walter Gropius, *Bauhausbauten Dessau* (München: Albert Langen Verlag, 1930) 47. Similarly, in the catalog to the Bauhaus Exhibition at the Museum of Modern Art in 1938, Gropius merely stated that "one must walk around this structure" in order to

understand the "three-dimensional character of its form and the function of its parts." Herbert Bayer, Walter Gropius, and Ise Gropius, eds., *Bauhaus, 1919–1938* (New York: Museum of Modern Art, 1938) 102.

54. https://lfi-online.de/ceemes/en/blog/leica-and-bauhaus-less-is-more-1873.html; and Walter Gropius, *Bauhausbauten Dessau* (München: Albert Langen Verlag, 1930) 49, 52.
55. László Moholy-Nagy, *von material zu architektur* (1929) facsimile reprint (Berlin: Gebrüder Mann, 1929) 221. For Itting's image, 234.
56. Sigfried Giedion, *Space, Time and Architecture* (1954), 545.
57. Sigfried Giedion, *Walter Gropius. Work and Teamwork* (New York: Reinhold Publishing, 1954) 55.
58. Giedion, *Walter Gropius*, 30.

8 Bauhaus Specters and Blueprint Illuminations

Josef Albers and Robert Rauschenberg

Vanessa S. Troiano

When Robert Rauschenberg enrolled at Black Mountain College in the middle of the 1948 fall semester, it was for two reasons. First, he had developed a relationship with Susan Weil, a fellow American artist, whom he had met in Paris the summer before at the Académies Julian and de la Grande Chaumière, and who had just begun her own studies at the college. Second, among Black Mountain's notable faculty was Josef Albers, the longest-serving member of the Bauhaus and its first master to emigrate. Rauschenberg had heard Albers was "the world's greatest disciplinarian," and he believed he most needed discipline to become a good artist.[1] Although his report cards indicate he struggled with this (Albers' evaluation of Rauschenberg states, "could be better with more discipline"), the years he spent at Black Mountain in 1948–49 and 1951–52 were arguably the most formative in his career.[2] In this remote yet fertile artistic community in North Carolina's Blue Ridge Mountains, Rauschenberg learned from and collaborated with some of the most innovative thinkers in the American arts at the time, including John Cage, Merce Cunningham, Cy Twombly, and Hazel Larson Archer. Many of these associations developed during his second sojourn at the college, a highly productive period and the focus of much scholarship on his early work. Yet, the blueprints (1949–51), the earliest series in his oeuvre and the art for which he first won recognition, have received comparatively little attention. Created by both Rauschenberg and Weil the summer after their first year of college, these cyanotypes, featuring ethereal figures floating in a Prussian blue haze, are the first photograms to capture one-to-one ratios of entire human bodies.[3]

This chapter reevaluates the blueprint series in Rauschenberg's practice, as well as his first year at Black Mountain, the only time when he studied with Albers. Despite their brief acquaintance, Albers' impact upon Rauschenberg is well acknowledged, perhaps most adamantly by the wayward student himself, who considered Albers his "most important teacher."[4] Many accounts of their relationship highlight its significance to the development of Rauschenberg's celebrated Combines, but little has been written about Albers' influence on the blueprints, the works which ignited Rauschenberg's illustrious practice. The blueprints exemplify Albers' lauded instructional methods, especially in visual perception, formal composition, and material analysis, all of which stem from the Bauhaus' artistic and pedagogical practices. Shining new light on the blueprints strengthens the connection between the work of Albers and Rauschenberg, and, as a result, positions the Bauhaus as a crucial determinant of Rauschenberg's neo-avant-garde practice.

DOI: 10.4324/9781003268314-9

A superficial glance at the oeuvres of Albers and Rauschenberg suggests they had little in common. The aesthetics embraced by each lie at opposite ends of the spectrum of abstraction and figuration. Rauschenberg is often considered the pivotal figure in American post-abstract expressionism who challenged pure abstraction by introducing representational imagery into the context of "action painting" brushwork.[5] However, despite apparent stylistic divergences, an examination of the two artists' practices reveals a shared desire to create art that activates the viewer through a cohesion of formal elements. Albers and Rauschenberg's mutual ambition to make art an experience rather than a mere object originates in the Bauhaus' synthesis of art and life, which in itself was a utopian response directed by Walter Gropius "to build up something new" from Germany's ruinous defeat in World War I.[6] Laying a new foundation for design education, the Bauhaus sought a practical application of art through a unity with craftsmanship, welcoming unconventional methods and materials to create a more meaningful existence. Albers absorbed and transferred these revolutionary ideas to an impressionable yet rebellious young Rauschenberg, who reinterpreted them for a thriving, post-World War II, American consumer society.

Albers at Black Mountain: Transplanting Bauhaus Pedagogy

The crucial vector in transmitting Bauhaus ideas from Albers to Rauschenberg was the school's legendary preliminary course and the instructional elements from it that Albers adapted to Black Mountain's arts curriculum. The brainchild of Johannes Itten, an art theoretician and original Bauhaus master, it provided fundamental training to students in form, materials, and color, before they advanced to workshop apprentices. Albers took the class in 1920 when he enrolled at the Bauhaus. Two years later, he was one of the first students appointed to teach. Initially, he supervised the glass workshop, but by 1923 he led the preliminary course alongside his new colleague, László Moholy-Nagy, who was hired to replace Itten as the Bauhaus shifted its focus toward industrial design.[7] Following Moholy-Nagy's 1928 departure, Albers was its sole instructor. Fortuitously, following the closure of the Bauhaus in 1933, John Andrew Rice, the founder of Black Mountain, invited Albers to join its faculty, and in November Albers arrived with his wife Anni, a Bauhaus-trained weaver, to establish the art department.

The shared philosophical foundations of the Bauhaus and Black Mountain facilitated Albers' transition, even though the two institutions were distinct: the former dedicated its instruction to art and design, while the latter, a liberal arts college, offered courses in a range of academic subjects.[8] Both Gropius and Rice believed in art's primacy and the power of progressive educational reforms for societal betterment. By dismantling traditional academic hierarchies between disciplines as well as those between teachers and students, they set the methodological framework for art's pragmatic application to solve real-world problems in community-oriented learning environments. Gropius focused on architecture as the means to unite all creative effort. Rice more generally conceived of individual enhancement through art for the greater good. He declared,

> This then is the kind of man we should like to produce, one in whom there is a nice balance of forethought, action and reflection. [...] This is why we at Black Mountain begin with art. The artist thinks about what he himself is going to do, does it himself, and then reflects upon the thing that he himself has done.[9]

Commenting upon his experience at both institutions, Albers succinctly remarked, "In the Bauhaus I was more or less obliged to develop a way of study, but in Black Mountain I came more to it to develop people."[10]

Embracing his new leadership role at Black Mountain, Albers adapted Bauhaus pedagogy, deemphasizing utilitarian design production in favor of developing students' faculties for processing information. He affirmed in a 1934 college prospectus, "art is the province in which one finds all the problems of life reflected [...] For this reason art is an important and rich medium for general education and development."[11] Instructional elements from the preliminary course were compatible with Black Mountain's objectives because, in its essence, the class was a holistic experience designed to nurture creative potential.[12] The hands-on exercises in visual perception and material analysis taught students critical thinking and problem-solving skills. Since Black Mountain had neither required classes nor preliminary courses, Albers integrated such practices into all of his classes.

Under Albers' tutelage at the Bauhaus, lessons in the preliminary course increasingly focused on optical illusions, reflecting his growing interest in visual perception's "discrepancy between physical fact and psychic effect."[13] Symptomatic of Weimar Germany's pervasive state of epistemological doubt and fueled by advancements in photography and Gestalt theory, Albers' work with optical illusion sought to develop students' visual literacy by training them to distinguish what exists from how the mind perceives it. Arriving at Black Mountain, he proclaimed his primary teaching objective, "to open eyes," and he carried over his investigative approach to art instruction, explaining, "our overemphasis on the psychic vision often makes us see incorrectly. For this reason we learn to test our seeing."[14] Albers' instruction in visual perception was among the most successful Bauhaus pedagogical features transplanted in America, and, as Rauschenberg acknowledged, it critically shaped his own perspective and practice: "He didn't teach you how to 'do art.' The focus was on the development of your own personal sense of looking."[15]

To develop students' visual literacy, Albers assigned compositional exercises in contrasts, which, like Itten's, underscored elemental relativity between form and color, positive and negative values, and material and texture.[16] *Materienstudien*, studies of material appearances and textures, kindled Rauschenberg's painterly obsession with found objects, especially through *matière* exercises, a French term Albers adopted to encapsulate his combined visual and tactile approach.[17] *Matières* required students to create "interesting" relationships between disparate materials in assemblages by working with material appearances as if painting with them.[18] Albers welcomed any material, encouraging students to employ nontraditional materials, like sand and eggshells. He preferred, however, that students use as few tools as possible to attain a "finger-tip feeling" for material.[19] In German, *Fingerspitzengefühl* is also an idiom that describes the fine art of navigating interpersonal relationships, whereby a sensitive touch helps to handle delicate social situations. Similarly, Albers hoped to cultivate in his students this sensitive approach to creating unified compositions from diverse materials. Unlike Itten's "texture montages," Albers' *matières* often contain a level of formal cohesion that obfuscates the tactile nature of the distinct materials. As such, a successful *matière* deceives the eye into believing a smooth material to be rough or a strong material to be brittle.[20] "Art is swindle," Albers would tell his students as he encouraged them to "make magic," since, like magicians, artists can create illusions.[21]

At Black Mountain, Albers assigned *matières* in a basic design course he called *Werklehre*, retaining the German term because the course's problem-solving tactile exercises resembled those of the Bauhaus workshops or *Werklehre*. Originating from the German words for work and lesson, *Werklehre* accurately described Albers' objective for basic design at Black Mountain. By learning through their work, students would develop a "feeling for material and space."[22] *Werklehre* revolutionized art education by placing craft at its core, fostering a learning-by-doing approach that reinforced the humanist aspirations of both the Bauhaus and Black Mountain, to which Albers attested in the college's prospectus: "This method emphasizes learning, a personal experience, rather than teaching. And so it is important to make inventions and discoveries."[23] Albers encouraged students to produce work not with the intent to create art, but rather "to share experience gained through tinkering," replacing the onus of making art with the freedom of independent thinking and inventive courage.[24]

This playful, experimental approach to artmaking inspired Rauschenberg and Weil's blueprint creations, made while vacationing at her family's home on Outer Island, Connecticut, the summer after studying with Albers in 1949. Remembering her childhood on the island, when she made blueprints in the sun with her older brother Danky, Weil bought a roll of blueprint paper and introduced Rauschenberg to the technique. In their first attempt to capture a full-body image, the artists enlisted Weil's six-year-old brother, Jim, who lay upon the cyanotype paper as they surrounded him with leaves, grasses, and flowers. "We were thrilled with the results," Weil recalled, "and in the next couple of years we made many full-scale blueprints."[25] By 1950, the couple moved to Manhattan, where they continued making blueprints after discovering that they could use a sunlamp to expose the cyanotype to the necessary ultraviolet light.[26] At this time, the artists produced *Female Figure* with their friend Pat Pearman, whose nude body with raised arms and downward pointing toes appears as a white apparition floating in a blue mist. Six months later, curator Edward Steichen showcased this work in the exhibition *Abstraction in Photography* at New York's Museum of Modern Art.

Life magazine also featured a story on Rauschenberg and Weil's blueprints in its April 9, 1951 issue, published one month before Rauschenberg's first one-man show at the Betty Parsons Gallery. Wallace Kirkland, a *Life* photojournalist, documented the artists as they created the images with a nude model in their apartment.[27] Presented under "Speaking of Pictures," the magazine's section reserved for stories about unconventional photography, the spread highlights the couple's innovative use of a handheld sunlamp and their process of fixing the images in a solution of peroxide in their bathtub. The article also illustrates the careful thought with which the artists composed their images and, by describing the couple as "painters," brings attention to the unique, painterly qualities in their blueprints. Just two years earlier, *Life* had catapulted Jackson Pollock to fame as "the greatest living painter in the United States" in a spread from which Kirkland appears to have taken a cue.[28] Like his action-painting predecessor, Rauschenberg crouches on the floor, pouring light from the sunlamp onto the cyanotype to record the ephemeral arrangements of objects. These early performance gestures with the blueprints intimate Rauschenberg's full embrace of the art form in 1952, when he participated in John Cage's *Theatre Piece #1,* choreographed by Merce Cunningham at Black Mountain.

Even though Black Mountain nurtured some of the most esteemed American artists, Rice asserted at its inception, "It is not expected that many students will become

artists; in fact, the college regards it as a sacred duty to discourage mere talent from thinking itself genius."[29] According to Howard Dearstyne, an American who was both Albers' Bauhaus student and Black Mountain colleague, this attitude aligned with Albers' own practice as he never used the word art.[30] For Albers, art was life, and rather than distinguish the two, he sought to make art part of everyday living. By importing the Bauhaus' experiential art pedagogy to Black Mountain, Albers fostered the development of skills that students could apply to all aspects of their lives. He especially focused on educating students in the processes of perceiving and creating art because, he reasoned, "artistic seeing and artistic living are a deeper seeing and living."[31] With a new perspective and approach to art, shaped by Bauhaus thought and practice, Rauschenberg and Weil revisited her childhood pastime of blueprint-making, and in doing so, reconceptualized the photogram by incorporating the entire human body to produce a painterly document of a lived experience that challenges the viewer to see the world differently. For Rauschenberg, the blueprints were the first of several series in which, inspired by his surroundings, he reimagined the forms art could take. While Albers may not have recognized it at Black Mountain, Rauschenberg was the "open-eyed and open-minded" student he desired:

> a youth with criticism enough to recognize that [...] some great art important to our parents does not say anything to us [...] We want a student who sees art [...] as a spiritual documentation of life; one who sees that real art is essential life and essential life is art.[32]

Vaporous Fantasies and Bauhaus Specters

While most of Rauschenberg's work seemingly bears no stylistic affinity with that of Albers', there is one blueprint, *Fugue* (c. 1950), that resembles Albers' stark, geometrical aesthetic, if not his own work by the same German title, *Fuge* (1925) (Figures 8.1 and 8.2). *Fugue* is an anomaly among the blueprints because it is entirely abstract. Comprised of square shadows varying in intensity, it mimics the grid structure of Albers' work, a sandblasted-glass painting composed of black and white rectilinear color bars, rhythmically spaced against a red background. Rauschenberg and Weil may very well have seen Albers' *Fuge* at Black Mountain since three versions exist, and at least one remained in Albers' possession throughout his lifetime.[33] The Bauhaus master believed abstraction and avoiding personal expression were necessary for art to become universal. Hence, in order to erase evidence of the artist's hand, he developed the process of sandblasting flashed-glass to seamlessly fuse multicolored pieces into one structure.[34] Although Rauschenberg did not fully embrace abstraction, like his teacher he sought to detach himself from his art, and he found in the blueprint a means to do so, explaining, "if I drew an image like the shadows in my photogra[m]s [...] [e]very line would draw my own limitations into it. There aren't any limitations in what is actually there."[35]

Aside from photographs, most of Albers' art is abstract, with the notable exception of *Glove Stretchers III* (1928). Another sandblasted glass work, it is also a prime example of Albers' interest in optical illusions and suggests a connection between his students' blueprints and the New Vision. Developed by Moholy-Nagy at the Bauhaus, this revolutionary theory proposed that photography, especially the photogram, could enhance visual perception and create new perspectives. Albers appeared

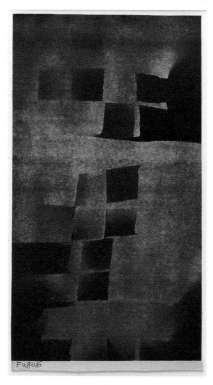

Figure 8.1 *Fugue* from Blueprint Portfolio, Robert Rauschenberg and Susan Weil, cyanotype, the Menil Collection, Houston, Texas, purchased with funds from the George R. Bunker Living Trust (1997-06.05 DJ), c. 1950. © 2021 Robert Rauschenberg Foundation/Licensed by VAGA at Artists Rights Society (ARS), NY.

Figure 8.2 *Fuge,* Josef Albers, sandblasted flash glass with black paint, the Josef and Anni Albers Foundation, Bethany, Connecticut, c. 1926. © 2021 The Josef and Anni Albers Foundation/Artists Rights Society (ARS), New York.

Figure 8.3 Untitled, László Moholy-Nagy, gelatin silver print, Los Angeles County Museum of Art, Ralph M. Parsons Fund (M.86.23), 1926. © 2021 Estate of László Moholy-Nagy/Artists Rights Society (ARS), New York.

to acknowledge the New Vision in *Glove Stretchers III*, which looks similar to Moholy-Nagy's 1926 photogram of a hand and overlapping grill-like apparatuses (Figure 8.3). Albers' glass painting depicts three hand-shaped forms: one a solid white, another black with a white outline, and the third a mixture of the first two. These are suspended at various heights against a uniform background of diagonally parallel gray and black lines. The black lines change to gray as they overlap with the gloves, making it ambiguous as to whether the gloves should be perceived as on top or beneath the lines, much like the grills and hand in Moholy-Nagy's work. Such optical incongruity is easily generated in a photogram since it does not replicate the pictorial convention of one-point perspective; as Moholy-Nagy observed, the photogram is "governed by optical laws peculiar to itself."[36] Instead, the light-sensitive medium captures the abstract effects of light obstructed rather than reflected by objects, defamiliarizing them and their space. Rauschenberg and Weil exploit this phenomenon in their blueprints, creating otherworldly images that *Life* described as "vaporous fantasies."[37]

MoMA's "Abstraction in Photography" exhibition also highlighted the abstract qualities of the young couple's blueprints by displaying *Female Figure* despite the discernible presence of a female nude. Moholy-Nagy demonstrated that all photography is to some extent abstract; even pictures that appear to reproduce their subjects

faithfully are still flat, two-dimensional translations of the real world.[38] He coined the term photogram to underscore the medium's elemental role in photography and visual literacy, proclaiming, "The illiterate of the future will be the person ignorant of the use of the camera as well as of the pen."[39] Since photograms directly record light phenomena without the mediation of a camera, they expose the artifice of their creation, which camera photography conceals in its reflective nature. Albers was also skeptical of photography as a reproductive device, and it is this skepticism, especially of one's knowledge of the visual world, that he imparted to his students, and which Rauschenberg and Weil capture in their blueprints.[40]

Albers generated the tension he saw between appearances and actuality in his sandblasted-glass paintings, almost half of which he executed solely in the black-white-and-gray color palette of the photography of the time.[41] Through sharp contrasts of positive and negative forms, he activated the *negativa*, his own description of the form-creating protentional in negative values, such as surrounding spaces.[42] Albers might have encountered this concept in Itten's class, where students explored the compositional dichotomy between negative and positive values through light and dark contrasts. In *Design and Form: The Basic Course at the Bauhaus*, published in 1963, Itten detailed an exercise in chiaroscuro in which students learned that a circle drawn on white paper only appears to be white when its surrounding space is made a darker tone.[43] It also seems that Lao Tzu's eleventh saying from the *Tao Te Ching* impacted how both Bauhaus masters saw form-creating potential in voids. In their writings, they each reference the passage, which poetically conveys the significance of the immaterial in material constructions. Itten prominently concluded the introduction to his book with this quote, signaling its importance to Bauhaus design principles:[44]

Thirty spokes meet at the hub,
But the void within them creates the essence of the wheel.
Clay forms pots,
But the void within creates the essence of the pot.
Walls with windows and doors make the house,
But the void within them creates the essence of the house.
Fundamentally:
The material contains utility,
The immaterial contains essence.

It is precisely the absence of light, one of the creative materials in the photogram process, that produced the forms in Rauschenberg and Weil's blueprints. In making these images, the artists arranged objects on photosensitive paper, creating shadows that developed as white forms, while the surrounding spaces exposed to light became dark blue. One can see parallels in Rauschenberg's coursework for Albers, *This Is the First Half of a Print Designed to Exist in Passing Time* (1948), suggesting his familiarity with the *negativa* concept. In this compilation of prints, Rauschenberg methodically carved lines into a woodblock, printing the block after cutting each line. The negative values created by the removal of wood produced positive values of white forms that appear to emerge from the printed black backgrounds. One could say that he had a similar objective in mind when he infamously erased Willem de Kooning's drawing in 1953 since he claimed he did so to see if

he could make a drawing through erasure.[45] Rauschenberg's awareness of the photogram process and the value of *negativa* also seem to have informed his camera work, giving credence to Moholy-Nagy's assertion, "Whoever obtains a sense of writing with light by making photograms without a camera, will be able to work in the most subtle way with the camera as well."[46] Indeed, Rauschenberg's photographs explored optical effects like double exposure, a technique he first used in the blueprints.

While Albers may not have directly taught Rauschenberg about photograms and photography, he valued these media as important educational tools, and records exist of their use in *Werklehre* exercises. A 1928 cyanotype made in his preliminary course by former Bauhaus student Charlotte Voepel-Neujahr illuminates Rauschenberg and Weil's artistic innovation (Figure 8.4). Exposed to a likely static source of light, Voepel-Neujahr's photogram captures a variety of geometrical and manmade forms, which appear to include gauze, nails, and wire mesh. Lacking a sense of formal cohesion, the image looks more like a technical study, especially when compared with a still-life blueprint the American artists made during their *Life* photoshoot (Figure 8.5). The young couple seem to have better heeded Albers' guidance to create "interesting" relationships among the more whimsical yet still disparate materials of leaves, netting, lace, and keys. For instance, the teardrop-shaped leaves share a formal affinity with the lace's curved edges and keys' curvilinear handles. The netting,

Figure 8.4 Exercise for preliminary course taught by Josef Albers, Charlotte Voepel-Neujahr, cyanotype, Bauhaus Archiv Berlin, c. 1928. © Cecilia Neujahr-Schoemann.

Figure 8.5 Untitled cyanotype, Robert Rauschenberg and Susan Weil, whereabouts unknown, 1951. © 2021 Robert Rauschenberg Foundation/Licensed by VAGA at Artists Rights Society (ARS), NY.

which overlaps with many of these elements, also lacks rigidity, appearing to float in the blue vapor that consolidates the forms. Furthermore, the handheld sunlamp allowed the artists to manipulate the light's concentration on different areas of the blueprint, creating a more nuanced composition than would have been afforded by a static light source. This dynamic generated the ethereal forms that seemingly emerge from a haze rather than stark darkness, unifying the image.

Albers encouraged students to practice artistic economy by working with available materials, often leading them into the surrounding woods to collect leaves and twigs for *matière* exercises.[47] This lesson appears to manifest itself in the blueprints since *Life* reported that the artists salvaged leaves, ferns, and other objects from a florist's shop. Discovering the possibilities of nontraditional art materials with Albers also made trash duty enjoyable for Rauschenberg and Weil, who performed the task as part of their college community contribution. Weil remembered, "We'd go to the dump, and it was like playtime! I mean, Bob was that way in the rest of his life, you know, having so much happiness in the dump!"[48] Rauschenberg's work with found objects earned him notoriety, and this practice started with the blueprints. Artistic economy is also a quality inherent in the photogram since only the paper is not reusable, and as *Life* highlights, "Blueprints are cheap to make. Ten-yard roll of paper costs about $1.75 [sic]."[49] Albers' lessons in thrift emerged from his early practice as a

Bauhaus student, when Germany's postwar economic devastation produced art supply shortages. This prompted Albers' own trash excursions, from which he created his first significant series, the *Scherbenbilder* (shard pictures) around 1921.[50] These compositions of shards of colored glass, metal, mesh, and other detritus are precursors of Rauschenberg's Combines, found-matter assemblages that blur the divide between painting and sculpture.

In the *Scherbenbilder*, Albers incorporated the effects of "direct light" and material transparency, elements that also factored greatly into Rauschenberg and Weil's blueprints.[51] Experiments in light and transparency were fundamental to the New Vision and informed the Bauhaus' influential pedagogical approach to material analysis and visual perception. For Moholy-Nagy, who similarly sought to paint with light directly in space, reconsideration of the photogram was "a technical first stage" in the creation of "new space relationships."[52] In their blueprints, Rauschenberg and Weil wielded the sunlamp like a paintbrush, controlling the light's effect by varying its intensity and exposure, in addition to strategically deploying materials with different degrees of transparency. Consequently, they produced images that are more complex than they seem.[53] For example, in *Sue* (c. 1950), Weil appears to have been captured in a windswept moment, holding onto her cane as her sheer skirt flares out behind her (Figure 8.6). In reality, the artists exposed Weil's skirt separately to

Figure 8.6 Sue, Robert Rauschenberg and Susan Weil, cyanotype, private collection, c. 1950. © 2021 Robert Rauschenberg Foundation/Licensed by VAGA at Artists Rights Society (ARS), NY.

reproduce its pleating and top edge, which her body would have obscured had they produced the image in one exposure. *Sue* has the illusion of an x-ray and anticipates Rauschenberg's *Booster* (1967), a silkscreen that reprints a real, full-body x-ray of the artist. Rauschenberg more directly alluded to the blueprints' significance in his practice by embedding a small copy of *Female Figure* into his Combine *Odalisk* (1958), a work featuring images of influential women in his life. He also inserted electrical lights into this Combine and several others, describing the effort as, "Trying to make the light come from the painting."[54] Throughout his oeuvre, Rauschenberg maintained an interest in light and transparency that is also notably evident in the series *White Paintings* (1951) and *Carnal Clocks* (1969), the latter of which exude a similar x-ray sensation to the blueprints.

Despite transparency's connotation of clarity, the photogram illuminates a distinction between material transparency and the more ambiguous illusionistic transparency, and a dialectic between the two emerges in Rauschenberg and Weil's blueprints.[55] For example, in the making of *Sue*, Weil's sheer skirt was literally transparent unlike the opacity of her physical body. However, in the blueprint, their pictorial forms both appear transparent because of the spatial ambiguity generated by staggering their exposures. The photogram's ability to create "perspectives of a hitherto wholly unknown morphosis" is exactly why Moholy-Nagy championed it as "the most completely dematerialized medium which the new vision commands."[56] According to him, he arrived at the photogram technique of altering spatial and material appearances by studying Cubist collages and Kurt Schwitters' *Merzbilder*.[57] This strengthens the connection between the Bauhaus and Rauschenberg, with the blueprints as the crucial link.

Although early critics were quick to describe Rauschenberg as a "latter-day Schwitters" and his Combines as "paraphrases of Cubist collage," the reasons for such comparisons have been less apparent.[58] In fact, there was an inherent relationship fostered by Albers, whose practice and pedagogy assimilated New Vision ideas. His *matière* exercises, which taught students how to "swindle" material appearances, were consonant with Schwitters' belief that "a significant art product" should no longer bear "an outward relationship to the material elements that formed it."[59] Despite differing objectives – Schwitters sought to keep painting "a self-related entity," whereas Albers solicited viewer participation through optical illusions – the *matières* as well as the blueprints "dematerialized" found objects in a manner akin to the *Merzbilder*. As Schwitters described, "By being balanced against each other, these materials lose their characteristics - their personality poison."[60] The photogram takes the process further, sublimating almost all material and complicating perspective beyond logical comprehension. Thus, the blueprints demand a level of viewer engagement that negates the artwork's autonomy, a concept central to Rauschenberg's Combines. Schwitters' influence on the New Vision, which in turn impacted the work and teachings of Moholy-Nagy and Albers, and, as a result, Rauschenberg's practice, was acutely perceived by the rising artist, who, after first seeing a *Merzbild* in 1953, exclaimed, "I felt like he made it all just for me."[61] Scholars underscore this moment in the Combine's evolution; yet the blueprints indicate that Albers planted the seeds for these ideas in Rauschenberg's mind already at Black Mountain.[62]

The young American's revelatory encounter with Schwitters' *Merzbild* occurred at the Sidney Janis Gallery, where Marcel Duchamp organized "Dada 1916–1923," an exhibition surveying the subversive avant-garde movement to which Rauschenberg's

work has often been compared. Labeled neo-dada and neo-avant-garde, the Combines appear to have revived dada's renegade tactics with an Oedipal assault on modernism. However, Rauschenberg consistently denied such interpretations, asserting that his approach was "not out of any negative response" nor "any resistance to the abstract expressionists."[63] Instead, his explanations for using found objects echoed Albers' directives to create a "spiritual documentation of life" and avoid self-expression: "I don't want my personality to come out through the piece," Rauschenberg said. "I want my paintings to be reflections of life."[64] Avoiding self-expression, which, noted previously, informed the blueprints, also prompted Rauschenberg's *White Paintings* (1951), the series of white canvases devoid of painterly expression that inspired Cage's *4'33"* (1952).

Rauschenberg attributed Albers' demonstration of color's inherent subjectivity as the catalyst for his *White Paintings*, and, while less intuitive, these lessons were also important to the blueprints for elucidating illusionistic transparency.[65] "Color is almost never seen as it really is," Albers asserted, since one color can look like a different color depending on its compositional relationship with other colors.[66] Colors can also generate spatial illusions of depth and transparency in two dimensions, like a photogram. Albers was revolutionary in applying these principles to abstract compositions, working methodically to explore variations on formal themes in a serial practice that culminated with the *Homages to the Square* (c. 1950–76). In addition to proving color's relativity, Albers' art complicates traditional notions of transparency, transcending a literal state defined by material condition and overlapping planes to a visual phenomenon produced by the abstract juxtaposition of flat, opaque forms. Deceptively simple, his paintings present the viewer with the same great challenge that guided his teaching practice: to distinguish physical fact from optical illusion. This is also the photogram's intrinsic proposition, which Rauschenberg and Weil appear to have grasped as they tinkered with the blueprints.

Both artists have underscored the importance of the color course that Albers designed and instituted at Black Mountain, drawing from methodologies previously formulated at the Bauhaus.[67] Departing radically from theoretical dogma, Albers' lessons centered on the direct observation of color's behavior through *Werklehre* experiments. Students handled color as a "working material," examining its properties by experimenting with colored paper arrangements, similar to the color contrasts in Itten's class.[68] Additionally, variations on Albers' now-iconic square-in-square format appear in the work of Wassily Kandinsky and Ludwig Hirschfeld-Mack, the latter of whom taught an extracurricular color workshop at the Bauhaus.[69] However, perhaps most significant to the development of Rauschenberg's practice and the blueprints were Albers' color lessons that emulated Paul Klee's theories and teachings on pictorial formation (*Gestaltung*), especially those that concerned the observation and production of painterly optical phenomena, like illusionistic transparency. Albers assimilated these ideas when he coordinated preliminary exercises with Klee's *Gestaltungslehre: Form*.[70]

Gestaltung is analogous to painterly composition, and like other Bauhaus painters, Klee, who was also a violinist, drew from music theory to define its basic elements and rules. Abstract painters particularly derived inspiration from music, which, abstract by nature, has a well-established annotation system with notes, scales, and other conventions that guide the formation of musical compositions. Albers professed, "there are musical qualities in all art" because "every art work is built (i.e., composed), has

order, consciously or unconsciously," a sentiment Rauschenberg shared in "Random Order," a 1963 photo-essay illuminating his practice of assemblage and collage.[71] In rationalizing a color system, Klee, Albers, and their Bauhaus colleagues reflected upon Goethe's observation that, "painting has long lacked knowledge of the *Generalbass;* it lacks an established, accepted theory as exists in music."[72] Popularized during the Baroque era by Bach's fugues, *Generalbass* (thoroughbass) notates for chord instruments the appropriate tonal range for the bass line's harmonic accompaniment. Applied to painting, *Generalbass* seeks to establish its irreducible formal elements and the guidelines with which to arrange them in balanced compositions. This notion was fundamental to understanding color's behavior through contrasts since, as a type of counterpoint, a fugue sets one tone against another to form a harmony. Itten, whose color-contrast exercises set the template for Albers' instruction, also likened his 1921 twelve-point color star to the twelve-tone chromatic music scale, remarking, "I must see my twelve tones as precisely as a musician hears the twelve tones on his chromatic scale."[73]

Defining painting's *Generalbass* advanced pictorial formation's Gestalt interpretation, especially for Klee, whose view of painting as the harmonious composition of basic formal elements informed Albers' instruction and hence Rauschenberg's perception of art. "The picture is the whole;" Klee asserted, "the parts should be evaluated in relation to the whole, that is, in relation to the picture."[74] Philosopher Christian von Ehrenfels first applied Gestalt theory to music and auditory perception in his 1890 foundational text "On 'Gestalt Qualities'" ("Über 'Gestaltqualitäten'"), arguing that a melody is more than the sum of its constituent tones as it develops over time.[75] Like music, Klee considered painting a temporal art, a living expression and experience "connected with movement," and for this reason he preferred the term *Gestaltung* as opposed to *Formung* because it "contains the idea of underlying mobility" and "emphasizes the paths that lead to form rather than the form itself."[76] In Black Mountain's 1934 prospectus, Albers reiterated *Gestaltung's* importance to art instruction: "By making an extended study in the main provinces of form; namely shape, material, and color, we provide a broad foundation for [...] creative, productive possibilities (*Gestaltungstrieb*)."[77] In addition to cultivating a fundamental understanding of pictorial formation, Albers' exercises underscored art's process and thus *Gestaltung's* temporal component, a facet reflected by how Rauschenberg and Weil staggered blueprint exposures to create illusionistic transparency. They examined this visual phenomenon in Albers' color lessons that drew upon Klee's "transparent polyphony," his method for articulating time's dimension pictorially with color contrasts that produced spatial "interpenetration" from their illusion of transparency.[78] Inspired by musical polyphony, Klee sought to create in painting the "multi-dimensional phenomenon" of a fugue, which he believed eliminated time's linear progression by simultaneously playing different melodies to form a harmony.[79] Similarly, transparent polyphony manipulates spatial representation through color contrasts that create the "simultaneous view of many dimensions."[80] Moholy-Nagy also championed this painting approach in the *New Vision*, writing "The use of transparencies, the ability of the colors to change with the subtlest differentiation through a nearby color, etc., enriches considerably the scope of new space relationships."[81] Likewise, Albers' works and teachings demonstrated that, like a fugue's counterpoint, individual colors are interdependent on their form and placement in a painting's composition.

Figure 8.7 Fugue in Red, Paul Klee, watercolor and pencil on paper on cardboard, private
collection on extended loan to Zentrum Paul Klee, Bern, 1921. Photo: Zentrum
Paul Klee Image Archive.

Klee's application of music theory to develop painting's *Generalbass* was so pre-
cise, he produced as a byproduct a system for the pictorial translation of music,
the remnants of which are visible in Rauschenberg and Weil's blueprint, *Fugue.*
Illustrating his concept of transparent polyphony, Klee's *Fugue in Red* (1921) is also
a visualization of musical counterpoint, which he described as, "Rhythmic articu-
lation combined with tonal movement in the realm of color" (Figure 8.7).[82] Painted
in watercolor, a fluid medium that evokes movement and probably helped create the
illusion of transparency, the image contains multiple geometric and organic shapes,
suggestive of a fugue's independent melodies, which are colored in shades of red
and float against a black background. Spatial interpenetration and temporal shift
are represented by overlapping and repeating shapes that gradually change to darker
tones as the brightest seemingly advance to the right. In 1922, Klee began assign-
ing Bauhaus students the task of graphically transcribing the Adagio movement's
opening two measures from Bach's Sonata for violin and harpsichord in G major
(BWV 1019), whereby horizontal rectilinear bars in the form of a music staff and
ledger lines represented the fugue's individual tones.[83] In addition to the prelimi-
nary course, Albers taught the glass painting workshop alongside Klee's form lessons,
likely inspiring his glass painting *Fuge* (1925) and, consequently, Rauschenberg and
Weil's *Fugue.*
 Apart from the obvious titular connection, the arrangement of rectilinear shapes in
Albers' *Fuge* shares a formal affinity with the grids produced in Klee's transcription

exercise. The glass painting's color palette of red, white, and black is also the same as Klee's *Fugue in Red*, and similarly generates transparent polyphony through its rhythmic arrangement of colors and shapes. Unlike the *Scherbenbilder*, which Albers designed for placement in front of windows so that light could shine through the translucent glass shards, Albers flashed and sandblasted opaque glass for *Fuge* since he intended it to hang on a wall. Hence, transparency in *Fuge* is purely an illusion perceived by its formal arrangement and any light reflecting off its surface. The work's sheen especially belies its opacity since glass is a medium typically associated with transparency. Hence, it deceives the eye in multiple ways, exemplifying one of Albers' primary artistic and instructional objectives. In interviews, he reiterated, "my teaching was not teaching art directly. It was a kind of philosophy to train a thinking in art."[84] Commenting upon the holistic experience he hoped students would have by studying art, Albers said, "we at Black Mountain are content when our student, for instance, sees a connection between a modern picture and music by Bach."[85] Rauschenberg and Weil appear to make this connection in their blueprint *Fugue*, which, while monochromatic, suggests spatial interpenetration and temporal shift pictorially by the rhythmic arrangement of repetitive floating squares with varying degrees of apparent transparency, much like Klee's *Fugue in Red*.

Recognizing that art, like language and music, is a form of communication, Albers asserted that its aim should be the "revelation and evocation of vision."[86] Generating new perspectives was a common motivation among the Bauhaus artists who sought to create a "new vision" and the "simultaneous view of many dimensions." Albers maintained that one's worldview connected to their ocular seeing.[87] Thus, in order to generate new thought perspectives, he believed it was necessary to "learn to see;" that is, to acquire "the ability to read the meaning of form and order."[88] His approach to teaching art was like that of language and literacy, which he underscored with linguistic rhetoric and analogies, saying, "There is no verbal communication before there are sounds of words with meaning. Similarly there is no writing before there is an alphabet. For the same reason there is no visual formulation before there is visual articulation."[89] For Albers, effective communication through art required knowledge of a medium's constituent formal properties and an exploration of the skills needed to articulate them. He remarked, "articulation is distinctive formulation," a relational description that recalls Moholy-Nagy's categorization of the photogram as elemental to photography and visual literacy.[90] Using the same Greek prefix photo, from *photos* meaning light, Moholy-Nagy adopted the suffix gram from *gramma* meaning alphabetic letter to distinguish it from *graphos* meaning writing. Visual literacy is essentially what Albers called "visual empathy," the "disciplined seeing and sensitive reading of form."[91] Teaching this, along with "self-control and mastery of medium and tools," is the discipline for which he became known and which Rauschenberg sought.[92]

At Black Mountain, Albers disseminated the idea of painting's *Generalbass* with the pictorial language developed at the Bauhaus, dedicating his color course to the observation and articulation of this most basic formal element. As he explained in its prospectus, "Sound production comes before speech, tone before music. And so at first we study systematically the tonal possibilities of colors, their relativity, their interaction and influence on each other. [...] We practice color tone scales, color mixtures and interpenetrations."[93] Fundamental to developing visual literacy, optical illusions were central to Albers' teaching, especially those generated by color's deceptive behavior,

such as transparent polyphony. He remarked, "One and the same color evokes innumerable readings," thus "to use color effectively it is necessary to recognize that color deceives continually."[94] For Rauschenberg, printed media became a relational formal element like color, subject to a "personal sense of looking" dependent upon its formal arrangement and the viewer's perception for interpretation. Conjuring Albers' color lessons, Rauschenberg explained,

> As the paintings changed, the printed material became as much of a subject as the paint, causing changes of focus and providing multiplicity and duplication of images. A third palette with infinite possibilities of color, shape, content and scale was then added to the palettes of objects and paint.[95]

The blueprint experiments Rauschenberg conducted with Weil the summer after studying with Albers were critical to developing his painterly approach to printed media because they fortified Albers' lessons in visual empathy, producing the first of many series for Rauschenberg concerned with multidimensional interpenetration and new perspectives. As a medium that alters spatial and material appearances, the photogram presented the artists with the opportunity to create works by combining concepts absorbed from Albers' color and *matière* exercises, a practice Rauschenberg continued throughout his career. Albers' color lessons stressed illusionistic transparency and spatial ambiguity, which are pictorial considerations the couple made in composing their blueprints. With Bauhaus thought and practice, work on this series primed Rauschenberg for the media saturation of postwar American consumer culture by guiding him to his forefathers' revelation that neither the photograph nor the supposed reality it captured were entirely transparent or without illusion.

Like Albers, Rauschenberg used similar linguistic terminology to describe his practice, as exemplified in the quote below, which is an excerpt from his 1963 "Note on Painting." Published the same year as "Random Order," the statement reinforces his practice with printed media through its interspersion of seemingly random words that disrupt the logical, linear progression of thought:

> The concept I *plantatarium* struggle to deal with *ketchup* is opposed to the logical continuity *lift tab* inherent in language *horses* and communication. My fascination with images *open 24 hrs.* is based on the complex interlocking of disparate visual facts *heated pool* that have no respect for grammar.[96]

Rauschenberg's desire to break free from grammar and the "logical continuity [...] inherent in language" is what the Bauhaus experimentation in photograms and color transparencies achieved visually by breaking the logic of one-point linear perspective to generate spatial interpenetration and new perspectives. Klee also lamented, "in language there is no way of seeing many dimensions at once," believing this could be overcome in music and art by polyphony.[97] He even declared, "Polyphonic painting is superior to music because its time is more spatial. The idea of simultaneity comes out more richly."[98] It is as if Rauschenberg continued the pursuit of this quest begun by the Bauhaus artists to make painting more spatial and dynamic with his Combines. Instead of illusionistically generating new space-time relationships, the Combines reconfigure the picture plane, entering the viewer's space to demand a prolonged engagement by deciphering meaning from the images and their random order.[99]

There is no singular understanding of a Rauschenberg Combine as there is no singular viewpoint in an Albers painting. To account for these multiple perspectives, Albers distinguished between "factual facts and actual facts," the latter of which may relate to Rauschenberg's notion of "disparate visual facts."[100] For Albers, actual facts are psychologically determined, whereas factual facts physically exist, and, according to him, the discrepancy between the two is the "origin of art."[101] Depending upon its formal placement, the perception of color could constitute an "actual fact," much like how the perception of an image in a Rauschenberg painting is a "disparate visual fact." In their own ways, both artists skillfully create a balance of compositional elements in dialogue with each other that demand concentrated viewing and analysis. Whereas Albers' work generates optical ambiguities, Rauschenberg's invokes multiple connotations. These develop not only from the formal relationships among the images and materials, but also the associations each viewer has with them and their iconography since everyone's lived experience is unique. As a result, people will make different associations with the objects and images in Rauschenberg's Combines, in a similar way to how people might see the colors differently in Albers' paintings.

From Albers' Dunce to His Protégé

Rauschenberg often candidly reflected upon his experience of studying with Albers, describing it as, "Total intimidation. Abuse."[102] He explained, "I was Albers's dunce, the outstanding example of what he was *not* talking about."[103] Weil also specifically recalled, "For one assignment involving leaves, Bob made a portrait of the music teacher's dog by carefully assembling the leaves. Albers had a fit - he wanted abstraction - he didn't want a dog!"[104]

While Albers may have admonished the representational and photographic imagery in Rauschenberg's art, the young American artist came to see it as a material in its own right beginning with his tactile approach to the blueprints. "Materialized image" is Rosalind Krauss' term for Rauschenberg's method of physically embedding found imagery into his paintings and Combines, which built upon Leo Steinberg's earlier observation that the works "no longer simulate vertical fields, but opaque flatbed horizontals."[105] Krauss claimed the "practice of materializing images had entered Rauschenberg's art through an earlier experience of materializing color," in which she is referring to his monochrome paintings of the early 1950s.[106] However, it is evident that Rauschenberg began materializing images from the start of his career when he first crafted the blueprints with Weil. Furthermore, with this series, the artist already started to address the physical nature of the picture plane, recording impressions of the objects layered upon the blueprint paper in a manner similar to the imprinting and embedding of images onto the canvas planes of his prints and Combines.

Like Krauss, Branden Joseph also foregrounds Rauschenberg's monochrome canvases in his early practice, contending that with the *White Paintings*, Rauschenberg brought Greenbergian high modernism to its logical end, ushering in "a new paradigm of avant-garde production."[107] Interestingly, in discussing this series, Joseph connects it with the New Vision and Moholy-Nagy; however, he only does so with regard to Cage's interpretation of the paintings, which, Joseph maintains, drew upon Moholy-Nagy's book, *The New Vision*.[108] Making no mention of Albers, Joseph fails to draw a more direct relationship between Rauschenberg's work and his exposure to

the New Vision as a student. Rather, he suggests that Rauschenberg's approach to the *White Paintings* came out of a "newfound engagement with the developmental logic of modernist painting," remarking, "Greenberg's specter hovers over Rauschenberg's observations."[109] While this may be true, by considering Rauschenberg's blueprints as integral to his early practice, a palpable presence of Bauhaus specters reveal themselves, which, as Joseph observes, Cage unwittingly perceived. Although no history is ever complete, overlooking Albers' influence produces an inadequate if not flawed understanding of Rauschenberg's neo-avant-garde practice, which, as the blueprints elucidate, is critically indebted to the Bauhaus.[110]

Despite Albers' criticism of his student, in 1967 he acknowledged the significant degree to which Rauschenberg's practice manifested his instruction:

> What he is doing now is much more a part of my classes he participated in than he will ever recognize. [...] we played a lot with combination of materials, 'combination' was a great word in our [vocabulary] – and changing surface qualities, [...] changing of articulation, that was a very exciting study at Black Mountain. And I think that is what lives on in his work now.[111]

As with many learning experiences, an inspiring teacher can have a profound impact on a student. So, it is not unusual that a student should absorb the lessons of a teacher, who has himself absorbed similar lessons from his own experience as a student.

What is remarkable about Albers' impact on Rauschenberg is how the young American adapted his teacher's instruction to create a strikingly new and different aesthetic. Tenets that inspired the Bauhaus' sleek, modern designs and Albers' stark, geometrical abstractions, *also* inspired Rauschenberg's amalgamations of disparate, found objects and popular imagery, which consequently rebuked abstraction's supremacy. As an institution that was founded to reject orthodoxy and dissolve the boundaries between art and craft, the Bauhaus instilled within its artists a refusal of traditional definitions of art. Perhaps it should not be surprising that Rauschenberg turned Albers' instruction on its head, and with it the modernist picture plane, in order to create the new ways of seeing that his teacher requested.

This chapter expands upon my earlier publication, "The 'Bauhaus Idea' in Robert Rauschenberg's Blueprints," *Cloud-Cuckoo-Land, International Journal of Architectural Theory*, Ute Poerschke and Daniel Purdy, eds. 24.39 (*Bauhaus Transfers*), 2019: 99–113. I am indebted to Sabine Kriebel, whose thorough and thoughtful feedback guided this chapter's development. Rosemarie Haag-Bletter, Gail Levin, and Shiraz Biggie offered critical insight and guidance, and the Albers and Rauschenberg Foundations, as well as the Western Regional Archives, were generously supportive. Additionally, I am grateful to Kathleen James-Chakraborty and the organizers and audiences of the 2019 Bauhaus Effects conference at the National Gallery of Ireland and Bauhaus Transfers symposium at Pennsylvania State University for creating the platforms and discussions that helped to shape this chapter. I would like to extend my thanks to both Hal Foster and Leah Dickerman, whose stimulating graduate seminar first sparked my interest in Rauschenberg and Weil's blueprints. In my forthcoming Ph.D. dissertation on Susan Weil, whom I have the privilege and pleasure of knowing, I examine this series further from her perspective.



Notes

1. Rauschenberg, in Barbara Rose, *Rauschenberg* (New York: Vintage Books, 1987) 23.
2. Report cards for Milton [Robert] Rauschenberg, Black Mountain College 1948–49. See Leah Dickerman, "Disciplined by Albers," *Robert Rauschenberg*, Dickerman and Achim Borchardt-Hume, eds. (New York: The Museum of Modern Art, 2016) 39 and footnote 26.
3. Walter Hopps. *Robert Rauschenberg: The Early 1950s.* (Houston: The Menil Collection/Houston Fine Art Press, 1991) 25.
4. Rauschenberg, in Calvin Tomkins, *The Bride & Bachelors: Five Masters of the Avant-Garde* (New York: Viking Press, 1968) 199.
5. Rose, *Rauschenberg*, 3.
6. Gropius, letter to Tomás Maldonado, November 10, 1964. See Nicole Colin, "Bauhaus Philosophy," *Bauhaus*, Jeannine Fielder and Peter Feierabend, eds. (Cologne: Könemann Verlagsgesellschaft mbH, 1999) 22.
7. Brenda Danilowitz, "Teaching Design," in *Josef Albers: To Open Eyes*, Frederick Horowitz and Brenda Danilowitz, eds. (London: Phaidon Press Limited, 2006) 21 and footnote 66.
8. JoAnn C. Ellert, "The Bauhaus and Black Mountain College," *The Journal of General Education* 24.3 (1972): 144–52.
9. Rice, in Louis Adamic, *My America: 1928–1938* (New York: Harper & Brothers, 1938) 637.
10. Albers, interview, November 11, 1967. See Danilowitz, "Teaching Design," 35.
11. Albers, "Concerning Art Instruction," *Black Mountain College, Bulletin* 2 (June 1934): 2.
12. Itten, "Preliminary Course, Weimar," in *Bauhaus: 1919–1928*, Herbert Bayer, Walter Gropius, and Ise Gropius, eds. (New York: Museum of Modern Art, 1938) 36.
13. Albers, *Interaction of Color*, 50th Anniversary Edition (New Haven: Yale University Press, 2013) 2.
14. John H. Holloway and John A. Weil, "A Conversation with Josef Albers," *Leonardo* 3 (1970): 459; and Albers, "Concerning Art Instruction," 4.
15. Rauschenberg, in Calvin Tomkins, *Off the Wall: A Portrait of Robert Rauschenberg* (New York: Picador, 2005) 29.
16. Itten, *Design and Form: The Basic Course at the Bauhaus and Later*, trans. John Maass (1963. New York: Reinhold Publishing Corporation, 1964).
17. Influenced by constructivism's *faktura*, Albers distinguished material studies (*Materialstudien*) from matter studies (*Materienstudien*), such that the former focused on the structural and constructive nature of materials, while the latter emphasized the appearance and feeling of texture.
18. Albers, "Teaching Form Through Practice," trans. Frederick Amrine et al., *Josef Albers: Minimal Means, Maximum Effect*, eds. Nicholas Fox Weber et al. (Madrid: Fundación Juan March, 2014) 213.
19. Albers, "Concerning Art Instruction," 5.
20. Horowitz, "Albers the Teacher," Horowitz and Danilowitz, *Josef Albers*, 125–30.
21. Ibid., 89.
22. Albers, "Concerning Art Instruction," 5.
23. Ibid.
24. Albers, "Teaching Form Through Practice," 211.
25. Weil, "My Blue Journey," *Susan Weil: Moving Pictures*, Paula Gribaudo, ed. (Milan, Italy: Skira Editore, 2010) 10.
26. See Tomkins, *Off the Wall*, 49.
27. Kirkland, "Speaking of Pictures..." *LIFE* 30 (April 9, 1951): 22–24. At least two models appear in archival photographs, but only one makes it into the spread. My earlier essay mistakenly states Pearman was the *Life* model, which she was not.
28. Martha Holmes, "Jackson Pollock," *LIFE* 27 (August 8, 1949): 42–45. My earlier essay mistakenly attributes the photographs to Hans Namuth.
29. Rice, in Adamic, *My America*, 646.
30. Dearstyne, *Inside the Bauhaus*, David Spaeth, ed. (New York: Rizzoli International Publications, 1986) 92.
31. Albers, "Art as Experience," in Weber et al, *Josef Albers*, 231.
32. Ibid., 232.

33. Wilfrid G. Hamlin described Black Mountain's décor, stating, "Paintings were put up often, or weavings. There was a lot of Albers work around, Josef Albers's paintings and Anni Albers's tapestries." Martin Duberman, *Black Mountain: An Exploration in Community* (New York: Dutton, 1972) 65. In an email to me on July 6, 2020, Brenda Danilowitz, Chief Curator of the Josef and Anni Albers Foundation, stated, "*Fugue* was one of the works that traveled to the US with Albers in 1933 and ... it remained in his possession throughout his life."
34. See Josef Albers et al., *Josef Albers Glass, Color, and Light* (New York, NY: Guggenheim Museum, 1994).
35. Rauschenberg, in Rose, *Rauschenberg*, 72. While clearly discussing the blueprint photograms, Rauschenberg accidentally called them photographs.
36. László Moholy-Nagy, "A New Instrument of Vision," in Krisztina Passuth, *Moholy-Nagy* (New York: Thames and Hudson, 1987) 326.
37. Kirkland, "Speaking of Pictures," 23.
38. See Susan Laxton, "Moholy's Doubt," in *Photography and Doubt*, Sabine T. Kriebel and Andrés Mario Zervigón, eds. (London: Routledge, 2016) 148.
39. László Moholy-Nagy, "Photography Is Creation with Light," in Passuth, *Moholy-Nagy*, 303.
40. Albers, "Photos as Photography and Photos as Art," in Sarah Hermanson Meister, *One and One Is Four: The Bauhaus Photocollages of Josef Albers* (New York: The Museum of Modern Art, 2016) 130.
41. See Hermanson Meister, *One and One Is Four*, 17.
42. Albers, "Teaching Form Through Practice," 212.
43. Itten, *Design and Form*, 19.
44. Ibid., 18. Albers discussed Lao Tzu's eleventh saying in letters to Franz Große-Perdekamp. See Danilowitz, "Teaching Design," 19–21 and footnote 65.
45. See Calvin Tomkins, "Profiles: Moving Out," *New Yorker* 40 (February 29, 1964): 66.
46. Moholy-Nagy, "Photography Is Creation with Light," 303.
47. See Horowitz, "Albers the Teacher," 127.
48. Weil, "The Reminisces of Susan Weil," *The Rauschenberg Oral History Project* (Columbia University: Center for Oral History, 2014), 27.
49. Kirkland, "Speaking of Pictures," 24.
50. See Margit Rowell, "On Albers' Color," in Weber et al., *Josef Albers*, 346.
51. Ibid.
52. László Moholy-Nagy, *The New Vision and Abstract of an Artist* (New York: Wittenborn, Schultz, 1947) 39.
53. Michael Lobel, "Lost and Found: Michael Lobel on Susan Weil and Robert Rauschenberg's Blueprints," *Artforum International* 54.6 (2016): 184–97.
54. Rauschenberg, in Rose, *Rauschenberg*, 56.
55. Robert Slutzky, a painter and Albers' student at Yale (1951–54), and Colin Rowe, an architectural historian, first articulated this distinction in their essay "Transparency: Literal and Phenomenal." The former describes an "inherent quality of substance" and the latter "an inherent quality of organization." However, I refrain from using their terms, which entail more specific criteria for categorization. Rowe and Slutzky, "Transparency: Literal and Phenomenal," *Perspecta* 8 (1963): 45–54. See also Tom Steinert, "Transparency," *Cloud-Cuckoo-Land* (*Bauhaus Transfers*): 81–98.
56. Moholy-Nagy, "A New Instrument of Vision," 326.
57. Moholy-Nagy, "Under the influence of cubist collages, Schwitters' 'Merz' paintings and dadaism's brazen courage, I started out with my photomontages, too. This led me in the same period to the rediscovery of the technique of the photogram (cameraless photography)." Moholy-Nagy, *The New Vision*, 72.
58. Barbara Rose addresses this criticism in *American Art Since 1900: A Critical History* (New York: Frederick A. Praeger, Inc., Publishers, 1967) 217.
59. Schwitters, in Sibyl Moholy-Nagy, *Moholy-Nagy: Experiment in Totality* (New York: Harper & Brothers, 1950) 24.
60. Ibid.
61. D. G. Seckler, "The Artist Speaks: Robert Rauschenberg," *Art in America* 54 (May-June 1966): 74

62. See Leah Dickerman, *Rauschenberg: Canyon* (New York: Museum of Modern Art, 2013) 12–14.

63. Rauschenberg in Rose, *Rauschenberg*, 51.

64. Ibid, 72.

65. Rauschenberg, "When Albers showed me that one color was as good as another and that you were just expressing a personal preference if you thought a certain color would be better, I found that I couldn't decide to use one color instead of another, because I really wasn't interested in personal taste. [...] That's why I ended up doing the all-white and all-black paintings," in "Statement on Josef Albers," undated, Robert Rauschenberg Foundation Archives, A607.

66. Albers, *Interaction of Color*, 1.

67. See Weil, "My Blue Journey," 10.

68. Albers, "Concerning Art Instruction," 6. See also Itten, *The Art of Color* (New York: Van Nostrand Reinhold, 1961).

69. Horowitz, "Albers the Teacher," 196–97.

70. Oral history interview with Josef Albers, June 22–July 5, 1968. Archives of American Art, Smithsonian Institution.

71. Albers, "Art as Experience," 231. Robert Rauschenberg, "Random Order," *Location* 1.1 (Spring 1963): 27–31.

72. Goethe: "In der Malerei fehle schon längst die Kenntnis des Generalbasses, es fehle an einer aufgestellten, approbierten Theorie, wie es in der Musik der Fall ist" (1807). *Goethe im Gespräch*, F. Deibel and F. Gundelfinger, eds., 3rd edition (Leipzig: Insel-Verlag, 1907) 94. See also Paul Klee, *Notebooks: Volume 1, The thinking eye*, Jürg Spiller, ed., trans. Ralph Manheim (1961. London: Lund Humphries, 1973) 467. See also Wassily Kandinsky, *Concerning the Spiritual in Art*, in *Kandinsky: Complete Writings on Art*, Kenneth C. Lindsay and Peter Vergo, eds. (Boston, MA: G.K. Hall & Co., 1982) 197.

73. Itten, *The Art of Color*, 34.

74. Klee, *Notebooks: Volume 1*, 47.

75. Christian Ehrenfels, "On 'Gestalt Qualities,'" in *Foundations of Gestalt Theory*, Barry Smith, ed. and trans. (Munich and Vienna: Philosophia Verlag, 1988) 82–116.

76. Klee, *Notebooks: Volume 1*, 24 and 17.

77. Albers, "Concerning Art Instruction," 7.

78. Klee, *Notebooks: Volume 1*, 157 and 85–86.

79. Ibid., 519, note for 380.

80. Ibid., 86.

81. Moholy-Nagy, *The New Vision*, 39.

82. Klee, *Notebooks: Volume 1*, 490.

83. Ibid., 285–87. See also Stephanie Probst, "Pen, Paper, Steel: Visualizing Bach's Polyphony at the Bauhaus," *Music Theory Online* 26.4, December 2020. https://mtosmt.org/issues/mto.20.26.4/mto.20.26.4.probst.html

84. Albers, interview, June 22–July 5, 1968, 12.

85. Albers, "Art as Experience," 232.

86. Albers, "The Origin of Art," in Weber et al., *Josef Albers*, 253.

87. Albers, *Search Versus Re-Search: Three Lectures by Josef Albers at Trinity College, April 1965* (Hartford, CT: Trinity College Press, 1969)17.

88. Ibid., 23 and 10.

89. Ibid., 10.

90. Albers, "Art at Black Mountain College" (1946), in Weber et al, *Josef Albers*, 264.

91. Ibid.

92. Ibid.

93. Albers, "Concerning Art Instruction," 6.

94. Albers, *Interaction of Color*, 1.

95. John Cage, "On Robert Rauschenberg, Artist, and His Work," in *Silence. Lectures and Writings, 50th Anniversary Edition* (1961. Middletown, CT: Wesleyan University Press, 2011) 99.

96. Rauschenberg, "Note on Painting," in John Russell and Suzi Gablik, *Pop Art Redefined* (New York: Praeger Publishers, 1969) 101. Rauschenberg's originally handwritten text

is uniform style; however, for the sake of clarification, the "random" words are italicized in my chapter.

97. Klee, *Notebooks: Volume 1*, 86.
98. Klee, *The Diaries, 1898–1918*, Felix Klee, ed. (1964. Berkeley/Los Angeles: University of California Press, 1992), 374.
99. Leo Steinberg was among the first critics to expound upon the change in nature of the picture plane in Rauschenberg's Combines, noting "the painted surface is no longer the analogue of a visual experience of nature but of operational processes." Leo Steinberg, "Reflections on the State of Criticism," in *Robert Rauschenberg*, Branden Joseph, ed. (Cambridge, MA: MIT Press, 2002) 28. Rosalind Krauss also discusses at length the linguistic and temporal facets of Rauschenberg's work in "Rauschenberg and the Materialized Image," ibid., 39–55, and "Perpetual Inventory." ibid., 93–131.
100. Albers, *Search Versus Re-Search*, 18.
101. Albers, "The Origin of Art," 253.
102. Rose, *Rauschenberg*, 25.
103. Tomkins, *Off the Wall*, 28.
104. Weil, "My Blue Journey, 10.
105. Steinberg, "Reflections on the State of Criticism," 28.
106. Krauss, "Rauschenberg and the Materialized Image," 45.
107. Joseph, *Random Order: Robert Rauschenberg and the Neo-Avant-Garde* (Cambridge, MA: MIT Press, 2007) 22.
108. Cage's commentary on Rauschenberg's *White Paintings* included such statements as, "The white paintings were airports for lights, shadows and particles." Cage, "On Robert Rauschenberg, Artist, and His Work," 102. Joseph contends that, by transforming the discursive framework of Rauschenberg's series, Cage allowed "the work to escape the aporias related to an understanding based on negation and to open up a new path beyond the endpoint of modernist painting represented by the monochrome." Joseph, *Random Order*, 33.
109. Ibid., 29–30.
110. In neglecting to acknowledge Albers' impact on Rauschenberg, Joseph, a student of Benjamin Buchloh, follows his own mentor's approach in that, "the reading of these neo-avant-garde works consists exclusively in assigning meaning to them from what traditional discourse would call the *outside*, that is, the process of their reception [...]." Buchloh, "The Primary Colors for the Second Time: A Paradigm Repetition of the Neo-Avant-Garde," *October* 37 (1986): 48. Buchloh developed this strategy as a rebuttal to Peter Bürger's critique of the revival of avant-garde artistic practices by the neo-avant-garde, and he demonstrated his methodology by comparing the monochromes of Alexander Rodchenko and Yves Klein. As Buchloh stated, there is "no evidence that [Klein] had come into contact with any examples of postcubist monochrome painting before 1957," and thus, "these phenomena must be addressed in a way that avoids mechanistic speculations about priority and influence." Ibid., 45. While this type of analysis may be suitable for Klein, it is not entirely applicable to Rauschenberg, who had exposure to avant-garde artistic thought through Albers.
111. Albers, interview, November 11, 1967, in Eva Díaz, "The Ethics of Perception: Josef Albers in the United States," *The Art Bulletin* 90 (2008): 282.

9 The Bauhaus in Britain, the Swinging Sixties and Vidal Sassoon

Mariana Meneses Romero

The legacy and influence of the Bauhaus was eventually nearly global, and Great Britain was among the shores it reached first.[1] Nevertheless, Britain stands out as a place where modernism was not accepted as easily as in the United States regardless of the fact that many *Bauhäusler*, including Walter Gropius, László Moholy-Nagy and Marcel Breuer, established themselves in London for a brief period of time after the Nazi regime forced the school to close down in 1933. The Bauhaus' determination to bring art and design into everyday life, and the school's advocacy for interdisciplinary practice permeated Great Britain's visual and popular culture in two different periods. The first one was the decade of the 1930s when the *Bauhäusler* arrived, settling mainly in London.[2] The second occurred in the late 1960s and early 1970s, a period when the post-war generation of young Fine Art students radically transformed the visual landscape of the country. Great Britain during London's "Swinging Sixties" was a site for experimentation, combining arts and craftsmanship. The ethos of the Bauhaus school was "in the air" and its preliminary course provided a solid basis for foundation courses in art schools.[3] Design students like Mary Quant and Terence Conran learned from the Bauhaus approach to design in ways that influenced the way in which they created furniture and clothes and helped them to transform fashion in these areas. The modernist aura of the Bauhaus and its ethos of simple and functional design, as well as the model it set for working as a community of creatives and producers, not only permeated fine art courses but also the way in which even haircutting and hair-coloring were transformed in London during these years. In particular, the Bauhaus' ethos and pedagogy shaped Vidal Sassoon's approach to hairstyling, itself a key component of youth and popular culture in London at this time.

Vidal Sassoon – The Early Years

The son of Ukrainian and Greek-Jewish immigrants, Vidal Sassoon (1928–2015), was born in Shepherds Bush, London, and lived for his first years in East London with his mother and brother after they were abandoned by his father. When he was five, his mother decided that he had a better chance of getting a good education if he entered a Spanish and Portuguese Jewish orphanage in Maida Vale, even if he was reluctant to leave home at such an early age. In 1939, after France and Britain declared war on Germany, he and his brother were among the children evacuated from London and sent off to the countryside. A year later his mother and his new

DOI: 10.4324/9781003268314-10

partner Nathan Goldberg came to the tiny village of Holt to pick them up. Sassoon recalls that Goldberg had worked as a foreman in a tailoring factory and was a man from who he learned about Caruso and philosophy, a passion that stuck with him for the rest of his life.[4]

After leaving school at age fourteen, Sassoon got a job as a glove cutter, a job that taught him how to cut patterns and how to handle his first pair of shears. After the family returned to East London, Sassoon's mother insisted he become a hair-dresser, even if Sassoon's dream was to become a footballer. As Sassoon recalls, he did not imagine himself "backcombing hair and winding up rollers for a living."[5] Nevertheless under the influence of his mother, Sassoon got an apprenticeship in the salon of Adolph Cohen, a well-recognized hairdresser in Whitechapel in the East End who was highly regarded as a wigmaker. Some of the first lessons he learned from Cohen, nicknamed "the Professor," included shampooing and massaging the scalp correctly. Cohen later taught him how to curl and wave hair, although this was practiced on wigs and not on clients. Only more than six months after starting his apprenticeship did Sassoon get to cut his first human head of hair. He recalled that apprentices had the chance to cut hair but only with clients who could not afford the price of a haircut. Cohen taught Sassoon the basics of hair cutting and hair-coloring and 18 months after he started, he was finally able to begin cutting the hair custom-ers, although Cohen still added the finishing touches. Cohen instilled in Sassoon the belief that hairdressing required discipline and that good appearance was essential in the hairdressing business.[6]

After two-and-a-half years with Cohen, Sassoon decided it was time to venture into new territory and look for a job in the West End. In the late forties, after taking on short-term jobs in different salons, he found himself frustrated with the rigid hairstyles that he saw on the streets. He later described these as "the rock-hard sets held in place by heavy lacquer [that] seemed to rob the women doomed to wear them of their sexuality and allure."[7] During this period he attended free classes in Italian, French, and British hairdressing academies in the West End, and in one of these he encountered hairstylist Freddy French, who had a salon in Mayfair. French's demonstrations made Sassoon realize that hairstyling could be simple, using nothing more than a brush. To Sassoon, French was someone "way ahead of his time" and "visionary."[8] It was during this time that Sassoon joined the salon House of Raymond, also known as "Mr Teasy-Weasy," who also appeared in a weekly tele-vision show on Friday nights that Sassoon and his mother watched together. While working for Raymond, Sassoon started to develop his own style, taught younger styl-ists, and was able to establish enduring relationships with customers, including Lila Burkeman, who helped him find financial backers to open his own salon.

During the mid-1950s, when Sassoon was developing his hairstyling concept, the hairdressing trade was far from prepared to accommodate new ideas and demands. Hairstyles were complex and unique creations which only the hairdresser could craft by mastering a skill which he or she alone could exercise. Moreover, hairdressers looked at hair as something which needed to be tamed so that it had no "life of its own."[9] Hair as a material was considered a moving structure consisting of innumera-ble flexible elements that had to be brought under control and shaped as a solid mass. It was stiffened, curled, waved, knotted, woven, kept in place with clips and robbed of its natural properties, resulting in hairstyles that required considerable care and served, primarily, as ornamentation.[10] Once hairstyles had been destroyed, they could

only be recreated by another visit to the salon. Therefore, "well groomed" hair was a luxury available only to those who had the time and money to visit the hairdresser every other day and served as a symbol of social status.

In 1954, at the age of twenty-six, Sassoon opened his first salon at 108 New Bond Street. The salon's interior was designed to reflect his hairstyling approach, one that consisted in "eliminating the superfluous for clean, simple lines with no frills" and which coincided with his desire to modernize hairstyling.[11] The emerging prosperity of the 1950s brought a change in the basic requirements of the hairdressing trade that foreshadowed the emergence a decade later of rock and roll youth culture and of the women's liberation, both of which brought with them a search for new forms of self-expression.

Sassoon and the Swinging Sixties: A Revolution in Hair Design

During the late 1950s and early 1960s, some fashion designers began to take a more casual approach to everyday life, one that included modern and low-maintenance hairstyles. The formality represented by hats and gloves gave way to more relaxed styles that said less about social status. By the end of the sixties, London had taken the lead in the fashion world and Paris looked on for emergent trends. To Sassoon, all this validated his decision to break with established ways of hairdressing and to put all his artistry into the cut. He revolutionized hairdressing by swimming against the tide of virtuosity and forced originality. The style he created simultaneously enhanced and reflected the changes taking place in London, whilst influencing a long-lasting transformation in hairstyling and fashion that had its roots in modernism and the architecture of the Bauhaus.

Already in 1957, celebrities were visiting Sassoon's salon, including fashion designer Mary Quant, who often described Sassoon and the contraceptive pill as responsible for revolutionizing an era.[12] Quant's visit to Sassoon's salon marked a before and after in London's "Swinging Sixties" style. Her asymmetrical Vidal Sassoon signature bob cut – with one side shorter than the other – started to be replicated by others. Moreover, on the day she first got the bob, a long-lasting partnership was born. Quant asked Sassoon to collaborate on her next fashion show by cutting the hair of all the models participating in the catwalk of her newest collection, staged in the iconic shop Bazaar in King's Road in Chelsea. The haircuts Sassoon created for the show complemented Quant's clothing designs in their simplicity and geometry. As soon as they were featured in *Vogue* magazine and the *Daily Mirror*, the fashion editors of both publications went to get their haircut by Sassoon. They believed that these styles produced a refreshing look and sense of freedom to a new generation of women.[13] Their views quickly bolstered Quant and Sassoon's reputation, helping to make them an integral part of the London fashion scene in the late fifties and early sixties.

During this period, Sassoon realized that simplicity should be the result of his haircuts, hence the need to emphasize the methodical technique he used to achieve them. His aesthetic ideal opened his eyes to the principle of handling materials according to their intrinsic properties. Sassoon "dreamt [about] hair in geometry: squares, triangles, oblongs and trapezoids" and understood hair as an organic material in movement that needed to be treated as such.[14] The study of rational design in terms of techniques and materials was only the first step in the development of a new and

modern sense of beauty. The aim was to take the essential quality of the material as a basis and to use the inherent structure of the hair itself to create a form which would allow the hair to swing freely and still hold a shape. The structure of Sassoon's hair designs ensured that hair regained its original style after washing, either by simply combing it or with a minimum of blow-drying. If the cut was right, the customer would be able to reproduce the hairstyle at home and styling products were only used to strengthen structures already created by the cut.[15]

Sassoon's most creative period was between 1954 and 1963. Nancy Kwan's haircut for the film *The Wild Affair* (1963), for example, was a turning point in his career.[16] One of the producers of the film approached Sassoon and asked him to give Kwan a dramatic and modern look. The bob cut he bestowed on the actress was innovative and represented a liberation from fixed haircuts and hairstyles. It cut a simple line that moved with the wearer. The haircut session was photographed by Terence Donovan. As soon as the cut was finished and sent to the editor of *Vogue* magazine, Sassoon knew that it would change the hair and fashion industry.[17] Along with his collaborations with fashion designers like Mary Quant, the Kwan haircut inspired young women, raising interest in geometrical and simple designs in clothes and hair as a staple for a modern look (Figure 9.1).

Though the classic bob as represented by Kwan became a turning point in Sassoon's career, his most iconic design was Grace Coddington's five-point cut of 1964. An

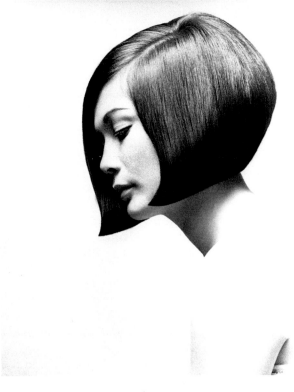

Figure 9.1 Nancy Kwan, hair by Vidal Sassoon, August 9, 1963. Photograph Terence Donovan © Terence Donovan Archive/Condé Nast Publications Ltd.

"accident," according to Sassoon, but also one of the "hardest geometrical cuts to achieve," it was the culmination of all the earlier architectural shapes – cuts characterized by their geometric look, based on very sharp lines – that the team and him had created over the ten previous years.[18]

Sassoon's creations moved along with fashion trends and adapted to them. For example, in 1970s as a response to the hippie era, Sassoon developed layered geometric cuts that made the hair softer and unstructured. Permanent waves became more popular and aided in achieving this sense of softness. The early 1980s witnessed the punk explosion, and the team of hair colorists working with Sassoon developed new looks. During this period, just as in the 1960s, street fashion and youth culture were dominant. Hair was almost warrior-like, especially as punk eventually gave way to what was called the "power look." Following the decline of punk and the colorful hairstyles worn by David Bowie, haircuts in the 1990s haircuts softened once again.

Vidal Sassoon and the Bauhaus

Gerald Battle-Welch, who in the 1990s was executive director of Vidal Sassoon Haircare in Germany, posited that a direct connection between Sassoon and the Bauhaus may come as a surprise or even as a provocation. Sassoon, however, often admitted in interviews as well as in his autobiography to the ways in which modernism and the principles of the Bauhaus greatly influenced his practice. Sassoon referred to meetings he had with Ludwig Mies van der Rohe and Marcel Breuer, but also to the arrival in Britain during the 1930s of modernism through the work of the *Bauhäusler*, such as Gropius, Moholy-Nagy and Breuer, who stopped there before moving on to the United States.[19] This suggests that Sassoon was well aware of the Bauhaus well in advance of the *50 Years Bauhaus* exhibition held at the Royal Academy in London in 1968 and that the Bauhaus had already permeated the realm of visual and popular culture in Britain.[20]

Mies and Breuer both had a great impact on Sassoon. In 1961 Sassoon started a partnership with the beauty brand Clairol, as a result of which he undertook an American tour. During this time, he came in contact with the architecture of Mies and his followers in Chicago and New York. Sassoon was particularly impressed by the lightness of Mies and Philip Johnson's Seagram building in New York, completed in 1958. Its structures, clear geometry and precision of execution all chimed with his own goals as did the concept of an internationally viable approach to modernism. Although he had the opportunity to meet Mies, Sassoon recalled that the former director of the Bauhaus was not so impressed by his geometrical haircuts.[21] Several years after meeting with Mies, Sassoon and Breuer dined together in a London restaurant. They discussed the Whitney Museum, which opened in New York in 1966, and the principles behind its design.[22] Sassoon visualized a clear analogy between an architectural design for a particular urban context and the design of a form for a face. To Sassoon, Breuer's ideas about geometry and architecture paralleled the emphasis that his geometrical haircuts placed on shapes, bone structure, and angles and the revolution in hair design of which they were a part.

Sassoon's reception of the Bauhaus needs to be understood as a productive process. On the one hand, he was inspired by the aesthetic admiration for a specific aspect of the Bauhaus tradition. On the other hand, he did not simply take the aesthetic principles of the Bauhaus and apply them directly to hairdressing. He also eventually

implemented them in the training of his students at the Vidal Sassoon Academy, thus contributing to the larger transformation that took place in London during the sixties and which had an enduring impact upon hairstyling and fashion.

The Vidal Sassoon Academy and the Bauhaus

For Sassoon, teaching and training were key to the success of his brand, especially when he began at the end of 1968 to opening salons in the United States.[23] It was vital that a haircut in New York was performed as well as one in London. Training was key to this emphasis on reproducibility and quality control. Here, he introduced aspects of both Bauhaus pedagogy as well as design.

The first Vidal Sassoon Academy opened in 1969 in Knightsbridge, London. Hairdressers from around the world came to learn Sassoon's geometrical technique in the first hairdressing program that focused on "hair design." As he often mentioned, he "wanted the world to know [his] methods and the philosophy behind them."[24] The curriculum of the Vidal Sassoon training method was designed in a collaborative manner with his former trainees and colleagues, including Christopher Brooker, Joshua Galvin, and Anne Humphries. For Sassoon, training others had to be done in a collaborative manner.

In its early years, the program consisted of a one-year course where beginners would learn haircutting and hair-coloring procedures in a systematic way.[25] A teaching session at the Vidal Sassoon Academy would include Sassoon or other senior hairdressers demonstrating a particular cut that the students would then recreate and reinterpret. The focus of the Sassoon training course was and remains, first and foremost, a geometric method that allows the hairdresser to design the hair. It teaches the craft of controlling the material (hair) rather than considering it as an ornamental feature, keeping in mind that the result should be functional for the wearer and easy to replicate during subsequent hairdressing appointments.[26] The method teaches the most effective and functional way to achieve the final result without spending hours with a single customer. This was much like the Bauhaus workshops where technical and formal experiments aimed at developing prototypes for industrial manufacturing and make it possible for purchasers to buy well-designed, affordable goods.

The training program was and remains imbued with Bauhaus influences. As with the Bauhaus master-apprentice model, teaching was overseen by those who were more advanced in their craft. Those specialized in hair cutting, like Christopher Brooker, trained students in this field, while Anne Humphries did the same with hair color. Second, the training manuals of the Sassoon Academy mention and rely on theoretical texts written by Bauhaus masters during the preliminary course, including Johannes Itten's color theory *The Art of Colour*, published in English in 1961, and Paul Klee's *Pedagogical Sketchbook*, which originally appeared in German in 1923.[27] These texts were not only fundamental for the Bauhaus' preliminary course but are also the foundation for Sassoon teaching manuals still in use today. The current version states:

> The triangle, square and circle are very significant as they provide a recognizable basis upon which to explore shape and form. They formed a major part of the instruction at the Bauhaus School of Art in Germany in the 1920s, and are used extensively in constructing contemporary artworks.[28]

Humphries mentioned in an interview that Sassoon and his collaborators "read the theoretical writings of the Bauhaus 'Masters,'" but Itten was extremely relevant because his colour theory [was] so comprehensive."[29]

Although it is unclear how Sassoon became aware of these texts or decided to apply them to hairdressing, his many possible sources included his avid interest in philosophy, the impact of his first trip to the United States, and the exhibition *Bauhaus: 50 Years* held at the Royal Academy in London in 1968.[30] Moreover, artists teaching in the United Kingdom had been reading Bauhaus-related texts by Itten, Klee, and Wassily Kandinsky already for a decade. When he was Director of the Camberwell College of Art, William Johnstone designed a Basic Design course which introduced Bauhaus teaching methods and principles to post-war Britain. He also appointed artists like Richard Hamilton and Victor Pasmore, who subsequently moved to Newcastle, where they influenced a subsequent generation of British artists, as professors in the crafts and design studios.[31] As Basic Design courses evolved, students in Fine Art and Design courses, including Sassoon's friends and collaborators Quant and Conran, absorbed and subsequently applied the Bauhaus aesthetic and principles.[32] Sassoon's interest Bauhaus pedagogy, as demonstrated in his teaching manuals, may have been transmitted through these links.

The third similarity between the Vidal Sassoon program and the Bauhaus relates to the structure of the educational program. Sassoon's program is divided into three categories that go from basic to more complex methods and that he termed Classical, Contemporary and Creative. These stages of training rely on Bauhaus ideas and are intended to teach students to avoid recreating the same model of a haircut and instead to create functional haircuts. The first stage or Classical course bears a close similarity to the Bauhaus' preliminary course in the sense that first-year students undertake basic training in geometrical shapes, structure, color, and composition. During it, students learn basic cutting techniques and conventional hairdressing skills, as well as the properties of hair and color theory. This foundational course is based on five principles and students are encouraged to understand them all so that in the end they will be able to express their creative impetus. These comprise lines, graduation, layering, form, and color (total, partial, and combination).[33] Afterwards, and depending on the skills and preferences of individual students, they enter specialized workshops and disciplines, where they may master, for instance, advanced haircutting techniques or advanced hair-coloring techniques. These comprise the second or Contemporary training category. Finally, the third stage or Creative training allows trainees to focus on their individual creative development.[34] These two stages parallel the workshops into which Bauhaus students progressed following completion of the preliminary course.

Sassoon named his training manuals *The ABC Principles of Haircutting* and *The ABC of Hair Colouring*. The ABC manual of haircutting (also known as *Cutting Hair the Sassoon Way)* defines the three fundamental elements of a Sassoon haircut as lines (A), graduation (B), and layering (C).[35] Each of them, explains Mark Hayes, can be used in isolation to create shapes that have an infinite number of variation when integrated with the geometric shapes of the triangle, square, and circle.[36] These basic forms are significant since they provide a recognizable basis upon which to explore shape. In this sense, this geometric approach lies at the heart of the Sassoon ethos and its teaching method.

The ABC coloring method pays special attention to Itten's principles of color as set forth in *The Art of Colour*. These are then applied to hair design. Itten's text

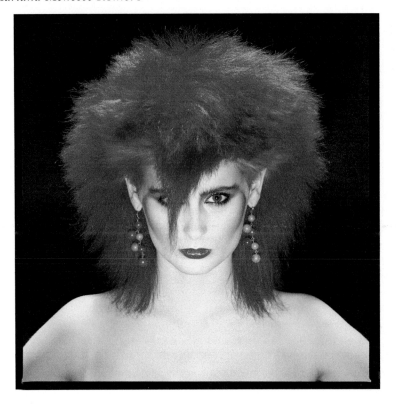

Figure 9.2 Kabuki, hair by Tim Hartley for Vidal Sassoon, color and perm by Al MacDonald, 1981. Photograph by Al MacDonald, image courtesy of Sassoon.

explains how colors react, neutralize, and complement each other. He categorizes them in primary (red, blue, yellow); secondary – a mix between primary colors – (green, orange, purple); and tertiary (combinations between primary and secondary colors).[37] The Sassoon color manual is designed to teach trainees how colors coordinate, react, neutralize, and complement each other. Another important element taken from Itten is the color grid, which helps students to understand the depth and corresponding pure tone of a color. When this is applied to hair, Hayes explains, darker colors tend to fall into the background. This is the reason why they are used to contour shapes and make them appear more solid or graphic. In contrast, lighter colors reflect more light, and strategically give an impression of volume (Figures 9.2 and 9.3).[38]

The overall philosophy behind the Vidal Sassoon training program is "solid craftmanship as the basis for creativity."[39] To this day, Sassoon teachers believe that by teaching the fundamentals, students will then be able to specialize and to interpret the principles creatively, encouraging them to bring their own personality to the fore. The hairstylist, believed Sassoon, was similar to the architect or designer and must be equipped for artistic, technical, social, economic, and spiritual aspects of the modern world, so that he or she may function in society not as a decorator but as a vital participant.

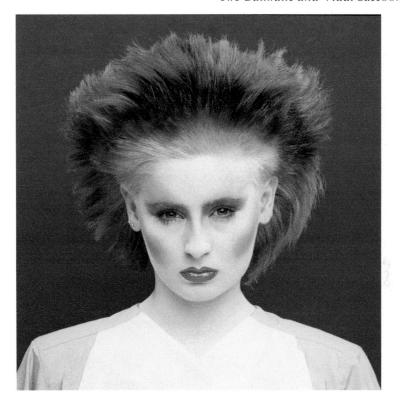

Figure 9.3 Firebird, hair by Tim Hartley for Vidal Sassoon, color and perm by Al MacDonald, 1982. Photograph by Robyn Beeche. Rights: Robyn Beeche Foundation, image courtesy of Sassoon.

Oskar Schlemmer's *Triadic Ballet*: From the Bauhaus to the Catwalk

In the 1980s, Sassoon expanded his fascination with the Bauhaus after seeing an exhibition of Oskar Schlemmer in Los Angeles and footage of the *Triadic Ballet* (1922).[40] This whetted his interest in other aspects of the Bauhaus.

Schlemmer's *Triadic Ballet* so inspired Sassoon that he commissioned Christopher Brooke, who was the International Creative Director of Vidal Sassoon at the time, to design a hair show based on Schlemmer's costumes this ballet. Hair shows, much like fashion catwalks, display trends in hairstyling, and Sassoon was one of the major contributors to and organizers of London shows.[41]

Brooke was fascinated by the idea of a show inspired by the *Triadic Ballet* and soon gathered a team of designers and hairstylists that reinterpreted the original costumes and headpieces. The headpieces designed by the Sassoon team used wigs cut into geometrical shapes. Models wore the costumes, wigs and make-up and posed for pictures taken by Robyn Beeche. The Vidal Sassoon and Bauhaus show was presented in 1983 at the Barbican in London. Though Sassoon himself was not present during the show, he surely saw footage and images taken that day.[42] The Schlemmer-inspired catwalk is another example of how the Bauhaus was a strong influence in Sassoon's practice and aesthetic of his hair shows (Figure 9.4).

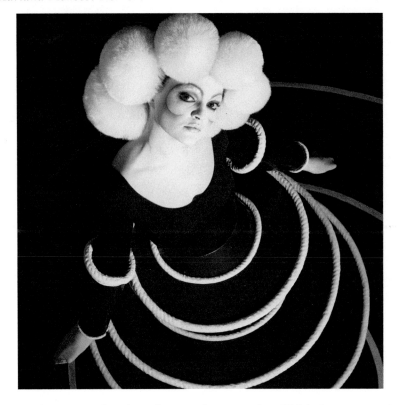

Figure 9.4 Bauhaus (Spirals), hair by Mitch Barry for Vidal Sassoon, make-up by Phyllis Cohen, 1986. Photograph by Robyn Beeche; image courtesy of Robyn Beeche Foundation.

Despite the fact that Sassoon never trained in fine arts or design, his admiration for the Bauhaus ethos infused his aesthetic as well as his training method. He was able to channel Bauhaus principles in ways that revolutionized hair design and had a direct impact upon London's popular and youth culture. Without his input contemporary haircuts would not be the same. So next time you ask a hairstylist for a bob or highlights, pay attention to the mix of colors or how s/he is shaping your hair using geometrical shapes, angles, and lines. The result is a haircut that will fit a hectic, modern lifestyle. The Bauhaus remains part of our everyday life, even in our hair.

Notes

1. The "Bauhaus Imaginista" exhibition held at the Haus der Kulturen der Welt in Berlin explored the legacy of the Bauhaus from a global perspective and read its entanglements against a century of geopolitical change. See Grant Watson and Marion von Osten, eds., *Bauhaus Imaginista* (New York: Thames & Hudson, 2019).
2. Alan Powers, *Bauhaus Goes West* (New York: Thames & Hudson, 2019).
3. Foundation courses were also known as Basic Design courses. In the booklet for the "Basic Design" exhibition on view at Tate Britain March 25–September 25, 2013, Elena Crippa describes how Basic Design emerged as a "radical new artistic training" in British art schools in the 1950s, and that these courses were rooted in the Bauhaus pedagogy and particularly Johannes Itten's preliminary course.

4. Vidal Sassoon, *Vidal: The Autobiography* (London: Macmillan, 2010).
5. Sassoon, *Vidal*, 28.
6. Sassoon, *Vidal*, 38.
7. Sassoon, *Vidal*, 55.
8. Sassoon, *Vidal*, 55.
9. Vidal Sassoon et al., *Vidal Sassoon and the Bauhaus* (Stuttgart: Cantz Verlag, 1994) 36.
10. Sassoon et al., *Vidal Sassoon and the Bauhaus*, 36.
11. Sassoon, *Vidal*, 83.
12. Mary Quant, "He Freed us as Much as the Pill and the Mini-Skirt," *Daily Mail*, May 11, 2012.
13. Sassoon, *Vidal: The Autobiography*, 99.
14. *Vidal Sassoon: The Movie*. 2010
15. Sassoon et al., *Vidal Sassoon the Bauhaus*, 36.
16. Sassoon, *Vidal: The Autobiography*, 137.
17. Sassoon, *Vidal*, 133–37.
18. Sassoon, *Vidal*, 143.
19. Sassoon et al., *Vidal Sassoon and the Bauhaus*, 37.
20. Wulf Herzogenrath et al., *50 Years Bauhaus. German Exhibition* (London: Royal Academy of Arts, 1968).
21. Susie Mutch, Mark Hayes, and Edward Darley, Personal Interview at the Vidal Sassoon Academy about the Bauhaus and the training principles, November 26, 2018.
22. Sassoon, *Vidal*, 122; Sassoon et al., *Vidal Sassoon the Bauhaus*, 7.
23. Sassoon, *Vidal*, 211.
24. Sassoon, *Vidal*, 211.
25. Nowadays the academy offers a one-year course (30 weeks) diploma, as well as short-term courses and postgraduate courses. *See* https://www.sassoon-academy.com/en/academy/uk/courses/london
26. Mutch, Hayes, and Darley, Personal Interview at the Vidal Sassoon Academy about the Bauhaus and the training principles.
27. Paul Klee, *Pedagogical Sketchbook* (London; Boston: Faber and Faber, 1968); and Johannes Itten, *The Elements of Color. A Treatise on the Color System of Johannes Itten*, Ernst van Haagen, trans. (New York: Van Nostrans Reinhold Co, 1970), 28–30.
28. Vidal Sassoon, *Cutting Hair the Sassoon Way* (London: Vidal Sassoon Academy, 2019) 10.
29. Humphries also mentions that some of colourist techniques developed during the early 1970s were influenced by the postimpressionists, particularly Seurat's *pointillism*, which provided a basis for the "spotlight" technique that was developed in hairstyles part of the series of "Flying Colours," where the color is applied with a comb to emphasize certain areas of the haircut. It is a flexible technique and often a client's first introduction to hair color. See Sassoon et al., *Sassoon and the Bauhaus*, 149.
30. Quant noted that she attended the Royal Academy exhibition, and she was impressed by the simplicity of Bauhaus design, which was a turning point for her and other young designers. Mary Quant, "He Freed Us as Much as the Pill and the Mini-Skirt," and Emily Chan, "How a Century of Bauhaus Has Influenced Fashion," Vogue, March 20, 2019, https://www.vogue.co.uk/article/bauhaus-influence-in-fashion
31. In a similar way, Harry Tubron and Tom Hudson, established a Basic Design course in Leeds Polytechnic. See Crippa, "Basic Design;" Richard Robin Yeomans, "The Foundation Course of Victor Pasmore and Richard Hamilton 1954-1966," PhD Dissertation, University of London, 1987; Mariana Meneses, "The Bauhaus Journey in Britain,"; and Gavin Butt, "Bedsit Art in the Leeds Experiment," both in *Bauhaus Imaginista Journal*, Edition 4: Still Undead (March 11, 2019). http://www.bauhaus-imaginista.org/articles/4262/the-bauhaus-journey-in-britain/en; http://www.bauhaus-imaginista.org/articles/5685/bedsit-art-in-the-leeds-experiment/en
32. Conran, for example, founded *Habitat* – a furniture company inspired by Modernism, simple forms, understanding of materials, and a fresh color palette that helped to transform the visual landscape of Great Britain's domestic interior in the sixties. In a similar way, Mary Quant's geometrical designs dressed a younger generation avid to embrace

a modern look. See Ben Highmore, "Habitat's Scenographic Imagination,' *Journal of Design History* 30, (2016): 33–49; and "Terence Conran," Design Museum, https://designmuseum.org/designers/terence-conran.

33. Mutch, Hayes, and Darley, Personal interview at the Vidal Sassoon Academy about the Bauhaus and the training principles.
34. Mutch, Hayes, and Darley, Personal interview at the Vidal Sassoon Academy about the Bauhaus and the training principles.
35. Vidal Sassoon, *Cutting Hair: The Vidal Sassoon Way* (New York: Routledge, 2012).
36. Mutch, Hayes and Darley, Vidal Sassoon, the Bauhaus and training.
37. Itten, *The Elements of Color*, 1970.
38. Mutch, Hayes, and Darley; Vidal Sassoon, the Bauhaus, and training.
39. Vidal Sassoon et al., *Vidal Sassoon and the Bauhaus*, 211.
40. The exhibition *Degenerate Art: The Fate of the Avant-Garde in Nazi Germany* was on display in Los Angeles County Museum of Art in the early 1990s, which Sassoon probably saw at the time. See: http://www.lacma.org/sites/default/files/reading_room/New%20PDF%20from%20Images%20Output-10compressed5.pdf
41. Gerald Battle-Welch, Vidal Sassoon, the Bauhaus, and the Triadic Ballet, Telephone interview, January 11, 2019.
42. Battle-Welch interview.

10 Paul Klee's Pedagogy and Computational Processing

Ingrid Mayrhofer-Hufnagl

Over the last 50 years, our world has turned digital at breakneck speed. There is a clear line of influence regarding digital esthetics and computational art that starts from the Bauhaus and extends to the computer-generated approach to art taken in the 1960s, as well as more contemporary works of computational processing. The computational approach in art, in particular, can be traced back to Paul Klee's *Bildnerische Gestaltungslehre*.[1] This is scarcely surprising, as geometry, abstraction and chance are important themes in all art of the twentieth century, not just for the Bauhaus artist or in generative art, which is a form of artistic creation that uses a computer, in which the artwork or end product is not necessarily at the center but instead the process of creation and the ideas underlying it.[2]

In January 1924, Klee summarized his teachings on creativity by saying, "Formation is good. Form is bad. Form is the end is death. Formation is movement is action. Formation is life."[3] He continued by pointing out the fundamental principle of his teaching, namely the idea of form as a process or as becoming. He asked his students to concentrate on the "way to form" instead of the result.[4] Klee's main intention was to provide students with the procedural aspect of pictorial design. As the introduction to an exhibition catalogue on his work states, "His notion that a form should not be understood as 'Being' but rather as 'Becoming' pervades his teaching and explains his interest in the generation and inner workings of form."[5] This idea already indicates why the Bauhaus artist had a significant influence on computer-generated art as a procedural form.

In his pedagogical sketchbook, Klee repeatedly addressed three topics: the idea of form as a process, the meaning of movement, and his concept of dynamics. All three – procedure, movement, and dynamics – are closely related and essential to computer-generated art. For instance, Klee was convinced that movement underlies all becoming, that the laws of creation are based on dynamics, and that these laws are ideas that can constantly change. His teachings are therefore not based on rigid rules. Rather, he identified a dynamic design of law as the origin.

In order to illustrate the vitality of pictorial means and elements, Klee drew, especially in the initial years of his teaching activity, on concrete examples from nature. However, he considered these examples, as he explained in a lecture, as assistive devices to illustrate the procedural. It was not the phenomena of nature that had to be imitated, but the laws that governed their design. Nature is, in this sense, only a means to an end, a way to explain complex issues.[6] Later, he renounced detailed

DOI: 10.4324/9781003268314-11

explanations of natural processes in his teaching and explained the emergence of geometric forms only through the movement of pictorial elements.[7]

According to Klee, movement is the basic requirement for a design (*Gestaltung*) to emerge at all. It is the basis of all becoming. Furthermore, he pointed out that movement is everywhere because there are no rigid things. Thus, for him "movement is, in fact, the norm. And if movement is, in fact, the norm, then dynamism is also the norm. Norm means 'ordinary condition.' The ordinary condition of things in the universe is, therefore, the condition of movement."[8] Movement is, therefore, at the core of his thoughts on creation, and in the way he taught at the Bauhaus. Klee was interested in different forms of movement, such as linear primal movement, which turns into a curve through the influence of an attractor. The appearance of stasis is misleading, Klee postulated, as all things and all living entities move. In fact, there is no rest but "inhibited movement," which is driven by an attractive force or something that appears to be motionless because it represents a common movement that is with us. We will return to this point. Furthermore, according to him, movement is not only based on the process of productive work but also on the receptive process.[9] Klee pleaded for an interpretation of artwork *in statu nascendi*. This refers to the viewer's process of completing the movement and allowing the artwork to emerge again. He understood "[t]he work of art first and foremost [as] Genesis, it is never experienced purely as a product."[10] In this context of genesis, movement includes the concept of potentiality. Forms appear and disappear again; new forms appear and dissolve again. The ongoing genesis of a work of art demonstrates the changing conditions, the different "truths" in which we find ourselves and objects. Therefore, things appear "in an expanded and manifold sense," as Klee wrote, "often seemingly contradictory to the rational experience of yesterday."[11] Due to the primacy of the possible over the real, there is not just one configuration, but rather many.[12] Art is not about an end result, one particular drawing or the reproduction of the visible, as he made clear at the beginning of his teachings.[13]

In summary, just as the act of painting is an active process, so is the process that the image initiates in the eye of the beholder. Seeing moves beyond simple objective cognition and becomes the productive process of perception. In this way, processes of movement and compositional and structural principles, which are created in the image, become visible. Klee focused on groups of works or series that made the process of visualization sensually and intellectually tangible.

The Bauhaus Effects on the Pioneers in Computer Art

If we consider these essential topics and design principles – movement, dynamic and procedure – it is no surprise that Klee's theory of pictorial creation had an influence on digital and generative art. What matters in this art form is also the procedure of formation and the underlying idea rather than the end product or the result. The algorithms or computer programs of computer artists like German pioneer Frieder Nake, who earned a doctorate in mathematics in his native Stuttgart before being appointed the professor of computer science in Bremen, for instance, can be considered as equivalent to Klee's *Gestaltungsgesetze*.[14] For this reason, Klee was also the springboard for an early piece of computer art by Nake titled *Hommage à Paul Klee*, created in 1965 (Figure 10.1), which reflects Klee's principles of creation. Nake was inspired by Klee's work and several drawings, especially Klee's painting *High Road*

Figure 10.1 13/9/65 No. 2 (also called *Hommage à Paul Klee*), Frieder Nake, algorithmic drawing, 50 × 50 cm, 1965. Courtesy of the artist.

and Byroads (Figure 10.2). The starting point of Nake's algorithm, or computer program, was influenced by Klee's exploration of proportion and the relationship between vertical and horizontal lines. In this sense, he "instructed" the computer in Klee's *Gestaltungsgesetze* (laws of design) and translated them into new variations. Such images were directly printed with graphomats, plotters with inserted felt or ink sticks, as no computer screen or monitor on which to preview the drawing was available at this time. The final image – just one of a wider series, which Nake estimates as including 30 or 40 drawings – was only recognizable when the machine was finished. This drawing is in no way an attempt to simulate the artist's work by algorithmic description but rather an exploration of visual effects based on Klee's principles.

Klee's first course – the *Compositionsprakticum* (composition practicum/ training) – at the Bauhaus in the summer 1921 consisted of examining formal and pictorial elements and their compositional idea, that is, the relations of the pictorial elements to one another.[15] Nake's drawing *Geradenscharen* (bundles of straight lines) (Figure 10.3) explains exactly this idea, that is the inscription of a compositional structure within the element of the line that is as such not seen. The question was whether it was possible to put into the program some description of compositional elements that would keep one line and the next line and so forth together in order to build new, more complex compositions.

Figure 10.2 High Road and Byroads, Paul Klee, Museum Ludwig, Cologne, 1929.

Figure 10.3 12/7/65 No. 1 (also called *Geradenscharen*), Frieder Nake, algorithmic drawing, 88.5 × 70 cm, 1965. Courtesy of the artist.

Figure 10.4 À la Recherche de Paul Klee, Vera Molnár, Frac Bretagne collection, 1970. © Bildrecht, Wien 2022, photographer: Hervé Beurel.

Early computer artist Vera Molnár, who studied art history in Budapest before moving to France, was also influenced by Klee. She was looking for a solution for the pictorial problem of distributing forms equally on a surface, while simultaneously escaping the classical laws of painting. She came across his work in the 1960s and found "everything she was looking for." She pointed to "the equitable distribution of the elements but in an excess of interferences and modulations."[16] Her work *A la recherche de Paul Klee* (Searching for Paul Klee) (Figure 10.4) – created between 1969 and 1971 – is rooted in this discovery of his studies. In a series of black-and-white and colored ink drawings, she attempted to formalize and systematize Klee's playful geometry, using the computer and chance. These series of drawings are based on a square grid already predetermined by Klee. Furthermore, in the spirit of Klee, she used "active" lines that "freely indulge, [taking] a walk for their own sake" and "medial" lines that indicate the shapes of areas and therefore stand between point movement and surface effect, that is, a medial line linearly outlines a surface.[17]

In computer-generated art, the creative process is quite often considered a purely logical procedure. Another early computer artist, Josef Hermann Stiegler, a native of Vienna whose background was in engineering, proved that the opposite is the case. Stiegler also referred explicitly to Klee and considered the Bauhaus as the forerunner of computer-generated art. He considered Klee's explanations of intuition to be a visionary anticipation of information-esthetic computer art, and as a

necessary irrational factor within a certain rationality. Stiegler compared intuition with the significant introduction of *randomness* and *chance* into art through the pioneers of computer art, criticizing the "modern school of rational esthetics" for their conviction that the creative process can be entirely logically formulated. Stiegler emphasized that Klee's theory of creation has to be considered as flexible guidance toward a methodology of pictorial creation and not as a dogmatic theoretical system.[18]

There were certainly other computer artists affected by the Bauhaus in the 1960s. More importantly, the Hochschule für Gestaltung in Ulm – a key institution of early computer art – was founded with the explicit intention of being rooted in the Bauhaus tradition. Swiss architect Max Bill was not only one of the founders and first director of the school, but also a former Bauhaus student. He and Walter Gropius had an extensive correspondence about the new school and its objectives.[19] Classes began in 1953, and among those who temporarily taught at the school immediately after it was founded were the *Bauhäusler* Walter Peterhans, who taught the basic course which corresponded to the preliminary course at the Bauhaus; Helene Nonné-Schmidt, a former student of Paul Klee's; Josef Albers; and Johannes Itten.[20]

The Bauhaus Legacy in Generative Art

Almost all of the pioneers of computer art in the 1960s were engineers, scientists, and mathematicians because only people in these fields had access to the computing resources available at university research labs. In addition, a scientific or mathematical education provided the necessary expertise to program cumbersome and complicated early computers that lacked a visual interface. In the 1990s, computers became affordable and efficient enough for public use. Artists could begin experimenting and creating artwork, and as a result, the golden age of generative art emerged. One did not need to be a computer scientist anymore to program sketches and create drawings, as new digital tools emerged with easily accessible programming languages, such as *Processing*, and a raft of other applications were brought to visually oriented fields.

Muriel Cooper was a key early generative artist who made an enormous contribution to the popularization of the genre. She was trained at Ohio State University and the Massachusetts College of Art in the design principles of the Bauhaus, which had a significant influence on her.[21] She imbued these principles at the Massachusetts Institute of Technology (MIT), where she began to work as a graphic designer in 1952. She is unjustly forgotten today, but tribute has been made recently to her work and her references to the Bauhaus.[22]

The crucial difference that Cooper introduced was a central focus on computing in conjunction with the design principles of the Bauhaus. Although she was not a computer programmer (she took a programming course with MIT computer scientist Nicholas Negroponte when she started work on designing Hans Wingler's tome on the Bauhaus), she was among the first who recognized that technological advancements were opening up new possibilities in design. More precisely, she recognized that implementing Klee's ideas of movement, dynamism, or procedural were now becoming possible. This is what made the computer so compelling to her.[23] In this sense, her shift toward computers reflected a continued pursuit of an enduring interest, namely the issue of dynamics and movement versus static or three-dimensional

spaces versus flat designs. She pointed out that in her early career as MIT Press' first design director, she explored motion implicitly in all of her books, and particularly in her best-known book, *The Bauhaus*, published in 1969, which she restaged in different media.[24] The book and its translation into multiple media should be considered as analogous prototypes to her research into using the computer to explored dynamism and motion, which she explored the rest of her career. Her design for Wingler's ground-breaking history of the school was a central source of inspiration to her work that followed. Even 20 years after its publication, she related her current work back to it.[25]

The Bauhaus volume she designed also became a linchpin for her teaching at the Visual Language Workshop (VLW). She founded the VLW in MIT's department of architecture in 1974. Robert Wiesenberger notes that "The workshop was named with self-conscious reference to the experimental, collaborative, and practice-oriented organizational units of the Bauhaus."[26] Establishing this workshop within the architecture department was a logical step, as György Kepes – who initially recommended Cooper to the MIT Press – had already created a program in visual design there and taught courses related to the Bauhaus' preliminary course.[27] Even though Kepes was never part of the original Bauhaus, he collaborated with László Moholy-Nagy in Berlin and London before Moholy-Nagy appointed him to the New Bauhaus in Chicago in 1937. Kepes introduced the design principles of the Bauhaus to MIT, where he started teaching in 1946. His book *Language of Vision*, published in 1944, dealt with the same design principles as the Bauhaus as Judith Wechsler pointed out, but Kepes' book "was more accessible to American students than those produced by the Bauhaus," at least until Cooper's design of Wingler's comprehensive survey.[28]

The VLW upheld the intention of helping architects communicate visually, both in the design process and later in representation. In the VLW, Cooper tried to introduce visual dynamism into the static and rigid media of print. Later, she also pursued the opposite, namely, how to transcode motion onto paper; "in other words," as Judith Wechsler put it, "how to turn time into space." The new technology of the computer was a means to support her abiding interest, which Wechsler characterized as being (like Klee's), "the relationship of dynamic to static."[29]

As the design director at the MIT Press, Cooper not only applied motion and the procedural approaches in her numerous book designs, but also designed processes for the various design solutions.[30] She also explored design systems that were responsive and that integrated feedback into the design system. These are key issues of generative design applications – such as processing – which were developed at the MIT Media Lab at the turn of the millennium. In Paul Klee's sketchbook, there is also a description of the creative process as a feedback loop:

> Already at the very beginning of the productive act, shortly after the initial motion to create, occurs the first counter motion, the initial movement of receptivity. This means: the creator controls whether what he has produced so far is good. The work as human action (genesis) is productive as well as receptive. It is *movement*.[31]

Another development at the VLW that paralleled aspects of Klee's pedagogical sketchbooks was the emphasis on "behavioral graphics." These "'intelligent' type"

were "endowed with [their] own inherent, but adjustable, physical attributes, such as gravity and bounce."[32] While teaching at the Bauhaus, Klee dealt intensively with the question of different forms of motion, influenced or inhibited, for instance, by gravity. In addition to the pictorial elements and devices, he also developed geometric forms and compositions from the inherent design movements (*Gestaltungsbewegungen*) such as gravity, tension, bounce, centrifugal, and centripetal forces. That means that he ascribed a certain behavior to the elements, which allows the formation of the (elementary) forms. The overall form, therefore, emerges from different behavioral process from within.[33]

The VLW later became one of the founding research groups of the MIT Media Lab.[34] Both are sometimes labelled as "latter-day [iterations of the] Bauhaus."[35] Cooper herself made such comparisons when the Media Lab was introduced in 1985 to the general public. In an interview with the *Boston Globe*, she commented, "To me, the Bauhaus flowered by responding to the Industrial Revolution. My fondest hope for the Media Laboratory is that we can encourage this same sort of flowering for the information society."[36] This analogy is by no means just a matter of chance. Both are based on an interdisciplinary and experimental approach to reforming esthetics. Furthermore, they share a connection to industry, the interweaving of art and technology and, finally, a techno-humanist idea.

The Media Lab became more important to the evolution of generative art than any other institution. John Maeda – who was a computer science student at MIT and was fascinated by the work of Cooper – and his students Ben Fry and Casey Reas developed the Processing software. Maeda's Aesthetic and Computation Group (ACG) at the Media Lab originates from the VLW.[37] They have stated that "Many of the ideas in Processing go back to Muriel Cooper's Visual Language Workshop."[38]

Such readymade systems and algorithms also did their part, in addition to increasing the affordability of the personal computer. They ushered in a new generation of procedurally literate artists. Similar descriptions can be found in user guides and manuals from different software applications such as Processing and in Klee's pedagogical sketchbook. Furthermore, many of these guides and manuals were clearly designed along Bauhaus lines.

A brief example of how drawing a line is conceptualized in both cases clarifies the conceptual relationship. Klee presumed that not only the pictorial elements themselves but also the relationships between individual elements are dynamic. He considered a line to be a trace of a moving point and a plane the product of a moving line.[39] Process is the essence of Klee's concept, and can, therefore, be described as generative. In this context, a line is a representation of action and a result of movement. Klee's approach included the fourth dimension, the factor time, and read a process into form. This is an approach that grew in importance with the advent of the computer as movement could now be visualized.

Movement along a straight path was, for Klee, the fundamental form. "This movement is of the first phase," he wrote, continuing "movement in its very essence [*Eigenbewegung*], free, uninhibited and influenced by nothing else" (Figure 10.5).[40] In generative art, the pictorial elements are conceptualized the same way. The manuals give the same explanation of the path to form as Klee does in his sketchbooks. The difference is that through the computer and its interface, it becomes possible to not only translate the significance of movement in the process of configuration, but also – as in Cooper's case – to visualize motion itself.

Figure 10.5 Coding Paul Klee's Thinking Eye. Static images selected from an infinite field of variations, 2016. Images by the author.

"This primordial movement of a straight line," Klee wrote, can be transformed into a curve by an intervening force of attraction. He described this movement as "influenced movement."[41] In generative art, we find the same understanding and explanation. According to David Shiffman, for instance, the line, or in this case, the trajectory of a so-called "mover" – the point – is influenced by the gravity of an attractor.[42] In his notebooks, Klee did not refer to purely visual factors but to indicators such as gravity or anything that is related to movement.[43] Klee explained that after the influence of an attractor, a trail continues in a straight line, but in a slightly deflected direction. He explained the various deviations from the ur-form – the straight line – caused by an "energetic knot" that attracts the line. Through the repetition of such influence by attractors, an open curve emerges. According to him, such an "influenced movement" falls within the realm of the dynamic. This is also the case if an attractor continues influencing a line. Curves similar to a spiral would form. In the third phase, Klee talked about "inhibited movement," which occurs if a center of energy that gains strength constrains a movement and yields to it. In this case, a closed curve emerges. The attractor has superiority and becomes the center. The movement around this center forms a closed trajectory that approximates to a circle. Klee considered free and influenced movement to belong to the realm of the dynamic, while inhibited movement fell within the realm of the static.

In generative art, it is now possible to apply Klee's *Gestaltungsgesetze* regarding "how to draw a line" to hundreds of points at the same time (Figure 10.5). His understanding of dynamism and movement can literally be visualized. Klee analyzed pictorial elements as the outcome of movement and also took their arrangement of mobile factors into account; this holds true also for generative art. In particular, he considered the notion of movement to be especially complex, as there are different kinds of movements acting at the same time, while they need to be conceptualized one after the other.[44]

From Klee to Software Art

Conscious or unconscious allusions to Klee's pedagogy can also be detected in more recent approaches to art and technology as a unity – or to be more precise, the connection between art and software that has prompted a new art form. So-called artist-programmers are writing their own software or manipulating or misconfiguring existing software, which has itself become a form of artistic expression in itself. Thorhallur Magnusson notes that this "includes any form of programming activity involved with creating artistic systems that generate works of art and/or are works of art themselves. It focuses on the aesthetic aspect of software creation," while hacking the commercial and creating irrational software is a form of critique.[45]

In his computational sketchbook *Mobility Agents*, published in 2005, American John F. Simon Jr., one of the pioneers in the development of software art and a full generation younger than Nake, Molnár, Stiegler, and Cooper, referred explicitly to Klee.[46] Lev Manovich has pointed out that many other works implicitly reference Bauhaus protagonists as well, but Simon's systematic explorations of conceptual linkages to Klee's sketchbooks are particularly significant in the field of software art.[47] The artist-programmer not only affirmed that Klee's ideas are larger than technological innovations, but also argued that an algorithmic approach – simply an approach to experimentation by rule-making – to art practice can be traced throughout the history of art.

In *Mobility Agents*, subtitled *Computational Sketchbooks* (the title expressly refers to Klee's *Pedagogical Sketchbooks*), Simon focused on the fundamental elements of drawing – point, line, and surface – just like Klee, whom he considered remarkable and important because of his ideas about the dynamics of elements. He demonstrated that "the choice of how to construct the tool," – as there is more than one way – in order to draw a certain kind of line or how to reinterpret it into many different forms "is as much a part of the creative process as deciding what to draw" (Figure 10.6).[48] Simon considered software the best medium for the exploration of the dynamics and the movement of the pictorial elements that Klee highlighted. This is because it allows the exploration of these elements interactively, allowing him to push Klee's ideas much further. Simon wrote that "Klee was embracing dynamism with his use of arrows and lines, but he had no dynamic medium to use [...]. So, I thought to activate it, and see where it takes us."[49] Simon got the idea of dynamic picture space from Klee. Another of Simon's work that explored the theories of Klee is *Color Panel v 1.0*. According to the artist, this particular piece "interprets color 'rules' into software [...]. The activation of these studies [by Klee and Wassily Kandinsky] results in a dynamic composition of changing color pallets that never repeat."[50]

Since software consists of a set of formal instructions, in other words algorithms, it is "just a precise way of explaining how to do something" as the American artist Casey Reas pointed out, that can, but does not have to be executed by a machine.[51] Thus, it is hardly surprising that repeated references can be found to Klee's pedagogy and his *Gestaltungsgesetze*. It might seem odd to associate software and programming with Klee's teaching, especially as one might assume that the extra level of abstraction through computer language could hinder the creative process. However, there are other examples that demonstrate that this connection is not far-fetched.

Reas, for instance, who studied at MIT and developed Processing at the ACG there, explored ideas that relate art to software. His ambition in developing the Processing

Figure 10.6 Color Panel v1.0, John F. Simon Jr., software, altered Macintosh 280c, and acrylic (plastic), 14.50 × 10.50 × 3.50 inches, 1999. Courtesy of John F. Simon, Jr. and Sandra Gering Inc., New York, NY.

software was to make programming "as immediate and fluid as drawing" by simultaneously minimizing the technical aspects and removing the rigidity of code "from the process of creation. The concept for the work develops intuitively entirely through sketches and the final piece is an annotated written description without reference to any computational implementation."[52] This way of working through sketches is a creative cognitive process, similar to Klee's *Bildnerisches Denken* insofar as it first brings the artist's knowledge into form through drawings and sketches. This form then conveys knowledge and enables esthetic cognition. Reas left ambiguity in his descriptions and therefore leaves the "work more open for interpretation," which separates it from any technical implementation.[53] This also reflects a connection to another form of movement that Klee described. The Bauhaus artist also understood interpretation as a certain kind of movement that re-originates and re-creates an artwork.

The final connection between art and computational processing resides in how Klee's pedagogy also finds valid application beyond art, for instance in learning and teaching programming. A 2007 study undertaken at the University of Worcester highlighted the synergies among art, design, and software development. The question was how art, particularly the structure of paintings and drawings, was able to inform coding and demonstrates that the work of Klee and his Bauhaus colleague

Kandinsky can be considered as object-oriented (OO) constructions. Furthermore, the study explored the question of how the Bauhaus pedagogy can improve the teaching of software development.[54] The analysis – a central aspect of Klee's teaching – of the Bauhaus artist's artworks into its components established their classification and the corresponding OO classes. In this sense, the teaching directly follows Klee's *Compositionsprakticum* which examined artworks, in particular, his own work or so-called "sample images: based on their formal elements and their compositional context." Moreover, in the programming courses, the paintings were considered "complex interacting system of objects and their methods."[55] However, "the painting as a whole can only be understood as a *Gestalt*. This is also true of a computer program, [...] students must learn how to understand the whole program, to see the *Gestalt*."[56]

The study also explored the cognitive aspect of immediate visual feedback. Through such a visual approach, students can explore the effects of coding in a more creative way, making the code become more productive and introducing a dynamic process of learning. On the other hand, according to Price:

> A traditional programming course may output quantities as a series of numbers on the console. These numbers require a further level of interpretation by the students who must think about the code, the numbers, and the algorithm. As a consequence, they do not obtain immediate intuitive feedback of their coding; they must work simultaneously with two mental models, the program and the algorithm, and of course interpret the "experimental data."[57]

My own experience was the reverse. While teaching first-year architectural students about formal analysis and undergraduates and graduates on the basics of coding (OOP), I recognized the relationship between Klee's *Bildnerische Gestaltungsgesetze* and *Formlehre*. In other words, I observed how his pedagogical sketchbook can be used to introduce OO principles and relate them to formal instructions in art and design.

Conclusion

When artists started working with the computer in the middle of the twentieth century, their focus was on building a bridge between the fields of technology and art. In this sense, this was a continuation of the Bauhaus approach to art and technology as a new unity. Indeed, parallels can be drawn among the Bauhaus' concerns with formalism, a lack of ornamentation, rationality, its interdisciplinary approach, and computer art, not to mention the esthetic appearance, especially as early computer art tend to be abstract, linear, and geometric. However, we can also see these elements in generative and software art, such as in the work of Reas' *Process Compendium*.[58]

By recognizing the renewal of such a bridge between technology and art – in this specific case, between software and art – we can also observe categorical changes in the role of the designer, the artist, the programmer, the engineer, or the computer scientist. The last in particular demonstrates that the development of software is a creative process, similar to the construction of an artefact. This proves how Klee's pedagogy also found a valid application beyond art. Programmers and computer scientists are aware that software applications are highly visual. Thus, in the search for

a theoretical and practical basis to inform such a visual approach, they turn to disciplines that are inherently creative and visual, such as art, architecture, and design, including Klee's theory of pictorial creation. The reverse also holds true. The boundaries between disciplines are blurring, and we recognize this tendency in universities and academia with the advent of new interdisciplinary studies and labs that provide spaces for experimentation.

The impact of the Bauhaus – in particular, Klee's pedagogy – continues in computer-generated and software art, but also in a domain that no one has yet considered, namely programming and computer science. Klee's theory can offer a means to question the implications of contemporary technology. It is not a question that can solely be explored by the sciences as different examples have shown. Art can explore this question from other perspectives, considering cultural connotations as well as conceptual frameworks that are inaccessible to sciences.

Notes

1. Paul Klee, "Bildnerische Gestaltungslehre (BG): Vorlesungsmanuskripte, 1922–30," Zentrum Paul Klee, Bern, http://www.kleegestaltungslehre.zpk.org/
2. There are many definitions of generative art. Philip Galanter is probably most often cited for, "What is Generative Art? Complexity Theory as a Context for Art Theory," in *6th International Conference on Generative Art and Design* (2003). I agree with Matt Pearson that Galanter's definition is incomplete and sketchy. Therefore, I refer to Pearson's more comprehensive explanation. Matt Pearson, *Generative Art: A Practical Guide using Processing* (Shelter Island, NY: Manning, 2011).
3. Klee, BG, I. 2/78.
4. Klee, BG, I. 1/4.
5. Fundación Juan March. "Klee, Again, Anew: Introduction," in *Paul Klee – Bauhaus Master: On the Occasion of the Exhibition "Paul Klee: Bauhaus Master,"* Fabienne Eggelhöfer and Marianne Keller Tschirren, eds., (Madrid: Fundación Juan March; La Fábrica, 2013) 10.
6. Klee, BG I. 2/76. Lecture from January 9, 1924. Klee may have used examples of nature, especially during the first years of his teaching, due to his inexperience as a teacher. See Fabienne Eggelhöfer, "Paul Klees Lehre vom Schöpferischen," PhD dissertation, University Bern, 2012.
7. The lectures from 1923–24 contain many explanations of processes and laws in nature. This can be traced in the section "Principle Order" (*Principielle Ordnung*) in the "General Part" (*Allgemeiner Teil*) of the pictorial laws of design (*Bildnerische Gestaltungslehre*) BG I. 2. and in the lectures from 1921–22 which are summarized in "Contributions to the Theory of Form" (*Beiträge zur bildnerischen Formlehre*) (BF). These references are missing from his lectures after 1925 as, for instance, his pedagogical sketchbook demonstrate. See Paul Klee, *Pädagogisches Skizzenbuch*, Bauhausbücher 2 (München: Albert Langen Verlag, 1925). For a more detailed explanation of his lecture as well as students' notes, see also Eggelhöfer, "Paul Klees Lehre vom Schöpferischen."
8. Klee, BG II. 21/6.
9. Paul Klee, "Beiträge zur bildnerischen Formlehre," unpublished manuscript, BF/97, BF/101.
10. Klee, "Schöpferische Konfession," in *Tribüne der Kunst und Zeit.: Eine Schriftensammlung*, Kasimir Edschmid, ed. (Berlin: Erich Reiss Verlag, 1920) 34.
11. Klee, "Schöpferische Konfession," 35.
12. Paul Klee, *Über die moderne Kunst* (Bern-Bümpliz: Benteli, 1945) 43.
13. Klee, "Schöpferische Konfession," 28.
14. Frieder Nake, *Ästhetik als Informationsverarbeitung: Grundlagen u. Anwendungen d. Informatik im Bereich ästhetischer Produktion und Kritik* (Wien-New York: Springer, 1974) 214–19.

15. In a letter to his wife Lily (April 14, 1921), Klee described the course in these terms. It was officially titled the *Analysekurs*. Paul Klee and Felix Klee, eds., *Briefe an die Familie: 1893–1940* 2 (Köln: DuMont, 1979) 1974.

16. Vera Molnár, "Auf der Suche nach Paul Klee oder: Der Versuch einer Extrapolation (2001)," in *Vera Molnár – als das Quadrat noch ein Quadrat war: Eine Retrospektive zum 80. Geburtstag*, Ludwigshafen Wilhelm-Hack-Museum, ed. (Bielefeld: Kerber Verlag, 2004) 114.

17. Klee, *Pädagogisches Skizzenbuch*, 6, 8.

18. Josef H. Stiegler, "Transmutation," *Alte und moderne Kunst* XV.109 (1970): 39.

19. Christiane Wachsmann, *Vom Bauhaus beflügelt.: Menschen und Ideen an der Hochschule für Gestaltung Ulm* (Stuttgart: avedition, 2018) 52.

20. Wachsmann, *Vom Bauhaus beflügelt.*, 64, 66, 99.

21. As she later pointed out in regard to Hans M. Wingler, *The Bauhaus: Weimar, Dessau, Berlin, Chicago* (Cambridge: MIT Press, 1969), "The people and works of the Bauhaus were my conceptual and spiritual ancestors, so I felt a particular bond with the material." Steven Heller, "Muriel Cooper (interview)," in *Graphic Design in America: A Visual Language History* (Minneapolis: Walker Art Center, 1989) 97. The connections and influence of former Bauhaus protagonists on Muriel Cooper were numerous. For a more comprehensive description on the importance of *The Bauhaus* and its publication as a "landmark and an inflection point" for Cooper but also as idea and its pedagogy, see Robert Wiesenberger's "Latter-Day Bauhaus? Muriel Cooper and the Digital Imaginary," in *Before Publication: Montage in Art, Architecture and Book Design*, Nanni Baltzer and Martino Stierli, eds. (Zürich: Park Books, 2016); and David Reinfurt, Robert Wiesenberger, and Lisa Strausfeld, *Muriel Cooper*, with the assistance of Nicholas Negroponte (Cambridge, MA and London: The MIT Press, 2017).

22. Marion von Osten and Grant Watson, eds., *Bauhaus Imaginista: Die globale Rezeption bis heute* (Zürich: Scheidegger & Spiess, 2019).

23. Janet Abrams, "Muriel Cooper's Visible Wisdom," in *I.D. Magazine* (1994). Accessed April 27, 2019: http://dpub.uriahgray.com/content/5-library/visible-wisdom_muriel-cooper.pdf?key=84800

24. Heller, "Muriel Cooper (interview)," 97.

25. Heller, "Muriel Cooper (interview)," 99.

26. Wiesenberger, "Latter-day Bauhaus?," 104.

27. Judith Wechsler, "György Kepes," in *The MIT years, 1945–1977*, György Kepes and Marjorie Supovitz, eds., Visual Arts Series (Cambridge, MA: MIT Press, 1978) 11.

28. Wechsler, "György Kepes," 11.

29. Abrams, "Muriel Cooper's Visible Wisdom," 52.

30. "The bulk of the work was standard and repetitive and required a set of systemic but variable design solutions for limited budgets. Developing systems that would accommodate a wide range of variable elements was very much like designing processes." Heller, "Muriel Cooper (interview)," 97.

31. Klee, *Pädagogisches Skizzenbuch*, 23. The English translation of the book by Sibyl Moholy-Nagy from 1953 closes with the words "It is *continuity*," instead of "*movement*." Moholy-Nagy probably wanted to point to the continuous movement Klee constantly talked about. Nevertheless, the translation is rather confusing in the overall context, especially as continuity has a different meaning in German.

32. Abrams, "Muriel Cooper's Visible Wisdom," 53.

33. Klee, BG II.5 *Wege zur Form*.

34. "Pioneering MIT: Visible Language Workshop, Muriel Cooper, 1975." Accessed April 22, 2019: http://museum.mit.edu/150/115

35. Abrams, "Muriel Cooper's Visible Wisdom," 50. See also "Looking Back on Muriel Cooper's Visions of the Future," The Professional Association for Design. Accessed April 27, 2019: https://eyeondesign.aiga.org/muriel-coopers-visions-of-a-future/

36. D. C. Denison, "Greetings from the 1990s: Predicting the Future by Inventing it," *Boston Globe Magazine* (June 23, 1985): 9. She repeated this argument, stating that "The Media Laboratory is a pioneering interdisciplinary center that is a response to the information revolution, much as the Bauhaus was a response to the industrial revolution." In

Muriel Cooper, "Computers and Design," *Design Quarterly* 142 (1989): 18. https://doi.org/10.2307/4091189

37. Steven Heller, "Out of the Lab: An Interview with John Maeda," AIGA – The Professional Association for Design. Accessed April 27, 2019: https://www.aiga.org/out-of-the-lab-an-interview-with-john-maeda

38. Ben Fry and Casey Reas, "Processing." Accessed April 27, 2019, https://processing.org/overview/

39. Klee, BF/7-8. With the emphasis on the movement necessary for the formation of the elements, Klee distinguished himself from the static definition of point, line and surface from Euclid.

40. Klee, BG II. 21/7.

41. In the second phase of the evolution of movement, Klee describes the drawing of a curve through the superiority of an *attractor*. See BG II. 21/8–9.

42. For instance, compare this to Daniel Shiffman, *The Nature of Code: Simulating Natural Systems with Processing* (The Nature of Code, 2012) 88–96.

43. Klee, BG II. 21/130–140. See also the sub-chapter BG II. 5, "Way to Form."

44. Klee, *Über die moderne Kunst*, 15.

45. Thorhallur Magnusson, "Processor Art.: Currents in the Process Orientated Works of Generative and Software Art." (PhD dissertation, University of Copenhagen, 2002) 6. Accessed April 27, 2019, https://www.academia.edu/1979586/Processor_Art

46. John F. Simon, *Mobility Agents: A Computational Sketchbook v1.0* (New York: Whitney Museum of American Art and Printed Matter, Inc., 2005).

47. Lev Manovich, "Generation Flash," in *Total Interaction*, Gerhard M. Buurman, ed. (Basel: Birkhäuser-Verlag, 2005).

48. See the Java applet "Double Klee," in John F. Simon, Jr., *Mobility Agents*, 2005. The "Gate Page" in the Whitney Artport website, https://artport.whitney.org/gatepages/artists/simon/intro.html

49. Dan Tranberg, "Digital Artist Writes Own Code for Endlessly Changing Images," *The Plain Dealer*. Accessed May 3, 2019.

50. John F. Simon, "Color Panel v1.0." Accessed May 3, 2019, http://numeral.com/panels/colorpanelv1.0.html

51. Casey Reas and Chandler McWilliams, *Form + Code in Design, Art, and Architecture* (New York: Princeton Architectural Press, 2010) 13.

52. Casey Reas, "{Software} Structures: A Text About Software & Art," Whitney Museum of American Art. Accessed May11, 2019, https://artport.whitney.org/commissions/softwarestructures2016/text.html

53. Reas, "{Software} Structures." He continued this work in the Process series. See Casey Reas, *Process compendium: 2004–2010*, Shannon Hunt, ed. (Los Angeles: Reas Studio, 2010).

54. Colin B. Price has published several articles exploring the relationship between abstract art, especially that of some of the Bauhaus teachers, and computer programming. See, for instance, "From Kandinsky to Java (The Use of 20th Century Abstract Art in Learning Programming)," *Innovation in Teaching and Learning in Information and Computer Sciences* 6.4 (2007), https://doi.org/10.11120/ital.2007.06040035. Even though the title of this article suggests an emphasis on Kandinsky, Price pays equal attention to Klee.

55. In object-oriented programming, *methods* describe and implement the behavior of objects. They describe how objects (elements) communicate with each other – their compositional context.

56. Price, "From Kandinsky to Java (The Use of 20th Century Abstract Art in Learning Programming)," 37.

57. Ibid. 38.

58. Reas, *Process Compendium*.

Bibliography

Albers, Josef. *Interaction of Color*. New Haven: Yale University Press, 2013.

Andrä, Erwin. "Verpflichtende Tradition und neue Aufgaben: Aus der Arbeit der Hochschule für industrielle Formgestaltung Halle-Giebichenstein [sic]." *Bildende Kunst* 4 (1967): 191–95.

Armstrong, Carol. "Florence Henri: A Photographic Series of 1928. Mirror, Mirror on the Wall." *History of Photography* 19 (1994): 223–29.

Baltzer, Nanni, and Martino Stierli, eds. *Before Publication: Montage in Art, Architecture and Book Design*. Zürich: Park Books, 2016.

Barr, Alfred H., ed. *Cubism and Abstract Art*. New York: Museum of Modern Art, 1936.

Barr, Alfred H., ed. *Picasso: Forty Years of His Art*. New York: The Museum of Modern Art, 1939.

Barry, Kevin. "Walter Gropius's Dammerstock and the Possibilities of an Architectural Resistance." In Deborah Ascher Barnstone and Elizabeth Otto, eds., *Art and Resistance in Germany*. New York: Bloomsbury Visual Arts, 2018. 39–54.

Bauhaus, ed. *Bauhaus: [junge menschen kommt ans bauhaus!]*. Dessau: Bauhaus, 1928.

Bauhaus-Archiv, ed., *Experiment Bauhaus*. Berlin: Kupfergraben, 1988.

Bauhaus-Archiv, Museum für Gestaltung, Stiftung Bauhaus Dessau, and Klassik Stiftung Weimar, eds. *Modell Bauhaus*. Ostfildern: Cantz, 2009

Baumeister, Ruth. "Asger Jorn's Bauhaus Politics." In Joowon Park, ed., *Alternative Languages: Asger Jorn, the Artist as a Social Activist*. Seoul: Museum of Modern and Contemporary Art, 2019. 160–71.

Bayer, Herbert, Walter Gropius, and Ise Gropius, eds. *Bauhaus, 1919–1938*. New York: Museum of Modern Art, 1938.

Behne, Adolph. *The Modern Functional Building*. Rosemarie Haag Bletter, ed., Michael Robinson, trans. Santa Monica: Getty Research Institute, 1996.

Behrendt, Walter Curt. *Der Sieg des neuen Baustils*. Stuttgart: Akademischer Verlag Dr. Fritz Wedekind & Co., 1927.

Bergdoll, Barry, and Leah Dickerman, eds. *Bauhaus 1919–1933: Workshops for Modernity*. New York: Museum of Modern Art, 2009.

Bergdoll, Barry, and Terrence Riley, eds. *Mies in Berlin*. New York: Museum of Modern Art, 2001.

Betts, Paul. "The Bauhaus as Cold War Legend: West German Modernism Revisited." *German Politics and Society* 14 (1996): 75–100.

Boyd, Gary, and John McLaughlin, eds. *Infrastructure and the Architecture of Modernity in Ireland*. Abingdon: Routledge, 2015.

Brandenburgisches Landesamt für Denkmalpflege, und Archäologisches Landesmuseum, eds. *Die Bundeschule des ADGB in Bernau bei Berlin: 1930–1990–2018*. Berlin: Hendrik Verlag, 2019.

Brentjens, Yvonne. *Piet Zwart (1885–1977), Vormingenieur.* Zwolle: Waanders Uitgevers, 2008.

Breuer, Gerda, ed. *Max Burchartz 1887–1961. Künstler Typograf Pädagoge.* Berlin: Jovis, 2010.

Bröhan Design Foundation, eds. *Wilhelm Deffke. Pioneer of the Modern Logo.* Berlin: Scheidegger & Spiess, 2015.

Brüning, Ute. ed. *Das A und O des Bauhauses.* Leipzig: Edition Leipzig, 1995.

Burke, Christopher. *Paul Renner. The Art of Typography.* London: Hyphen, 1998.

Buurman, Gerhard M. ed. *Total Interaction.* Basel: Birkhäuser-Verlag, 2005.

Carter, Peter. *Mies van der Rohe at Work.* New York: Praeger, 1974.

Darwent, Charles. *Joseph Albers: Life and Work.* London: Thames & Hudson, 2018.

Díaz, Eva. "The Ethics of Perception: Josef Albers in the United States." *The Art Bulletin* 90 (2008): 260–85.

Dickerman, Leah. ed. *Dada: Zurich, Berlin, Hannover Cologne, New York, Paris.* Washington, DC: National Gallery of Art in Association with Distributed Art Publishers, New York, 2005.

Dickerman, Leah, and Achim Borchardt-Hume. eds. *Robert Rauschenberg.* New York: The Museum of Modern Art, 2016.

Dluhosch, Eric, and Rostislav Švácha, eds. *Karel Teige 1900–1951. L'enfant Terrible of the Czech Modernist Avant-garde.* Cambridge, MA: MIT Press, 1999.

Dolgner, Angela, ed. *Burg Giebichenstein: die hallesche Kunstschule von den Anfängen bis zur Gegenwart.* Halle: Burg Giebichenstein – Hochschule für Kunst und Design, 1993.

Dolgner, Angela, and Renate Luckner-Bien. *Da wackelt die Ruine: Feste der Kunsthochschule Burg Giebichenstein.* Halle/Saale: Hasenverlag, 2009.

Droste, Magdalene. *Bauhaus 1919–1933.* Cologne: Taschen 2006.

Droste, Magdalene, and Boris Friedewald, eds. *Our Bauhaus: Memories of Bauhaus People.* Munich: Prestel, 2019.

De Rauly, Alexandre Dumas, and Michel Wlassikoff. *Futura – une gloire typographique.* Paris: Norma, 2011.

Duberman, Martin. *Black Mountain: An Exploration in Community.* New York: Dutton, 1972.

DuPont, Diana C. *Florence Henri: Artist-Photographer of the Avant-Garde,* San Francisco: San Francisco Museum of Modern Art, 1990.

Ebert, Hiltrud, ed. *Drei Kapitel Weißensee: Dokumente zur Geschichte der Kunsthochschule Berlin-Weißensee 1946 bis 1957.* Berlin: Kunsthochschule Berlin-Weißensee, 1996.

Eisele, Petra, Annette Ludwig, and Isabel Naegele, eds. *Futura. Die Schrift.* Mainz: Hermann Schmidt, 2016.

Eisold, Norbert, and Norbert Pohlmann, eds. *Maramm Magdeburg. Ausstellungs- und Reklamestadt der Moderne.* Magdeburg: Forum Gestaltung, 2016.

Eggelhöfer, Fabienne, and Marianne Keller Tschirren, eds. *Paul Klee - Bauhaus Master.* Madrid: Fundación Juan March; La Fábrica, 2013.

Ellert, JoAnn C. "The Bauhaus and Black Mountain College." *The Journal of General Education* 24 (1972): 144–52.

Feist, Günter, Eckhart Gillen, and Beatrice Vierneisel, eds. *Kunstdokumentation SBZ/DDR 1945–1990: Aufsätze, Berichte, Materialien.* Cologne: DuMont, 1996.

Feist, Werner David. *Meine Jahre am Bauhaus/My years at the Bauhaus.* Berlin: Bauhaus-Archiv, 2012.

Fiedler, Jeannine, and Peter Feierabend, eds. *Bauhaus.* Cologne: Könemann, 2000.

Fischer, Rudolf, and Wolf Tegethoff, eds. *Modern Wohnen: Möbeldesign und Wohnkultur der Moderne.* Berlin: Gebr. Mann Verlag, 2016.

Fleischmann, Gerd, ed. *Bauhaus drucksachen typografie reklame.* Düsseldorf: Edition Marzona, 1984.

Fleischmann, Gerd, Hans R. Bosselt, and Christoph Bignens, eds. *Max Bill. Typografie Reklame Buchgestaltung.* Zürich: Niggli, 1999.

Flierl, Thomas, and Philipp Oswalt, eds. *Hannes Meyer und das Bauhaus. Im Streit der Deutungen.* Leipzig: Spector Books, 2018.

Fraser, Murray with Joe Kerr. *Architecture and the "Special Relationship:" The American Influence on Post-war British Architecture.* Abingdon: Routledge, 2007.

Friedman, Alice. *Women and the Making of the Modern House: A Social and Architectural History.* New York: Harry N. Abrams, 1998.

Friedl, Friedrich, ed. *Walter Dexel. Neue Reklame.* Düsseldorf: Edition Marzona, 1987.

Forty, Adrian. *Words and Buildings: A Vocabulary of Modern Architecture.* London: Thames & Hudson, 2000.

Fox Weber, Nicholas, and Jeannette Redensek. *Josef Albers: Minimal Means, Maximum Effect.* Madrid: Fundación Juan March, 2014.

Geiser, Reto. *Giedion and America. Repositioning the History of Modern Architecture.* Zürich: gta Verlag, 2018.

Giedion, Sigfried. *Space, Time and Architecture: The Growth of a New Tradition.* Cambridge, MA: Harvard University Press, 1941.

Goff, Jennifer. *Eileen Gray: Her Work and Her World.* Dublin: Irish Academic Press, 2015.

Gribaudo, Paula. *Susan Weil: Moving Pictures.* Milan: Skira Editore, 2010.

Gropius, Walter. *Apollo in the Democracy: The Cultural Obligation of the Architect.* New York: McGraw-Hill, 1968.

Gropius, Walter. *Bauhausbauten Dessau.* Munich: Albert Langen Verlag, 1930.

Haanen, Karl Theodor. "Bauhausreklame." *Die Reklame* 22 (1929): 11–14.

Harwood, Elaine. *Space, Hope, and Brutalism: English Architecture, 1945–1975.* New Haven: Yale University Press, 2014.

Heller, Steven. *Paul Rand.* New York: Phaidon, 1999.

Henderson, Linda Dalrymple. *The Fourth Dimension and Non Euclidean Geometry in Modern Art. 1983.* Cambridge, MA: MIT Press, 2018.

Herbert, Gilbert. *The Dream of the Factory-Made House: Walter Gropius and Konrad Wachsmann.* Cambridge, MA: MIT Press, 1984.

Hermanson Meister, Sarah. *One and One Is Four: The Bauhaus Photocollages of Josef Albers.* New York: The Museum of Modern Art, 2016.

Herzogenrath, Wulf, et al. *50 Years Bauhaus. German Exhibition.* London: Royal Academy of Arts, 1968.

Hirdina, Heinz. *Gestalten für die Serie: Design in der DDR 1945–1985.* Dresden: Verlag der Kunst, 1988.

Hirdina, Heinz. ed. *Das neue Frankfurt, die neue Stadt. Eine Zeitschrift zwischen 1926 und 1933.* Dresden: Verlag der Kunst, 1984.

Höhne, Günter, ed. *Die geteilte Form: Deutsch-deutsche Designaffären 1949–1989.* Cologne: Fackelträger Verlag, 2009.

Hollis, Richard. *Schweizer Grafik. Die Entwicklung eines internationalen Stils.* Basel: Birkhäuser, 2006.

Horowitz, Frederick, and Brenda Danilowitz, eds. *Josef Albers: To Open Eyes.* London: Phaidon Press Limited, 2006.

Hüter, Karl-Heinz. *Das Bauhaus in Weimar: Studie zur gesellschaftspolitischen Geschichte einer deutschen Kunstschule.* Berlin: Akademie-Verlag, 1976.

Huygen, Frederike. *Modernism: In print. Dutch Graphic Design 1917–2017.* Eindhoven: Lecturis, 2017.

Isaacs, Reginald R. *Walter Gropius: Der Mensch und sein Werk.* Berlin: Gebr. Mann, 1983.

Itten, Johannes. *Design and Form: The Basic Course at the Bauhaus and Later.* John Maass, trans. New York: Reinhold Publishing Corporation, 1964.

Itten, Johannes. *The Elements of Color. A Treatise on the Color System of Johannes Itten.* New York: Van Nostrans Reinhold Co., 1970.

James-Chakraborty, Kathleen. "Beyond Cold War Interpretations: Shaping a New Bauhaus Heritage." *New German Critique* 116 (2012): 11–24.

James-Chakraborty, Kathleen, ed. *Bauhaus Culture from Weimar to the Cold War.* Minneapolis: University of Minnesota Press, 2009.

Janáková, Iva, ed. *Ladislav Sutnar: Design in Action.* Zürich: Museum für Gestaltung, 2003.

Joseph, Brandon. *Random Order: Robert Rauschenberg and the Neo-Avant-Garde.* Cambridge, MA: MIT Press, 2007.

Joseph, Brandon. *Josef Albers Glass, Color, and Light.* New York, NY: Guggenheim Museum, 1994.

Juncosa, Enrique, and Christine Kennedy, eds. *The Moderns.* Dublin: Irish Museum of Modern Art, 2011.

Kemp, Klaus, and Matthias Wagner, eds. *Alles neu! 100 Jahre neue Typografie und neue Grafik in Frankfurt am Main.* Stuttgart: Avedition, 2016.

Kennedy, Róisín. *Art & The Nation State: The Reception of Modern Art in Ireland.* Liverpool: Liverpool University Press, 2021.

Kentgens-Craig, Margaret, ed. *The Dessau Bauhaus Building.* Basel: Birkhäuser, 1998.

Kieselbach, Burckhard. *Bauhaustapete: Reklame & Erfolg einer Marke.* Cologne: DuMont, 1995.

Kepes, György, and Marjorie Supovitz, eds. *The MIT Years, 1945–1977.* Cambridge, MA: MIT Press, 1978.

Kermer, Wolfgang. *Willi Baumeister. Typographie und Reklamegestaltung.* Stuttgart: Edition Cantz, 1989.

King, Linda. "'Particles of Meaning': The Modernist Afterlife in Irish Design." In Paige Reynolds, ed., *Modernist Afterlives in Irish Literature and Culture.* London: Anthem Press, 2016. 125–40

King, Linda, and Elaine Sisson, eds. *Ireland, Design and Visual Culture: Negotiating Modernity, 1922–1992.* Cork: Cork University Press, 2011.

Kissane, Séan, and Anne Boddaert, eds. *Analysing Cubism.* Cork: Crawford Art Gallery, 2013.

Klee, Paul. "Schöpferische Konfession." In Kasimir Edschmid, ed., *Tribüne der Kunst und Zeit.: Eine Schriftensammlung,* 13. Berlin: Erich Reiss Verlag, 1920.

Klee, Paul. *Über die moderne Kunst.* Bern-Bümpliz: Benteli, 1945.

Klee, Paul. *The Diaries, 1898–1918.* Felix Klee, ed. Berkeley and Los Angeles: University of California Press, 1964/1992.

Klee, Paul. *Pedagogical Sketchbook.* London; Boston: Faber and Faber, 1968.

Klee, Paul. *Notebooks: Volume 1, The Thinking Eye.* Jürg Spiller, ed, Ralph Manheim, trans. London: Lund Humphries, 1973.

Kleiner, Ulrich, and Axel Paul. *Georg Muche: Vom Bauhaus an den Bodensee.* Munich: Allitera Verlag, 2018.

Koenig, Thilo, ed. *Hans Finsler und die Schweizer Fotokultur: Werk, Fotoklasse, moderne Gestaltung 1932–1960.* Zurich: gta, 2006.

Kriebel, Sabine T. "Florence Henri's Oblique," *October* 172 (2020): 8–34.

Kress, Celina. *Adolf Sommerfeld/Andrew Sommerfeld: Bauen für Berlin 1910–1970.* Berlin: Lukas Verlag für Kunst- und Geistesgeschichte, 2011.

Kries, Mateo, and Jolanthe Kugler, eds. *Das Bauhaus #allesistdesign.* Weil: Vitra, 2015.

Kruse, Christiane. *Das Bauhaus in Weimar, Dessau und Berlin: Leben, Werke, Wirkung.* Berlin: Braus Verlag, 2018.

Lambert, Phyllis, ed. *Mies in America.* New York: Harry N. Abrams, 2001.

Lammert, Angela, ed. *Topos Raum: Die Aktualität des Raumes in den Künsten der Gegenwart.* Berlin: Akademie der Künste, 2005.

Lane, Barbara Miller. *Architecture and Politics in German, 1918–1945.* Cambridge, MA: Harvard University Press, 1968.

Lane, Barbara Miller. ed., *Housing and Dwelling: Perspectives on Modern Domestic Architecture.* New York: Routledge, 2007.

Laxton, Susan. "Moholy's Doubt." In *Photography and Doubt.* Sabine T. Kriebel and Andrés Mario Zervigón, eds., Abingdon: Routledge, 2016.

Le Coultre, Martjin F. *Wendingen. A Journal for the Arts, 1918–1932.* New York: Princeton Architectural Press, 2001.

Lottner, Perdita. *Ring "neue werbegestalter" 1928–1933. Ein Überblick.* Wiesbaden: Landesmuseum, 1990.

Luckner-Bien, Renate, ed. *75 Jahre Burg Giebichenstein 1915–1990: Beiträge zur Geschichte.* Halle: Burg Giebichenstein, 1990.

Luckner-Bien, Renate. *Marcks kann lachen: Der Bildhauer Gerhard Marcks in Halle an der Saale.* Halle/Saale: Hasenverlag, 2019.

Magnusson, Thorhallur. "Processor Art.: Currents in the Process Orientated Works of Generative and Software Art." PhD dissertation, University of Copenhagen, 2002.

Marchant, Nick, and Jeremy Addas. *Kilkenny Design: Twenty-one Years of Design in Ireland.* London: Lund Humphries, 1984.

Maan, Dick. *Paul Schuitema. Visual Organizer.* Rotterdam: 0/10 Publishers, 2006.

Maciuika, John. *Before the Bauhaus: Architecture, Politics and the German State, 1890–1920.* Cambridge: Cambridge University Press, 2005.

Meer, Julia. *Neuer Blick auf die Neue Typographie: Die Rezeption der Avantgarde in der Fachwelt der 1920er Jahre.* Bielefeld: Transcript, 2015.

Mallgrave, Harry Francis, and Eleftherios Ikonomou, eds. *Empathy, Form, and Space: Problems in German Aesthetics, 1873–1893.* Santa Monica: Getty Center for the History of Art and the Humanities, 1994.

Mertins, Detlef, and Michel W. Jennings, eds. *G. An Avant-Garde Journal of Art, Architecture, Design, and Film 1923–1926.* Los Angeles: Getty Publications, 2010.

Moholy, Lucia. *Marginalien zu Moholy-Nagy: Dokumentarische Ungereimtheiten.* Krefeld: Scherpe, 1972.

Moholy-Nagy, László. *Von material zu architektur.* Berlin: Gebrüder Mann, 1929.

Moholy-Nagy, László. *Painting. Photography. Film. 1925.* Cambridge, MA: MIT Press, 1969.

Moholy-Nagy, Sibyl. *Moholy-Nagy: Experiment in Totality.* New York: Harper & Brothers, 1950.

Müller, Ulrich. *Raum, Bewegung und Zeit in Werk von Walter Gropius und Ludwig Mies van der Rohe.* Munich: Oldenbourg Akademie Verlag, 2004.

Muthesius, Stefan. *The Post-war University: Utopianist Campus and College.* New Haven: Yale University Press, 2000.

Nake, Frieder. *Ästhetik als Informationsverarbeitung: Grundlagen u. Anwendungen d. Informatik im Bereich ästhetischer Produktion und Kritik.* Vienna and New York: Springer, 1974.

Nerdinger, Winfried. *Walter Gropius: Architect der Moderne.* Munich: C. H. Beck, 2019.

Neue Gesellschaft für Bildende Kunst, ed. *Wunderwirtschaft: DDR–Konsumkultur in den 60er Jahren.* Köln: Böhlau Verlag, 1996.

Neumann, Dietrich. "'All the Struggles of the Present:' Alexander Dorner, Henry-Russell Hitchcock and *Rhode Island Architecture.*" In Sarah Ganz Blythe and Andrew Martinez, eds., *Why Art Museums? Alexander Dorner's Unfinished Project.* Cambridge, MIT Press, 2018. 69–92.

Neumann, Eckhard, ed. *Bauhaus und Bauhäusler: Erinnerungen und Bekenntnisse.* Cologne, DuMont Buchverlag, 1985.

Neumeyer, Fritz. "Giedion und Mies van der Rohe. Ein Paradox in der Historiographie der Moderne." *Architektur Aktuell* 183 (1995): 56–63.

Nierendorf, Karl, ed. *Staatliches Bauhaus in Weimar 1919–1923.* Weimar/Munich: Bauhausverlag, 1923.

O'Kane, Finola, and Ellen Rowley, eds. *Making Belfield: Space + Place at UCD.* Dublin: University College Dublin Press, 2020.

Oswalt, Philip. *Hannes Meyer neue Bauhauslehre: Von Dessau bis Mexico.* Basel: Birkhäuser, 2019.

Passuth, Krisztina. *Moholy-Nagy.* New York: Thames & Hudson, 1987.

Paul, Gerhard. "Die kommunistische Hochschulzeitschrift 'bauhaus' über den sozialistischen Aufbau in der Sowjetunion." *Dessauer Kalender* 21, 1977, 27–33.

Pelkonen, Eeva-Lisa, ed. *Kevin Roche: Architect as Environment.* New Haven: Yale University Press, 2011.

Perloff, Nancy, and Brian Reed, eds. *Situating El Lissitzky. Vitebsk, Berlin, Moscow.* Los Angeles: GRI, 2003.

Perren, Claudia, Torsten Blume, and Alexia Pooth, eds. *Moderne Typen, Fantasten und Erfinder. Große Pläne! Zur angewandten Moderne in Sachsen-Anhalt 1919–1933.* Bielefeld: Kerber, 2016.

Pfeiffer, Ingrid, and Max Hollein, ed. *László Moholy-Nagy: Retrospektive.* Munich: Prestel, 2009.

Pfützner, Katharina. *Designing for Socialist Need: Industrial Design Practice in the German Democratic Republic 1949–1990.* London/New York: Routledge, 2018.

Platz, Gustav Adolf. *Die Baukunst der Neuesten Zeit.* 1927. Berlin: Propyläen Verlag, 1930.

Pollard, Carole. "A Lifelong Affair – Liam McCormick and Imogen Stuart." In Lisa Godson and Kathleen James-Chakraborty, eds., *Modern Religious Architecture in Germany, Ireland, and Beyond: Influence, Process and Afterlife since 1945.* New York: Bloomsbury Visual Arts, 2019. 41–61.

Pommer, Richard. "The Flat Roof: A Modernist Controversy in Germany." *Art Journal* 43 (1983): 158–69.

Powers, Alan. *Bauhaus Goes West: Modern Art and Design in Britain and America.* London: Thames & Hudson, 2019.

Price, Colin B. "From Kandinsky to Java (The Use of 20th Century Abstract Art in Learning Programming)." In *Innovation in Teaching and Learning in Information and Computer Sciences* 6.4 (2007). https://doi.org/10.11120/ital.2007.06040035

Purvis, Alston W., and Cees W. De Jong. *The Enduring Legacy of Weimar: Graphic Design & New Typography.* Munich/London: Prestel, 2019.

Rattemeyer, Volker, and Dietrich Helms. *Friedrich Vordemberge-Gildewart. Typographie und Werbegestaltung.* Wiesbaden: Museum Wiesbaden, 1997.

Rattemeyer, Volker, and Dietrich Helms. *Kurt Schwitters. Typographie und Werbegestaltung.* Wiesbaden: Museum Wiesbaden, 1990.

Reas, Casey, and Chandler McWilliams. *Form + Code in Design, Art, and Architecture.* New York: Princeton Architectural Press, 2010.

Reinfurt, David, Robert Wiesenberger, and Lisa Strausfeld, eds. *Muriel Cooper.* Cambridge, MA: MIT Press, 2017.

Rose, Barbara. *Rauschenberg.* New York: Vintage Books, 1987.

Rössler, Patrick. *Die neue linie 1929–1943: Das Bauhaus am Kiosk.* Bielefeld: Kerber, 2007.

Rössler, Patrick, ed. *Bauhauskommunikation: Innovative Strategien im Umgang mit Medien, interner und externer Öffentlichkeit.* Berlin: Gebr. Mann, 2009.

Rössler, Patrick. *The Bauhaus and Public Relations: Communication in a Permanent State of Crisis.* Abingdon: Routledge, 2014.

Rössler, Patrick. *Bauhaus Typography. 100 Works from the Collection of the Bauhaus-Archiv Berlin.* Berlin: Bauhaus-Archiv, 2017.

Rössler, Patrick. *New Typographies. Bauhaus & Beyond: 100 Years of Functional Graphic Design in Germany.* Göttingen: Wallstein, 2018.

Rothery, Sean. *Ireland & The New Architecture, 1900–1940.* Dublin: Lilliput Press, 1991.

Rowley, Ellen. *Housing, Architecture and the Edge Condition: Dublin Is Building, 1935–1975.* Abingdon: Routledge, 2018.

Rowley, Ellen, ed. *More than Concrete Blocks: Dublin's Twentieth-century Buildings and Their Stories, 1940–72.* Dublin: Dublin City Council, 2019.

Sachsse, Rolf, *Lucia Moholy.* Düsseldorf: Editionen Marzona, 1985.

Saletnik, Jeffrey, and Robin Schuldenfrei, eds. *Bauhaus Construct: Fashioning Identity, Discourse and Modernism.* Abingdon: Routledge, 2009.

Sassoon, Vidal. *Vidal Sassoon and the Bauhaus.* Stuttgart: Cantz Verlag, 1994.

Sassoon, Vidal. *Vidal: The Autobiography.* London: Macmillan, 2010.

Schnaidt, Claude. *Hannes Meyer: Buildings, Projects and Writings.* Stuttgart: Verlag Gerd Hatje, 1965.

Schuldenfrei, Robin. "Images in Exile: Lucia Moholy's Bauhaus Negatives and the Construction of the Bauhaus Legacy." *History of Photography* 37.2 (2013): 182–203.

Schuldenfrei, Robin. *Luxury and Modernism: Architecture and the Object in Germany, 1900–32.* Princeton: Princeton University Press, 2018.

Schulze, Franz, and Edward Windhorst. *Mies van der Rohe: A Critical Biography.* Chicago: University of Chicago Press, 2012.

Schwarting, Andreas. *Siedlung Dessau-Törten: Rationalität als ästhetisches Programm.* Dresden: Thelman, 2010.

Schwartz, Frederic J. *The Werkbund: Design Theory and Mass Culture before the First World War.* New Haven: Yale University Press, 1996.

Semrau, Jens, ed. *Was ist dann Kunst? Die Kunsthochschule Weißensee 1946–1989 in Zeitzeugengesprächen.* Berlin: Lukas Verlag, 2004.

Shortt, Peter. *The Poetry of Vision: The ROSC Art Exhibitions, 1967–1988.* Dublin: Irish Academic Press, 2018.

Simon, John F. *Mobility Agents: A Computational Sketchbook v1.0.* New York, NY: Whitney Museum of American Art and Printed Matter, Inc., 2005.

Simon-Ritz, Frank. "'Ein gut fundiertes und aussichtsreiches Unternehmen': Vom Scheitern des Bauhausverlags." In Ute von Schneider, ed. *Imprimatur: Ein Jahrbuch für Bücherfreunde XXV.* Wiesbaden: Harrassowitz, 2017. 293–308.

Somol, Robert E., ed. *Autonomy and Ideology: Positioning an Avant-garde in America.* New York: Monacelli Press, 1997.

Stiftung Bauhaus Dessau, ed. *Das Bauhaus zerstört, 1945–1947, das Bauhaus stört* Dessau: Verlagsgesellschaft, 1996.

Stirton, Paul. *Jan Tschichold and the New Typography. Graphic Design between the World Wars.* New Haven: Yale University Press, 2019.

Strupkus, Annike, ed. *Bauhaus Global: Gesammelte Beiträge der Konferenz Bauhaus Global.* Berlin: Martin Gropius Bau/Bauhaus Dessau, 2009.

Szylvian, Kristin M. "Bauhaus on Trial: Aluminum City Terrace and Federal Defense Housing Policy during World War II." *Planning Perspectives* 9 (1994): 229–54.

Tegethoff, Wolf. *Mies van der Rohe: The Villas and Country House.* Cambridge, MA: MIT Press, 1985.

Thöner, Wolfgang, and Monika Markgraf. *Die Meisterhäuser in Dessau.* Leipzig: Spectormag, 2018.

Thöner, Wolfgang, and Alexia Pooth, eds. *Neue Meisterhäuser in Dessau, 1925–2014. Debatten, Positionen, Konstexte.* Edition Bauhaus 46. Leipzig: Spector Books, 2017.

Thorpe, Ruth, ed. *Designing Ireland: A Retrospective Exhibition of Kilkenny Design Workshops 1963–1988.* Kilkenny: Crafts Council of Ireland, 2005.

Tompkins, Calvin. *Off the Wall: A Portrait of Robert Rauschenberg.* New York: Picador, 2005.

Turpin, John. "The Irish Design Reform Movement of the 1960s." *Design Issues* 3 (1986): 3–21.

Von Osten, Marion, and Grant Watson, eds. *Bauhaus Imaginista*. London: Thames & Hudson, 2019.

Von Saldern, Adelheid. *The Challenge of Modernity: German Social and Cultural Studies, 1890–1960*. Ann Arbor: University of Michigan Press, 2002.

Wachsmann, Christiane, *Vom Bauhaus beflügelt.: Menschen und Ideen an der Hochschule für Gestaltung Ulm*. Stuttgart: Avedition, 2018.

Wahl, Volker, ed. *Die Meisterratsprotokolle des Staatlichen Bauhauses Weimar 1919 bis 1925*. Weimar: Böhlau, 2001.

Wehde, Susanne. *Typographische Kultur. Eine zeichentheoretische und kulturgeschichtliche Studie zur Typographie und ihrer Entwicklung*. Tübingen: Max Niemeyer, 2000.

Weizman, Ines, ed. *Dust and Data: Traces of the Bauhaus across 100 Years*. Leipzig: Spector Books, 2019.

Whitford, Frank. *Bauhaus*. London: Thames & Hudson, 1984.

Wingler, Hans Maria. *The Bauhaus: Weimar, Dessau, Berlin, Chicago*. Cambridge, MA: MIT Press, 1969.

Zitzmann, Lothar, and Benno Schulz. *Grundlagen Visueller Gestaltung*. Halle: Hochschule für Industrielle Formgestaltung Halle Burg Giebichenstein, 1990.

Index